XML FOR WEB DESIGNERS

USING
MACROMEDIA® STUDIO MX 2004

XML FOR WEB DESIGNERS

USING
MACROMEDIA STUDIO MX 2004

KEVIN RUSE

CHARLES RIVER MEDIA, INC.

Hingham, Massachusetts

Publisher: Jenifer Niles
Production: Publishers' Design and Production Services, Inc.
Cover Design: The Printed Image

CHARLES RIVER MEDIA, INC.
10 Downer Avenue
Hingham, Massachusetts 02043
781-740-0400
781-740-8816 (FAX)
info@charlesriver.com
www.charlesriver.com

This book is printed on acid-free paper.

Kevin Ruse. *XML for Web Designers Using Macromedia Studio MX 2004.*
ISBN: 1-58450-301-7

Library of Congress Cataloging-in-Publication Data
Ruse, Kevin, 1963–
 XML for web designers using Macromedia Studio MX 2004 / Kevin Ruse.
 p. cm.
 ISBN 1-58450-301-7
 1. XML (Document markup language) 2. Macromedia Studio MX. 3. Web
site development. I. Title.
QA76.76.H94R89 2004
006.7'4—dc22
 2003025970

Printed in the United States of America
04 7 6 5 4 3 2 First Edition

This book is dedicated with all my love to Mom and Dad,
who are everything that I aspire to be.

CONTENTS

PART III XML AND FIREWORKS MX PROFESSIONAL 2004 305

CHAPTER 6 XML AND FIREWORKS MX 2004 307

CHAPTER 7 MACROMEDIA FLASH MX PROFESSIONAL 2004 AND XML FUNDAMENTALS 331

APPENDIX A LIST OF DATA FILES FOR THE TUTORIALS 377

APPENDIX B SITE DEFINITION INSTRUCTIONS 389

ACKNOWLEDGMENTS

I would like to acknowledge everyone who helped me write this book: George, Deb, Susanne, Jody, Kerry, Erin, Danny, Jimmy, Skye, Chuck (who found everything I needed—"wait... I got it"), Joe Rivera (who helped with the data entry), Suzanne, Luis, Elliot and Tony Rivera, who fed me, and Ron and Linda, who encouraged and believed in me. Thank you especially to Jenifer Niles, who managed to leave me alone when I needed to write yet held my hand every step of the way.

PREFACE

INTRODUCTION

This book provides you with a thorough and detailed examination of the Extensible Markup Language (XML). What makes it different from other XML books is its perspective—this book is for Web designers who are familiar with Macromedia® Studio MX 2004. The XML syntax and concepts as well as its companion languages are taught through tutorials using Dreamweaver® MX 2004, Fireworks® MX 2004, and Macromedia® Flash™ MX Professional 2004. The author does not presuppose any knowledge of XML; however, you should have experience designing and coding Web sites, preferable with Macromedia® software.

Who Should Read This Book

Experienced Web designers who use the Macromedia Studio MX 2004 suite of products will receive a thorough introduction to XML using the software with which they are most comfortable, including Dreamweaver, Fireworks, and Flash. If you are a n Dreamweaver, Fireworks, or Flash, you may wish to c tutorials that come with Studio MX before beginning t that you are more familiar with the software.

What You Will Learn

You will learn the XML language as well as its com guages and technologies. Through a series of tutorials media products you will learn specifically how XML and leveraged by Dreamweaver, Fireworks, and Flas first chapter, you will understand the concepts behin

why the language has become so pervasive. When you are finished with this book, you will able to do the following:

- Understand XML and its role in the future of information technology and Web development
- Configure Dreamweaver MX 2004 as an XML editor
- Write both well-formed and valid XML code using Dreamweaver MX 2004
- Write an XSL-T stylesheet that transforms XML into HTML with Dreamweaver MX 2004
- Write an XSL-T stylesheet that prepares the XML data for use as a template in Dreamweaver MX 2004
- Create a Dreamweaver MX 2004 template that accepts data from an XML file
- Write a cascading stylesheet for an XML file using Dreamweaver MX 2004
- Build a dynamic, data-driven Web site with Dreamweaver MX 2004 and ColdFusion® Markup Language
- Build multiple graphics files (such as Web banner ads) with Fireworks MX 2004 using information from an XML file
- Send and receive live data from a Flash MX Professional 2004 file

The Focus of This Book

Many books describe XML in the field of programming and explain what computers can do with XML. This book concentrates on XML for the Web designer. It focuses on how you can visually deliver XML-based information, specifically using Macromedia products. It does discuss the big-picture aspect of XML; however, the concentration is the visual display of XML data through various types of media.

By adding XML and its related companion languages to your resume, you can participate in the awesome array of possibilities that the future of Web development is sure to bring, no matter where you are positioned in the workflow. Programmers, Web designers, and Webmasters all benefit from knowledge of XML.

The focus of the information in this text is for Webmasters, Web designers, and production staff who use the Macromedia Studio MX Suite of Web development tools and are wondering why they should learn XML and how they can incorporate it with their current tools.

Consider that new technologies often redefine the division of labor within an industry. All you have to do is look to the auto industry and the real estate industry to see the many ways technology has altered the processes inherent in these fields. The publishing field is another example. The growth of technology that began with desktop publishing has all but ended the career of the typographer, the camera operator, and the printing-plate maker. The Web design and production environment is no different. With its tight budgets and quick turnaround times, the division of labor often results in a loss of jobs or, at best, shared responsibilities among Web designers, programmers, and production artists. XML is a technology that can increase the productivity and effectiveness of any of the players in Internet-related solutions.

Part I is a two-chapter introduction to XML. Chapter 1 answers the question, "Why should Web designers learn XML?" Following the answer to that question, the idea of learning XML through Macromedia software is addressed. The chapter concludes with a description of the role a Web designer might take in implementing XML.

Chapter 2 contains an overview of XML and its related technologies. This chapter lays the groundwork for the tutorials that follow. After a brief history of XML, the chapter focuses on the principles and concepts that drive XML technology today. The chapter includes an exercise that allows you to view Web sites that use XML in some way.

Part II is the first of three parts that include hands-on tutorials that guide you through the intricate details of XML, XSL, CSS, DTD, schema, and more, using Macromedia products, beginning with Dreamweaver MX 2004.

Chapter 3 provides a thorough study of XML, including how to write well-formed XML, valid XML, DTDs, and schemas.

Chapter 4 expands on the XML files you created in Chapter 3 by making them suitable for the Web and includes three tutorials. The first tutorial uses CSS to format the XML file created in Chapter 3. The second tutorial uses the Extensible Markup Stylesheet Language to transform the XML file into an HTML file. The final tutorial in Chapter 4 provides details for configuring Dreamweaver MX 2004 as your XML editor.

Chapter 5 includes tutorials that demonstrate how to use the skills from previous chapters to prepare XML files for automated processing in Dreamweaver MX 2004. You will create templates

that accept the XML files created in Chapter 3 as the data that populates the templates.

Part III explores the XML support found in Fireworks MX 2004.

Chapter 6 includes a tutorial in which you will create Web banner ads from the information in the XML files created earlier.

Chapter 7 discusses XML for Flash MX Professional 2004 and includes tutorials that show how Flash MX Professional 2004 reads and displays XML data.

WHAT YOU WILL NEED TO COMPLETE THE TUTORIALS IN THIS BOOK

The system requirements to complete the tutorials for the book follow:

Minimum System Requirements

Minimal PC Hardware:

PC with a Pentium 486 MHz processor or equivalent
32MB RAM or higher
Windows 98 or higher

Minimal Mac Hardware*:

Power PC
400MHz or higher
32MB RAM or higher
OS 9.2 or higher

Software:

Macromedia Studio MX 2004 (full installation including the Cold-
 Fusion MX Developer Edition)
Alternatively you can download trial versions of each individual
 software product:
 Dreamweaver MX 2004
 Fireworks MX 2004
 Coldfusion MX 6.1
 Flash MX Professional 2004
Internet Explorer 5.x or higher
Simple text editor

Recommended System Requirements

PC with a 750 processor
Operating Systems:
 Windows XP
 Macintosh OS 10.2*

Using the Companion CD-ROM

Insert the CD-ROM in your CD-ROM drive. Copy the folder called "Tutorials" to your hard drive.

What's on the CD-ROM

Directories
Software
Tutorials
Resources

How to Contact the Author

You can visit the author's Web site at *www.kevinruse.com*, or e-mail comments and questions to him at kratraining@vzavenue.net.

* Due to limited support of XML on the Macintosh platform, some operations will not be successful.

I

Introduction to XML

The following two chapters serve as an introduction to XML—what it is and how it came to be. This introduction includes the problems and issues that helped shape the language. Chapter 1 answers the question "Why learn XML?" Chapter 2 covers XML and the various technologies and languages related to it. It serves as an overview of the language and its companion languages and concludes with a Web-based tour of XML that demonstrates how these technologies work together. Most Web designers are anxious to work through the tutorials and get their hands on the XML code; Chapters 1 and 2 serve as an excellent explanation of the many uses of XML, and are recommended reading if you are unfamiliar with the concepts of XML. In addition, these chapters provide a big-picture overview of XML and why it will soon be as common a file format as ASCII text is today. Understanding where XML came from and what problems it was intended to solve go a long way toward the effective application of XML in your work-flow.

1

INTRODUCTION TO XML

In This Chapter

- Why learn XML?
- Why XML and Macromedia products?
- The Web designer's role in implementing XML

Chapter 1 answers the question, "Why should Web designers learn XML?" A brief explanation of an XML file is followed by a description of XHTML and the second generation World Wide Web dubbed the "Semantic Web," all of which provide the means to answer our initial question, "Why should Web designers learn XML?"

WHY LEARN XML?

You should learn XML because it is the future of the Internet. The XML syntax has already replaced the Hypertext Markup Language, which is now known as XHTML 1.0. XML precedes Web-based Internet applications by installing itself as a structured, organized form of data storage for the content that is ultimately delivered via various mediums including print, Web, and devices that contain Web browsers such as cell phones and portable digital assistants (PDAs).

There is a growing momentum behind XML that began five years ago when the World Wide Web Consortium (W3C) XML working group commenced development of the Extensible Markup Language (XML). Members of the working group included Adobe, Microsoft, Netscape, Sun Microsystems, Hewlett-Packard, and 35 other major companies and organizations. Since that time XML has been written up in Internet technology publications such as *Info-World* and *PC Week*, as well as mainstream news magazines such as *Time* and *Scientific American*. Major industry analysts including the Gartner Group and industry newsletters such as *Seybold* now cover XML routinely.

According to analysts at IDC, sales of XML development tools will hit US$395 million worldwide by 2006. IDC concludes that XML has become the de facto standard for information integration, thus causing the XML tool market to grow by 41.5 percent annually through 2006. Perhaps the largest single contribution to the explosion of XML is the 250-billion-dollar, Web-based supply chain collaboration between automakers Ford, General Motors, and DaimlerChrysler, which enables the electronic procurement of parts and services between the auto manufacturers and their vendors. This procurement system is based on a Web services model, which itself relies heavily on XML.

Private industries' adoption of XML is just the beginning. With a federal budget of more than 48 billion (16 times the annual IT expenditure of GM alone), the U.S. government is poised to be potentially the largest consumer of structured information processing, and it appears to be focused on implementing XML for just this purpose. The General Services Administration has commissioned Booz-Allen and Hamilton to study the creation of a registry and repository of XML. The Federal Information Technology Service of the federal government has established the Chief Information Officers Council to improve practices for the management of informa-

tion technology. One of the CIO Council's main goals is to develop recommendations for federal information technology management, practices, and procedures. The council has formed an XML working group to further their goal and is working with the Federal Office of Management and Budget to incorporate plans for this XML registry and repository in the fiscal year 2004 budget. The government's XML efforts already underway include topics ranging from child support enforcement to federal grant processing. Further proof of the government's willingness to adopt XML is seen in the Department of Justice, State Department, and the U.S. Navy, all of which are working with the Organization for the Advancement of Structured Information Standards (OASIS), a consortium that develops electronic business standards including XML.

According to a recent study (March 2003) by Software AG (a German-based XML software company specializing in enterprise data integration and management), XML has caught on as a future-oriented technology. According to the survey the majority of XML users are in the financial industry followed by public administration, media, and manufacturing. Once companies experience the benefits of XML in an initial undertaking, they almost universally adopt it for future projects.

Software support provides a popular clue as to how a technology will grow. Are the major software manufacturers embracing the technology? For XML, the answer is a resounding yes. For example, the new version of Microsoft® Office has incorporated XML support throughout its products in both the user interface and in its background processes. Both Microsoft Excel 2003 and Access 2003 include what Microsoft calls workbook models with which to swap data to and from XML data sources. Excel 2003 can export to or receive XML data from user-specified databases. Microsoft includes the ability to tag or mark up your company's particular documents in an XML format called *schemas*, which facilitate computer data processing and data sharing. Other major software companies that have implemented XML in their applications include QuarkXPress™, Adobe®, and Macromedia®. The increase in the growth of Web browser support since 1996 is a clear indication of the momentum behind the technology. When the XML specification was first released by the W3C, Microsoft followed with the release of Internet Explorer 4.0 with XML support, followed by Internet Explorer 5.0, which expanded upon the initial XML functionality. Microsoft continues to develop their XML parser component to adopt the most recent XML developments. Netscape followed with their version

6.0 browser. Perhaps the most dramatic support comes from the original World Wide Web markup language, the Hypertext Markup Language (HTML). The latest version of HTML is now XHTML, based on XML.

As far as Web-based implementation of XML goes, examples abound, with more XML-based Web sites created daily. In the summer of 2002, *USA Today* implemented an XML-based system for delivery of its online newspaper. Editors now mark up their stored content in XML. Prior to this system, USAToday.com stored its content in HTML, making it difficult to ascertain headlines, bylines, and so on. Now editors tag wire stories (from Reuters, AP, and other services) with an XML editor. They have created their own language (using the XML metalanguage), which is loosely based on another XML language known as the News Markup Language, that includes metadata such as where the story should end up on their Web site. XML software tools then scan and categorize the stories, compose headlines, write summaries, and list keywords. The system frees up editors' time and also provides consistency in the way stories are categorized.

XML is indeed the future of the Internet, and its infrastructure is already in place to some degree throughout various industries. The tools Web designers use today, such as Macromedia Dreamweaver MX 2004, Flash MX Professional 2004, and Fireworks MX 2004, are now implementing XML and will continue to do so with more features added to each upgrade.

How Will XML Revolutionize the World Wide Web?

XML is an exciting technology that is poised to deliver on its promise of revolutionizing the World Wide Web. How does XML revolutionize the Web? One way is by attempting—time will tell if it succeeds—to future-proof our current systems of information storage and retrieval. In other words, it provides a file format in which you can store data without regard to future technologies. It is a file format that can change over time to accommodate whatever systems the future brings.

Consider this: Would you put an eight-track cartridge in a DVD player? Could you? The idea of recording music to devices for playback is not new. After eight-track cartridges, there were cassette cartridges; before both, LPs or records, and now compact discs and digital music formats, such as MP3, are available. With the birth of each new technology the thought exists that it is the ultimate tech-

nology, the last technology, the technology to end all others. History, however, has shown us that there is and always will be another way of doing things. The computer age has exemplified this fact of life with blazing speed. Consumers, both businesses and individuals, face this challenge every time they invest in a new technology, whether an operating system, software, hardware, or a programming language. Each of these investments comes at a cost. The implementation cost is usually counted in dollars spent on software and hardware, training, downtime in productivity, and so on. The idea that money can be invested in a technology that does not last has led to terms like *scalability*, *usability*, *backwards-compatibility*, and *future-proof*. One of the more recent buzzwords is *interoperatability*, a concept that goes beyond making your current investment in technology last the test of time to making sure it plays well with the other technologies.

The one thing that can be counted on in information technology–based life is change. After the first metalanguage, GML, evolved into the standard SGML and the reduced version XML, numerous markup languages, including VML, MathML, and WML, were developed. This explosion of markup languages is due primarily to XML, which is a framework with which you create your own markup language that describes data, documents, or processes. XML can describe virtually anything, including a picture, a book, a device, a database, a configuration, a process, or instructions. But what XML has succeeded in doing, and where prior technologies have failed, is it lets you put an eight-track cartridge in a DVD player. It allows for and was designed with the concept of change in mind.

What Is XHTML?

Another reason to learn XML is because it is the foundation of XHTML, which is the latest implementation of HTML—yet another example of XML revolutionizing the World Wide Web. If you choose to ignore XML, you may miss the boat that takes you on the ride to the future of the Internet.

Although the World Wide Web as it is known today has been in existence for a little over 12 years, its author, Tim Berners-Lee, envisions its adolescent years, like human adolescence, to be a time of incredible growth and maturation. In fact, this aspect of the Web, known as the Semantic Web, was at the heart of Berners-Lee's original concept. It is only now that the Web is taking steps toward

this vision, with the aid of Tim Berners-Lee and the organization he heads, the World Wide Web Consortium (W3C).

What Is the Semantic Web?

Most people know that Tim Berners-Lee invented HTML, a language that profoundly changed the Internet and its prevalence in our lives. Berners-Lee's grander vision of the Internet (dubbed the Semantic Web) is now gaining attention through the development of XML. In this vision, the Internet is a medium capable of understanding, capable of intelligence. An environment where a Yahoo!-type search engine would not only return a string of characters that matches the query but also would understand the query semantically and return an intelligent response. What makes the Semantic Web possible is the fact that XML describes data in a structural format, thus allowing the marked-up data to be processed by machines as well as understood by humans. Consider the following:

```
<myFavoriteMovies>
<movie>Casablanca</movie>
<actor>Humphrey Bogart</actor>
<co-stars>Ingrid Bergman</co-stars>
```

Can you figure out what this file is about? How about this one:

```
<resume>
  <name>
    <firstName>Kevin</firstName>
    <lastName>Ruse</lastName>
  </name>
  <address>
    <street>123 Main Street</street>
    <city>New York City</city>
    <zip>11111</zip>
  </address>
  <employmentHistory>
```

Essentially XML is a self-describing document that can be processed by a computer much like a database. In fact, many servers store XML in a relational database. What makes XML profoundly different from its predecessors are its companion technologies: schema, XSL, X-Path, and, in particular, XSL-T. These companion technologies are where XML's adaptability comes into play. XSL-T (XML Stylesheet Language-Transform) is yet another

markup language that is used to transform XML files into any other type of file. For example, data could be stored in an XML file and then transformed via XSL-T to HTML for the Web, Wireless Markup Language for Portable Digital Assistants (PDAs) and cell phones, PDFs for print, and so on. The possibilities are endless, including the possibility to transform XML into a language that has yet to be created.

How Is XML Structured?

How is it that XML will lead us into this next generation of the Web? XML is a self-describing document that structures both documents and data (information). Now add the Resource Description Framework (RDF), a concept that takes XML information and expresses its relationship to and between other information. The end result—in time, of course—is a Web document that not only describes itself but also is capable of being understood on a semantic level by other documents.

For example, do a Web search using a search engine such as Yahoo!, AltaVista, or Ask Jeeves on the question, "Where can I learn about XML for free?" The search engine uses the string you typed and returns Web pages that include those words, omitting words like *I, Where, about,* and *for.*The search results would return a large set of documents that include the words *XML* and *free*. Some search engines do a better job of returning relevant results than others, but they all use the same basic method. If more Web pages contained XML, a search engine could infer the meaning of these pages and, using RDF, consider the relationship these pages have to one another. It would then be possible for the search engine to *understand* what you are looking for, rather than just returning Web pages that contain the keywords in your search query. Thus, only Web sites that offer free training in XML would be returned. The program—call it a logic engine—would apply mathematical reasoning to each item found.

If you think you need to learn a new markup language in the same way you may have thought you needed HTML, you are mistaken. HTML is a medium. Actually, the World Wide Web is the medium, and HTML is the language used to communicate via that medium. XML is much more. Can you use XML to communicate on the World Wide Web? Yes. However, you can use it for much, much more than that. It transcends the visual environment and goes beyond the realm of information storage.

What does all of this mean to the Web designer? The answer is simple. This ubiquitous XML file is coming soon to a desktop computer near you. Indeed, it already has. As you examine the new MX upgrade of the Macromedia products, you will see how they have all adopted some degree of XML compatibility.

WHY XML AND MACROMEDIA PRODUCTS?

You could safely avoid the XML aspects of the Macromedia user interface, but you would miss the built-in architecture of efficiency and effectiveness, not to mention all the fun. Macromedia is excited to introduce this support of XML throughout their line of Web-design products, and the MX 2004 release is only the beginning of this support. XML-aware products are turning up everywhere. Perhaps the biggest boost will be the Microsoft Office 2003 Suite of products, including Microsoft Word, Microsoft Power-Point™, and Microsoft Excel. The first public beta version of Office includes XML as a native file format, so if you have heard that only programmers and database engineers will be creating XML, you are in for a surprise.

XML will become as ubiquitous as the text (.txt) file. Web designers are likely to see XML as the content from which they build their Web sites. Now is the time for Web designers to get a jump on XML before it is deeply embedded throughout your workflow.

For yet another reason to learn XML, let's take a look at why Macromedia chose to add XML support—user requests. Many designers already work in an environment that generates XML. Despite the fairly recent adoption of XML in the user interface, XML is a mature technology. The markup language became a recommendation of the W3C in February 1998, making the language already five years old. With the MX 2004 release, the user population has grown far and wide from its original base of Web designers. By combining Dreamweaver with Dreamweaver UltraDev and implementing .jsp, .asp, and ColdFusion, Macromedia has opened the use of Dreamweaver MX 2004 to developers, programmers, and database specialist, all working together with Web designers to create Web applications. All of these areas benefit from the use of XML, and Macromedia has responded to the requests of their users.

Supporting XML also aligns with the company's history of supporting industry standards. Macromedia supports both W3C recommendations as well as popular technologies such as .asp and .jsp

and .asp.net. As XML grew in maturity and gained popularity as a markup language, Macromedia adopted it.

Macromedia adapts itself to its users' workflows. By understanding its audience, the company has seamlessly interwoven its own products (Fireworks MX 2004, Flash MX Professional 2004, and Dreamweaver MX 2004) with minimal interruption and maximum efficiency. XML is rapidly becoming a part of the Web designer's workflow. Rather than working with raw text files generated from a word processor or records culled from a database, designers will frequently be handed an XML file. Recognizing this fact, Macromedia initiated the process that will allow the Web designer to succeed in created Web sites via XML data.

Finally, Macromedia has always geared its products toward the prevailing winds of technological change, and the prevailing wind now is XML. With the support of Macromedia, Microsoft, Oracle, IBM, and other major players, XML is well on its way to being a common file format for Web-bound information.

XML and Dreamweaver MX 2004

Web designers usually fall somewhere between the two extremes of HTML authoring methods. There are those who remain in the Dreamweaver MX 2004 Design Mode and never look at HTML code. These people might think, "Why should I learn XML? I don't want to learn a complicated markup language and that is why I use Dreamweaver MX 2004 in the first place." Then there are those who come from a background of writing Web pages in Notepad. They use Dreamweaver MX for its WYSIWIG environment but spend a great deal of time in Code View. Examining and often typing code directly, they use Dreamweaver MX 2004 to take advantage of its ease of use in maintaining Web sites and its automation features. These people wonder, "What can XML do for me?"

Even if you never work in Code View, Dreamweaver MX 2004 has still taught you some HTML (perhaps without your knowledge and consent). The Dreamweaver MX 2004 property inspector prompts you for heading styles and table code, such as cell padding and cell spacing, and other settings, all of which are HTML terms. Regardless of where you land on the raw code versus WYSIWIG scale, you may have noticed some new menu items in Dreamweaver MX 2004. Perhaps when you created your first Web page with Dreamweaver MX 2004, you noted the option to create an XML page. Or maybe while working with a Dreamweaver template

you saw the Import XML Data menu item. So, now you are more than a bit curious about XML and wonder why it has become part of the Dreamweaver MX 2004 user interface.

XML and Flash MX Professional 2004

Dreamweaver MX 2004 is not the only Macromedia product to support XML. Macromedia Flash has recognized XML since version 5. Macromedia Flash MX Professional 2004 has increased its support of XML through its scripting language, ActionScript. Macromedia Flash MX Professional 2004 is now capable of loading XML files and reading them, as well as writing XML, on both the client side and the server side. This functionality opens wide the possibility of dynamic, data-driven Web sites created completely within Flash MX Professional 2004.

XML and Fireworks MX 2004

Even Fireworks MX 2004 implements XML in its Data-Driven Graphics Wizard. This exciting component creates multiple graphics files using XML data. A banner ad, for example, can be created as a Fireworks template. The wizard then creates multiple banner ads, substituting different images and text for each banner. The images and text are located in an XML file that is read by the wizard through user-embedded variables. This functionality is similar to a macro, with the end result being a number of graphics files, all slightly different but based on a standard design.

THE WEB DESIGNER'S ROLE IN IMPLEMENTING XML

How productive would a designer be if he did not understand the basic file formats for graphics? Even if the designer's role is one of pure design and no production, he still needs to communicate effectively with the production artists. To aide that communication, designers learn the basic file formats and their capabilities. If the designer is also a production artist, he learned through trial and error the advantages and disadvantages of a TIFF file versus an EPS file. Understanding how software handles TIFF files versus EPS files went a long way toward eliminating production errors. By understanding the capabilities of a GIF file versus a GIF 89 file (in transparency, for example), the designer could choose exactly the file

format required. If other properties were desired (more than one level of transparency, for example), additional file formats, such as PNG, were created.

In addition to file formats for graphics, basic file formats exist for text. As more and more applications generated text files, the differences between a Microsoft Word file and a WordPerfect file became obvious and problematic. In addition to proprietary file formats are the basic generic file formats. Thus, you can ask clients for the type of file that would best suit your production environment. Knowing the difference between an ASCII file and a Rich Text file can shave several hours or days off the production schedule.

Eventually XML will be as ubiquitous as the text and graphics files designers work with on a daily basis today. In the same way that Web and graphic designers educated themselves about these issues, they must educate themselves about XML. They should be able to recognize and understand the basic structure of an XML file as well as have a fundamental understanding of what XML can do, either within a single design project as well as a source of data for other projects.

It is hard not to notice the hype behind XML as well. Articles about XML abound, appearing not only in trade publications but also in *Newsweek* and *Scientific American*. For Web designers, the news is everywhere. You may be the type of designer who feels it is wise to keep up with the latest standards, and this is how you discovered XML. Then the news hit that there would be no HTML 5.0 and that the latest markup language for the World Wide Web, XHTML 1.0, is based on the syntax of XML. Now you wonder if your Web site adheres to this new standard, and, more important, you wonder if it should.

How Does the Designer Implement His Role?

The trend in design software today is to incorporate XML functionality into the program itself. In addition to the design software is the software used by those who contribute the content for Web pages. Administrative assistants, project coordinators, and subject matter experts may be using word processing or database software that generates XML output files. A growing area of development, called content management software, relies on XML to sort, combine, manage, and query content files such as graphics, spreadsheets, word processing files, and database information. In the

design arena, XML is used for asset management—the archiving and administration of digital assets. Most in-house designers at large corporations have at one time or another created an ad hoc system for managing digital files (assets), such as images, text files, finished QuarkXpress layouts, and so on. Content management software is a complete system for controlling these digital assets. It is meant to reduce errors, such as incorporating an outdated graphic in a printed catalog, and streamline the workflow by making these digital files easy to locate.

The designer's goal today should be to identify this XML-aware software and use it. In most cases, it will be the software you have been using throughout your design and production career. This trend of incorporating XML functionality in desktop publishing is evidenced by the fact that Adobe offers its last version of Framemaker® as Framemaker+SGML and a basic version (without SGML functionality). The newest version, Framemaker 7.0, now includes the SGML authoring features in its basic program. This basic package also allows XML authoring. QuarkXpress adopted the same approach with its avenue.quark™. Originally released as one of the QuarkXTensions™ capable of formatting XML files for page layout, it is now incorporated as part of the latest release, QuarkXpress 5.0.

XML allows you to output the content for one design, such as a catalog, to another medium, such as the Web. To be productive in this type of workflow, the designer needs to familiarize himself with the software that accepts, edits, and outputs from XML. Macromedia created some of the first Web design tools in use and today holds the greatest market share among Web designers, making it an excellent choice for learning and implementing XML.

What Can a Web Designer Do?

One of the main selling points of XML has been its structured, self-describing format. XML is a pure data file that contains no information regarding how the data should look, thus, allowing designers to present it in any way they choose. In addition, they have the flexibility to present the data for a variety of devices or mediums, such as PDF for print and XHTML for Web, without having to rewrite the data. This separation of the function of data from its format can be liberating. How Web designers approach XML is, of course, up to them. From a design perspective, XML coding is not a required skill. From a production standpoint, however, designers have several choices regarding this new technology. As

more software outputs XML, Web designers can expect to receive content for design projects in the form of XML files. Thus, graphic designers must address the XML issue one way or another.

XML is a technology, not a religion. As such, it will not solve all of your problems and may not be suitable for all Web sites or projects. You do not have to follow it; however, your job opportunities will expand and your productivity will increase if you have an understanding of the basics. Tools already exist to facilitate the processing of XML files. Imagine the following scenario: You have painstakingly designed a 200-page catalog. You have written the specs and created stylesheets. Now comes the hours of work formatting each page in your page-layout program. Not with XML; XML can process several days' worth of work in a matter of hours.

Software applications will eventually be developed (à la Dreamweaver MX 2004) that provide an environment in which to design with XML without having to get caught up in the code. However, the best Dreamweaver MX 2004 authors are those that know and understand the strengths and limitations of HTML, which Dreamweaver MX 2004 writes. The designer who understands XML and its complementary languages will be better suited to use these newly developing XML tools.

Understanding the fundamentals of XML will go a long way for the designer of tomorrow in much the same way that understanding basic file formats, output devices, and vector and bitmap art helped the designers of the past.

What Should a Web Designer Do?

While any of these options provides a viable course of action, the designer must take one path—to accept the reality of today's design market. The design world has changed immensely. Although there is and probably always will be static design such as books, catalogs, and brochures, dynamic design, such as database-driven Web sites, XML-driven Web sites, and dynamic, interactive kiosks, is now available. Dynamic design is design that is dictated and controlled to some extent by forces outside the control of the designer. Web content, for example, must be formatted to fit a 19-inch television screen as well as the 1-inch screen of a cell phone. In addition, they must design for content that is in a continuous state of change, such as a Web site that contains stock information or sports statistics.

The designers' skills are still in demand, perhaps even more so as they are asked to design for more devices with challenging para-

meters, such as cell phone screens. The basics principles of proximity, alignment, repetition, and contrast are still in force; however, the medium is changing and so must the manner in which design principles are implemented. XML can keep the focus on the data and its inherent structure and, in so doing, aid in the implementation of designs in the most advantageous and aesthetically pleasing way. In other words, XML helps designers do what they are called upon to do: facilitate the understanding of information through graphical communication that enhances the user experience.

Designers have always had an important role in technological progress. They are the creators and the facilitators. The more active they are in this role, the more likely they will be to put forth great design. The less active they are, the more they can expect mediocre to bad design as programmers take on the design role. Just as surgeons are often responsible for the technological advances in medical science, so, too, can designers create the tools and software that will advance design. All too often the voice of the craftsmen is left unheard. A 30-year veteran of Detroit's assembly line once wrote that in his entire career on the factory floor, not once did management approach him to ask how his job might be made easier. XML can make the designers' job easier but only if they accept and embrace it.

SUMMARY

Chapter 1 has provided some basic information to whet your appetite for XML. It is clearly a technology that is here to stay and here to grow and take you to the next level of computer-based processing. Chapter 2 provides an overview of XML and its related technologies. Through a variety of exercise, you will explore first-hand some of the amazing things you can accomplish with XML. After completing Chapter 2 you will recognize the power of XML. Then it's on to Chapter 3 and using XML in Dreamweaver MX 2004, where you will learn the fundamentals of XML and its companion languages.

ADDITIONAL RESOURCES

XHTML:
 www.w3.org/MarkUp/
The Semantic Web:
 www.w3.org/2001/sw/

XML and the government:
www.xml.gov/
XML Standards Organizations:
www.oasis.com
www.webstandards.org/mission.html
www.w3.org
Macromedia Dreamweaver MX 2004:
www.macromedia.com/software/dreamweaver/
Macromedia Fireworks MX 2004:
www.macromedia.com/software/fireworks/
Macromedia Flash MX 2004:
www.macromedia.com/software/flash/
Macromedia ColdFusion MX:
www.macromedia.com/software/coldfusion/
Microsoft and XML:
http://msdn.microsoft.com/library/default.asp?url=/nhp/
default.asp?contentid=28000438
The Resource Description Framework:
www.w3.org/RDF/

2

OVERVIEW OF XML AND RELATED TECHNOLOGIES

In This Chapter

- Overview of XML
- The principles behind XML and Its Related Technologies
- Web browsers and XML
- Configuring your Web browser
- A Web-based tour of XML

Chapter 2 presents an overview of XML, explains some basic XML concepts, and shows how these concepts are used to enhance communication via the Web. The XML tour at the end of this chapter introduces you to the basic functionality of XML documents.

OVERVIEW OF XML

Asking the question "What is XML?" is a lot like the parable about the five blind men who were asked to describe what an elephant looks like. Each man touches a different part of the elephant and rapidly comes to his conclusion. The man who touches the elephant's side exclaims that an elephant must look like a wall. The man who grabs the tail says the elephant resembles a rope; the man who touches an ear claims that the elephant is like a piece of cloth, and so on. Of course, they are all right, but they each "see" only a part of the whole. When you ask a database developer what XML is, he might exclaim that it is a method of storing information. When you ask a software engineer, he might tell you that XML is the foundation of the new Web services. A Web designer may tell you it is a new way of communicating across the Internet. A Java programmer may report that it is the "missing link" needed to fulfill the early Java promise of programmed cars and household appliances capable of communicating with one another. The answers are similar to those of the five blind men in that they are all right, but they are only seeing a part of the whole. It is important to remember that XML is all this and more. It is equally important to remember that XML is a technology and not a religion. As your knowledge of XML increases you may be anxious to implement it to solve problems it was not intended to solve. This chapter describes some of the best uses of XML, including those that Macromedia software can help you implement.

For simplicity, the example files on the CD-ROM are intentionally small-scale files. Use your imagination to see these concepts being implemented on large-scale Web sites.

What Is XML?

XML is a markup language. It is a mature technology that the W3C officially recommended in February 1998. Its specification documentation, edited by Tim Bray, is approximately 25 pages. The official version of the language in use as of the writing of this book is version 1.0. XML, however, is considered not a language but a metalanguage. A *metalanguage* is a language that we use to write a unique language. XML is the metalanguage used to create the next generation Hypertext Markup Language, known as XHTML. In addition, XML is a piece of a much larger system that includes other technologies such as document type definitions, schemas, the XML Query Language, the XForms Language, Xlink (the XML linking language),

and the XML Stylesheet language. This larger system enables the possibilities described in Chapter 1 and makes all the previous answers to the question "What is XML?" correct.

A Brief History of XML

Because the focus of XML is storing and transmitting information, including documentation, a brief history of XML should begin at the creation of computer-generated documents. A true search for the ancestry of XML would lead to the origins of computer-generated documents known as typecasting. The linotype, invented by Ottmar Mergenthaler in 1886, was the first machine to automate typecasting. This creation was eventually replaced by phototypesetting, introduced in 1949. Despite the large size of these machines, they showed only one line of text at a time on a primitive computer terminal that was incapable of displaying the result of formatting instructions. Companies such as VariTyper and Compugraphic, which manufactured these early typesetting machines, were responsible for some of the earliest forms of text processing. Although they were revolutionary at the time, they are severely limited by today's standards. By creating code that mixed formatting instructions with the content information, these machines were capable of one function only: they permitted display on the terminal that could be output to paper. Phototypesetting was actually a form of black-and-white photography, where the letterforms chosen by the operator were photographed in the type size and weight specified onto photo paper and then developed.

This process was followed by desktop publishing in 1985. Although this new technology revolutionized the printing and graphics industry and brought many benefits, it essentially performed the same, somewhat limited function: it allowed the user to type documents into a computer, describe how the documents should look, and then print the document. The main difference is that the user can see what the output would look like prior to printing it, hence the acronym *WYSIWYG* or "what you see is what you get." This process could be performed on standard office bond paper and did not require the photographic aspect of its predecessor, thus reducing cost considerably.

Eventually companies recognized that they wanted to do much more with their documentation, such as store, search, manage, organize, and publish it, perhaps with a variety of styles and formatting. To accomplish these many tasks, various systems were needed, and these

systems would need to speak and understand the same language. In the late 1960s, researchers at IBM began to tackle this problem to meet their documentation needs. The result was a generalized markup language, as opposed to the formatting markup languages used at the time. Consider the following example:

```
<italic>some significant text goes here.</italic>
```

This line says nothing about the content; it merely declares that the line should be rendered in italic.

Now consider:

```
<citation>some significant text goes here.</citation>
```

This content is a quote cited by another document. The code can now be used in a search for citations. You can still render it in italic by way of a stylesheet that tells the processor that all citation tags should be in italics.

The researchers at IBM realized that document authors would have different needs, customized to their specific documentation. For example, authors of scientific data would have different needs than authors of financial data, and so forth. How could the generalized markup language address the needs of so many authors? It would take until 1974 for the solution, which was a document that described the various categories of documentation, known as a document type definition (DTD). The DTD would be useless without a validating parser. A *validating parser* is a program capable of reading a DTD and checking the accuracy of the markup without actually processing the document. The automobile and aircraft industry, as well as the military, quickly adopted the DTD, and its various implementations remain standards today. Thus, with the Generalized Markup Language, you could write data once, check its syntax via a DTD, and output it many times in as many formats as you wish through the use of a stylesheet. The aircraft industry, for example, can write their data, such as aircraft parts and manufacturing procedures, once and then, from that original data, create training manuals, procedural manuals, catalogs, and spec sheets without rewriting the information. It would take from 1978 to 1986 for Charles Goldfarb, the leader of the IBM team, and his researchers to finalize the Generalized Markup Language.

In 1989, Tim Berners-Lee, a researcher at CERN European Nuclear Research Facility, created the Hypertext Markup Language (HTML) using the Generalized Markup Language, which had become a standard (ISO 8879) known as the Standard Generalized Markup

Language (SGML) in 1986. Created primarily for the immediate needs of the scientific community, Berners-Lee saw far-reaching possibilities in the realm of worldwide communication. He called his system of hypertext and its associated markup language the World Wide Web. The rest, as they say, is history. It was quickly adopted thanks to its simplicity, ease of use, and forgiving nature in regard to syntactical errors. An important aspect of HTML, often forgotten now, is that its foundation was a generalized markup language, not a formatting language. Ponder the following simple document structure in pure HTML. Note the added content that further describes the tags:

```
<head>This is meant to hold header information
  <title>The title of the document</title>
</head>
<body>The main body of content
 The most significant heading</h1>
  The second-level heading</h2>
    <h3>The third-level heading and so on to h6</h3>
      <p>This is meant to indicate a paragraph</p>
```

In the original proposal for the language, Berners-Lee was more concerned with creating a universally linked information system, in which generality and portability were more important than graphics techniques and extra facilities.

What? No fancy graphics techniques? Of course, graphic designers quickly became dissatisfied with the language's structural aspects and lack of formatting capabilities. The World Wide Web, in all its glory, was all function and no form. Soon a medium in its own right, the public demanded a well-designed World Wide Web with eye candy for the masses. HTML, however, seemed to prohibit formatting such as font size and color, background images, and so on. And so, it came to pass that the humble HTML evolved from a generalized markup language to a formatting language. Technically speaking, this was a step backward to the days of typesetting with code that served only one purpose. That purpose had simply changed from print output to monitor output.

To further complicate the problem, HTML was evolving in a proprietary way. In an effort to make a browser that would outperform others, browser manufacturers introduced new tags to change the look of a Web page, making it more attractive to the viewer. The so-called browser wars escalated as each manufacturer, primarily Netscape Navigator and Internet Explorer, tried to outdo the other with more and more proprietary tags. When HTML au-

thors implemented these tags, the result was a stunning Web page in one browser that was incapable of being viewed in all its glory by the other browser.

Berners-Lee was now the founder and director of the W3C an organization devoted to, among other things, preventing the World Wide Web from being dominated by any one company. The W3C has become a de facto governing body of the Internet. In democratic fashion, it comprises members of the Internet community. To stop this growing trend toward proprietary markup, the W3C promoted a language called Cascading Style Sheets (CSS). The concept was simple: maintain the content of the Web page in the structural language of HTML and format it with CSS. CSS could be embedded in the head section of the Web page or maintained as a separate digital file with the extension .css.

At first CSS became a vehicle for allowing more proprietary code, as Netscape and Internet Explorer used different CSS implementations. However, as the W3C grew in popularity and acceptance, trends conformed to W3C recommendations, including the latest version of CSS known as CSS2.

The problems with HTML, however, run deeper than browser incompatibility. The HTML written by most Web designers lacks the language's initial structural form, preventing it from being a language capable of more robustness and functionality beyond mere Web page display. This lack of structure is because of the forgiving nature of HTML in terms of syntax. When writing HTML, you can type in upper- or lowercase, or in both cases mixed. You can close a tag more than once, and tags do not have to follow a strict order. For example, you could type a tag inside of a tag, although it would be illogical to do so, considering their relative significance to one another. The structure of HTML is not rigidly enforced by the applications that process it—the Web browsers.

In addition to the lack of enforcement of structure, HTML has other flaws. As has been demonstrated numerous times, HTML is not content aware. A Web page describing cars and their values might look like this HTML:

```
<table>
 <tr>
  <th>Auto</th><th>Model</th><th>Year></th><th>Value</th>
 </tr>
<tr>
<td>Toyota</td><td>Celica</td><td>1990</td><td>$5000<//
td>
```

```
  </tr>
 </table>
```

The tags surrounding the data have no meaning relative to what the data means; they represent only how the data should be presented. Compare that code to this self-describing, structured document:

```
<Auto>
 <Manufacturer>Toyota</Manufacturer>
 <Model_Name>Celica</Model_Name>
 <Model_Year>1990</Model_Year>
 <Book_Value>$5000</Model_Value>
</Auto>
```

Other problems include the fact that HTML is not inherently international. If we wish to express the value of the cars in yen, you must resolve the yen symbol, which is not available in ASCII, the encoding type for HTML. The default encoding type for XML is Unicode.

In the span of time that included the desktop publishing revolution and the age of the Internet, we have seen the problems introduced since text processing began come full circle. In each case, a system was created for disseminating information (via print or the Web). Each system is limited in its scope to the extent that it takes data and formats it for one output and one output only. The result is the same content being reformatted time and again for different purposes, while the output possibilities increase with each newly invented device (handheld computer, voice-activated response systems, cell phones, gaming devices, and so on).

Because SGML made great strides in solving print issues, why not use SGML to address the limitations of HTML? The problem with this solution is simply that SGML is too powerful for the Web. Remember, the Web's popularity is due in part to its simplicity. SGML is far from a simple language. Although HTML contains approximately 100 tags, it is a language unto itself with its own rules. SGML is a metalanguage—a language used to create other languages (remember that Berners-Lee used SGML to create HTML)—thus, its syntax must allow for all possible uses and DTDs. The specification for the SGML language was developed over eight years and is over 500 pages long. In three days, one can learn HTML almost in its entirety. It would take weeks, including months of practical, hands-on experience, to learn SGML. The training time alone makes SGML a

very expensive proposition. In addition to the training time, you must consider the cost of migrating documents from HTML to SGML—a cost that will be incurred (although not as steeply) for the migration to XML as well.

One more requirement must be met to implement the migration to SGML—Web browsers must be made capable of understanding SGML. The ability to identify that which is code from that which is content is called parsing. Today's Web browsers can parse HTML but lack an SGML parser. An SGML parser would need to be extremely complex to understand all that SGML offers—all the languages derived from the metalanguage SGML. The complexity of the parser would bloat the Web browser to an enormous size. One of the Web browsers' advantages is that they are relatively small applications. This benefit could not remain true if Web browsers contained an SGML parser. In all likelihood, browsers would no longer be freely distributed, thereby, driving the cost of this solution upward.

What is needed is a watered-down, simplified version of SGML suitable for the Web. In 1996, at the height of the browser wars, the W3C began work on a solution. They formed an XML Working Group, which hoped to combine the simplicity of HTML with the extensibility of SGML to create a language that would render the browser wars obsolete. Ultimately, they built a foundation for a transition from the loose nature of HTML to the strict nature of SGML, which when adopted would lead to standardization of the Web while allowing enough flexibility to render it future-proof.

By 1998, the W3C had built an impressive record of creating recommendations for the World Wide Web. It had attracted more than 300 members and boasted a successful advisory committee. Its status had grown to that of a leadership role. Although this status is challenged today and, like any good democratic organization, its leadership direction is often questioned, it remains a constructive voice in determining the future of the Internet. With XML well poised to take the Web into its next generation, the W3C's task would not be easy. To meet their long-range objectives, they set the following goals for XML firmly in place:

XML shall be straightforwardly usable over the Internet. The browser manufacturers have the ultimate responsibility for the effectiveness of this goal. To date, the best support of XML can be found in Internet Explorer 6.0 and Mozilla 1.0, as well as Amaya (the W3C browser). Netscape 6.0 and Opera 5.0 offer limited support.

XML shall support a wide variety of applications. An increasing number of applications support XML in numerous ways. Most support comes in the form of the ability to import and export XML.

XML shall be compatible with SGML. This compatibility allows those applications that support SGML (such as Adobe Framemaker) to more easily adapt to conversion to XML.

It shall be easy to write programs that process XML documents. This goal has been considerably more difficult to implement than others. In addition to being easy to write, the code must be efficient. The primary challenge in this area has been speed. Processing XML over the Internet, which is a large part of its intended use, has been slower than hoped for.

The number of optional features in XML is to be kept to the absolute minimum. The XML specification has achieved this goal by retaining the pure data aspect of an XML file. The sparse specification leaves the task of adding functionality to XML to other technologies and languages.

XML documents should be human readable and reasonably clear. The XML specification certainly makes this goal possible. However, the responsibility for implementing the goal lies with the XML file author. He must not use cryptic element names and must structure the file so that it is a logical representation of the data it describes.

XML should be prepared quickly. To allow XML to solve current problems in data processing and design of documentation, the specification itself could not take too long to finalize—certainly not as long as that for SGML.

The design of XML shall be formal and concise. For XML to meet its long-range goals, it must be capable of being easily parsed and understood by computer applications as well as readable by humans. The language was developed following a previously accepted form of easily parsed syntax generation called EBNF.

XML documents shall be easy to create. This goal was clearly achieved—XML is written in plain text with any simple text editor.

At the sixth World Wide Web Conference in April 1997, Tim Bray, the editor of the XML specification, received great applause at the introduction of the small yet powerful language, and XML was born. It achieved many but not all of its goals.

Despite some of its problems and usability issues, XML does have many inherent advantages. Unlike SGML and HMTL, which

are both based on ASCII, XML is truly international because it is based on Unicode, a language that includes foreign characters. It is structured in form, with a tight syntax that can be validated with the same methodology as SGML—the DTD. XML is easy to create thanks to its HTML-like simplicity. The list of benefits continues as more companion languages are created. To fully appreciate what XML can and cannot do, you must look at the big picture—and it is a big picture. A complete analysis of the appropriateness of using XML includes data management, document management, document design, and more and is beyond the scope and focus of this book. As a Web designer, you might ask yourself, "Where in my workflow (which might include Web, wireless, print, or dedicated Web browsers) would XML fit?" The answer for you lies in the remaining chapters, and an overview or general answer lies in the Web-based tour at the end of this chapter.

THE PRINCIPLES BEHIND XML AND ITS RELATED TECHNOLOGIES

The following section discusses some of the things you can do with an XML file. Not all of the uses for XML apply directly to Web designers; however, it is important to remember that the content of Web sites and Web applications comes from data files that will be written in XML. This data may have started out as database information or a Microsoft Word file. Very soon most, if not all, of the data you deal with will be in the form of XML or have originated from XML.

What Can You Do with XML?

XML's functionality begins with a programmer's perspective (or anyone whose role precedes the graphic design stage of a project).

XML can be stored in a database. This feature can take the form of replacing or enhancing a proprietary database. The XML data can be relational. An entire industry has evolved that creates software that retains the benefits of a proprietary database (such as ease of use, reporting functionality, basic processing or manipulation of data, and, of course, help and support in the customization and use of the software) while providing the added benefit of output to XML. Oracle has been a leader in implementing XML.

Documentation can be structured with XML. For example, a document, such as a manuscript for a play, can structure information into acts, scenes, or speakers. For similar documents, you can perform searches, reveal trends, and so on. You can also

process the document's calculations, such as lines devoted to one speaker, total words spoken by one speaker, and average number of scenes per act. Another example is a training manual, which can be structured via XML into exercises, concepts, and other categories. When published as a Web site with other manuals, you can create a dynamic library of skill sets that users can query to create their own lesson plans structured to their individual needs.

When your content is contained within an XML file, you can communicate among applications over the Web. An umbrella term for this type of communication is *Web services*. By combining the exchange of information with structured information you create entire vocabularies as well as applications that understand these vocabularies. Many such vocabularies or XML applications already exist, including:

- Financial information such as FinXML and OFX
- Resumes with Human Resource Management Markup Language
- Mathematical equations with Mathematical Markup Language
- Scientific information with:
 - Chemical Markup Language
 - Genealogical Data Markup Language
 - Astronomical Markup Language
 - Informatics Sequence Markup Language, which encodes and displays DNA, RNA, and protein sequences
- Music with Musical Markup Language
- Voice communication with Voice Markup Language
- Newspapers advertisements with Advertising Markup Language
- Court information with XML Court Interface
- Real Estate with Real Estate Transaction Standard
- Theological information with Theological Markup Language

In summary, XML and its related technologies enable applications to share data and information over the Web. XML itself is a metalanguage used to create unique markup languages that structure data or documentation for a variety of purposes. These XML applications have the capacity to drive Web sites as well as run software through a Web browser, and tools such as Macromedia Studio MX 2004 have the capability to exploit the many uses of XML with their new features and XML support.

WEB BROWSERS AND XML

This book focuses its coverage of browser support for XML on Internet Explorer and Netscape Navigator for Windows on PCs and

Macintosh. The first section discusses the basic aspects of XML and Web browsers, and the chapter concludes with step-by-step instructions for configuring your current Web browser to work with the XML files in this book.

Which Web Browsers Support XML?

For any Web browser to understand XML, it must have an XML parser. A *parser* is an application that can parse or extract that which is code from that which is content. For example the Web browser you used to surf the Internet today uses an HTML parser; thus, it is capable of rendering content created with HTML. In much the same way future browsers will understand and render XML. In fact, by the time this book is published, today's Web browsers will be capable of rendering XHTML, the next version of HTML, which is based on XML. XML can be built into the browser, as it is in Netscape, or it can be a component installed in the browser, as it is in Internet Explorer 5.x. The XML parser can be made more XML capable by added functionality. For example, if the XML parser can understand the XML companion languages, such as XPath, XSLT, XQuery, or XForms, then it becomes more valuable in the sense that it can not only understand and display XML but also process the XML to the extent that these companion languages allow. Therefore, the browsers discussed are those that contain XML parsers.

For completeness it should be noted that it is not necessary to parse XML with a Web browser. Standalone XML parsers are available, with the most popular ones created by the Apache group (see *www.apache.org*). XML parsers have been created for a variety of platforms. Some are written in C and C++, whereas the most common are written in Java. Like the Microsoft XML parser these parsers have different versions, and their capabilities change with each version.

Internet Explorer

The first browser discussed is Internet Explorer. MSXML 2.0 was the first XML parser to ship with Internet Explorer, and it shipped with version 5.0. The MSXML parser 2.5 shipped with Internet Explorer for Windows 2000. This parser was upgraded to versions 3.0 and 4.0. With each upgrade of the Microsoft XML parser came added functionality and closer conformance with the emerging XML standards such as schemas and XSL-T. The MSXML parser is a separate browser component that can be downloaded at *http://msdn.*

microsoft.com/xml/general/xmlparser.asp. Before you visit that Web site, remember that this chapter concludes with complete instructions for configuring your browser to work with the tutorials in the book. The Microsoft Developers Network is the best source of information regarding the various MSXML parsers and their capabilities. As XML and its companion languages evolve, Microsoft will continue to improve its XML parser. If you are currently using an Internet Explorer 5.x version browser and would like to install the MSXML parser, refer to the instructions at the end of this chapter.

Internet Explorer version 6.0 ships with the MSXML parser; therefore, you do not need to download the parser and install it. The parser that ships with Internet Explorer is MSXML 3.0. When Internet Explorer 6.0 was released, the MSXML 4.0 parser became a downloadable beta version.

Netscape Navigator

On April 1, 1998, Netscape announced new functionality in the Netscape Navigator browser. This functionality was enabled by an XML parser written by Netscape, but it was replaced by James Clark's Expat XML parser. This browser included support for XLink and XML namespaces, as well as CSS.

Mozilla 1.0

Mozilla included extensive support with its first official browser release, version 1.0. Mozilla 1.0 not only supports displaying XML, CSS, and XSL-T but also includes limited support for Xlink, XPath, and XPointer. In addition, you can manipulate an XML file with scripts using the XML Document Object Model.

The following figures show sample XML files as they are rendered by various browsers for the Windows and Macintosh operating systems.

Figure 2.1 shows a basic XML file as it appears in Internet Explorer 6.0, whereas Figure 2.2 shows the same file displayed in Internet Explorer 5.2, the latest version of the Microsoft browser for the Macintosh at the time of this writing.

Netscape 7.0 for the Macintosh also displays XML files. When displaying an XML file in Netscape 7.0 for the Macintosh, the XML file's content is displayed without the markup or tags. See Figure 2.3 for the results of the same file displayed in Netscape 7.0 for the Macintosh.

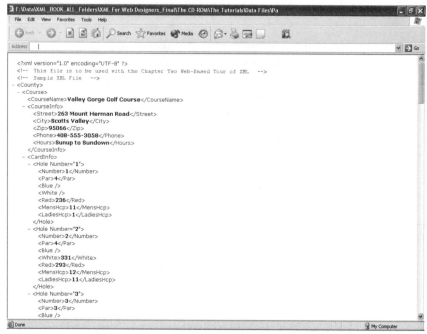

FIGURE 2.1 An XML file in Internet Explorer 6.0 for the Windows PC operating system. Screen shot reprinted with permission from Microsoft Corporation.

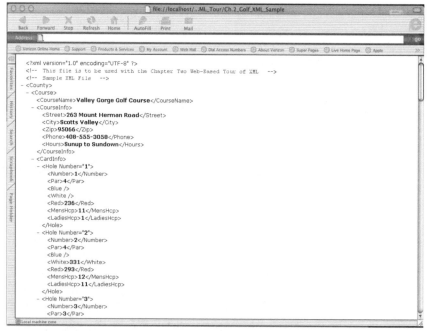

FIGURE 2.2 An XML file in Internet Explorer 5.2 for the Macintosh OS X. Screen shot reprinted with permission from Microsoft Corporation.

Valley Gorge Golf Course 263 Mount Herman Road Scotts Valley 95066 408-555-3058 Sunup to Sundown 1 4 236 11 1 2 4 331 293 12 11 3 3 141 131 14 16
4 5 452 427 4 4 5 3 138 131 18 18 6 4 312 267 6 9 7 4 381 331 1 2 8 4 336 320 10 6 9 4 317 275 8 13 10 4 236 11 1 11 4 331 293 12 11 12 3 141 131 14 16 13
5 452 427 4 4 14 3 138 131 18 18 15 4 312 267 6 9 16 4 381 331 1 2 17 4 336 320 10 6 18 4 317 275 8 13 56 5 55 82 A long short course in downtown Scotts
Valley. 9 holes with lovely views of the Santa Cruz Mountains perfect for beginners, but the mettle of good players will be tested. no yes no yes yes no no yes yes
yes $2.00 $4/$8 no no $12.00 $11.00 $8.00 $12.00

FIGURE 2.3 An XML file in Netscape Navigator 7.0 for the Macintosh OS X.

Netscape 7.1 for the Windows operating system resembles Internet Explorer, with both the markup and the content displayed in a color-coded view, as shown in Figure 2.4.

FIGURE 2.4 An XML file in Netscape 7.1 for the Windows operating system.

The Mozilla 1.0 browser for the Macintosh displays an XML file similar to Internet Explorer, with color-coded elements as well as content. See Figure 2.5 for an XML file in Mozilla 1.0 for the Macintosh.

When it comes to rendering XML files with stylesheets, more support is available for PCs than for Macintosh. Figure 2.6 shows an XML file attached to a XSL-T stylesheet in Internet Explorer 6.0 for the Windows operating system.

Figure 2.7 shows the same XML file attached to an XSL-T stylesheet displayed in Internet Explorer 5.2 for the Macintosh.

As you can see, the Macintosh version of Internet Explorer cannot render an XSL-T stylesheet. The same is true of CSS. Figure 2.8 shows an XML file with an attached CSS displayed in Internet Explorer for the Macintosh OS.

Figure 2.9 shows the same XML file with an attached CSS displayed in Internet Explorer for the Windows operating system.

FIGURE 2.5 An XML file in Mozilla 1.0 for the Macintosh OS X.

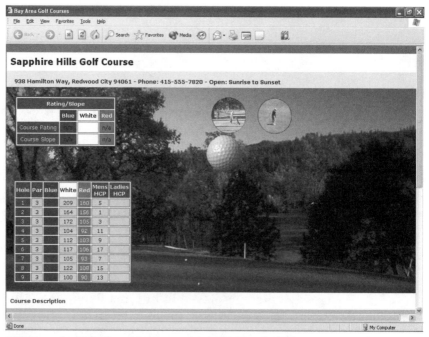

FIGURE 2.6 An XML file with an attached XSL-T stylesheet in Internet Explorer 6.0 for the Windows operating system. Screen shot reprinted with permission from Microsoft Corporation.

FIGURE 2.7 An XML file with an attached XSL-T stylesheet in Internet Explorer 5.2 for the Macintosh OS. Screen shot reprinted with permission from Microsoft Corporation.

FIGURE 2.8 An XML file with an attached CSS in Internet Explorer 5.2 for the Macintosh OS. Screen shot reprinted with permission from Microsoft Corporation.

FIGURE 2.9 An XML file with CSS in Internet Explorer 6.0 for the Windows operating system. Screen shot reprinted with permission from Microsoft Corporation.

Mozilla 1.0 for the Macintosh, on the other hand, renders an XML file with a CSS. See Figure 2.10 for the result.

The Macintosh version of Netscape renders XML files with a CSS. See Figure 2.11 for the result.

FIGURE 2.10 An XML file in Mozilla 1.0 for the Macintosh OS rendered with an attached CSS.

FIGURE 2.11 An XML file in Netscape 7.0 for the Macintosh OS rendered with an attached CSS.

Figure 2.12 indicates the major browsers and the degree of XML supported.

Web Browser Support Table

BROWSER	PLATFORM	VERSION	XML DISPLAY	DTD VALIDATION	W3 VALIDATION	RENDER CSS	RENDER XSL-T
I.E.	Windows	6.0	✔	*	*	✔	✔
I.E.	Windows	5.5	✔	*	*	✔	*
I.E.	Windows	5.x	✔	*	No	✔	*
I.E.	Windows	4.x	No	No	No	No	No
I.E.	Macintosh	5.2	✔	No	No	No	No
I.E.	Macintosh	4.x	No	No	No	No	No
Netscape	Macintosh	7.1	Yes	No	No	Yes	Yes
Netscape	Macintosh	6.0	Yes	No	No	Yes	Yes
Netscape	Macintosh	4.7	No	No	No	No	No
Netscape	Windows	7.1	Yes	No	No	Yes	Yes
Netscape	Windows	6.0	Yes	No	No	Yes	No
Netscape	Windows	4.7					
Mozilla	Windows	1.0	Yes	No	No	Yes	Yes
Mozilla	Macintosh	1.0	Yes	No	No	Yes	Yes

FIGURE 2.12 Table of XML browser support.

CONFIGURING YOUR WEB BROWSER

This section explains how to configure your Web browser so that you can complete the tutorials in the book. You can select any browser you wish for Chapter 3, Tutorial One. Tutorials Two and Three, also in Chapter 3, work only with Internet Explorer 6.0 or 5.x configured with the following instructions. However, the tutorials in the remaining chapters, specifically Chapter 4, do not work with Internet Explorer on the Macintosh. For results that match the author's screen shots, it is recommended that you use Internet Explorer 6.0 for the Windows operating system. The remaining tutorials work with Internet Explorer 5.x or later (PC version) configured with the following instructions. Netscape 7.1 or Mozilla 1.0 works for either platform (PC or Macintosh).

Configuring Your Web Browser for the PC

Operating System: Windows 98 or later
Browser: Internet Explorer 6.0

The Internet Explorer 6.0 browser for Windows 98 and later includes an XML parser. In addition to the XML parser, you need to add a component to the browser to facilitate the validation process explored in Chapter 3. The following instructions guide you in setting up this component.

If you are running Internet Explorer 5.x or later (including Internet Explorer 6.0) on a PC, you need the Internet Explorer Tools for Validating XML to complete the tutorials for writing valid XML. This component is not available for the Macintosh version of Internet Explorer. Use the following instructions to download and install these tools.

1. Launch your Web browser and access the Internet.
2. Go to the Microsoft Web site: *http://msdn.microsoft.com/*
3. Click the Downloads link on the uppermost navigation bar as shown in Figure 2.13. (The text is white and the background is blue. Do not click the Downloads link in the black bar at the top right of your browser window.)
4. On the left navigation panel, place your mouse over Downloads by Topic, and click the XML General option, as shown in Figure 2.14.

You should now be viewing the Microsoft XML General Downloads page, as seen in Figure 2.15.

FIGURE 2.13 The Microsoft Developers Network home page, as seen in Internet Explorer. The solid black bar with white text at the top contains the Download link you should click. Screen shot reprinted with permission from Microsoft Corporation.

FIGURE 2.14 The left navigation bar indicating XML General in Downloads by Topic from the Microsoft Developers Network Web site, as displayed in Internet Explorer. Screen shot reprinted with permission from Microsoft Corporation.

FIGURE 2.15 The XML General Downloads page from the Microsoft Developers Network Web site, as displayed in Internet Explorer. Screen shot reprinted with permission from Microsoft Corporation.

5. Scroll to the Tools category, and click the Internet Explorer Tools for Validating XML and Viewing XSL Output, as shown in Figure 2.16.

6. Follow the instructions to download the tools to your computer. Choose the Save file to your computer option. When prompted where to install the download, choose a folder on your C drive and call it *XML Tools*. The directory's name and location does not affect the download or its usability; you can install it anywhere you choose. You will put the files in this directory to make them easier to find later. You have now downloaded an executable file called *iexmltls*.

7. Locate the executable file that you downloaded to the directory you made earlier called *XML Tools*.

8. Double-click the downloaded executable file. This action places a folder named *IEXMLTLS* wherever you designate. Once again, the location of the folder is not important; however, you should note its location so you can find the directory to complete the next step.

9. Open the folder. It should contain the files shown in Figure 2.17.

10. Right-click the .inf files and choose install.

FIGURE 2.16 The Web page containing the Microsoft Internet Explorer Tools for Validating XML and Viewing XSL Output. Screen shot reprinted with permission from Microsoft Corporation.

FIGURE 2.17 The *IEXMLTLS* directory downloaded from the Internet Explorer Developers Network. Screen shot reprinted with permission from Microsoft Corporation.

11. To verify the installation was successful:
Launch Internet Explorer and right-click anywhere on the screen. You should see the choices shown in Figure 2.18.

Browser: Internet Explorer 5.0 to 5.5

The Internet Explorer 5.0 to 5.5 browsers for Windows 98 and later does not include the XML parser. The following instructions guide you in configuring Internet Explorer 5.x. After completing these instructions, you will have added the Microsoft XML parser to your Web browser. The file is named *msxml.dll*. If you are using Internet Explorer 6.0 for the PC, you can skip this step because IE 6.0 includes the XML parser. If you are using a Macintosh, you must use the Microsoft Internet Explorer browser for the Macintosh (OS X) Version 5.2.2. This version of the Internet Explorer browser includes the XML parser; therefore, you do not need to configure the browser.

1. Launch your Web browser and access the Internet.
2. Go to the Microsoft Web site: *http://msdn.microsoft.com/*

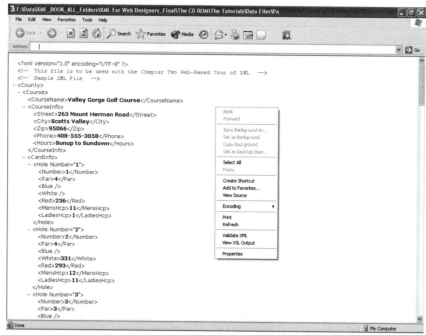

FIGURE 2.18 The Web browsers display the new right-click functionality that includes the options Validate XML and View XSL Output. The installation is complete. Screen shot reprinted with permission from Microsoft Corporation.

3. Click the Downloads link on the top blue navigation bar, as indicated in Figure 2.19. (Do not click the Downloads link in the black bar at the top right of your browser window.)

4. The solid blue area with white text at the top contains the Download link you should click. (Do not click the Downloads link in the black bar at the top right of your browser window.)

5. On the left navigation panel, place your mouse over Downloads by Topic, and click the XML General option. You should now be viewing the Microsoft XML General Downloads page, as seen in Figure 2.20.

6. Scroll to the Microsoft XML Core Services 4.0 Service Pack 2, and click the link. Downloading this component allows the Internet Explorer browser to read, parse, and display XML files in a variety of ways.

7. Read the XML 4.0 Service Pack 2 description, and follow the download instructions. You are now finished adding this component.

FIGURE 2.19 The Microsoft Developers Network Home page, as seen in Internet Explorer. Screen shot reprinted with permission from Microsoft Corporation.

FIGURE 2.20 The XML General Downloads page from the Microsoft Developers Network Web site, as displayed in Internet Explorer. Screen shot reprinted with permission from Microsoft Corporation.

Configuring Your Web Browser for the Macintosh

Operating System: OS X or OS 9
Browser: Internet Explorer 5.2.2 for the Macintosh

The Internet Explorer 5.2.2 browser for the Macintosh includes an XML parser; therefore, no other setup is required.

Browser: Netscape 7.0 for the Macintosh

The Netscape 7.0 browser for the Macintosh includes an XML parser; therefore, no other setup is required. The Netscape XML parser displays XML files considerably differently than Internet Explorer does. These differences are pointed out throughout the various tutorials. It is recommended that you work through the tutorials using Internet Explorer.

You are now ready to take a Web-based tour of XML. In addition, your Web browser is set up to complete the tutorials in Chapters 3 through 7.

A WEB-BASED TOUR OF XML

You are about to take a Web-based tour of XML through a series of files designed to show you how XML is used and displayed on the Web. Each file includes an explanation of what the file is, where it originated, and how it is displayed in the Web browser. You will create many of these files in the tutorials that follow in the remaining chapters.

Sample File One

Objective

To examine and understand the limitations of a pure HTML file compared to an XML file.

What You Need

Internet Explorer 6.0 or later

Some components of the Internet Explorer browser must be downloaded and installed from the Microsoft Web site. See the previous section, Configuring Your Web Browser, for important instructions on configuring the Internet Explorer browser.

A pure HTML file serves one purpose: it displays the information written in the file according to the instructions written in the markup. The end result is a file that contains data (golf course information, in this example) with presentation information such as bold, italic, and font color woven throughout it. This example is fairly simple. However, if a Web page contains user interactivity, you will also see a scripting language such as JavaScript embedded throughout the document. If the Web site is driven by information in a database, you will also see programming logic code such as Active Server Pages (ASP) or Java Server Pages (JSP) throughout the document.

Before You Begin

You must define a site with the following root directory: *Data Files\Part_1\Chapter 2\Ch_2_The_XML_Tour*

1. Launch the Internet Explorer Web browser.
2. Click File → Open.
3. Browse to the *Section One* directory.
4. Open the *Chapter 2* directory.

ON THE CD

5. Open the *Ch_2_The_XML_Tour* directory on the companion CD-ROM.

6. Open the file called *Ch.2_BayAreaGolfCourse_HTML.html*. The Web page should resemble Figure 2.21.

FIGURE 2.21 A Web site written in HTML. Screen shot reprinted with permission from Microsoft Corporation.

This is a partial example of one of the fictitious Web sites you will build with XML. Figure 2.21 shows the Web site. Review the site's information. The final site contains more than 50 golf courses.

7. From the Web browser's main menu bar click View → Source. The Web site's source code is displayed in Figure 2.22.

The HTML source code is revealed. Updating and maintaining an HTML Web site can be a laborious task because the information or data that you are updating is buried within code. Often it is not just the HTML code but also JavaScript, CSS, ASP, or JSP. For example, locate the yardage for the red flag at hole number 16. How long did it take? Of course, it would take considerably less time with a WYSIWYG editor, such as Dreamweaver MX 2004. Changing or updating an HTML file is still a tedious task. This drawback,

```
Ch.2_BayAreaGolfCourse_HTML.html - Notepad
File  Edit  Format  View  Help
<html>
<head>
<title>Bay Area Golf Courses</title>
<style type="text/css">
        a {
              font-family: Verdana, Arial, Helvetica, sans-serif; font-size: 10px;
              color: #009933; text-decoration: none;display:block;
            }

        * {
              font-family:verdana, arial, helvetica, sans-serif; font-size:10pt;
            }

        H1 {
              font-family:verdana, arial, helvetica, sans-serif; font-size:24pt;margin-left:18px;
            }

        .courseStyle
                {
                  font-family:verdana, arial, helvetica, sans-serif; font-weight:bold;
                                    font-size:16pt;padding-left:18px;line-height:10pt; background: white;
padding:10px;         }

        .courseDescription
                        {
                          font-family:verdana, arial, helvetica, sans-serif; font-weight:bold;
font-size:14pt;padding-left:18px;padding-top:12px; line-height:18px;
                            background: white; position:relative; height:45px;
                        }

        body
                {
                  background-image:url(GolfBG1.jpg); background-attachment:fixed;
                            background-repeat:no-repeat;bgcolor:lightgreen;margin:0px;
                }

        </style>
</head>
<body>
<img src="greenBorder.gif" width="1024px" height="18px" />
<div class="courseStyle">Valley Gorge Golf Course</div>
<div style="padding-left: 20px; padding-right:6px; padding-top:0px; padding-bottom:6px;
                  position:relative; left:0px; top:0; width:1024; background:#CCFFCC"> <br />
  <b>263 Mount Ethel Road, Scotts valley 95066 - Phone: 408-555-3058 - Open:
  Sunup to Sundown</b> </div>
<p />
<div style="margin-left:18px">
  <table border="0" cellpadding="1" cellspacing="1" style="margin-left:8px;" width="782" align="center">
    <tr valign="top">
      <td width="385" align="left"> <table border="3" bordercolor="#009933" cellpadding="4" bgcolor="white">
        <tr>
          <th colspan="3" bgcolor="#009933"> <font color="white" face="Verdana, Arial, Helvetica, sans-serif" size="2">
<b>RATING/SLOPE</b> </font> </th>
```

FIGURE 2.22 The golf Web page source code. Screen shot reprinted with permission from Microsoft Corporation.

along with the desire to deliver timely information to the Web, led to the invention of database-driven Web sites. Perhaps the worst part of updating the content in a Web site is the fact that the Web site is usually only one of many locations in which the data needs to be changed. For example, if the golf course decides to change the par value for each hole on the course, in addition to changing the golf cards, they might also need to change the Web site, the brochures, the printed golf cards, and, if the Web site supported wireless devices, the files that make the cell phone and PDA code. As more information becomes automated, the burden of maintaining these automated systems increases.

This file represents the functionality of HTML, which is to markup information for display in a Web browser. This file cannot be reused as is for any other purpose.

8. Close the source code window.

Sample File Two

Objective

To view an XML file in both a word processor and Web browser to examine its look, feel, and structure.

What You Need

A simple text editor such as Notepad for Windows or SimpleText for the Macintosh. You can also use a more sophisticated word processor such as Microsoft Word.

ON THE CD

1. Launch a simple word processor such as Notepad or SimpleText.
2. Click File → Open and select *Part 1/Chapter 2/Ch_2_The_XML_Tour/Ch.2_Golf_XML_Sample.xml*. The XML file is shown in Figure 2.23.

```
Ch.2_Golf_XML_Sample.xml - Notepad
File Edit Format View Help
<?xml version="1.0" encoding="UTF-8"?>
<!-- This file is to be used with the Chapter Two Web-Based Tour of XML -->
<!-- Sample XML File -->
<County>
        <Course>
                <CourseName>Valley Gorge Golf Course</CourseName>
                <CourseInfo>
                        <Street>263 Mount Ethel Road</Street>
                        <City>Scotts Valley</City>
                        <Zip>95066</Zip>
                        <Phone>408-555-3058</Phone>
                        <Hours>Sunup to Sundown</Hours>
                </CourseInfo>
                <CardInfo>
                        <Hole Number="1">
                                <Number>1</Number>
                                <Par>4</Par>
                                <Blue/>
                                <white/>
                                <Red>236</Red>
                                <MensHcp>11</MensHcp>
                                <LadiesHcp>1</LadiesHcp>
                        </Hole>
                        <Hole Number="2">
                                <Number>2</Number>
                                <Par>4</Par>
                                <Blue/>
                                <white>331</white>
                                <Red>293</Red>
                                <MensHcp>12</MensHcp>
                                <LadiesHcp>11</LadiesHcp>
                        </Hole>
                        <Hole Number="3">
                                <Number>3</Number>
                                <Par>3</Par>
                                <Blue/>
                                <white>141</white>
                                <Red>131</Red>
                                <MensHcp>14</MensHcp>
                                <LadiesHcp>16</LadiesHcp>
                        </Hole>
                        <Hole Number="4">
                                <Number>4</Number>
                                <Par>5</Par>
                                <Blue/>
                                <white>452</white>
                                <Red>427</Red>
                                <MensHcp>4</MensHcp>
                                <LadiesHcp>4</LadiesHcp>
                        </Hole>
                        <Hole Number="5">
                                <Number>5</Number>
                                <Par>3</Par>
                                <Blue/>
                                <white>138</white>
```

FIGURE 2.23 An XML file displayed in Notepad. Screen shot reprinted with permission from Microsoft Corporation.

XML is similar to HTML in its look and feel; however, the tag names are not familiar to you because they are not predefined tags as in HTML. XML is a metalanguage that allows you to create your own tags. The file is meant to

be self-explanatory. Read through the file and see if you find it to be a self-describing document. The first line is the XML declaration and asserts to the Web browser that it is a document written in the Extensible Markup Language. The <County> *element is the equivalent of the* <html> *element in that it contains all the other elements in the document.*

XML is a file format that organizes and stores information in a well-formed and highly structured configuration that does not include any formatting instructions or presentation information. This structure allows the information to be rendered for any device. In other words, the data in an XML file can be made suitable for a cell phone browser or a Palm Pilot–type device. The same XML file can be ported to an automated phone delivery system or prepared for printing by conversion to a Portable Document Format (PDF).

3. Close the XML file.

ON THE CD

4. Return to Internet Explorer and open the file *Ch.2_Golf_Sample_XML.xml*. The XML file is displayed in Internet Explorer, as shown in Figure 2.24.

FIGURE 2.24 An XML file displayed in Internet Explorer. Screen shot reprinted with permission from Microsoft Corporation.

This file appears to have some formatting instructions. It is color-coded and indented with white space. If you place your cursor on the dashes and click, you will see JavaScript functionality that collapses and expands the individual tags, called elements. These elements are displayed in a tree-like structure that is enhanced by the indents and color-coding. The trees root is the <County> element, and it branches off into other elements. The tree structure combined with the formatting instructions makes it easy to locate specific tags and content. So, what is causing this formatting in a file that does not include formatting instructions? The answer is a stylesheet. This stylesheet is written in the Extensible Markup Language Stylesheet Language-Transformation (XSL-T). Microsoft's Internet Explorer browser automatically applies a stylesheet that transforms the XML file you open into HTML. This HTML file is rendered by way of the stylesheet, which contains CSS code that causes the colors of the individual tags such as the angle brackets (< >) to be displayed in blue and the tag names displayed in red, whereas the actual information within the tags is black.

5. From the main menu bar click View → Source. The XML file's code opens in Notepad. In addition to seeing the XML code, Internet Explorer allows you to view the HTML code that was created by way of the stylesheet. When the XML file is loaded, the Internet Explorer browser applies its stylesheet, which converts the XML into HTML. What you are viewing in the browser window is actually this HTML page.
6. Close Notepad.

 This step requires completion of the setup instructions found in the previous section, Configuring Your Web Browser.

7. To view this HTML file, return to Internet Explorer.
8. Place your cursor in the browser window and right-click. From the drop-down menu, choose View XSL Output. Now you are viewing the XML after it has been transformed by the XSL-T stylesheet to HTML, as shown in Figure 2.25. You can write your own XSL-T stylesheet and attach it to your XML file through a line of code, similar to the way you write CSS and attach or link them to HTML files.
9. Close the XSL-T Output window.

FIGURE 2.25 The HTML source code of the transformed XML file. Screen shot reprinted with permission from Microsoft Corporation.

Now you'll open a new XML file that has been linked to an XSL-T stylesheet. This stylesheet overrides the Microsoft Internet Explorer stylesheet and renders the XML file in an HTML format that has been specified in the stylesheet.

Sample File Three

Objective

To view and examine an XML page and its source code, which has been transformed with an XSL-T stylesheet into HTML.

What You Need

Internet Explorer 6.0 or later

ON THE CD

1. Return to Internet Explorer and click File → Open and select *Part 1/Chapter 2/Ch_2_The_XML_Tour/Ch.2_Golf_XML_with_XSLT. xml*. The file appears as shown in Figure 2.26.
2. Click View → Source. The source code of this file remains XML. You are, however, viewing HTML in your Web browser

FIGURE 2.26 The original XML file opened in step 6 on page 43 transformed into HTML. Screen shot reprinted with permission from Microsoft Corporation.

because the XML file has been linked to an XSL-T stylesheet. Look at the fourth line of code in the source code window.

```
<?XML-stylesheet type="text/xsl"
href="Ch.2_Golf_XSLT.xsl"?>
```

This line of code links the XML file to the stylesheet.

3. Using the source code file opened in Notepad, locate the Red Course Rating for the Dan Marsh Course at the Marsh Golf Complex. This file is as long as the HTML file; however, the lack of extraneous formatting information makes it easier to locate. More important, this pure data file can now be used to output other files, such as a Palm Pilot application, proprietary software that makes reservations, a voice response system, and so on. As more applications embrace XML, the possibilities for re-purposing the data become endless.

You might have noticed a slight delay when this page loaded. One of the current issues with XML is that of speed. These some-times lengthy XML files being transformed via XSL-T can be slow to

process—an issue perhaps not fully anticipated by the original authors and one that is considered a problem by those implementing XML solutions. In trying to make XML both human and machine readable, speed has been compromised.

In the fictitious golf example, if the course owner wishes to update his Web site information he can do so through the Internet. First he logs on to a password-protected page on the site that contains his course information. (XML security issues are being addressed by the W3C at the time of this writing.) At this point the course owner is directed to a page that allows him to update any portion of the information regarding his golf course. He may add a golf pro, change the weekend green fees, move all the white flags back two feet, or offer a senior discount on Wednesdays. He confirms the changes, and by so doing, the XML file associated with his course is updated. The change is effective on the Web site immediately because the data is maintained independent of the presentation. This structure allows the course owner to edit his information without disturbing the display of that information. He need not have any knowledge of HTML. This scenario can be executed in Dreamweaver MX 2004 or Flash MX Professional 2004. The same scenario for the golf course Web site could be created without the use of XML. A combination of technologies such as CGI, JavaScript, JSP, and others could accomplish these goals as well and, in many cases, may be all that is needed. You must remember, however, that you will have solved only one issue or performed only one task—you will have made a Web-based solution for the golf course promotion. One of the main advantages of using XML over HTML is the ability to repurpose the data. Maintaining a pure data file of golf courses in XML facilitates multichannel publishing.

What if the golf course owner would like to make this directory of golf courses available for other media? Using XSL-T, you can easily transform the original XML golf data to the Wireless Markup Language for cell phones.

What You Learn from These HTML and XML Files

You have opened quite a few files. Whereas some files were standalone documents, others referenced another file such as a stylesheet. Let's review what you have learned from the files you have opened.

XML can be formatted with stylesheets that tell the Web browser how to render the individual elements. XML supports stylesheets written in CSS, which is the same language used to format HTML. In

addition, a new stylesheet language designed specifically for XML can be used. This language is known as the XML Stylesheet Language (XSL), and it contains two separate specifications.

XSL-T is one of two XML Stylesheet Specifications. (The other is XSL-FO.) XSL-T is a stylesheet language that transforms an XML file into another type of file. For most designers the transformation is to HTML.

What Causes XML to Display the Way It Does in Internet Explorer?

Internet Explorer uses its own stylesheet to render XML files as HTML with color coding, indentation, and scripting capabilities. To learn more about how to write XML, see Chapter 3, Tutorial One, How to Write Well-Formed XML.

Transforming XML data file to HTML is not the only way to render XML in a Web browser. You can also use CSS to tell the browser how to render the XML tags in your document, in much the same way you use CSS to render HTML files. The next sample file uses a different XML file that contains information about fictitious wineries in the Central California region to demonstrate this concept.

Sample File Four

Objective

To see how an XML file can be formatted for the Web with CSS and understand the limitations of this method.

1. Return to Internet Explorer
2. Click File → Open and navigate to *Part 1/Chapter 2/Ch_2_ The_XML_Tour/Ch.2_Wine_XML_with_CSS.xml*. The XML file is displayed as shown in Figure 2.27.

ON THE CD

This XML file as shown in Figure 2.27 has been formatted with CSS. This page represents one of many pages throughout the Web site that describe various fictitious wineries in California's San Francisco Bay area. Each winery's information includes the name of the winery at the top. Below the winery name is the address and phone number, followed by the hours of operation. The middle section includes one or more paragraphs describing the winery. Each winery has features that might include wine tasting, banquet facilities, guided tours, a picnic area, or a gift shop, each being represented by the graphical icons at the bottom of the page. However, not all the

FIGURE 2.27 An XML file formatted with CSS. Screen shot reprinted with permission from Microsoft Corporation.

wineries offer these facilities. The CSS stylesheet has no logic capabilities. The browser places the graphical icons at the bottom of the Web page or it does not. For example, it cannot place the graphic for the gift shop on some pages but not on others.

CSS was designed to add more layout options and typographical control for HTML pages. It brings the systems closer to separating the data from its graphical representation. A far more powerful language for representing XML data is available, and that is XSL-T, as demonstrated in the next example.

3. From the main menu bar click View → Source. This action opens Notepad and displays the XML file. Locate the second line of code in the Notepad file. This is the processing instruction that tells the browser to display the XML file with the CSS file *Winery1.css*.

4. Open the CSS file in Notepad. It looks similar to a CSS file that you might see formatting HTML, the only difference being the tag selectors. This stylesheet is not formatting <p> tags. Instead, it is formatting the custom tags of the XML application.

Notice that when the file is viewed in the Web browser, you do not see any content that is not in source code. CSS is not capable of adding new content to the XML file. What CSS can do is tell the browser how to render the tags that it finds in the XML file. It cannot add tags or data that is not already present in the file.

What You Learn from This File

CSS is a language that provides formatting instructions for an HTML file. It is also compatible with XML and can be used to format XML elements. It does not add any new content to the file; therefore, the XML file may need additional information to explain the tags. CSS is purely presentation information, formatting the tags that currently exist in the XML file. XSL-T, on the other hand, transforms those tags into other tags, such as HTML, which can include CSS as well.

To learn more about how to write CSS, see Chapter 4, Tutorial One, How to Write CSS for XML.

Sample File Five

Objective

To view an XML file that has been transformed into HTML with an XSL-T stylesheet and compare it with a CSS style sheet.

ON THE CD

1. In Internet Explorer click File → Open and browse to *Part 1/ Chapter 2/Ch_2_The_XML_Tour/Ch.2_Wine_XML_with_XSLT.xml.* The XML file is displayed as shown in Figure 2.28.

This XML file has been formatted by an XSL-T stylesheet that transforms the XML file into what you see on your screen (Figure 2.28), which is an HTML file. To view the XML code, click View → Source. Notepad opens with the XML file as the source code. Note the similarity of the second line of code to the CSS file examined earlier. This code contains the same processing instruction as in the XML file that was linked to a CSS stylesheet; however, this time it points to an XSL-T file called *Ch.2_Winery_XSLT.xsl.*

Because XSL-T contains programming logic, you can examine the XML data and style based on what you find. For example, this stylesheet allows you to read the XML element for the facilities such as `<banquetFacilities>`, `<wineTasting>`, and `<giftShop>`. If those elements contain the word *yes*, the stylesheet places the proper icon

FIGURE 2.28 An XML file transformed to HTML with an XSL-T stylesheet. Screen shot reprinted with permission from Microsoft Corporation.

on the left side of the Web page. If the element contains the word *no*, then it does not place the icon on the Web page.

ON THE CD

2. In Internet Explorer, click File → Open and browse to *Part 1/ Chapter 2/Ch_2_The_XML_Tour/Ch.2_Wine_XLST.xsl*. The XSL file is displays as shown in Figure 2.29.

Internet Explorer opens and displays the file with its default stylesheet as shown in Figure 2.29, because XSL-T is written in XML. To view the file in Notepad, click View → Source.

To learn more about how to write XSL-T, see Chapter 4, Tutorial Two, How to Display XML Documents with XSL-T.

What You Learn from This File

XSL-T allows for the creation of an HTML file using the data from an XML file. Programming logic can be added to the XSL-T stylesheet to enables the output HTML file to be processed according to specific instructions, such as sorting the data alphabetically or numerically or preparing different HTML output files depending on what type of data is found in the XML file.

FIGURE 2.29 An XSL-T stylesheet displayed in Internet Explorer. Screen shot reprinted with permission from Microsoft Corporation.

Sample File Six

Objective

To examine an XML file that has been transformed into the Wireless Markup Language (WML).

What You Need

To view the XML file on a cell phone, you must download phone simulation software.

To test your WML file using the Openwave Mobile Browser, you must download and use Openwave SDK 5.1. The SDK features an integrated development environment (IDE) for creating, testing, and debugging mobile applications written in both WML and XHTML Mobile Profile/CSS.

System Requirements

You must be running one of the following operating systems to successfully install and run this release of the Openwave SDK:

- Microsoft Windows 2000, Service Pack 2
- Microsoft Windows NT, Service Pack 6a
- Microsoft Windows 98
- Microsoft Windows ME

In addition, you must have Microsoft Internet Explorer 5.5 or 6.0 installed.

1. Download the SDK from the Openwave Developer Web site, *http://developer.openwave.com.*

Be sure to download the correct SDK software. The Windows NT and Windows 2000 version has NT and 2000 in the .exe file name, and the Windows 98 and Windows ME version has 98 and ME in the .exe file name.

2. Double-click the downloaded .exe file.
3. Respond to the InstallShield prompts until the installation is complete. The SDK installation program does the following:

 - Installs the SDK files in the specified directory.
 - Adds a program group and icons for the SDK, documentation, uninstall, and related SDK prompts.
 - Adds an Openwave SDK 5.1 menu to the Start → Programs menu.

ON THE CD

4. Using Internet Explorer, open the XML file *Part 1/Chapter 2/Ch.2_Golf_XML_for_WML.xml*. The XML file is displayed as shown in Figure 2.30.
5. To view the source code, click View → Source. As in previous examples, the second line of code links this XML file to an XSL stylesheet and transforms the file. Upon examining the stylesheet, you will see that the transformation that takes place is not from XML to HTML, as in the previous example, but from XML to WML, which is used to display the text in the Web browsers of cell phones.

ON THE CD

6. In the open Notepad window, click File → Open and select the stylesheet *Part 1/Chapter 2/Ch.2_Golf_XSL_to_WML.xsl*, which the XML file references.

Remember that XSL is written in XML; therefore, it can also be opened in Internet Explorer. It may be easier to read in Explorer due to the color-coding and indentation.

ON THE CD

7. In Internet Explorer, click File → Open and browse to *Part 1/Chapter 2/Ch.2_Golf_XSL_to_WML.xsl*.

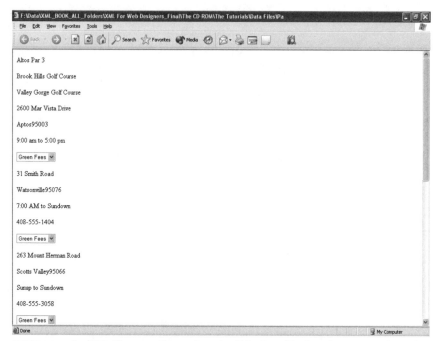

FIGURE 2.30 An XML file transformed to the Wireless Markup Language (WML) through an XSL-T stylesheet, as displayed in Internet Explorer. Screen shot reprinted with permission from Microsoft Corporation.

It may look confusing right now, but this stylesheet basically locates elements in the XML file and uses templates to transform them to other elements. It is transforming the raw XML data from an XML file to a WML file.

Look at the transformed XML file using Internet Explorer. To learn more about writing XSLT stylesheets, refer to Chapter 4.

In the next step, you open the XML file that will be transformed to WML in Internet Explorer.

ON THE CD

8. Open *Ch.2_Golf_XML_for_WML.xml*.

9. Right-click the browser window and choose View XSL Output. This action displays the transformed WML. Line breaks and white space are not represented in this view, making it difficult to read. See Figure 2.31.

ON THE CD

10. Close the Transformation window. You now open the completed WML file in Dreamweaver MX 2004. The file, called *Ch.2_Golf_WML.wml*, is in the *Chapter 2* directory. This file is the XML file after it has been transformed to WML. Dream-

```
<?xml version="1.0" encoding="UTF-16"?><wml><card title="Santa Cruz"><P><anchor>Altos Par 3<go href="#Altos" /></anchor></P><P><anchor>B
    </option><option onpick="#&#xA;    AltosCourseRating">Rating
    </option><option onpick="#AltosCourseSlope">Slope
</option></SELECT></card><card title="Brook Hills Golf Course" id="Brook"><P>31 Smith Road</P><P>Watsonville95076</P><P>7:00 AM to Sundo
    </option><option onpick="#&#xA;    BrookCourseRating">Rating
    </option><option onpick="#BrookCourseSlope">Slope
</option></SELECT></card><card title="Valley Gorge Golf Course" id="Valle"><P>263 Mount Herman Road</P><P>Scotts Valley95066</P><P>Sunu
    </option><option onpick="#&#xA;    ValleCourseRating">Rating
    </option><option onpick="#ValleCourseSlope">Slope
</option></SELECT></card><card title="Altos Par 3" id="AltosGreenFees"><P>Not Available</P></card><card title="Brook Hills Golf Course" id="Bro
    Blue: <P></P>

    White:

    Red: <P></P></P></card><card title="Brook Hills Golf Course" id="BrookCourseRating"><P><P>Course Rating</P>
Blue: 69.4<P></P>

    White: 68.8

    Red: 70.8<P></P></P></card><card title="Valley Gorge Golf Course" id="ValleCourseRating"><P><P>Course Rating</P>
Blue: 56.5<P></P>

    White:

    Red: 55<P></P></P></card><card title="Altos Par 3" id="AltosCourseSlope"><P><P>Course Slope</P>
Blue:

    White:

    Red: </P></card><card title="Brook Hills Golf Course" id="BrookCourseSlope"><P><P>Course Slope</P>
Blue: 117

    White: 115

    Red: 114</P></card><card title="Valley Gorge Golf Course" id="ValleCourseSlope"><P><P>Course Slope</P>
Blue: 82
```

FIGURE 2.31 The golf XML file as transformed to WML and viewed in Internet Explorer. Screen shot reprinted with permission from Microsoft Corporation.

weaver MX 2004 displays WML files in code view. Note the visual enhancements Dreamweaver MX 2004 adds for readability, including indentation and color-coding. See Figure 2.32.

To see this file as it was meant to be displayed, you use the phone simulator in the OpenWave Developers Kit. Launch the OpenWave SDK 5.1 Software. Figure 2.33 shows a screen shot of the OpenWave Developers Kit.

11. From the main menu bar, click Simulator → Go To Address, as shown in Figure 2.34.

ON THE CD

12. Click the browse button, navigate to the *Chapter 2* directory, and open the file called *Ch.2_Golf_WML.wml*. This action simulates the cell phone's Web browser request to a server to load the file.

13. Use the instructions in the phone to navigate to the document in the phone simulator, as shown in Figure 2.35.

FIGURE 2.32 The WML file as viewed in Dreamweaver.

FIGURE 2.33 The OpenWave Developers Kit software. Openwave SDK ©2003 OpenWave Systems, Inc.

FIGURE 2.34 Opening the WML file that is displayed in the OpenWave cell phone simulator. Openwave SDK ©2003 OpenWave Systems, Inc.

FIGURE 2.35 The OpenWave cell phone simulator with navigation instructions. Openwave SDK ©2003 OpenWave Systems, Inc.

What You Learn from This File

The files in this tour show how you can use the same data (an XML file) that you used to create Web pages to create wireless Web pages.

What Is WML?

WML is an XML application used in the Wireless Application Protocol (WAP) to display information on wireless devices, especially mobile phones. Dreamweaver MX 2004 writes WML, providing code hints as you enter your data.

How Can You Repurpose XML Files?

At this point you have seen how you can transform the initial golf course XML file for display on a Web browser using CSS, as well as transforming the XML into HTML with XSL-T and, in the last example, to WML for cell phones. As more applications become XML aware, even more ways of using or repurposing this information will be created. In subsequent chapters, you will see how Macromedia software is capable of using this XML file.

SUMMARY

This concludes the quick tour into XML. You will now begin the tutorials and learn how you can exploit these features of XML using Macromedia Flash MX Professional 2004, Fireworks MX 2004, and Dreamweaver MX 2004.

ADDITIONAL RESOURCES

The official specifications for the languages introduced in Chapter 2 include:

HTML:	*www.w3.org/MarkUp/*
XML:	*www.w3.org/XML/*
XSLT:	*www.w3.org/Style/XSL/*
CSS:	*www.w3.org/Style/CSS/*
XHTML:	*www.w3.org/TR/xhtml1/*
WML:	*www.wapforum.org/what/technical.htm*

The OpenWave Web Site: *www.openwave.com/*

XML and
Dreamweaver MX 2004

Part II of the book is the first of three parts that includes hands-on tutorials to guide you through the intricate details of XML, XSL, CSS, DTD, schema, and more, using Macromedia products, beginning with Dreamweaver MX 2004. In the next three tutorials, you'll explore XML support in Dreamweaver MX 2004. In Chapter 3, you will use Dreamweaver MX 2004 to create well-formed and valid XML files, as well as write DTDs and schemas. In Chapter 4, you will learn how to display your XML files with CSS, configure Dreamweaver MX 2004 as an XML editor, and transform your XML files into HTML with XSL-T. Chapter 5 contains more advanced topics, including creating and using XML-based templates and building dynamic Web pages using both XML and ColdFusion.

3

DREAMWEAVER MX 2004 AND XML FUNDAMENTALS

In This Chapter

- Tutorial One: How to Write Well-Formed XML
- Tutorial Two: How to Write Valid XML with a DTD
- Tutorial Three: How to Write Valid XML with a W3C Schema

Chapter 3 is the first of the tutorials. Accordingly, you learn the fundamentals of XML. Chapters 1 and 2 explored what XML is and why it has become a popular solution to a number of problems. Chapter 3 explains the nuts and bolts of the language: its syntax and logic. You learn the basic terminology associated with XML as well as how to write it. In keeping with the focus of the book, the tool of choice will be Macromedia Dreamweaver MX 2004.

TUTORIAL ONE: HOW TO WRITE WELL-FORMED XML

OBJECTIVES

- To understand the syntax and logic of an XML file
- To write a well-formed XML file using Macromedia Dreamweaver MX 2004

BEFORE YOU BEGIN

What You Will Need for This Tutorial

- Dreamweaver MX 2004 (Macintosh or PC version)
- (PC) Microsoft Internet Explorer 5.x or later
- (Mac) Microsoft Internet Explorer 5.2 or later

ON THE CD

The Data Files

- **Tutorial One Directory:** *Data Files/Part_2/Chapter 3/Ch_3_Well-Formed_XML_1*
- **Student Files Directory:** *Data Files/Part_2/Chapter 3/Ch_3_Well-Formed_XML_1/How To Write Well-Formed XML*
- **Student Files:** There are no student files to open.
- **Finished Files Directory:** *Data Files/Part_2/Chapter 3/Ch_3_Well-Formed_XML_1/Ch_3_1 Finished*
- **Finished Files:** *Ch.3_Finished_Well_Formed_Error.xml Ch.3_Finished_Well_Formed_Golf.xml*

You will begin this tutorial by defining a site in Dreamweaver MX 2004 with the specifications shown in Figure 3.1.

FIGURE 3.1 The site definition summary.

INTRODUCTION: WHAT IS WELL-FORMED XML?

XML is a markup language used to describe something. It can be used to describe an action, a procedure, or a process. Complicated configurations for large-scale networks and their associated routers can be described with XML. Yet, you can use the same metalanguage to describe your resume or to describe the information contained in a database. As an XML author you define your own custom tags for nearly any type of document.

As you will learn, XML looks and feels very much like the familiar HTML, with angle brackets (< >) that store information as plain text. The main difference is the tags themselves. Unlike HTML tags which are predefined, XML tags, known as elements, are defined by you, the XML author. When you create your own XML vocabulary you have created an XML application. Some now-familiar XML applications include the Wireless Markup Language (WML) and the Voice Markup Language (VML).

When you see a need to store data in a format that both computers and humans can understand, and when you need to share that data, you have found an opportunity to implement an XML solution. Think of writing XML as writing your own language. You decide the vocabulary to use.

The next step is to consider the grammar for that vocabulary. Consider this grammar the rulebook for how to structure your new lan-

guage. This rulebook takes the form of a file called a Document Type Definition (DTD) or a schema. These files are discussed in more detail in the next chapter.

Deciding how to name your elements as well as how to structure your data is perhaps the most difficult aspect of authoring XML. This tutorial focuses on the syntax of XML and its key concepts. Most Web designers will not be authoring XML. However, they do need to understand its components to apply the styles or rendering information that is needed to design with XML.

The title of this chapter is not "How to Write XML" but "How to Write Well-Formed XML." Well-formed XML is simply XML that does not break any rules of syntax. A summary of these rules is provided at the end of this chapter. You will now learn each rule of syntax as you create the sample XML file, line by line. Fortunately, there are not many rules of syntax. It is imperative, however, that no rule be broken, because XML is meant to be a highly structured, organized file. Breaking any of the rules of syntax breaks its rigid structure.

Each step begins with a brief explanation of the concepts relevant to the line of code you write. For more complex aspects, a summary follows the code. The XML file you will create is a directory of fictitious golf courses located in San Francisco's Bay area.

The first line of code in the file declares the file to be written in XML. In addition, you must also state the version of XML with which you are writing (currently 1.0). You then state whether the document can be displayed and processed alone or whether it requires another file such as a stylesheet. You indicate this with the attribute `standalone`. The value of `standalone` is equal to yes or no. This attribute is optional and the default value is yes. Next you declare the encoding type. A digital file's encoding type is simply how the characters in the document are to be represented as bits and bytes, or ones and zeros, when stored in a computer's memory space. In XML the encoding type is yet another way that the document is self-identifying. Unlike HTML, which is written in ASCII code (ASCII code includes the upper- and lowercase letters of the alphabet, numbers 0 through 9, and common American symbols like the dollar sign, colon, and semicolon), XML's encoding type allows for the use of characters such as the yen symbol and others, making it more international in scope. Declaring the encoding type is optional, because the default code recognized by the XML processor must be Unicode 8 or 16. Otherwise, you can state the encoding type explicitly.

Dreamweaver MX 2004 can be set up to create new documents with a default encoding type. Step 2 provides the instructions for this process.

This line of code is called the XML declaration and is technically known as a processing instruction. A processing instruction is a line of code in your XML file that is written for the benefit of the software (or processing application) that processes (or parses) your XML file (data) in some way. This application might be written in Java or C++ to process the data in the XML file or it may be simply an XML browser such as Internet Explorer 5.x or later. The XML declaration and any other processing instructions that follow it are known as the prologue component of the XML file.

1. Launch Dreamweaver MX 2004.

 If Dreamweaver MX 2004 launches a blank document window; close it by clicking File → Close or by clicking the close box in the upper right corner of the application window.

2. Click Edit → Preferences. Select the New Document category on the left, as shown in Figure 3.2.

FIGURE 3.2 Dreamweaver preferences for setting the default encoding type.

3. From the Default Encoding drop-down menu, choose UTF-8 Unicode and click OK.
4. To create a new document, Choose File → New. The New Document dialog box opens. Make sure the General tab is selected in the New Document window, as shown in Figure 3.3.

FIGURE 3.3 The New Document dialog box.

5. Click the Basic Page category on the left. From the Basic Page portion of the window on the right, click XML. Dreamweaver MX 2004 provides the simple description of this file as Extensible Markup Language (XML) document.
6. Click → Create. Dreamweaver MX 2004 switches to Code View automatically and displays the XML declaration. Dreamweaver MX 2004 does not add the standalone attribute.
7. Place your cursor in the code after the encoding attribute and type the following attribute:

```
<?xml version="1.0" encoding="UTF-8" standalone="yes"?>
```

All well-formed XML files begin with the XML declaration, followed by the document's root element. The root element is the element (or opening tag) that nests all the other elements. There can be, therefore, only one root element. For example, the root element of a Web page is <HTML> because that is the tag that contains all the other tags in the Web page. Like HTML tags, an XML tag consists of an opening tag, some data or content, and a closing tag. Together, all three components are known as an *element*. The root element is known as the document element component of the XML file.

8. Type the following root element:

```
<County>
```

Note that this is just the opening tag. The document ends with the root element's closing tag:

```
</County>
```

9. After pressing the Enter key several times, type the closing `</County>` tag. You will write the rest of the XML tags between the opening and closing `<County>` tags.

CONCEPT: ELEMENTS AND THE RULES OF WELL-FORMEDNESS

Although you create your own tag names in XML, you must follow certain rules when naming them. An element name must meet the following specifications:

- Consists of at least one letter
- Starts with an underscore or a colon.
- Contains one or more letters, digits, hyphens, underscores, Unicode symbols, and accents only if starting with an underscore or colon
- Does not contain spaces or tabs
- Contains only hyphens and periods as punctuation

All Start Tags Must Have End Tags

The next tag will be the `<Course>` tag, which will be a container tag, in that it does not hold any content other than other tags. Nested inside the `<Course>` tag is the `<CourseName>` tag. Like all XML elements, both tags must contain an opening and a closing tag. Consider the following example:

```
<CourseName>some content goes here</CourseName>
```

The closing tag, similar to HTML, is simply the opening tag proceeded by a / (slash). Unlike HTML, however, you cannot have tags that are not closed, such as the HTML tags, `
` and `<hr>`. These tags are referred to as empty elements (tags that contain no content). Empty elements can be used in XML; however, they must follow the rules of well-formedness, which state that all tags must be closed. XML provides two methods for closing empty tags.

Example 1: `<Blue></Blue>`
As in HTML, white space and returns are ignored. (Exceptions to this rule are explained throughout the upcoming tutorials). Thus, example 1 could be written as follows:

```
<Blue>        </Blue>
```

or

```
<Blue>
</Blue>
```

Example 2: `<Blue/>`

Example 2 is the shorthand method for both opening and closing the tag within the same angle brackets. Both methods satisfy the rule of well-formedness that requires opening tags to have closing tags; however, when using XML files for Dreamweaver templates, you cannot use this shorthand method. Dreamweaver MX 2004 accepts the following short-cut without causing XHTML error messages: `<Blue />`. The difference in this shortcut is the addition of a space before the slash and the closing angle bracket (>).

XML Is Case Sensitive

XML is normally written in lowercase letters. XML is still case sensitive; therefore, the following element breaks rule 1 of well-formedness.

```
<Course>Name of Golf Course goes here</course>
```

The XML parser (Internet Explorer, for example) would return an error here, indicating the end tag `</course>` does not match the start tag `<Course>` due to the difference in the initial "C," which is uppercase in the opening tag and lowercase in the closing tag.

XML Must Be Properly Nested

If an element starts within another element, it must also end within that same element. This rule ensures that the content or data follow a logical structure. This logical structure is the strength of XML and what differentiates it from HTML.

Add the following element to the document, using indentations to indicate the nesting of one tag inside of another:

```
<Course>
```

We will close this tag after nesting several more elements inside:

```
<CourseName>Valley Gorge Golf Course</CourseName>
  <CourseInfo>
  <Street>263 Mount Ethel Road</Street>
  <City>Scotts Valley</City>
```

```
    <Zip>95066</Zip>
    <Phone>408-555-3058</Phone>
    <Hours>Sunup to Sundown</Hours>
</CourseInfo>
```

CONCEPT: COMMENTS

XML comments are written to add clarification to the document, for the readers of the XML file or perhaps the author of the document. The syntax for an XML comment is the same as the syntax for HTML comments. For example:

```
<!- -  The comment goes here - - >
```

10. Place your cursor at the end of the XML declaration and add this comment:

```
<?xml version="1.0" encoding="UTF-8" standalone="yes"?>
<! - - This is a directory of Fictitious San Francisco Bay
Area Golf Courses - - >
```

11. Place your cursor after the last line of code, `</CourseInfo>`, and add the opening tag:

```
<CardInfo>
```

CONCEPT: ATTRIBUTES

Like HTML attributes, XML attributes add information that further describes the tag. Consider the following HTML example of an attribute: ``. When writing an XML application, you define the tags as well as the attributes. Thus, the previous example could be structured as follows:

```
<font>
  <face>Arial</face>
  <color>Red</color>
</font>
```

Although there is nothing wrong with this approach, the general rule is to use attributes when you are adding information that merely further defines a tag. This is a general rule, and there will be times when you prefer the second approach. Another way to approach this situation is to think of the tag names as nouns and attributes as adjectives. The syntax for using attributes is the same as that for HTML. The tag

names come first, followed by a space and the name of the attribute, followed by an equals sign (=), followed by the attribute's value. One important distinction is the XML rule requiring the document to be well formed, which requires that attribute values be in quotation marks. Placing attribute values in quotation marks is common practice in HTML as well, but it is not strictly enforced as it is in XML.

12. Add the following element and attribute, nesting it inside the `<CardInfo>` tag:

```
<Hole Number="1">
    <Number>1</Number>
    <Par>4</Par>
```

13. Add the following empty element:

```
<Blue></Blue>
```

14. Add the remaining nested tags and the closing tag for `<Hole>`. The completed XML file is shown in Figure 3.4.

FIGURE 3.4 The completed XML file in Dreamweaver MX 2004.

```
<Hole>
    <White>245</White>
    <Red>236</Red>
    <MensHcp>11</MensHcp>
    <LadiesHcp>1</LadiesHcp>
</Hole>
```

15. Add the remaining `<hole>` tags for this nine-hole golf course.

```
<Hole Number="2">
<Number>2</Number>
    <Par>4</Par>
    <Blue></Blue>
    <White>331</White>
    <Red>293</Red>
    <MensHcp>12</MensHcp>
    <LadiesHcp>11</LadiesHcp>
</Hole>
<Hole Number="3">
    <Number>3</Number>
    <Par>3</Par>
    <Blue></Blue>
    <White>141</White>
    <Red>131</Red>
    <MensHcp>14</MensHcp>
    <LadiesHcp>16</LadiesHcp>
</Hole>
<Hole Number="4">
    <Number>4</Number>
    <Par>5</Par>
    <Blue></Blue>
    <White>452</White>
    <Red>427</Red>
    <MensHcp>4</MensHcp>
    <LadiesHcp>4</LadiesHcp>
</Hole>
<Hole Number="5">
    <Number>5</Number>
    <Par>3</Par>
    <Blue></Blue>
    <White>138</White>
    <Red>131</Red>
    <MensHcp>18</MensHcp>
    <LadiesHcp>18</LadiesHcp>
</Hole>
<Hole Number="6">
    <Number>6</Number>
    <Par>4</Par>
    <Blue></Blue>
```

```
        <White>312</White>
        <Red>267</Red>
        <MensHcp>6</MensHcp>
        <LadiesHcp>9</LadiesHcp>
    </Hole>
    <Hole Number="7">
        <Number>7</Number>
        <Par>4</Par>
        <Blue></Blue>
        <White>381</White>
        <Red>331</Red>
        <MensHcp>1</MensHcp>
        <LadiesHcp>2</LadiesHcp>
    </Hole>
    <Hole Number="8">
        <Number>8</Number>
        <Par>4</Par>
        <Blue></Blue>
        <White>336</White>
        <Red>320</Red>
        <MensHcp>10</MensHcp>
        <LadiesHcp>6</LadiesHcp>
    </Hole>
    <Hole Number="9">
        <Number>9</Number>
        <Par>4</Par>
        <Blue></Blue>
        <White>317</White>
        <Red>275</Red>
        <MensHcp>8</MensHcp>
        <LadiesHcp>13</LadiesHcp>
    </Hole>
```

16. **Add the remaining child elements of the** `<Course>` **elements.**

```
        <CourseRating>
        <Blue>56.5</Blue>
        <Red>55</Red>
    </CourseRating>
    <CourseSlope>
        <Blue>82</Blue>
    </CourseSlope>
</CardInfo>
<CourseDescription>
<Paragraph>A long short course in downtown Scotts Valley.
9 holes with lovely views of the Santa Cruz Mountains
perfect for beginners, but the mettle of good players will
be tested.
```

```
        </Paragraph>
        </CourseDescription>
        <Facilities>
            <DrivingRange>no</DrivingRange>
            <PuttingGreen>yes</PuttingGreen>
            <ChippingGreen>no</ChippingGreen>
            <Reservations>yes</Reservations>
            <SnackBar>yes</SnackBar>
            <CreditCards>no</CreditCards>
            <BanquetFacilities>no</BanquetFacilities>
            <GolfPro>yes</GolfPro>
            <ProShop>yes</ProShop>
            <Lessons>yes</Lessons>
            <PullCarts>$2.00</PullCarts>
            <Clubs>$4/$8</Clubs>
            <GolfCar>no</GolfCar>
            <CocktailLounge>no</CocktailLounge>
        </Facilities>

<GreenFees>
<Fees>
    <conditions>
        <condition type="Day">Weekday</condition>
        <Fee>11.00</Fee>
    </conditions>
</Fees>
<Fees>
    <conditions>
        <condition type="Day">Weekends</condition>
        <condition type="Day">Holidays</condition>
        <Fee>12.00</Fee>
    </conditions>
</Fees>
<Fees>
    <conditions>
        <condition type="Day">Wednesdays</condition>
        <Discount>Junior</Discount>
        <Discount>Senior</Discount>
        <Fee>$8.00</Fee>
    </conditions>
</Fees>
</GreenFees>
```

17. Add the closing `<Course>` element, followed by the tag that closes the root element `</County>`.

```
</Course>
    </County>
```

CONCEPT: SAVING XML FILES

Because you initially specified XML as the new document type in the New Document dialog box, you can click File → Save at this point. Otherwise, when saving an XML file in Dreamweaver MX 2004, you must make sure to add the .xml extension to the filename and save the file as XML files.

18. Save this file in the *Chapter 3/How to Write Well-Formed XML* directory as *Ch.3_Student_XML.xml*.
 The Save As dialog box opens, as shown in Figure 3.5.

FIGURE 3.5 The Dreamweaver MX 2004 Save As dialog box.

CONCEPT: VIEWING AND EDITING XML FILES IN DREAMWEAVER MX 2004

Dreamweaver MX 2004 has added some features and panels that facilitate the creation and editing of XML files. From the Window menu, choose Tag Inspector. When you place your cursor in any of the XML tags, the Tag Inspector indicates the tag name in the title bar of the

panel. In addition, the Tag Selector in the status bar of the document window does the same. Place your cursor in the first `<Condition>` tag in the file. Note that the Tag Selector reads:

`<County><Course><GreenFees><Fees><conditions><condition>`.

Note that you can edit the attribute name or value in the Tag Inspector, as well as select the value dynamically (from a database).

CONCEPT: VIEWING XML IN INTERNET EXPLORER 5.X

If you followed the instructions in Chapter 2, your browsers should now be capable of viewing XML files. If not, see the section in Chapter 2, "Configuring Your Browser," for setup instructions.

19. From the Dreamweaver MX 2004 File menu, click Preview in Browser → Internet Explorer. The result is displayed in Figure 3.6.

FIGURE 3.6 The file as displayed in Internet Explorer 5.x. Screen shot reprinted with permission from Microsoft Corporation.

20. Place your cursor over the dash before the root element. The cursor turns into a hand. Click the dash to collapse the document's elements. Any element that contains nested elements can be collapsed in this way.

Internet Explorer color-codes the elements as follows:

- Angle brackets are blue: `< >`
- Element name is red: `<CourseName>`
- Element content is black:

```
<CourseName>Valley Gorge Golf Course</CourseName>
```

This display is caused by an XSL stylesheet (written in an XML application called XSL-T), which transforms the XML file into an HTML file. When the file is opened in Internet Explorer, the browser uses its built-in XSL-T processor to process the stylesheet supplied by the Microsoft browser. After the file is transformed into HTML, it is displayed in the browser window.

21. To examine the transformed XML file, which is now an HTML file, place your cursor on the document window, right-click, and click View XSL Output.
22. Click View → Source. The XML file opens in Notepad.
23. Close the source code window and return to Dreamweaver MX 2004.
24. Close the current file in Dreamweaver MX 2004.

You have now learned the basic rules of syntax for writing well-formed XML. Like HTML, XML is written in plain text that encloses elements in angle brackets. White space is ignored (with some exceptions discussed later).

The simple rules of well-formed XML include:

- All start tags must have end tags.
- All start tags and end tags must match.
- XML is case-sensitive.
- All tags must be properly nested.
- All XML files must begin with the XML declaration.
- All attribute values must be in quotation marks.

Internet Explorer does not display XML files that are not well-formed. Instead of opening the file as expected, Internet Explorer returns an error message indicating the line and character number that contains the error and a brief description of the error. The

Dreamweaver MX 2004 Results panel indicates any structural errors of well-formedness. The next tutorial shows how the Results panel works.

1. Open the file *Ch.3_Student_XML.xml* in Dreamweaver MX 2004.

If you have not completed the Ch.3_Student_XML.xml *file, you can use the finished version called* Ch.3_Finished_Well_Formed_Golf.xml *from the* Ch_3_1 Finished *directory in the site's root directory.*

2. Locate the first `<CourseInfo>` tag and its corresponding closing tag, `</CourseInfo>`.
3. Delete the closing tag, `</CourseInfo>`, and save the file as *Ch.3_Student_with_Error_Golf.xml*.
4. Click Window → Results → Validation to open the Results panel with the Validation tab active.
5. Place your mouse on the Validate drop-down list, which is the right-facing green triangle on the Validation panel. Select Validate Current

FIGURE 3.7 The Results panel below the document indicating an error of well-formedness in the XML file.

Document or Validate Current Document as XML. Double-click the red exclamation point to highlight the line of code referenced in the error line number and description. The Results panel is shown in Figure 3.7.

The Results panel indicates the lines that contain errors as a result of the `<CardInfo>` tag remaining unclosed. This document is not well-formed.

The completed file can be found in the directory Finished Files/Chapter 3/Ch.3_Finished_with_Error_Golf.xml. *In this file, you will see that the closing* `</CourseInfo>` *tag has been commented via the comment code* `<!- - -->`.

6. Click File → Preview in Browser → Internet Explorer. You should see the error message shown in Figure 3.8.

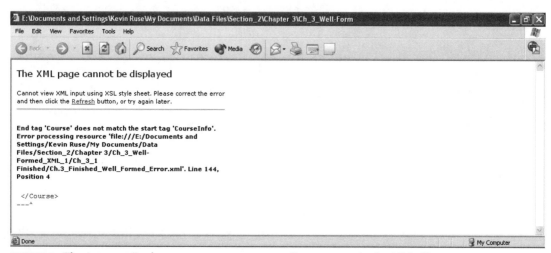

FIGURE 3.8 The Internet Explorer error message regarding an error in the XML file. Screen shot reprinted with permission from Microsoft Corporation.

This error is the result of opening in Internet Explorer an XML file that is not well formed. The error message is displayed because the closing tag, `</CourseInfo>`, is not used.

XML applications must be well-formed. The rules of well-formedness ensure that the data in your XML document is highly structured and, thus, readable by both humans and machines. The Results panel in Dreamweaver MX 2004 validates an XML file by indicating syntax errors such as missing quotations or angle brackets (< >) as well as structural errors such as unclosed tags or improper nesting of tags. Dreamweaver MX 2004 does not validate an XML file against a DTD or schema, as you will learn in the next two tutorials.

What Is a Processing Instruction?

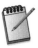

Processing instructions are added as an aid to applications that are processing an XML file in some way. For example, if you have a Java application that calculates a golfer's handicap, at some point in the XML file you want to trigger this Java application to execute. The processing instruction would take the following structure:

```
<?GolfApp: getHandicap?>
```

GolfApp *would be the name of the Java application and* getHandicap *would be the command you wish to execute.*

When Should You Nest Tags?

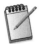

Tags are nested to add clarity and human readability to the XML file. Nesting tags also facilitates machine processing. Consider the following:

```
<wineVarieties>
    <Red>
        <Merlot>
        <Cabernet>
        <Chianti>
    </Red>
    <White>
        <Chardonnay>
        <Sauvignon Blanc>
    </White>
</wineVarieties>
```

The purpose of <wineVarieties> *is to add a label to this section of the document. The purpose of the* <red> *and* <white> *elements is to further categorize the elements in this section of the document. The nesting of tags helps to make the XML a self-describing document.*

What Is an XML Parser and Do You Need One?

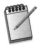

To "parse" is to identify the various parts of a document and their function. A parser examines a document and deciphers that which is content from that which is code. Internet Explorer, Netscape, Mozilla, and all other Web browsers are HTML parsers because they are capable of examining the HTML document and determining where the content begins and ends and where the markup begins and ends, ultimately rendering the markup and displaying the content. For you to open XML files in a Web browser, the browser must have an XML parser. Internet Explorer 5.x and later, Netscape 6.0 and later, Opera 5.x and later, and Mozilla 1.0 all contain an XML parser. XML parsers are commonly created with Java and C++ as well. Many of these XML parsers are available on the Internet. Dreamweaver MX 2004 contains an XML parser.

ADDITIONAL RESOURCES

The World Wide Web Consortium: *www.w3.org*
About the XML Specification: *www.xml.com/axml/testaxml.htm*
The XML Specification: *www.w3.org/TR/REC-xml*
XML.com XML Guide: *www.xml.com/pub/98/10/guide0.html*
XML Tutorials: *www.w3schools.com*

TUTORIAL

TUTORIAL TWO: HOW TO WRITE VALID XML WITH A DTD

Tutorial Two contains four exercises. The first three exercises involve the creation of a document type definition (DTD). The only difference between Exercise Two and Exercise Three is the location of the DTD within the XML file. In Exercise Two the DTD is internal, whereas in Exercise Three the DTD is external. Both methods are described in detail. In Exercise Four, you use the Internet Explorer Tools for Validating XML to verify that your XML file is valid.

EXERCISE ONE: HOW TO WRITE A DOCUMENT TYPE DEFINITION

OBJECTIVES

- To understand the concept of valid XML and why it is necessary
- To understand the syntax of the document type definition (DTD)
- To write valid XML with a DTD in Dreamweaver MX 2004
- To validate an XML file using Dreamweaver MX 2004

BEFORE YOU BEGIN

What You Will Need for This Tutorial

- Dreamweaver MX 2004 (Macintosh or PC version)
- (PCs) Microsoft Internet Explorer 5.x or later
- (Mac) Microsoft Internet Explorer 5.2 or later

The Data Files

- **Tutorial Two Directory:** *Data Files/Part_2/Chapter 3/Ch_3_DTD_2*
- **Student Files:** *Ch_3_Finished_Well_Formed_Golf.xml*
- **Finished Files Directory:** *Ch_3_2 Finished*
- **Finished Files:**
 Ch.3_Golf_XML_with_Entity_dtd.XML
 Ch_3_Golf.dtd
 Ch_3_Golf_ExternalDTD.xml
 Ch_3_Golf_InternalDTD.xml
 Ch_3_Golf_InternalDTDwError.xml

Defining the Site for Chapter 3 Tutorial Two

You begin this tutorial by defining the Web site. Your root directory is the *Ch_3_DTD_2* directory located inside the *Chapter 3* directory on the CD-ROM. Name the site *Chapter_3_2*.

INTRODUCTION: WHAT IS VALID XML?

If using XML involves creating your own vocabulary, then the document type definition (DTD) can be considered the grammar of that vocabulary. English words such as *XML, becoming, is, the, quickly, standard, format, file, data, for,* and *storage* mean little until you apply the rules of English grammar to form a valid sentence like "XML is quickly becoming the standard file format for data storage." Like English grammar, a DTD indicates what XML elements are allowed in a given document, how often they should appear, and in which order they should appear.

In the DTD you determine how your elements should be structured. For example, you are creating a directory of employees and have decided to use XML so that the employee data can be shared across departments (Human Resources, Purchasing, and so on). If you use XML, the data can be shared across computer systems as well, such as the company's main telephone switchboard. (In a more complex example involving Java, each individual's phone can contain an XML browser that contains the XML directory of employee names, phone numbers, fax numbers, and so on.)

Your root element is `<EmployeeDirectory>`. The next level of tags are the departments in which the individual employees are found: `<Engineering>`, `<Administration>`, and so forth. The variety of computer systems and software used within the company will function seamlessly, depending on the structure of the XML data. If the browser's telephone

numbers, for example, cannot be programmed to sort automatically by first name, you can add content formatted as follows:

```
<Name>Kevin Ruse</Name>
```

For increased sort capabilities, the following structure is preferred:

```
<Name>
<First>Kevin</First>
<Middle>Michael</Middle>
<Last>Ruse</Last>
</Name>
```

In addition, many people with first names that are long or difficult to spell or pronounce often use a nickname. In that case, you might want to make an optional <Nickname> tag.

These types of rules are found in a DTD file—rules such as what elements are allowed, which of those elements are required, in what order the elements should be, and how frequently the elements can appear in the XML document. Remember that an element is defined as the opening tag, the content data, and the closing tag. Thus, the following is an element:

```
<First>Kevin</First>
```

Well-formed XML, which you learned how to write in Chapter 3, Tutorial One, makes no assumptions about the structure of the document. Our golf guide may take this form:

```
<CourseName>My Golf Course</CourseName>
<Par>5</Par>
<City>San Jose</City>
    <Hole Number="1">
        <Hole>3</Hole>
        <Red>345</Red>
    <Hole>
<Zip>95129</Zip>
<White>365</White>
```

This file is well formed and would open and display successfully in an XML parser or browser, but it makes no sense in terms of structure. The information regarding the golf courses' location is interspersed throughout the document, rather than combined and enclosed as a discrete section of information. The <Hole> tag with the number attribute has a

<Hole> tag with a different number nested within it, and the <Par> tag is situated in a position in the document with no corresponding information; thus, you know it is a par five, but for which hole? There is a <White> element with a distance of 365 yards, but, again, for which hole? The document is not built in a way that you can infer its meaning through its structure, as you can in the XML file created in Chapter 3, Tutorial One.

To enforce structure requirements, there must be rules as well as a methodology for testing whether or not these rules have been followed. The DTD provides a method of doing this. This document declares the elements, the attributes, and the entities you are allowed to use. In addition, it determines how often you are allowed to use these elements and in what order they should appear in the XML document.

The ability to check the XML file against its associated DTD is called *validation*. If the document does not break any of the rules set forth in the DTD, it is considered valid XML and will be parsed by the processing application. As noted in the previous chapter, Dreamweaver MX 2004 can validate an XML file for well formedness but does not validate an XML file against a DTD. In this tutorial, the XML parser is the Internet Explorer 6.0 browser. The validation process does not happen automatically. You must initiate the process by right-clicking in the browser and selecting Validate XML.

In short, in writing XML, you create your own custom markup language (also known as an XML application). To ensure its successful implementation, you should also author a document that informs others how to properly write in your XML language. This document is the DTD.

WHY WRITE VALID XML?

As graphic designers, you will be using the XML file as the data or content for your Web design. As you will learn in subsequent chapters, you can use techniques in Macromedia software that requires the XML to be structured in a consistent way. When you write a stylesheet, for example, the XSL-T code instructs the XML parser how to transform the XML to display as HTML.

Example

An XSL-T stylesheet can instruct the XSL processor inside the Web browser to locate all <Hole> tags and build an HTML table with a new row for each hole number. Each row contains columns for that hole number's par, white flag distance, red flag distance, blue flag distance, the mens' handicap, and the ladies' handicap. In addition, the Web

browser will build one table for a nine-hole golf course and two tables for an 18-hole course, as shown in Figure 3.9.

FIGURE 3.9 The golf file with XSL-T–generated tables displaying the golf card information. Screen shot reprinted with permission from Microsoft Corporation.

This code works only when the XML files all share a similar structure. The Card Information section in particular must be structured with proper nesting of tags. Recall the structure from the file created in Chapter 3, Tutorial One:

```
<CardInfo>
        <Hole Number="1">
            <Number>1</Number>
            <Par>4</Par>
            <Blue/>
            <White>450</White>
            <Red>346</Red>
```

```
        <MensHcp>11</MensHcp>
        <LadiesHcp>1</LadiesHcp>
    </Hole>
```

If someone were to author a file without a `<Hole>` tag or a file with a `<Par>` tag in the wrong location, the XSL-T stylesheet could not be processed.

Software applications that can process XML, such as Dreamweaver MX 2004 and Fireworks MX 2004, also depend on the consistent structure of the XML data. In addition, Dreamweaver MX 2004 can load a DTD or schema. It can then build a tag library from the DTD or schema that authors can use to build XML files that conform to that DTD.

Designers are not the only group that require valid XML. Application developers also want to ensure the integrity of the data to facilitate the exchange of information between computer systems and ensure the successful processing of the XML document.

In this tutorial, you learn how to write a DTD for the golf directory. You associate the XML file created in Chapter 3, Tutorial One with the newly created DTD, open the file in Internet Explorer 6.0, and validate the golf directory against the DTD.

Recall from Chapter 2, "Overview of XML" that XML is a metalanguage derived from the Standard General Markup Language (SGML). DTD files were first developed to structure SGML; therefore, they predate XML (by approximately 30 years). Even the acronym DTD denotes a file that validates the structure of a document, as in a publication or written piece. XML, on the other hand, is frequently used to describe data as well as documentation. Although a DTD is an adequate language when it comes to describing a document, it falls short when describing a database. DTD still offers advantages when validating XML, and it is often the preferred method. However, there will be times when a DTD does not accurately or thoroughly set the rules for an XML application. In such cases, we will turn to an XML schema file to do the work. A schema serves the same purpose as a DTD, with some critical differences. After learning how to write a DTD, you will progress to Tutorial Three, How to Write Valid XML with a W3C Schema.

EXERCISE TWO: HOW TO WRITE VALID XML WITH AN INTERNAL DTD

The DTD can be located in one of two places. In this tutorial, the DTD appears in the prologue of the XML file to which it applies. This placement is known as an internal DTD. The DTD can also be a separate file, in

which case you would need to write a line of code in the prologue of the XML file that associates the XML data with the DTD rules. That arrangement is known as an external DTD.

1. Launch Dreamweaver MX 2004 and open the file you created in Chapter 3, Tutorial One.

If you did not complete this file, you can open the completed file in the directory *Chapter 3/Ch_3_DTD_2/Ch_3_2 Finished/Ch_3_Finished_ Well_Formed_Golf.xml.*

The DTD begins with the <!DOCTYPE element, which contains several important keywords. Note that XML is case sensitive, and you must type the <!DOCTYPE element in all caps; therefore, <!Doctype is not acceptable.

2. Place your cursor after the XML declaration and press Enter to add a new line of code. Type the following:

```
<!DOCTYPE
```

3. Type a space followed by the document's root element, followed by square brackets, which contain the DTD. The line is closed with the closing angle bracket >.

```
County        [

]>
```

Figure 3.10 shows the XML file with an internal DTD.

The rules for how to write your XML application are contained within the square brackets. These rules include what elements are allowed and how to write each element. Elements can be declared in any order. You will begin by declaring the root element.

4. To declare an element, begin with:

```
<!ELEMENT
```

followed by a space and then the name of the element you are declaring, County, followed by a parenthesis that indicated what that element is allowed to contain:

```
(Course+)
```

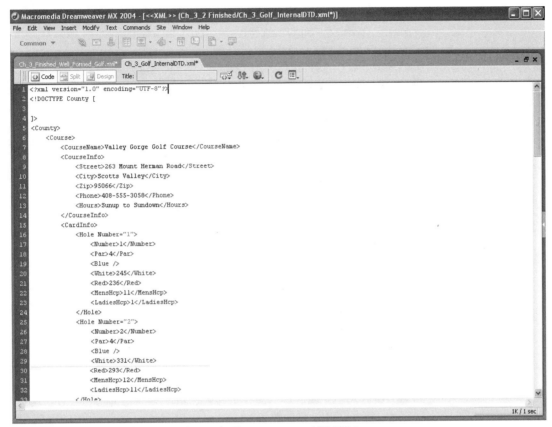

FIGURE 3.10 The internal DTD, as shown in Dreamweaver MX 2004.

followed by the closing angle bracket:

```
>
```

Thus your first element declaration looks like this:

```
<!ELEMENT County (Course+)>
```

You have now declared an element named `<County>`, which contains the child element `Course`. No elements will be inside the `<County>` element other than the `<Course>` element.

XML Example:

```
<County>
    <Course></Course>
    <Course></Course>
</County>
```

You may be wondering about the + (plus sign) after the <Course> element. Symbols following the elements inside the parentheses indicate how often the element is allowed to appear in the document at that location. This is known as the *frequency indicator*. The + (plus sign) allows the <Course> element to appear more than once, and it must appear at least once. The absence of a frequency indicator symbol results in the element being required in the document at that location at least once but not more than once. The remaining symbols are ? (question mark) and * (asterisk). The element is optional if it is followed by ?; however, it cannot appear in that location in the document more than once. * means the element is optional and repeatable.

5. To declare the next element, type the following:

```
<!ELEMENT Course (CourseName, CourseInfo, CardInfo,
CourseDescription, Facilities, GreenFees)>
```

The previous step declares the <Course> tag, which will contain the children <CourseName>, <CourseInfo>, <CardInfo>, <CourseDescription>, <Facilities>, and <GreenFees>.

You know the element Course contains the elements listed in the parenthesis. However, you also want to restrict the order in which they must appear. Like the frequency indicators, you accomplish this through the use of two symbols—, (comma) and | (pipe)—called *occurrence indicators*. Using , indicates that the elements must appear in the XML file in the order in which they appear in the DTD. Thus, the following XML would not be valid according to the DTD:

```
<Course>
    <CardInfo>    </CardInfo>
    <CourseInfo>    </CourseInfo>
    <Description>    </Description>
<Facilities>    </Facilities>
<CourseDescription>    </CourseDescription>
<CourseName>    </CourseName>
</Course>
```

This code would not be valid because the DTD indicates that the elements must appear in the order expressed by the DTD:

```
<!ELEMENT Course (CourseName, CourseInfo, CardInfo,
CourseDescription, Facilities, GreenFees)>
```

In addition, the element `<GreenFees>` is required to appear in the `<Course>` element at least once. The | would indicate that these elements (while still children of the `<Course>` element) may appear in any order.

6. Type the following code:

```
<!ELEMENT CourseDescription (Paragraph+)>
  <!ELEMENT CourseInfo (Street, City, Zip, Phone?, Hours)>
```

In the previous step, you declared an element called `<CourseDescrip-tion>`, which will contain one or more `<Paragraph>` elements. The second element you declare, `<CourseInfo>`, will contain at least one (but not more than one) `<Street>` element, which must be followed by at least one (but not more than one) `<City>` and `<Zip>` elements. The next element, `<Phone>`, is optional. It must appear in the document at this location, either once or not at all. The last element nested inside the `<CourseInfo>` element is the `<Hours>` element, which is a required element, but it is not repeatable.

CONCEPT: ELEMENTS THAT CONTAIN DATA

So far, you have only declared elements that contain other elements. Some elements will contain data, for example:

```
<CourseName> Valley Gorge Golf Course</CourseName>
```

To indicate that an element contains only text, as in the previous example, use #PCDATA inside the parenthesis, which stands for parsed character data. PCDATA means that the element contains content that is not markup, including numbers, letters, and symbols.

7. Type `<!ELEMENT CourseName (#PCDATA)>`.

CONCEPT: ELEMENTS THAT MAY CONTAIN ANYTHING

The word ANY within the parenthesis indicates that the content of the element may be any combination of unspecified elements and text. It does not, however, allow elements that have not been declared in the DTD.

8. Type the element declarations for BanquetFacilities, Blue, CardInfo, ChippingGreen, City, Clubs, CocktailLounge, CourseInfo, CourseRating, CourseSlope, CreditCards, and Discount:

```
<!ELEMENT BanquetFacilities (#PCDATA)>
<!ELEMENT Blue (#PCDATA)>
```

```
<!ELEMENT CardInfo (Hole+, CourseRating, CourseSlope)>
<!ELEMENT Championship (Fee)>
<!ELEMENT ChippingGreen (#PCDATA)>
<!ELEMENT City (#PCDATA)>
<!ELEMENT Clubs (#PCDATA)>
<!ELEMENT CocktailLounge (#PCDATA)>
<!ELEMENT CourseRating (Blue?, White?, Red?, Mens?, Ladies?)>
<!ELEMENT CourseSlope (Blue?, White?, Red?, Mens?, Ladies?)>
<!ELEMENT CreditCards (#PCDATA)>
<!ELEMENT Condition (#PCDATA)>
```

Figure 3.11 shows the XML file with the internal DTD that declares your elements.

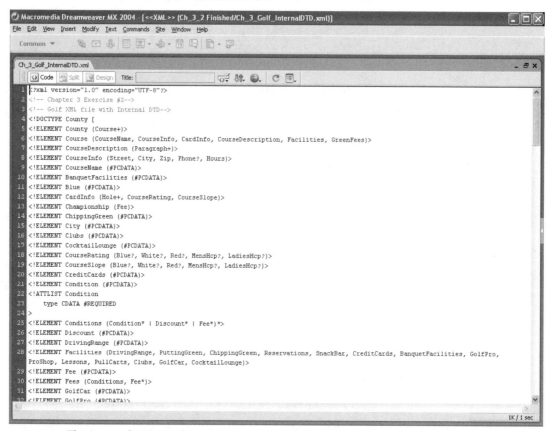

FIGURE 3.11 The internal DTD, as shown in Dreamweaver MX 2004.

CONCEPT: DECLARING ATTRIBUTES AND THEIR KEYWORDS

In addition to declaring elements, DTDs declare attributes. Attributes can be declared anywhere in the DTD. For clarity, declare attributes directly beneath the element to which they apply. Attributes are declared with syntax similar to the declaration of elements. When declaring attributes, you must consider the attributes' possible values as well. The attributes' values are defined through the use of keywords within the attribute declaration. Such keywords may indicate whether or not the value can be more than one word—if it must be a unique value within the XML file, if it is a required attribute, or if it has a fixed value. These keywords are described in the next section as they are encountered. Any keywords that are not used in your DTD appear in a list of keywords and their definitions at the end of this section of the tutorial.

9. Type the following to declare an attribute:

```
<!ATTLIST
```

At this point, you could list all the attributes that belong to an individual element. In this step, however, you are declaring only one attribute. After the `<!ATTLIST` declaration, type the name of the element to which the attribute will be applied.

```
Condition
```

followed by the name of the attribute itself:

```
Type
```

followed by any keywords that further describe the attribute:

```
CDATA
```

This keyword is used if the attributes' value consists of any combination of characters. For example, the HTML color attribute of the font tag contains values such as red, blue, #330099, and so on, and would be declared:

```
<!ATTLIST font color CDATA> #REQUIRED
```

This keyword essentially makes the attribute a required attribute. Thus, when authoring an XML file of this type, it is invalid to type a `<Condition>` element without a `Type` attribute.

In the previous step, you declared that the `<Condition>` element must contain the attribute `Type`, which can have any string of characters as its value.

10. Continue typing the DTD:

```
<!ELEMENT Conditions (Condition* | Discount* | Fee*)*>
<!ELEMENT Discount (#PCDATA)>
<!ELEMENT DrivingRange (#PCDATA)>
<!ELEMENT Facilities (DrivingRange, PuttingGreen,
ChippingGreen, Reservations, SnackBar, CreditCards,
BanquetFacilities, GolfPro, ProShop, Lessons, PullCarts,
Clubs, GolfCar, CocktailLounge)>
<!ELEMENT Fee (#PCDATA)>
<!ELEMENT Fees (Conditions, Fee*)>
<!ELEMENT GolfCar (#PCDATA)>
<!ELEMENT GolfPro (#PCDATA)>
<!ELEMENT GreenFees (Fees+)>
<!ELEMENT Hole (Number, Par, Blue, White, Red, MensHcp,
LadiesHcp)>
```

CONCEPT: MORE KEYWORDS

The next attribute contains a list of possible values with the | indicating that this is a choice of values, not a list of required values. You also use the keyword #REQUIRED to indicate that this attribute must contain one of the values on the list.

11. Declare the following `Number` attribute that the element `Hole` must accept as possible values: 1, 2, 3, 4, 5, 6, 7, 8, 9, 10, 11, 12, 13, 14, 15, 16, 17, or 18.

```
<!ATTLIST Hole
Number (1 | 10 | 11 | 12 | 13 | 14 | 15 | 16 | 17 | 18 | 2 | 3
 | 4 | 5 | 6 | 7 | 8 | 9 |10 | 11 | 12 | 13 | 14 | 15 | 16 | 17
 | 18) #REQUIRED>
```

Figure 3.12 shows the XML file with the internal DTD declaring attributes.

12. Finish the DTD:

```
<!ELEMENT Hours (#PCDATA)>
<!ELEMENT LadiesHcp (#PCDATA)>
<!ELEMENT Lessons (#PCDATA)>
<!ELEMENT MensHcp (#PCDATA)>
<!ELEMENT Number (#PCDATA)>
```

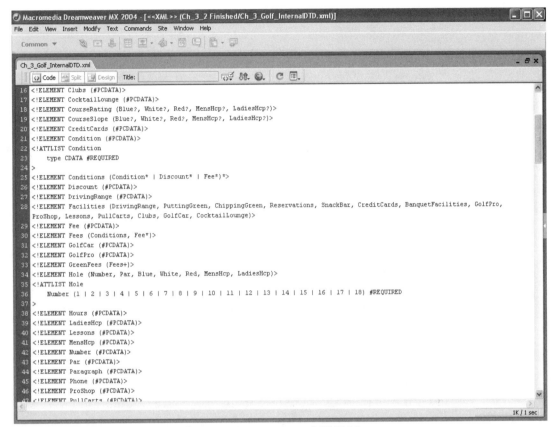

FIGURE 3.12 The internal DTD, as shown in Dreamweaver MX 2004.

```
<!ELEMENT Par (#PCDATA)>
<!ELEMENT Paragraph (#PCDATA)>
<!ELEMENT Phone (#PCDATA)>
<!ELEMENT ProShop (#PCDATA)>
<!ELEMENT PullCarts (#PCDATA)>
<!ELEMENT PuttingGreen (#PCDATA)>
<!ELEMENT Red (#PCDATA)>
<!ELEMENT Reservations (#PCDATA)>
<!ELEMENT SnackBar (#PCDATA)>
<!ELEMENT Street (#PCDATA)>
<!ELEMENT White (#PCDATA)>
<!ELEMENT Zip (#PCDATA)>
```

The DTD is now complete.

13. Save the XML file with the internal (or embedded) DTD as *Ch.3 _Golf_XML_with_InternalDTD.xml*.

CONCEPT: ATTRIBUTES AND MORE KEYWORDS

Some keywords not used in your DTD followed by their meaning:

`"default"`—If text is quoted in the attribute declaration, it is considered the default value for that attribute.

CDATA—The attribute's value may consist of any combination of characters.

#FIXED—The attribute's value is fixed at the default value.

Example:

```
<!ATTLIST GreenFees teeTimes "7 days advance" CDATA #FIXED>
```

The attribute `teeTimes` belongs to the tag `GreenFees` and is fixed at the default value of `7 days advance`.

CONCEPT: ATTRIBUTES WITH UNIQUE VALUES

Keywords that identify a unique value type for the attribute follow:

ID—The value associated with this attribute cannot be used in the XML file more than once. In other words, the attributes value must be unique.

IDREF—The value associated with the attribute can match an existing ID type attribute. Thus, it is a reference to an ID attributes value.

IDREFS—This value is the same as IDREF; however, you can reference more than one ID attribute.

NMTOKEN—The value associated with the attribute is an XML name and it contains no spaces (the value must be one word).

NMTOKENS—This value is the same as NMTOKEN; however, white space is allowed, thus, you can indicate a list of possible XML names as values.

In addition to declaring elements and attributes, the DTD is also where you declare entities. You may recall that characters entities from HTML always begin with an ampersand and end with a semicolon. A common character entity is , which creates a space in your Web page. You use the non-breaking space entity because Web browsers do not recognize more than one typed space. Other common character entities include ©, which creates a copyright symbol, and &, which creates an ampersand. Character entities are used for two main reasons:

To access characters, such as the registration mark and copyright symbol, that cannot be entered directly from the keyboard.

To access characters that will not be interpreted as markup. For example, if a Web-based tutorial that teaches HTML attempts to explain the HTML `` in the following line of code:

```
<P>The HTML <B> tag is used to render text in bold.
```

the browser would interpret the characters `` as markup and would display the following text in bold. What is needed here is a way to display the `< >` (angle brackets) without having them interpreted as markup code—thus, the character entities `>` and `<`.

XML uses character entities as well. True to the form of creating your own language via elements and attributes, you also create your own character entities. In fact, XML-aware browsers do not recognize most HTML entities. XML parsers understand only the following five entities:

`&`—ampersand
`<`—left angle bracket
`>`—right angle bracket
`"`—quotation mark
`'`—apostrophe

All other entities must be declared in the DTD. The syntax for adding an entity declaration begins with `<!ENTITY` followed by the characters that make up the entity, followed by the resolved entity in quotes.

In this next exercise, you both declare an entity and use it in your XML file.

14. Add the following entity declaration at the end of the DTD:

```
<!ELEMENT Holidays (Fee)>
<!ELEMENT Fee (#PCDATA)>
<!ENTITY day "Sunup to Sundown">
]
>
```

15. Save the file as *Ch.3_Golf_XML_with_Entity_dtd.xml*.

Now that you have declared the entity has been declared, you can use it in the XML file.

16. Find the first `<Hours>` element in the first `<Course>` element and modify it using the newly declared entity:

```
<CourseName>Valley Gorge Golf Course</CourseName>
    <CourseInfo>
        <Street>263 Mount Ethel Road</Street>
        <City>Scotts Valley</City>
```

```
<Zip>95066</Zip>
<Phone>408-555-3058</Phone>
<Hours>&day;</Hours>
```

17. When you open the file in Internet Explorer, you will see the character entity &day; spelled out (or resolved) as <Hours>Sunup to Sundown</Hours>.

Entities save time and ensure accuracy. If you have 100 golf courses than needed to change their <Hours> tag to contain 6:00 a.m. to 6:00 p.m., you would just need to change the entity &day; in the DTD.

EXERCISE THREE: HOW TO WRITE VALID XML WITH AN EXTERNAL DTD

The external DTD process consists of two steps. The first step is to write the DTD exactly as you did in the previous tutorial, without the first line of code shown below:

```
<!DOCTYPE County [

]
>
```

1. Create a new document in Dreamweaver MX 2004. Choose the category Other on the left side of the dialog box. Choose text for the right category.
2. On line one, write the comment that describes this file.

```
<!- - Document Type Definition File for XML Golf Files -- >
```

3. Open *Ch.3_Golf_with_DTD.xml.*

ON THE CD

If you did not complete this file, you can open the completed file in the directory *Chapter 3/Ch_3_DTD_2/Ch_3_2 Finished/Ch_3_Golf_InternalDTD.xml.*

4. Copy the DTD portion (excluding the <!DOCTYPE … > element). See the following code, which indicates the text to be copied:

```
<!ELEMENT BanquetFacilities (#PCDATA)>
<!ELEMENT Blue (#PCDATA)>
<!ELEMENT CardInfo (Hole+, CourseRating, CourseSlope)>
```

```
<!ELEMENT ChippingGreen (#PCDATA)>
<!ELEMENT City (#PCDATA)>
<!ELEMENT Clubs (#PCDATA)>
<!ELEMENT CocktailLounge (#PCDATA)>
<!ELEMENT County (Course+)>
<!ELEMENT Course (CourseName, CourseInfo, CardInfo,
CourseDescription, Facilities, GreenFees)>
<!ELEMENT CourseDescription (Paragraph+)>
<!ELEMENT CourseInfo (Street, City, Zip, Phone?, Hours)>
<!ELEMENT CourseName (#PCDATA)>
<!ELEMENT CourseRating (Blue?, Red?, White?, Mens?,Ladies?)>
<!ELEMENT CourseSlope (Blue?, Red?, White?, Mens?,Ladies?)>
<!ELEMENT CreditCards (#PCDATA)>
<!ELEMENT Discount (#PCDATA)>
<!ELEMENT DrivingRange (#PCDATA)>
<!ELEMENT Facilities (DrivingRange, PuttingGreen,
ChippingGreen, Reservations, SnackBar, CreditCards,
BanquetFacilities, GolfPro, ProShop, Lessons, PullCarts,
Clubs, GolfCar, CocktailLounge)>
<!ELEMENT Fee (#PCDATA)>
<!ELEMENT Fees (Conditions, Fee)>
<!ELEMENT GolfCar (#PCDATA)>
<!ELEMENT GolfPro (#PCDATA)>
<!ELEMENT GreenFees (Fees+)>
<!ELEMENT Hole (Number, Par, Blue, White, Red, MensHcp,
LadiesHcp)>
<!ATTLIST Hole
    Number (1 | 2 | 3 | 4 | 5 | 6 | 7 | 8 | 9) #REQUIRED
>
<!ELEMENT Hours (#PCDATA)>
<!ELEMENT LadiesHcp (#PCDATA)>
<!ELEMENT Lessons (#PCDATA)>
<!ELEMENT MensHcp (#PCDATA)>
<!ELEMENT Number (#PCDATA)>
<!ELEMENT Par (#PCDATA)>
<!ELEMENT Paragraph (#PCDATA)>
<!ELEMENT Phone (#PCDATA)>
<!ELEMENT ProShop (#PCDATA)>
<!ELEMENT PullCarts (#PCDATA)>
<!ELEMENT PuttingGreen (#PCDATA)>
<!ELEMENT Red (#PCDATA)>
<!ELEMENT Reservations (#PCDATA)>
<!ELEMENT SnackBar (#PCDATA)>
<!ELEMENT Street (#PCDATA)>
<!ELEMENT White (#PCDATA)>
<!ELEMENT Zip (#PCDATA)>
<!ELEMENT condition (#PCDATA)>
<!ATTLIST condition
    type CDATA #REQUIRED
```

```
>
<!ELEMENT conditions (condition+, Discount*)>
```

5. Save this file as *Ch.3_DTD_for_Golf_XML.dtd*. See Figure 3.13.

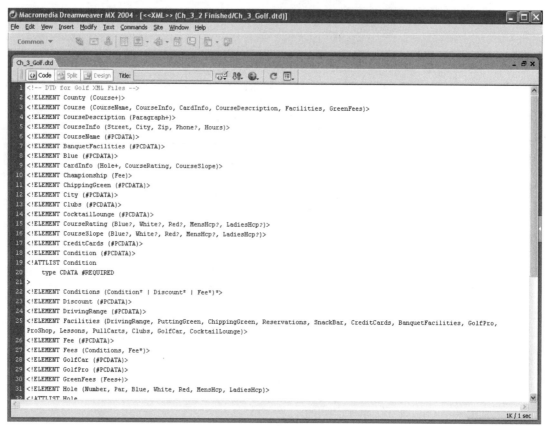

FIGURE 3.13 The External DTD file, as shown in Dreamweaver MX 2004.

This file consists only of what is between the brackets, which constitutes the DTD rules themselves, the element declarations, the attribute declarations, the entity declarations, and so on. Then save this file with the extension .dtd.

After writing the external .dtd file, the second step is to attach the DTD to an XML file in the prologue of the document.

6. The DTD file is now complete. You must now attach it to an XML file. Open the original XML file, *Ch.3_Finished_Well_Formed_Golf.xml*. The Web browser requires another document, the DTD, to process the XML file. You must change standalone to no in the XML declaration.

7. Place your cursor in the XML declaration and modify it as indicated by the bold text in the following code:

```
<?XML version="1.0" encoding="UTF-8" standalone="no"?>
  <!-- Chapter 3: Final Version of Student Exercise #1 -->
  <!-- Chapter 3: This File Contains Only 1 Golf Course -->
<County>
```

In the prologue of the XML file, you used <!DOCTYPE to declare a document type definition. As in an internal or embedded DTD, you must now type the root element of the XML file.

8. Place your cursor below the XML declaration and type the following code:

```
<!DOCTYPE County
```

CONCEPT: PUBLIC DTDS VERSUS SYSTEM DTDS

As indicated earlier in this chapter, the DTD has long been associated with SGML and has been widely used by industries as well as the government. Many DTDs exist as public domain. They can be found at various locations on the Internet, and their existence over many years is indicative of their popularity and widespread use. When using one of these public DTDs, you can be assured that you're using rules for an XML vocabulary that has a proven track record. In addition, if you are concerned about sharing data with others, it is wise to use a DTD that other industries follow.

Public DTDs can be found at the following URLs: *www.biztalk.org*, *www.oasis-open.org*, and *www.XML.org*. Some of the DTDs you work with are private and proprietary. Thus, they are found on a local or network drive as opposed to the Internet. When associating a DTD with an XML document, the syntax changes depending on whether or not you are using a public or a private DTD. If you are using a public DTD, the next word in your code is PUBLIC. If it is a private DTD, the next word is SYSTEM. The last line of code is quoted, and it is the URL of the DTD if it is a public DTD; otherwise, it is the location of the DTD expressed in normal file path notation.

9. Type the word SYSTEM, followed by *Ch.3_DTD_for_Golf.dtd*. The completed <!DOCTYPE element is shown beneath the root element <?XML version="1.0" encoding="UTF-8"?>.

```
<!DOCTYPE County SYSTEM "Ch.3_DTD_for_Golf_XML.dtd">
```

Figure 3.14 shows the completed XML file linked to the external DTD.

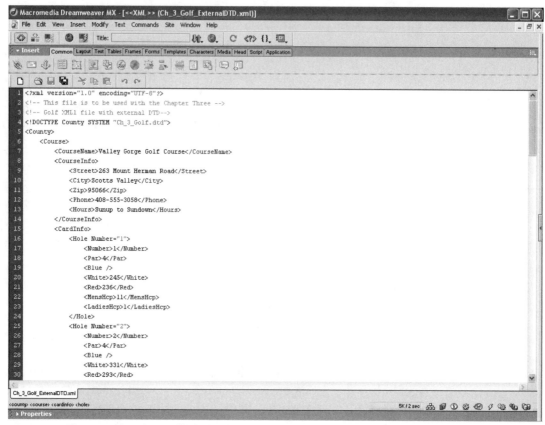

```
1  <?xml version="1.0" encoding="UTF-8"?>
2  <!-- This file is to be used with the Chapter Three -->
3  <!-- Golf XML1 file with external DTD -->
4  <!DOCTYPE County SYSTEM "Ch_3_Golf.dtd">
5  <County>
6      <Course>
7          <CourseName>Valley Gorge Golf Course</CourseName>
8          <CourseInfo>
9              <Street>263 Mount Herman Road</Street>
10             <City>Scotts Valley</City>
11             <Zip>95066</Zip>
12             <Phone>408-555-3058</Phone>
13             <Hours>Sunup to Sundown</Hours>
14         </CourseInfo>
15         <CardInfo>
16             <Hole Number="1">
17                 <Number>1</Number>
18                 <Par>4</Par>
19                 <Blue />
20                 <White>245</White>
21                 <Red>236</Red>
22                 <MensHcp>11</MensHcp>
23                 <LadiesHcp>1</LadiesHcp>
24             </Hole>
25             <Hole Number="2">
26                 <Number>2</Number>
27                 <Par>4</Par>
28                 <Blue />
29                 <White>331</White>
30                 <Red>293</Red>
```

FIGURE 3.14 The completed XML file linked to the external DTD, as shown in Dreamweaver MX 2004.

10. Save the file as *Ch.3_Golf_XML_with_ExternalDTD.xml*.

This chapter introduced some XML principles at work. The concept of valid XML was explored, including why it is necessary to write valid XML. The syntax for writing valid XML by way of the document type definition (DTD) was explained as well as the methods for writing both an internal and external DTD and the advantages and disadvantages of each. If you were to write an XML file for a new golf course, would it be valid? How would you know? Attempting to write valid XML is of no real use if you do not have the ability to test your XML file against its associated DTD or rules. What is needed is a *validating parser*, that is, a browser or XML processor that is capable of opening an XML file, understanding its syntax to the extent that it can separate that which is markup from that which is data and check the

file against its associated DTD to verify whether or not it breaks any of the rules.

Microsoft Internet Explorer 5.x does just that (provided you follow the Internet Explorer setup described in Chapter 2). However, you must initiate the validation process. This initiation can be as easy as a right-click in the browser window. Dreamweaver MX 2004 can check an XML file for well-formedness but does not validate an XML file against a DTD.

EXERCISE FOUR: VALIDATING AN XML FILE IN INTERNET EXPLORER 5.X

ON THE CD

1. Open the file *Ch.3_Golf_XML_with_Internal_DTD.xml* in Dreamweaver MX 2004. Figure 3.15 demonstrates the shortcut command, Validate XML, in Internet Explorer.

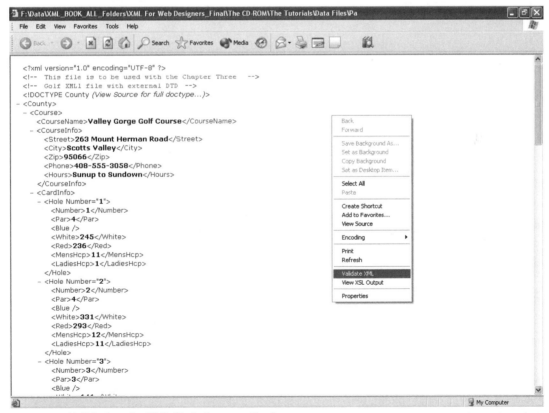

FIGURE 3.15 Validating the XML file in Internet Explorer. Screen shot reprinted with permission from Microsoft Corporation.

ON THE CD

If you did not complete this file, you can open the completed file in the directory *Chapter 3/Ch_3_DTD_2/Ch_3_2 Finished/Ch_3_Golf_InternalDTD.xml.*

2. Right-click the blank area of the browser window and select Validate XML. The file does not break any of the rules set forth in the DTD, and a confirmation message is displayed, as shown in Figure 3.16.
3. Click OK.

Concept: Invalid XML

Now you will see how Internet Explorer 5.x handles XML files that are not valid.

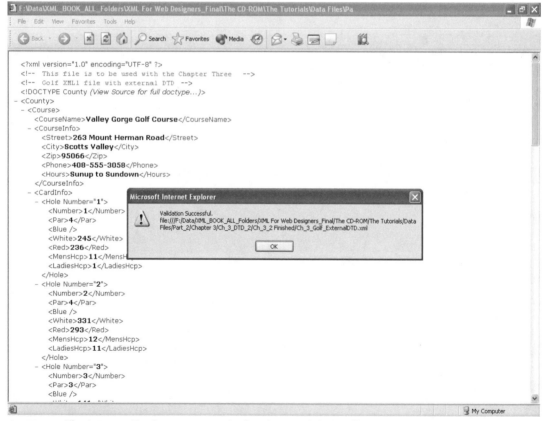

FIGURE 3.16 The Internet Explorer message indicating a valid XML file. Screen shot reprinted with permission from Microsoft Corporation.

ON THE CD

4. Open the file *Ch.3_Golf_XML_with_Internal_DTD.XML* in Notepad.

Locate the `<Phone>` element in the first `<Course>` element and add the `<Fax>` element, as shown in bold in the following code:

```
<County>
<Course>
  <CourseName>Valley Gorge Golf Course</CourseName>
    <CourseInfo>
        <Street>263 Mount Ethel Road</Street>
        <City>Scotts Valley</City>
        <Zip>95066</Zip>
        <Phone>408-555-3058</Phone>
        <Fax>408-555-3059</Fax>
        <Hours>Sunup to Sundown</Hours>
```

5. Save the file as *Ch.3_Golf_XML_with_Mistake_Wdtd.XML*. You have now added a new tag called `<Fax>`, which you did not declare in the DTD.

ON THE CD

You can also open the finished version of this file from the *Ch_3_2 Finished* directory. It is named *Ch_3_Golf_InternalDTDwError.xml*. Be sure to rename it as *Ch.3_Golf_XML_with_Mistake_Wdtd.XML*.

6. Open the file *Ch.3_Golf_XML_with_Mistake_Wdtd.XML* in Internet Explorer 5.x
7. Right-click the blank area of the browser window, and select Validate XML from the shortcut menu. The file uses an undeclared element, making the file invalid. The error message is displayed in Internet Explorer, as shown in Figure 3.17.
8. Now try to validate the file in Dreamweaver MX 2004. From the Window menu, click Results → Validation.
9. Click the green triangle on the left and select Validate Current Document.

The error that makes the file invalid according to the DTD is found, and a message is displayed in the Results panel, as indicated in Figure 3.18.

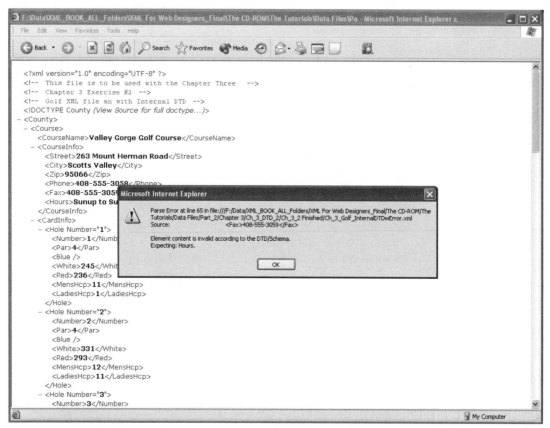

FIGURE 3.17 The XML file containing the validation error, as shown in Internet Explorer. Screen shot reprinted with permission from Microsoft Corporation.

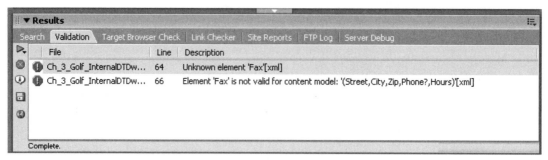

FIGURE 3.18 The XML file containing the validation error, as shown in Dreamweaver MX 2004.

Valid XML is useful only if you have a mechanism for validating it. Not all XML parsers are validating parsers. As of this writing, Macromedia Flash 5.0, which accepts XML as input, is an example of a non-validating parser. This tutorial has also demonstrated that although Internet Explorer 5.x is a validating parser, you must initiate the validation process by selecting the command from the shortcut menu. A great deal of XML processing requires our XML file to be structured. Building templates in Quark XPress that accept XML as input is a perfect example of creating a structure, and there are many others. This structure is accomplished through the use of a DTD, and a validating parser ensures the document follows this structure. In addition to these examples, you will use Dreamweaver MX 2004 to create a Web page template that will accept XML as the data that populates the template. If this data is not structured properly, the template will not work. You can create a DTD that validates the data before processing by Dreamweaver MX 2004.

HOW SHOULD YOU NAME YOUR XML TAGS?

In most, but certainly not all, cases, simplicity is a good goal. Consider a naming convention when you begin your XML application. For example, a directory of names and addresses includes a first name field. This field can be identified with a number of different names including:

```
<firstname>
<FirstName>
<first_name>
<firstName>
```

Once you choose a format, make that format standard. For example, if you choose the third format, the rest of your elements should look as follows:

```
<last_name>
<address>
<street>
<suite_number>
<city>
```

Notice how all elements are in lowercase letters, and two words are separated by an underscore. It doesn't matter how you

format your elements, but your code maintenance will be more efficient if you are consistent.

Avoid unnecessarily long element names. Instead of `<address_business>`, `<address_residence>`, and `<address_summer_home>`, consider using attributes. By using one `<address>` tag with the attribute `type="business"` or `type="residence"`, you have much less code to maintain. Not only is there less typing, but you have fewer elements to declare.

Only use as many container tags and elements as necessary.

```
<employee_name>
    <formal_name>
        <first_name>
        <middle_initial>
        <last_name>
    </formal_name>
    <nickname>
</employee_name>
```

This example may show far more container tags than are necessary for your purposes. Instead try the following:

```
<name nickname=" ">
    <first_name>
                    <middle_initial>
    <last_name>
</name>
```

ADDITIONAL RESOURCES

Public DTDs:
www.biztalk.org
www.oasis-open.org
www.XML.org
The HTML DTDs: *www.w3.org/TR/REC-html40/sgml/dtd.html*
Tutorials at W3 Schools: *www.w3schools.com/dtd/default.asp*

TUTORIAL THREE: HOW TO WRITE VALID XML WITH A W3C SCHEMA

OBJECTIVES

- To understand the difference between a DTD and a schema
- To understand the difference between a Microsoft schema and a W3C schema
- To write a W3C schema

BEFORE YOU BEGIN

What You Will Need for This Tutorial

- Dreamweaver MX 2004 (Macintosh or PC version)
- (PC) Microsoft Internet Explorer 5.x or later
- (Mac) Microsoft Internet Explorer 5.2 or later

ON THE CD

The Data Files

- **Tutorial Three Directory:** *Data Files/Part_2/Chapter 3/Ch_3_ Schema_3*
- **Student Files:**
 Ch.3_Finished_Golf_MSSchema.xdr
 Ch.3_Golf_XML_with_External_DTD.xml
- **Finished Files Directory:** *Ch_3_3 Finished*
- **Finished Files:**
 Ch.3_Finished_Golf_MSSchema.xdr
 Ch.3_Finished_Golf_W3Schema.xsd
 Ch.3_Finished_Golf_XML_ParFour_wDTD.xml
 Ch.3_Finished_Golf_XML_with_Mistake_dtd.xml
 Ch.3_Finished_Golf_XML_with_Mistake_xdr.xml
 Ch.3_Golf_XML_with_InternalDTD.xml
 Ch.3_Golf_XML_with_MSSchema.xml
 Ch.3_Golf_XML_with_W3Schema.xml

Defining the Site for Chapter 3 Tutorial Three

This tutorial begins by defining the Web site. Your root directory is the *Ch_3_ Schema_3* directory located inside the *Chapter 3* directory from the CD-ROM. Name the site *Chapter_3_3*.

INTRODUCTION: WHAT IS A SCHEMA?

The dictionary defines *schema* as follows:

> sche • ma: A summarized or diagrammatic representation of something; An outline or model

Various programs and languages utilize the schema concept. Database authors are more than familiar with the concept of a schema. For XML purposes, a schema is an outline or model that represents an XML application. The schema serves the same purpose as the DTD. It declares what elements can be used in a specific XML application as well as what those elements can contain, how often they appear in the document, where they appear in the document, and what type of data they should hold. Like DTDs, a schema also declares attributes as well as values and datatypes.

ON THE CD

1. Launch Dreamweaver MX 2004 and open the XML file you created in Chapter 3, Tutorial Three, from the Chapter 3 folder *Ch.3_Golf_ XML_with_Internal_DTD.xml*

If you have not completed the previous lesson that created the file Ch.3_Golf_XML_with_External_DTD.xml, *you can use the finished version called* Ch.3_Golf_XML_with_InternalDTD.xml *from the* Ch_3_3 Finished *directory.*

2. Locate the first instance of a `<Par>` element and modify its content from `<Par>4</Par>` to `<Par>Four</Par>`.

Save the file and click File → Preview In Browser → Internet Explorer. Right-click the browser window and select Validate XML from the shortcut menu. The file should validate successfully. Resave the file as *Ch.3_Golf_XML_ParFour_wDTD.xml*.

The file remains valid even though the element's datatype has been changed from a letter (string) to a number (integer). Imagine you have written an XSL-T stylesheet that adds all the `<Par>` elements to calculate the total par of the golf course. Your XSL-T stylesheet would fail because it cannot mathematically add `Four` with the remaining numbered `<Par>` tags. DTDs do not allow for enforcement of datatypes such as integer or number. Thus, when the `<Par>` tag is declared in the DTD, the element is allowed to contain parsed character data, which means the element may contain anything—numbers, letters, underscores, punctuation, and so on. Recall the element declaration specifically:

```
<!ELEMENT Par (#PCDATA)>
```

One of the advantages of a schema is its ability to enforce datatypes. In step 4, you attach the XML file with a completed schema that requires the <Par> tag to contain an integer and see if it remains valid.

3. In Dreamweaver MX 2004, remove the processing instruction that attaches the file to the DTD.
4. Locate the root element and modify it so it attaches the XML file to the schema file found in the *Chapter 3* folder.

```
<County xmlns:xsi = "http://www.w3.org/2001/
XMLSchema-instance"xsi:noNamespaceSchemaLocation=
"Ch.3_Finished_Golf_W3Schema.xsd">
```

ON THE CD

5. Save the file as *Ch.3_Golf_XML_with_W3Schema.xml*.

If you have not completed the Ch.3_Golf_XML_with_W3Schema.xml *file, you can use the finished version called* Ch.3_Golf_XML_with_ W3Schema.xml *from the* Ch_3_3 Finished *directory.*

CONCEPT: THE NAMESPACE

The first item altered is the root element. The line that begins with `xmlns:xsi ="http://www.w3.org/2001/XMLSchema-instance"` is known as a namespace. The namespace is being used at this point to declare that all tags that begin with `xsi:` have been written in and belong to the official schema language developed and finalized in May 2001 by the W3C. In other words, this document is an instance of a schema document. For now, you can think of the W3C as a governing body of the Internet.

The next line, which reads, `xsi:noNamespaceSchemaLocation="Ch.3_ Finished_Golf_W3Schema.xsd"` serves several purposes. First of all, it states that the schema itself does not declare a namespace for our golf elements. Namespaces are used to define a language and make it unique. For example, if you wanted to share the Golf Course Description Language with other organizations, you would define elements as belonging to the official Golf Course Description Language. Why would you want to do this? Well, further assume that the Web site has become a global repository for golf course owners not only to provide information about their courses but also to allow users to make reservations. This reservation system is maintained by the golf managers themselves, who log into the site to make changes (such as when they move the flags and thus, the yardage, or make changes to the holes' par). Individ-

uals can use the site to make reservations, which are then logged into the golf courses reservation system. The entire system is driven by XML data moving back and forth. It is, therefore, imperative that this data follow the structure laid out in the DTD or the schema. The software that drives the system is expecting the incoming XML data to be enclosed in the correct tags with appropriately typed data (such as phone numbers, zip codes, and integers). In other words, every golf course that participates in this Web-based system should use the Golf Course Description Language set up in your DTD or schema. So as not confuse your language with any other language that may share the same element names, you must declare a namespace, such as GOLF. To assert ownership of our Golf Course Description Language, point to a location on the Web that you own (usually your domain name on the Web). Your namespace declaration, which would be located in your root element, would look like this:

```
<County xmlns:GOLF="http://www.GolfGuide.com">
```

The xmlns: stands for XML namespace. In this example, it is followed by :GOLF, which informs the reader or XML processing software—remember, XML is meant to be understood by both humans and computers—that all tags that begin with GOLF, for example, <GOLF:Par>, belong to your namespace (the official Golf Course Description language) located at the domain name *www.GolfGuide.com*. In other words, you are not writing in merely any XML language but in the official Golf Course Description Language maintained by the *www.GolfGuide.com* domain. A common misconception exists that the Web browser, upon interpreting this line of code, traverses this link to validate the document, or that the user can follow the link for an explanation of the golf tags. This is not the case, and a URL is used here only because URLs are unique values. Uniform Resource Names can be used as well.

The second purpose of the line xsi:noNamespaceSchemaLocation=" Ch.3_Finished_Golf_W3Schema.xsd" is to let the browser (or XML processing software) know where the schema is located, so that validation can be performed. In your file, you did not declare a namespace, so you used the code xsi:noNamespaceSchemaLocation = followed by the path and name of your schema file. Note the xsi: prefix before this line of code denotes that the code following the xsi: belongs to the namespace declared above, *http://www.w3.org/2001/XMLSchema-instance*, and is a valid component of the W3C schema vocabulary.

6. Save the file and click View → Preview in Browser → Internet Explorer. Right-click and validate the XML. It validates successfully; however, this is incorrect.

The Microsoft parser at the time of this writing (called MSXML3) does not validate XML files that use the W3C schema language. Instead, it validates XML based on the use of their own version of schema, known as a Microsoft Data-Reduced schema. This schema language was created by Microsoft prior to the release of the W3C schema version and uses the file extension .xdr. This tutorial describes the W3C schema. For now, however, load the Microsoft Data-Reduced version of your Golf schema and validate the XML file with the `<Par>Four</Par>` element.

7. In Notepad, modify the root element as follows:

```
<County xmlns="x-schema:Ch.3_Finished_Golf_MSSchema.xdr">
```

Notice how the XML file is attached to the schema through the root element `<County>`.

8. Again, use the `xmlns` to declare the namespace and point to the schema file called *Ch.3_Finished_Golf_MSSchema.xdr*.
9. Save the file as *Ch.3_Golf_XML_with_MSSchema.xml*.

ON THE CD

The finished file can be found in the *Ch_3_3 Finished* directory called *Ch.3_Golf_XML_with_MSSchema.xml*.

10. Click View → Preview in Browser → Internet Explorer.
11. Right-click and validate the XML.

As expected, Internet Explorer returns the error regarding its inability to parse the `<Par>` tag as an integer datatype due to its content being in the form of the string `<Par>Four</Par>`.

12. Close Internet Explorer.
13. Using Dreamweaver, MX 2004 open the Microsoft Data-Reduced Schema file called: *Ch.3_Golf_MSSchema.xdr*. You see the schema has been named *Golf-Schema*.

```
<Schema name="Golf-schema" xmlns="urn:schemas-microsoft-
com:xml-data" xmlns:dt="urn:schemas-microsoft-com:datatypes">
```

In addition a namespace has been declared indicating the schema is written in the XML Data-Reduced Language, as defined by Microsoft.

Because no prefix follows the `xmlns` (as opposed to the W3C schema example, which looked like this: `xmlns:xsi`), the namespace applies to all

the elements in the document. It is the default namespace. In other words, every element in this document belongs to the Microsoft schema language known as XML Data-Reduced. Immediately following this statement is another `xmlns` declaring that all elements that are preceded by `dt:` belong to a separate namespace also maintained by Microsoft. This namespace is used exclusively to enforce an element to hold the different types of data as defined by Microsoft. Some examples include:

`int`—integer

`date`—stores dates such as 2002-11-07

`float`—number with unlimited number of digits. It can also have a leading sign or fractional digits such as 1.34789467.

These namespaces allow you to enforce your `<Par>` tag so that it only contains a number and would be invalid as `<Par>Four</Par>`. Validate this file in Internet Explorer.

14. Close the Microsoft Data-Reduced schema.

In keeping with Macromedia support of W3C standards, the balance of this tutorial focuses on the W3C schema and its syntax, as well as its advantages over the DTD.

15. Open the file *Ch.3_Golf_W3Schema.xsd* from the *Chapter 3* folder.

CONCEPT: SCHEMA ADVANTAGE—SCHEMA IS WRITTEN IN XML

The first thing you should notice about this W3C schema (hereafter referred to simply as schema) is that it is written in well-formed XML. Why is this an advantage? For starters, you already know the syntax. Instead of being a syntax unto itself as the DTD is, it is written in the now-familiar syntax of XML. Furthermore, because it is XML, it contains all the flexibility of any other XML file, including the ability to apply a stylesheet to turn it into a different file. Because the schema is the rulebook for how to write an XML application (or language), the ability to change the schema file is equivalent to changing the rules. Therefore, the XML format is uniquely suited to the ever-changing rules of e-commerce, such as when conducting a transaction across the Internet. As long as the file on the receiving end of the equation is XML, you have the ability to change, on one side of the processing end, both the structure of the incoming information as well as the rules for how to write that information. Once both the data and the rules have been validated, they can be accepted into the system without having to worry about the integrity of the data itself, which has remained untouched.

From a design perspective, you can manipulate the data structure to suit your needs as well. In the future, as more of our tools become XML aware, you may, in fact, change or retain the structure, depending on your design goals. In Chapter 5 you will alter the structure of the original golf XML file to make it suitable for importing into a Dreamweaver template.

```
<?xml version="1.0" encoding="UTF-8"?>
<!--W3C Schema for BayAreaGolfCourses.xml -->
<xs:schema xmlns:xs="http://www.w3.org/2001/XMLSchema">
```

Because it is well-formed XML, the schema must begin with the XML declaration. Line two is a comment describing the schema and its purpose. Line three is the root element `<Schema>`. The root element for a W3C schema is `<Schema>`. Note that it is in the W3C namespace. As such, the element is preceded by an `xs:` prefix as are the remaining elements throughout the document. The namespace is described with `xmlns:xs="http://www.w3.org/2001/XMLSchema"`. This line may be interpreted as follows: All tags that are preceded by an `xs:` are elements that belong to the language known as XML Schema, which was released as an official specification of the W3C in 2001.

CONCEPT: DECLARING ELEMENTS

```
<xs:element name="County">
    <xs:complexType>
```

The `<element>` element declares an element and assigns its name. Here you are declaring the `<County>` element. The next line declares this element as a `complexType` element, which means it contains another element or attributes. Elements that do not fit the criteria of `complexTypes` are `simpleTypes`.

```
<xs:sequence maxOccurs="unbounded">
    <xs:element name="Course" maxOccurs="unbounded">
```

The previous code states that the `<County>` element contains nested elements, which must appear in the document in the sequence in which they are declared beginning with an unlimited amount of `<Course>` elements.

```
<xs:complexType>
  <xs:sequence>
    <xs:element name="CourseName" type="xs:string"/>
```

Here, you are still describing the element <Course>, indicating that it must contain the following sequence of elements, beginning with the <CourseName> element whose content may be any string of characters or numbers:

```
<xs:element name="CourseInfo">
  <xs:complexType>
    <xs:sequence>
      <xs:element name="Street" type="xs:string" minOccurs="1"
      maxOccurs="1"/>
        <xs:element name="City" type="xs:string"
minOccurs="1" maxOccurs="1"/>
        <xs:element name="Zip" type="xs:string"
minOccurs="1" maxOccurs="1"/>
        <xs:element name="Phone" type="xs:string"
minOccurs="0" maxOccurs="unbounded"/>
         <xs:element name="Hours" type="xs:string"
maxOccurs="unbounded"/>
      </xs:sequence>
    </xs:complexType>
</xs:element>
```

In the previous code the <CourseInfo> is declared next in the sequence of tags for the <Course> tag following the <CourseName> tag. The element <CourseInfo> is declared as a complexType because it has children. The children must be listed in the XML file in the order they are declared here due to the element: <xs:sequence>. The <CourseInfo> tag is a complexType that contains the following tags in sequence: <Street>, <City>, <Zip>, <Phone>, and <Hours>, all of which may contain any string of characters and must appear in the document at least once but not more than once. The frequency indicators are the values of the attributes minOccurs and maxOccurs. The <Phone> element is optional, according to the attribute minOccurs being set to 0. However, there is no limit to the number of phone number tags that may be used. There is also no limit to the amount of <Hours> tags as defined by maxOccurs="unbounded".

```
<xs:element name="CardInfo">
    <xs:complexType>
      <xs:sequence>
        <xs:element name="Hole" maxOccurs="18">
            <xs:complexType>
     <xs:sequence>
        <xs:element name="Number" type="xs:int"
        maxOccurs="18"/>
        <xs:element name="Par" type="xs:int"/>
```

```
        <xs:element ref="Blue"/>
        <xs:element ref="White"/>
        <xs:element ref="Red"/>
        <xs:element name="MensHcp" type="xs:int"/>
        <xs:element name="LadiesHcp" type="xs:int"/>
            </xs:sequence>
          <xs:attribute name="Number" type="xs:string"
            use="required"/>
      </xs:complexType>
    </xs:element>
```

The balance of code in the schema declares the remaining tags and indicates what they should contain as well as their datatypes. �

SUMMARY

A schema performs the same function as the document type definition (DTD). It declares the names of the elements to be used in the XML file and the order and structure in which they must appear. A schema can also dictate what type of information (known as the datatype) the elements may hold. There are other differences as well, which make the schema file much more capable than its counterpart, the DTD. Recall from Tutorial Two the frequency indicators, as well as the absence of a symbol, which indicates that the element must appear once and only once— + (plus sign), which indicates that the element must appear once but can appear more than once; ? (question mark), which indicates the element is optional but not repeatable; * (asterisk), which indicates that the element is optional and repeatable. The schema language goes well beyond these few frequency indicators with the attribute minOccurs and maxOccurs. The value of these attributes can be any number. Thus, you can state that an element may occur at a given point in your XML file at least seven times but no more than eight times. These are just a few of the advantages of using a schema over a DTD. Schemas are capable of structuring information such as you would find in a database with the strictest rules, including the ability to create your own custom datatypes, which can be used over and over again. The complexity of the W3C schema is beyond the scope of this book, and only its most basic concepts have been included in this tutorial.

As you have seen in this tutorial, the W3C schema allows you to dictate exactly what type of data an XML element must contain. For example, you can force a `<ProductCode>` element to contain a four-digit number from 1,000 to 2,000, followed by a hyphen and a letter from A to D. This is not possible with a DTD. Schemas can also force an XML author to have a certain amount of elements within a given range. For instance, the `<ProductCode>` element must appear in the document at a specified location at least five but no more than eight times. However, at other locations within the document it can appear an unlimited number of times. Here again, a DTD cannot enforce this type of structure in terms of the frequency in which the element may occur. Another drawback of the DTD is its unique syntax. Schemas are written in XML and, as a result, inherit all the extensibility of an XML file, including the ability to apply an XSL-T stylesheet that can change the schema dynamically.

At this point, you might conclude that schemas are inherently better than DTDs. This may not be always be the case, however. DTDs have advantages as well. The most prominent advantage is their age. DTDs have been in use since the days of SGML. Therefore, you may be able to find a DTD that has been used for several decades and suits your current needs, thus, eliminating the job of creating a new DTD. In addition, many tools exist that are capable of converting a DTD into a schema. A schema may be more information than is really needed to describe an XML application that is based on a certain type of document. In these cases, a DTD would be more appropriate as well as backward compatible with any existing SGML files.

ADDITIONAL RESOURCES

XML Schema activities at the W3C: *www.w3.org//XML/Schema*

The W3C Schema Specification Part 0: Primer: *www.w3.org/TR/xmlschema-0/*

The W3C Schema Specification Part 1: Structures: *www.w3.org/TR/xmlschema-1/*

The W3C Schema Specification Part 2: Datatypes: *www.w3.org/TR/xmlschema-2/*

The W3C Namespace Specification: *www.w3.org/TR/REC-xml-names*

Schema Tutorials: *www.xml.com/pub/rg/Schema_Tutorials*

Schema Software: *www.xml.com/pub/rg/Schema_Software*

4

DREAMWEAVER MX 2004 AND XML ADVANCED TOPICS

In This Chapter

- Tutorial One: How to Write CSS for XML
- Tutorial Two: How to Display XML Documents with XSL-T
- Tutorial Three: How to Configure Dreamweaver MX 2004 as an XML Editor

Chapter 4 addresses more advanced topics of Dreamweaver MX 2004 with the focus on displaying XML files in the Web browser. Tutorial One describes how to use the Cascading Style Sheet (CSS) language to format the elements in an XML file, thus introducing the idea of providing presentation information to a pure content file in XML. The concepts covered include where the stylesheet can be written and how CSS for XML differs from CSS for HTML. Tutorial Two explains the limitations of using CSS to format XML and introduces a second method for displaying XML in the Web browser called XML Stylesheet Language-Transform (XSL-T). XSL-T is a complex language that can transform an XML file into any other type of file. The components required of the Web

browser to enable this functionality are explained in detail. Chapter 4 concludes with Tutorial Three, which relates how to customize and configure Dreamweaver MX 2004 as an XML editor. This tutorial includes exercises for automatically creating new XML files and adding menu items and buttons to the user interface to facilitate the creation of XML code.

TUTORIAL

TUTORIAL ONE: HOW TO WRITE CSS FOR XML

OBJECTIVES

- To explore the new CSS features in Dreamweaver MX 2004
- To write a CSS file that provides formatting instructions for an XML file
- To attach an XML file to a Cascading Style Sheet

BEFORE YOU BEGIN

What You Will Need for This Tutorial

- Dreamweaver MX 2004
- (PC) Microsoft Internet Explorer 5.x or later
- (Mac) Microsoft Internet Explorer 5.2 or later

ON THE CD

The Data Files

- **Tutorial One Directory:** *Data Files/Part_2/Chapter 4/Ch_4_Display XML with CSS_1*
- **Student Files:** *Ch.4_XML_For_CSS_Golf.xml*
- **Supporting Files:**
 golfBallicon.gif
 GOLFBG1.JPG
- **Finished Files Directory:** *Ch_4_1 Finished*
- **Finished Files:**
 Ch.4_Finished_XML_For_CSS_Golf.xml
 Ch.4_Finished_XML_Golf_CSS.css
 Ch.4_Finished_XML_Golf_CSS_Modified.css
 Ch.4_Finished_XML_Modified_Golf.xml
 Ch.4_XML_For_CSS_Golf1.xml

Ch.4_XML_For_CSS_Golf2.xml
Ch.4_XML_For_CSS_Golf3.xml
Ch.4_XML_For_CSS_Golf4.xml
Ch.4_XML_For_CSS_Golf5.xml
Ch.4_XML_For_CSS_Golf6.xml
Ch.4_XML_For_CSS_Golf7.xml
Ch.4_XML_Golf_CSS1.css
Ch.4_XML_Golf_CSS2.css
Ch.4_XML_Golf_CSS3.css
Ch.4_XML_Golf_CSS4.css
Ch.4_XML_Golf_CSS5.css
Ch.4_XML_Golf_CSS6.css
Ch.4_XML_Golf_CSS7.css

- **Supporting Files:**
 golfBallicon.gif
 GOLFBG1.JPG
- **Finished Files Directory:** *Finished Wine Examples*
- **Finished Files:**
 Ch.4_Wine_XML_with_CSS.xml
 Ch.4_Wine_CSS.css
- **Supporting Files:**
 BanquetICON.gif
 GiftICON.gif
 PicnicICON.gif
 SHIM.GIF
 TastingICON.gif
 TourICON.gif
 wineryBG.jpg

Defining the Site for Chapter 4 Tutorial One

You will use the following root directory when defining your site for Chapter 4 Tutorial One: *Chapter 4 Chapter/Ch_4_Display XML with CSS_1.*

INTRODUCTION: WHAT IS CSS

If Web designers are artists and HTML their paintbrush, creating Web pages is like using a paintbrush that makes only horizontal and vertical

strokes. You can never seem to place artwork exactly where you want it, nor can you angle the brush for more interesting strokes. Recall that HTML was originally meant to structure documents that were primarily scientific, such as headings, paragraphs, and citations. Cascading Style Sheets (CSS), like HTML tables before them, were an attempt to bring the designer closer to designing without the restrictions of HTML. CSS brought three main benefits to Web design.

The first benefit of CSS was to overcome the limitations of HTML. All Web browsers display a heading 1 tag in HTML as the most significant heading type in the Web page. Depending upon the browser, the heading would be rendered in bold, flush left, and have one to two spaces above it and one to one and a half spaces below it. The designer could not guarantee exactly how it would be rendered, particularly its size. With CSS, however, the designer could direct the browser to render one or all of the tags as 36 point, Helvetica Bold, blue type.

The second benefit CSS brought to the designer was the ability to style many components of a Web site at once. The nature of CSS is similar to style sheets in Adobe PageMaker, Adobe InDesign, Microsoft Word, and Quark XPress. The stylesheet that instructed the browser how to render the tag could be linked to 100 Web pages. Thus, when the designers wish to change the point size and color of the headings, they merely change the style on the stylesheet. The change in style will then propagate through the 100 linked Web pages.

An additional benefit of CSS to Web design may not have been obvious to the graphic designer at first. However, if you have been reading this book sequentially, you can see that CSS is a move toward separating the structure of the Web page from the format of the page. Thus, the movement toward XML for the Web really began with CSS.

In this tutorial you will take the golf data and format it for the Web using CSS to provide style information to the XML tags. If you are already familiar with CSS you will notice that stylesheets for XML are somewhat different from stylesheets for HTML. These differences will be noted as they occur.

The stylesheet can be located in one of two places. The stylesheet can appear in the prologue of the XML file to which it applies. This placement creates what is known as an embedded CSS. The CSS can also be a separate file, in which case a line of code appears in the prologue of the XML file that associates the XML file with the CSS file. This structure is known as an external CSS.

1. Launch Dreamweaver MX 2004. Open the XML file you created in Chapter 3 from the Chapter 3 folder, *Ch_3_Student_Golf.xml*. If you do not have this file see the following note.

If you have not completed the file Ch_3 _Student_Golf.xml, *you can use the file called* Ch.4_XML_for_CSS_Golf.xml *from the* Chapter 4 *folder.*

This is the file you will be formatting with CSS. You are now opening it just for reference.

ON THE CD

2. Click File → New. From the General tab choose the category Basic Page. From the Basic Page category on the right, click CSS → Create. A blank document window opens with the comment `/* CSS Document */`.

You can view both the XML file and the CSS file simultaneously by clicking Window → Tile Vertically or Window → Tile Horizontally. You can also print the file to avoid switching back and forth between the two windows by choosing File → Print Code.

To write a CSS, you must first declare the XML element for which the CSS rules will apply. Using step three as an example, this tag is `County`. This portion of the CSS is known as the tag selector. The CSS rules follow within curly brackets (as shown in step three). Each CSS rule is terminated with a semicolon.

3. Begin by writing the style rules for the root element. Type the following code:

```
County
    {
display:block;
background-image:url(golfbg1.jpg);
border: green solid 8 px;
background-repeat: no repeat;
border-style:ridge;
height:100%;
width:100%;
position:absolute;
left:0px;
top:0px;
    }
```

Figure 4.1 shows the first CSS rule, as displayed in Dreamweaver MX 2004.

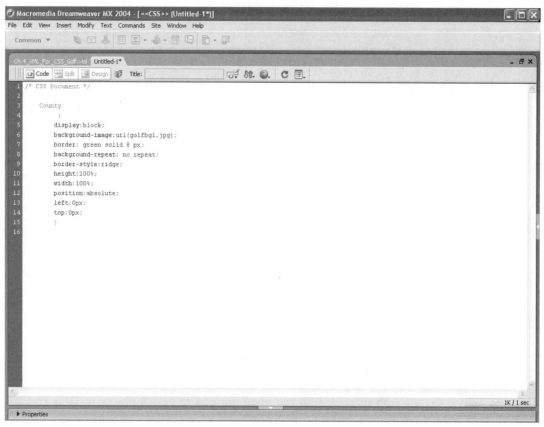

FIGURE 4.1 The first CSS rule, as displayed in Dreamweaver MX 2004.

CONCEPT: A CSS RULE

This first CSS rule is `display:block`, and it forces the root element to be on a line by itself along with the children of the `<County>` tag.

The next rule, `background-image:url` (*golfbg1.jpg*), causes the graphic to appear as a background to the Web page. This background does not tile due to the rule `background-repeat:no repeat`. The entire page is outlined with an 8-pixel, solid green border because of the next rule. In addition, this border has a ridge effect around it due to `border-style:ridge`. The remaining rules indicate that the element should compose 100 percent of the Web browser's height and width and be positioned at the top-left corner of the browser window, 0 pixels from the top and 0 pixels from the left. When displaying an XML file with a background image, borders around the entire page, and background colors, you must write the CSS rule in the XML file's root element, which represents the entire document.

CONCEPT: ATTACHING THE STYLE SHEET

The XML file requires a processing instruction to tell the processing application (in this case, the Web browser Internet Explorer) to process the stylesheet with the XML file and thus render it in the browser according to the CSS specifications. This processing instruction takes the following form:

```
<?XML-stylesheet
```

followed by the attribute `type=`

The value for this attribute is `text` (because you are writing your stylesheet in plain text)/`css` (because your stylesheet is written in the language CSS). For the browser to process the stylesheet with the XML file it must be able to find it. Thus, the last attribute is `href=`. The value for this attribute is the path and filename of the .css file.

4. Save the CSS file as *Ch.4_XML_Golf_CSS1.css*. You will now attach this CSS file to the XML file opened in step one. Activate the document *Ch.4 _XML_for_CSS_Golf.xml*, and type the following processing instruction below the XML declaration:

```
<?XML version="1.0" encoding="UTF-8"?>
<?XML-stylesheet type="text/css" href="
Ch.4_XML_Golf_CSS1.css "?>
<County>
```

Note the `?` that precedes and terminates this line of code.

5. Save the file as *Ch.4_XML_For_CSS_Golf1.xml*.
6. Save the XML file in Dreamweaver MX 2004, and click File → Preview In Browser. Alternatively, you can use the keyboard shortcut F12 to preview the page in the Internet Explorer browser, as shown in Figure 4.2.

The completed CSS file is the Ch.4_XML_Golf_CSS1.css *file, and the completed XML file with the stylesheet attached is the* Ch.4_XML_For_CSS_ Golf1.xml *file. Both files are located in the* Ch_4_1 Finished *directory.*

The CSS rule applies only to the root element `<County>`. The children of `<County>` are displayed inline in the default typeface, size, and color because no style rules pertain to typeface, size, or color in the parent `<County>` element.

FIGURE 4.2 The XML file as displayed with a partially completed CSS file. Screen shot reprinted with permission from Microsoft Corporation.

7. Write the CSS rules for the next element in the XML file, `<Course>`.

```
    Course
{
display:block;
  margin-left: 1in;
  margin-right: .75 in;
  text-align:left;
}
```

See Figure 4.3 to see the result of the CSS file with the `County` and `Course` style rules.

8. Save the file as *Ch.4_XML_For_CSS_Golf2.xml*, and refresh the view in Internet Explorer. See Figure 4.3 to see the result.

```
/* CSS Document */
  County
    {
        display:block;
        background-image:url(golfbgl.jpg);
        border: green solid 8 px;
        background-repeat: no repeat;
        border-style:ridge;
        height:100%;
        width:100%;
        position:absolute;
        left:0px;
        top:0px;
    }

  Course
    {
        display:block;
        margin-left: 1in;
        margin-right: .75 in;
        text-align:left;
    }
```

FIGURE 4.3 The CSS file with the County and Course style rules.

The completed CSS file is the Ch.4_XML_Golf_CSS2.css *file, and the completed XML file with the stylesheet attached is the* Ch.4_XML_For_CSS_Golf2.xml *file. Both files are located in the* Ch_4_1 Finished *directory.*

The CSS rules here call for the Course tag to be displayed on a line by itself. Note that the left and right indents as well as text-align:left are inherited by the children of the <Course> element.

9. Write the CSS rule for the next element in the XML file, <CourseName>.

```
Coursename
    {
        font:20pt Arial;
        color:green;
        font-weight:bold;
        display: block;
        padding-top: 16pt;
    }
```

10. Save the file as *Ch.4_XML_For_CSS_Golf3.xml*, and click File → Preview In Browser. See Figure 4.4 to see the result.

Valley Gorge Golf Course
263 Mount Ethel Road Scotts Valley 95066 408-555-3058 Sunup to Sundown 1 4 245 236 11 1 1 4 331 293 12 11 3 3 141 131 14 16 4 5 452 427 4 4 5 3 138 131 18 18 6 4 312 267 6 9 7 4 381 331 1 2 8 4 336 320 10 6 9 4 317 275 8 13 56.5 55 82 A long short course in downtown Scotts Valley. 9 holes with lovely views of the Santa Cruz Mountains perfect for beginners, but the mettle of good players will be tested. no yes no yes yes no no yes yes yes $2.00 $4/$8 no no $12.00 $11.00 $8.00 $12.00

FIGURE 4.4 The XML file as displayed with three CSS rules. Screen shot reprinted with permission from Microsoft Corporation.

The completed CSS file is the Ch.4_XML_Golf_CSS3.css *file, and the completed XML file with the stylesheet attached is the* Ch.4_XML_For_CSS_Golf3.xml *file. Both files are located in the* Ch_4_1 Finished *directory.*

The CSS rules here calls for the CourseName tag to be displayed on a line by itself in 16-point, bold, green Arial with 16 points of additional space above it.

The golf course name is rendered to stand out from the text that follows it. So far, so good, because the data is self-explanatory. In other words, the reader can infer that "Valley Gorge Golf Course" is the name of the golf course. The element <CourseName> is self-explanatory, and you

do not need a corresponding heading to tell what this information is. The CSS that follows is also self-explanatory.

11. Write the CSS rules that control the format and display of the `<Cour-seInfo>` element information, including the complete address (Street, City, Zip) as well as the phone number and hours.

```
CourseInfo
{
   font: 11pt/24pt times new roman;
   display: inline;
 }

    Phone
 {
  font: 12pt/15pt Arial;
  display: block;
  font-weight: bold;
  padding-bottom:12pt;
          padding-top:12pt;
 }

 Hours
      {
     font: 12pt/20pt times new roman,serif;
      display: block;
      font-weight: bold;
      text-transform:capitalize;
      padding-bottom:12pt;
  }
```

Here again, the text is self-explanatory. For example, when formatting the `Course Information` element (12-point Times New Roman with 18 points of line spacing) to flow together on one line (`display:inline`), which includes `<Street>`, `<City>`, and `<Zip>` information, the information does not need an explicit definition in the final Web page, as in this example:

Street: 263 Mount Ethel
City: Scotts Valley

The information "263 Mount Ethel Scotts Valley" stands alone and you still know what it means. The next piece of information in the XML file, `<Phone>408-555-3058</Phone>`, is also easily recognized as a phone number without any explanation. The viewer will also understand that the text "Sunup to Sundown" is the golf course's hours of operation.

Review the CSS rules you have just added, as shown in Figure 4.5. Most of these rules are easy to understand for the graphic designer. Note how `text-transform: capitalize` renders initial caps, as opposed to rendering the element in all caps. `Padding-bottom` puts 12 points of additional space below the element.

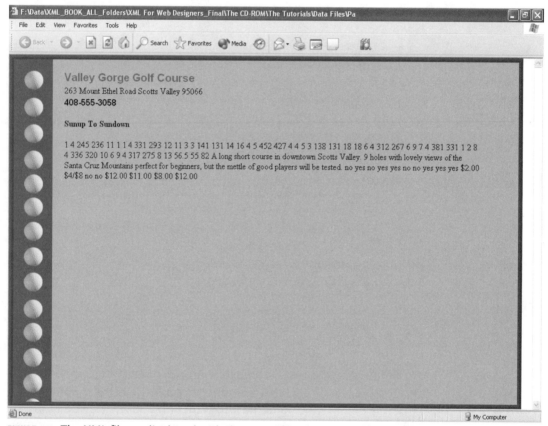

FIGURE 4.5 The XML file, as displayed with the new CSS rules. Screen shot reprinted with permission from Microsoft Corporation.

12. Save the file as *Ch.4_XML_For_CSS_Golf4.xml*, and click File → Preview In Browser. Other browsers that support the display of XML with CSS include Netscape 7.0 and Mozilla 1.0. See Figure 4.5 for the result.

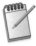

The completed CSS file is the Ch.4_XML_Golf_CSS4.css *file, and the completed XML file with the stylesheet attached is the* Ch.4_XML_For_CSS_Golf4.xml *file. Both files are located in the* Ch_4_1 Finished *directory.*

13. Write the CSS rules for the `<Hole>` element and its children.

```
Hole
  {
     position:relative;
     width:700px;
     border-style:inset;
     border-width:2px;
     border-color:darkgreen;
     padding:6px;
     background-color:white;
     padding-left: 6pt;
     font: 12pt/20pt times new roman,serif;
     display:block;
     padding-right:6pt;
  }
```

14. Save the file as *Ch.4_XML_For_CSS_Golf5.xml*, and click File → Preview In Browser. See the result in Figure 4.6.

FIGURE 4.6 The XML file with the newly added CSS for the Hole element. Screen shot reprinted with permission from Microsoft Corporation.

 The completed CSS file is the Ch.4_XML_Golf_CSS5.css *file, and the completed XML file with the stylesheet attached is the* Ch.4_XML_For_CSS_Golf5.xml *file. Both files are located in the* Ch_4_1 Finished *directory.*

At this point, the reader may be confused. Clearly, he is looking at a chart of numbers, but what do they represent? The original data in the XML file is no longer self-explanatory. For example, `<MensHcp>14</MensHcp>` is self-describing in the XML file—the men's handicap for this course is "14". CSS, however, does not display the tag, only the content, thus you are left with 14, with no explanation as to what this content means. When using CSS, you cannot add content to the file. Therefore, you cannot display "Men's Handicap: 14" in the Web browser:

15. Write the CSS rules for `<CourseRating>` and `<CourseSlope>`.

```
CourseRating
 {
  padding-top: 12pt;
  font: 14pt/30pt times new roman,serif;
  display: block;
  font-variant: small-caps;;
 }

CourseSlope
 {
  font: 14pt/30pt times new roman,serif;
  display: block;
  font-variant: small-caps;
 }
```

Note that with the exception of the `padding-top` on `<CourseRating>`, the styles are identical. The CSS syntax provides a method for grouping elements that are to receive the same style information. Simply list the elements and separate them with a comma, as in the following step.

16. Write the CSS rules that apply to the following elements:
 - `<DrivingRange>`
 - `<PuttingGreen>`
 - `<ChippingGreen>`
 - `<Reservations>`
 - `<SnackBar>`
 - `<CreditCards>`
 - `<BanquetFacilities>`

- `<GolfPro>`
- `<ProShop>`
- `<Lessons>`
- `<PullCarts>`
- `<Clubs>`
- `<GolfCar>`
- `<CocktailLounge>`

```
DrivingRange, PuttingGreen, ChippingGreen, Reservations, SnackBar,
 CreditCards, BanquetFacilities,GolfPro, ProShop, Lessons,
PullCarts,Clubs, GolfCar, CocktailLounge
    {
                margin-left:1in;
            display:list-item;
            list-style-image:url(golfBallicon.gif);
            font-family: sans-serif;
            vertical-align:super;
    padding-top:2px;
          }
```

17. Write the remaining CSS rules for the XML file.

```
CourseDescription     {
    font: 13pt/16pt times new roman,serif;
    display: block;
    padding-bottom: 24pt;
    padding-right: 24pt;
    position:relative;
    width:700px;
    }

Facilities    {
    position:absolute; left:360; top: 188;
    display:block;
    }

Condition
{
padding-top:14pt;
color:darkgreen;
margin-right:3in;
display:inline;
padding-right:6px;
}

Discount
{
```

```
padding-top:14pt;
margin-left:8px;
margin-right:3in;
display:inline;
}

Fees { display:inline;}

Fee    {
padding-top:14pt;
font-weight:bold;
color:darkgreen;
margin-left:16px;
margin-right:3in;
display:inline;
padding-bottom:8px;
}

Number        {
padding-right:6pt;
padding-left:6pt;
border: light solid green;
border-right: 1px solid green;
color:black;
text-align:left;
}

Par    {
padding-right:6pt;
padding-left:6pt;
border-right: 1px solid green;
text-align:right;
}

Blue  {
padding-right:6pt;
padding-left:6pt;
color:blue;
border-right: 1px solid green;
text-align:right;
}

White {
padding-right:6pt;
padding-left:6pt;
color:black;
```

```
border-right: 1px solid green;
text-align:right;
}

Red    {
padding-right:6pt;
padding-left:6pt;
color:red;
border-right: 1px solid green;
text-align:right;
}

MensHcp        {
padding-right:6pt;
padding-left:6pt;
border-right: 1px solid green;
text-align:right;
}

LadiesHcp      {
    padding-right:6pt;
    padding-left:6pt;
    border-right: 1px solid green;
    text-align:right;
    }
```

18. Save the CSS file as *Ch.4_XML_For_CSS_Golf6.xml*, and refresh the page display in Internet Explorer. See Figure 4.7 to see the result.

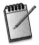

The completed CSS file is the Ch.4_XML_Golf_CSS6.css *file, and the completed XML file with the stylesheet attached is the* Ch.4_XML_For_CSS_Golf6.xml *file. Both files are located in the* Ch_4_1 Finished *directory.*

Notice the many areas in which the context is not clear. Following the description, which is self-explanatory text, are the course facilities. Of course, the reader has no way of knowing this because all he sees is the content of the tags—yes, no, and so on—and not the tag names or meanings. This is also true for the green fees.

CSS works well with HTML because the HTML file includes content that is completely described and fully understandable. For example, tables have table headings that describe the data in the table. XML files, on the other hand, contain pure data. They are self-describing files only to the extent that they are being read in their native format—with the markup intact.

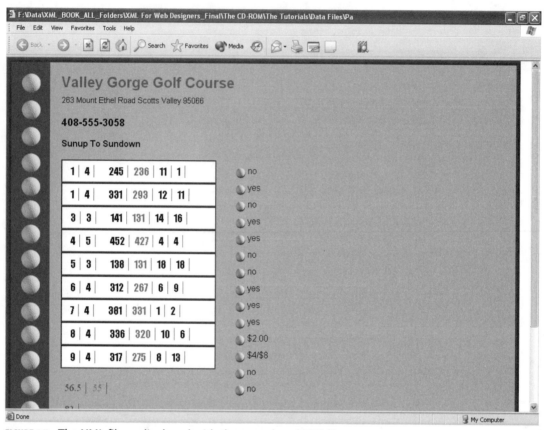

FIGURE 4.7 The XML file as displayed with the completed CSS file. Screen shot reprinted with permission from Microsoft Corporation.

The following information is understood due to its context within the markup:

```
<GreenFees>
  <Weekends>
  <Fee>$12.00</Fee>
  </Weekends>
  <Weekdays>
      <Fee>$11.00</Fee>
   </Weekdays>
   <Discount junior="true" senior="true"
   conditions="Wednesdays">
     <Fee>$8.00</Fee>
   </Discount>
   <Holidays>
     <Fee>$12.00</Fee>
```

```
        </Holidays>
    </GreenFees>
```

With CSS, however, the browser is given instructions, which describe only how to render these tags. CSS cannot output the tags themselves in the Web page or add new content that is not in the original file. Thus you are left with the following text displayed in the browser:

Weekdays
$12.00
Weekends
Holidays
$11.00

There is no description for the reader as to what these numbers mean.

To render a file in the Web browser that defines these elements, you would have to include that data in the original XML file. Unfortunately, that defeats the purpose of XML, which is to be a file of pure data with the meaning expressed in both the name and structure of the tags. Therefore, the designer may need to modify the XML file they intend to style with CSS.

ON THE CD
19. Open the file *Ch.4_Finished_XML_Modified_Golf.xml*. In this file the XML file has been modified to contain some explanatory information. Review this file for the added content.

20. Attach this file to the .css file that you created and saved in step 17.

```
<?xml version="1.0" encoding="UTF-8"?>
<?xml-stylesheet type="text/css"
href="Ch.4_XML_Golf_CSS.css"?>
<County>
```

21. Save the file as *Ch.4_Student_XMLwCSS_Modified.xml,* and click File → Preview In Browser. The file is displayed in the browser as shown in Figure 4.8.

The completed CSS file is the Ch.4_XML_Golf_CSS7.css *file, and the completed XML file with the stylesheet attached is the* Ch.4_XML_For_CSS_Golf7.xml *file. Both files are located in the* Ch_4_1 Finished *directory.*

ON THE CD
To view another XML file with CSS that uses absolute positioning, open in Internet Explorer the file called *Ch.4_Wine_XML_with_CSS.xml* in the *Finished Wine Examples* directory. This file is shown in Figure 4.9 as it is displayed in Internet Explorer.

FIGURE 4.8 The modified XML file as displayed with the completed CSS file.
Screen shot reprinted with permission from Microsoft Corporation.

FIGURE 4.9 The wine XML file as displayed with the CSS file. Screen shot reprinted
with permission from Microsoft Corporation.

To determine the file name of the CSS stylesheet, view the source code of this XML file. Open the CSS file that is referenced by this XML file in Dreamweaver MX 2004. ✄

When using XML to store information, you have flexibility that allows you to manipulate the data to suit your needs. When presenting your XML file for the Web, you can style it with CSS. As illustrated in this tutorial, the information in the XML file may lose its meanings as a result of the stylesheet. However, in the golf example, you can write an XSL-T stylesheet that converts the original XML data file, *Ch.4_Golf_XML_for_CSS.xml*, to look like the XML data in the file, *Ch.4_Golf_XML_Modified.xml*. Thus, you are taking advantage of the malleable nature of XML to restructure the file, making it easier to incorporate in your workflow.

Since the computer revolution began, one "killer app" after another has appeared. When the dust and hype settle, the end result is always the same. The killer app suits some needs and workflows but not all; it is not a standalone solution. There is no one-size-fits-all environments solution. Some Web sites rely completely on CSS, some on ASP or JSP, and others a proprietary custom-designed system. Macintosh environments often run database-driven Web sites from FileMaker™ Pro. Windows machines often run the same type of sites using Microsoft Access or Oracle database software. Therefore, no solution in the form of software has been able to meet the needs of all production and design environments. XML is no different. It is not a final solution suitable for all cases. However, the data is standardized and at the same time flexible enough to be restructured for any unique situation.

ADDITIONAL RESOURCES

Cascading Style Sheets Level 1 specification: *http://www.w3.org/pub/WWW/TR/PR-CSS1*

Cascading Style Sheets, Level 1 specification: *www.w3.org/TR/REC-CSS2*

W3C CSS validator: *http://jigsaw.w3.org/css-validator/*

CSS tutorial: *www.w3schools.com*

W3C CSS home page: *www.w3.org/Style/CSS/*

TUTORIAL

TUTORIAL TWO: HOW TO DISPLAY XML DOCUMENTS WITH XSL-T

OBJECTIVES

- To understand the basic concepts of an XSL-T Stylesheet including:
 - Templates
 - Loops
 - Conditionals
 - Adding text, elements, and attributes to the transformed file
- To write an XSL-T file that transforms an XML file into HTML with Dreamweaver MX 2004

BEFORE YOU BEGIN

What You Will Need for This Tutorial

- Dreamweaver MX 2004
- (PC) Microsoft Internet Explorer 5.x or later (The Macintosh version of Internet Explorer does not work for this tutorial.)
- A word processor
 - Macintosh: Text Editor, TeachText, SimpleText
 - Windows PC: Notepad, WordPad

ON THE CD

The Data Files

- **Tutorial Two Directory:** *Data Files/Part_2/Chapter 4/Ch_4_How to write XSLT_2*
- **Student Files:** *Ch_4_Golf_A_E.xml*
- **Supporting Files:**
 CIRCLE1.GIF
 CIRCLE2.GIF
 golfBallCircle.gif
 golfBallicon.gif
 GolfBG1.jpg
 greenBorder.gif
- **Student Files Directory:** *Data Files/Part_2/Chapter 4/Ch_4_How to write XSLT_2/XML Files*
- **Student Files:**
 Cold Springs Golf Course.xml
 Altos Par 3.xml
 Altos Seas Gold Course.xml
 Blueberry Farm Golf Course.xml

Black Creek Golf Club.xml
Diamond Ridge Par 3 Golf Course.xml
Cabernet Golf Club.xml
Mason Reef Golf Course.xml
City of San Rivera Golf Course.xml
Sycamore Golf Course.xml
Deep Ridge Golf Course.xml
Del Skye Golf Course.xml
Delacruz Golf Course.xml
Dan Marsh Course at the Marsh Golf Complex.xml
Sapphire Hills Golf Course.xml
Hilroy Golf Course.xml
Roneagles Golf Club.xml
Full Moon Bay Golf Links.xml
Yanez Park Golf Course.xml
Open Valley Lake Golf Club.xml
Cowboy Valley Golf Club.xml
John Clark Course at the Marsh Golf Complex.xml
Two Lagoons Golf Course.xml
Lake Kabob Golf Course.xml
Las Limas Golf Course.xml
Catrina Golf Course.xml
Mt. St. Milo Golf Course.xml
Atlantic Grove Golf Links.xml
Najaro Valley Golf Club.xml
Middleton Municipal Golf Course.xml
Boardwalk Golf Course.xml
San Pilgrim Golf Course.xml
Sutherland Greens Golf Course.xml
Seashore Golf Links.xml
Brook Hills Golf Course.xml
Red Valley Golf Course.xml
Hourglass Hill Golf Course.xml
Lookout Point Golf Club.xml
Noel Springs Golf Course.xml
The Links at Latin Bay.xml
Tony Rivera Golf Course.xml
Valley Gorge Golf Course.xml
GolfCourses_3.xml
Multiple.xml
Ch_4_Golf_XSLT_Final.xsl
Ch_4_Multiple_Golf_XSLT_Final.xsl

- **Supporting Files:**
 CIRCLE1.GIF
 CIRCLE2.GIF
 golfBallCircle.gif
 golfBallicon.gif
 GolfBG1.jpg
 greenBorder.gif

Defining the Site for Chapter 4 Tutorial Two

From the CD-ROM you will use the following root directory when defining your site for Chapter 4 Tutorial Two: *Chapter 4/Chapter 4 How to write XSLT*.

INTRODUCTION: WHAT IS XSL-T

In the previous tutorial you learned how to format an XML file with CSS. However, you can only style that which is present in the original XML file. You cannot add content as you style. With XSL-T, you can go beyond merely giving style information to actually transforming the XML file into another type of file. You can use the XML Stylesheet Language (XSL) to transform one XML file into another XML file, or from XML to HTML (or XHTML) as well as to a text file. To accomplish this, you add content as you go along this transformation process. In this tutorial, you will transform your XML golf data file into HTML suitable for viewing in Internet Explorer. Along the way, you learn the basic concepts of this transformation language called XSL-T.

CONCEPT: THE XSL-T PROCESSOR

You have learned in the previous tutorials that viewing XML requires an XML parser. You have been using the Microsoft XML Parser 4.0 as installed in Internet Explorer 6.0. To use the XSL-T transformation language, you need an XML file, an XSL stylesheet, and an XSL-T processor. Internet Explorer 6.0 includes an XSL-T processor in the XML parser.

The processor analyzes the XML file and converts it into a tree of nodes. Nodes are simply the individual components of the XML file, consisting of elements and their content. They include the root element, the remaining elements, attributes, processing instructions, namespaces, comments, and the text between the elements. The tree struc-

ture is the hierarchy of the nodes or their relationship to one another. For example, given the following file:

```
<A>
  <B>Text B goes here</B>
  <C>
      <D>Text D goes here</D>
  </C>
  <E>Text E goes here</E>
  <F G="value">
</A>
```

`<A>` is the root element node.
`` is an element node that is a child of the root node.
`<C>` is a child element node of the root node.
`<D>` is a child element node of `<C>`. This relationship can also be expressed as `<C>` is a parent node to `<D>`.
`<E>` is a child element node of the root node `<A>` that contains a text node.
`<F>` is a child element node of the root node `<A>`.
`G` is an attribute node.
`Text E goes here` is a text node.

Let's examine this tree structure in more detail. XML is considered as text formatted in a tree structure. A tree structure is a data structure with connected nodes, beginning with a single root node (the root element) that connects to child nodes. Nodes with no children are called leaves. Each node and its children make their own tree. The root node of an XML file contains the entire document. Element nodes contain the element node and its children. (For the purpose of processing XML, these elements are processed in the order in which they appear in the document). Element nodes are parents to their attribute nodes, but attributes are not children to their parent. The text inside elements is considered the text node. Pure white space without text is considered a text node. It should be noted that the XSL-T processor resolves CDATA sections, which you will learn about in Chapter 5. The text inside comment tags is considered as comment nodes.

XSL-T accepts one XML tree as input and produces as output a different tree.

ON THE CD

1. Launch Dreamweaver MX 2004, and open the XML file *Ch_4_Golf_ A_E.xml* from the *Chapter 4* directory on the companion CD-ROM. This is the file you transform via XSL-T into HTML.

As you learned when writing well-formed XML, the prologue is the first few lines of code in an XML file that precede the file's root element. XSL-T is a language that is written in the XML and, therefore, has a prologue. Start by typing that prologue, beginning with the XML declaration.

2. Click File → New and select Basic Page from the Category section and XML from the Basic Page section.

3. The root element for an XSL stylesheet is `<stylesheet>`. You will use the prefix `xsl:` before all elements to identify those as belonging to the XSL namespace as defined by the W3C Version One. For more information about namespaces, see Chapter 3, Tutorial Three. Therefore, the root element will be typed in its entirety as follows:

```
<xsl:stylesheet version="1.0"
xmlns:xsl="http://www.w3.org/1999/XSL/Transform">
```

CONCEPT: `<output>`

The W3C specification for XSL allows you to use an optional element that declares the language you are transforming the XML file into called `<output>`. The `<output>` element uses the attribute `method`. The three possible values for `method` are HTML, XML, or text. Note that when using a custom-created XSL-T processor (written in C++ or Java, for example), other custom output methods can be declared. Because you are transforming an XML file into HTML, set the `method` attribute to HTML.

4. Type the `<output>` element as follows:

```
<xsl:output method="html"/>
```

followed by the comment that describes the template you are about to write:

```
<!-- Main Template Begins-->
```

CONCEPT: TEMPLATES

The XSL-T processor analyzes an XML file and then processes (transforms) it according to the instructions in the XSL file. These instructions are called *templates*. Templates contain two parts. The first part, the identifier, tells the XSL-T processor to which node in the XML file the templates instructions pertain. The identifier takes the name of a node in the XML file. The second part of the template contains the instructions that the XSL-T processor uses to transform the XML element.

The `<xsl:template match = " ">` tag instructs the XSL-T processor to process a template. The `match` attribute tells the processor which element in the XML file to process. The `match` attribute's value is always a node on the XML tree, a location in the XML file. That location is derived by way of an expression from another W3C XML specification called XPath.

The template is processed by the XSL-T processor from top to bottom. Basically, the processor traverses the XML file until it finds an element for which a template has been created. Once it finds this element, it proceeds to transform the element according to the template's instruction. For example, you have the following simple XML file:

```
<A>
   <B>
    <C>Some Text Here</C>
   </B>
</A>
```

and the following XSL-T template:

```
<xs:template match="B/C">
    <xs:value-of select="C"/></H2>
</xs:template>
```

In this template the XSL-T processor looks for a `<c>` tag that is a direct child of a `` tag. When it locates a match, it transforms the contents of the `<c>` tag into an HTML Heading 1 tag, which contains the text inside the `<c>` tag. The resulting file would look as follows: `Some Text Here</H1>`.

CONCEPT: XPATH

To understand XSL, you must understand XPath, the language that allows the stylesheet to locate specific nodes in the XML file. Let's examine XPath in more detail.

XPath is a notation method used to describe a unique location within an XML file. An XML document is like a huge, 10-story parking garage. Finding elements, like finding your car, is not always easy. It helps to know what floor you are on and the letter or number of the general area where you parked. XPath is the language that identifies specific locations within the XML file, similar to the way a claim ticket that reminds you that you are on Level Five, Area B, Spot 26. You will learn numerous XPath expressions, as they are called, as you build your stylesheet. Let's look at some simple XPath expressions, just to get the hang of it. In the following example, the XPath expression is printed in bold.

```
<xsl:template match = "/">
```

The "/" denotes the XML files root element, which is essentially the entire document. Remember the definition of an element is the opening and closing tags as well as everything in between.

```
<xsl:template match = "CourseRating/Red">
```

This line denotes `<Red>` tags that are direct children of the `<Course-Rating>` tag.

```
<xsl:template match = "//phone">
```

This line denotes the `<phone>` tags, regardless of where they appear in the XML file.

```
<xsl:template match = Hole@Number>
```

This line denotes the `Number` attribute of the `<Hole>` tag.

XPath expressions can be much more complicated than this. Eventually your XSL-T stylesheet will finish processing one template and look for further templates to process. Furthermore, there may be times when, while processing one template, the stylesheet calls upon another template to process. In other words, while a template uses an XPath expression to tell the processor which nodes to process, it can use another XPath expression within the same template. For this reason, the XSL-T processor must always be aware of the location in the XML file that it is currently processing. This is known as the context node. For example, the XPath expression `match = "."` denotes the current node. But which node does the processor refer to as the current node? It depends on the context. In the following example, if the last template added is in `<TagC>`, then the current node's value is from the context of `<TagC>` and it is 4.

```
<TagA>
     <TagB>
<TagC>
     <Par>4</Par>
</TagC>
          </TagB>
</TagA>
```

The XPath language describes the location of something (a node) in the XML document, so that you can process that something (node) into something else. Consider the XML like a filing cabinet. It contains many

files (nodes) organized into folders. The file folder is the parent node or container tag. The papers in the files are the children of that parent. When you open the bottom drawer of the file cabinet, you have established the context. Perhaps you are going to the file folder marked "Correspondence." However, there is also a file folder called "Correspondence" in the top drawer. How do you know which correspondence you are looking at? It is easy if you know the context you are in. In this case the top drawer is labeled "Clients" and the bottom drawer is labeled "Vendors." Therefore, when writing stylesheets, you must always be aware of what context you are in, to avoid addressing the wrong element.

To summarize, an XSL-T stylesheet consists of templates that are composed of patterns called XPath expressions and instructions to follow when a pattern matches a pattern in the XML file. The pattern describes which source nodes should be processed, and the template describes the structure to generate when nodes match the pattern.

5. Type the stylesheet's first template, beginning with the template element and the `match` attribute.

```
<xsl:template match="/">
```

This `<template>` tag tells the XSL-T processor that what follows are the instructions for transforming the document. The `match` attribute is used to express which nodes you want to match. `match="/"` matches the root node. Later you will use `match= "element name"`, for which you will supply an element's name to match. Here, the root element of your golf file is now transformed according to the following template's instructions.

6. Type the template's instructions:

```
<html>
  <head>
      <title>Bay Area Golf Courses</title>
      <style type="text/css">
        * {font-family:verdana, arial, helvetica, sans-serif;
        font-size:10pt;}
        H1 {font-family:verdana, arial, helvetica, sans-serif;
        font-size:24pt;margin-left:18px;}
        .courseStyle  {font-family:verdana, arial, helvetica,
        sans-serif; font-weight:bold; font-size:16pt;padding-
        left:18px;line-height:18pt; background: white padding:
        10px;;}
        body {background-image:url(GolfBG1.jpg); background-
        attachment:fixed; background-repeat:no-repeat;}
      </style>
```

```
</head>
<body leftmargin="0" topmargin="0" marginwidth="0"
marginheight="0" bgcolor="cccccc">
```

At this point the instructions are basic HTML. You begin a Web page with the title "Bay Area Golf Courses," followed by some CSS nested inside a style tag. Your CSS includes formatting for the entire document with the * (wildcard character). * tells the browser that all tags within the HTML file are formatted as indicated (Verdana, Arial, or Helvetica or another sans serif typeface in 10 point). The CSS also includes formatting instructions for the Heading 1 tag. The body tag is formatted with a background graphic (*GolfBG1.jpg*), which remains stationary as the user scrolls and does not tile or repeat. The style and head tags are then closed, and the body of the Web page begins with the <body> tag, which includes attributes that set the Web page's margins at 0 all around the document and a background color of gray. The instructions for the <xsl:template match="/"> are now complete, and you can continue to process the XML file with further XSL instructions.

CONCEPT: RECURSION

At this point in your newly created HTML file, you want to continue processing the XML file by formatting all of the <Course> elements that are children of your root element, <County>. XSL-T provides an element that tells the XSL-T processor to transform each instance of an element as defined by the XPath expression. In other words, in this example, you will instruct the XSL-T processor as follows: for each <Course> element inside a <County> element, perform the following transformation (as written in the template). This XSL-T element is fittingly called <xsl:for-each>. The for-each element requires an attribute similar to the match attribute in the <template> element that identifies which element in the XML file should be processed. The attribute is select, and its value is the element to be processed. This value can be expressed as a tag name or an XPath expression that identifies the element you wish to transform.

7. Type the <xsl:for-each> tags that identify the next element or, in this case, set of elements that the stylesheet will process:

```
<xsl:for-each select="County/Course">
```

The <xsl:for-each> element is used to process each element chosen by its select attribute in turn. The select attribute is used to select a particular set of children (child nodes).

As you may recall, you cannot add content to the XML file merely by styling it with CSS. XSL-T, however, allows you to add text content to the output file. In this example, where you are transforming an XML file into HTML, you can add content in the form of HTML tags. In addition, you can and will add text to your Web page as you create it. The next line of code adds an HTML tag to the output file. The XSL vocabulary includes an element whose job is to create elements in the output file. In this example, you will create an HTML anchor <a> tag. You must remember, however, that this element can create any type of element for any language. This is how XSL-T is used to transform XML into the Wireless Markup Language, the Voice Markup Language, or any other markup language that requires different elements. The element you will use is the <xsl:element>. It requires a name attribute, whose value is the name of the element you are creating. In addition to creating elements, you can also create attributes.

8. To create an HTML anchor tag with a name attribute, type the following lines:

```
<xsl:element name="a">
  <xsl:attribute name="name">
```

At this point, you have created an anchor tag with a name attribute, for every Course element in your XML file. Thus, if you counted the Course elements in your XML file, you could predict the number of anchor tags in your new HTML output file. So far as the transformation is concerned, your new HTML file would look as follows:

```
<html>
  <head>
    <title>Bay Area Golf Courses</title>
    <style type="text/css">
    *{font-family:verdana, arial, helvetica, sans-serif;
    font-size:10pt;} H1 {font-family:verdana, arial, helvetica,
    sans-serif; font-size:24pt;margin-left:18px;}.courseStyle
    {font-family:verdana, arial, helvetica, sans-serif;
    font-weight:bold; font-size:16pt;padding-left:18px;
    line-height:18pt; background: white padding: 10px;;} body
    {background-image:url(golfbg.jpg); background-
        attachment:fixed;
    background-repeat:no-repeat;}
    </style>
  </head>
  <body leftmargin="0" topmargin="0" marginwidth="0"
  marginheight="0" bgcolor="cccccc">
  <a name=
```

As you can see, your `<A>` tag is here to create a named anchor, to be used as a link for another document. However, there is no value for the name attribute. To provide this value, you use the XSL element `<xsl:value-of>`, which simply tells the XSL-T processor that the text that follows will be the value of some other element in the XML document. Tell it which element through the `select` attribute. For example, the following XML file:

```
<Name>
<First>Kevin</First>
<Last>Ruse</Last>
<MiddleInitial>M</MiddleInitial>
</Name>
```

combined with the following XSL-T code:

```
<xsl:element name="a">
  <xsl:attribute name="name">
    <xsl:value-of select="First">
  </xsl:attribute>
</xsl:element>
```

would produce the following output:

```
<a name="Kevin">
```

You tell the XSL-T processor to create an anchor tag with a `name` attribute whose value is taken from the value of the element `<First>`, therefore, making it "Kevin." Basically, you are copying the value of an XML node from the input tree of nodes to the output tree of nodes.

For the golf example, you will populate the `name` value of the anchor tag with a slightly more complex method. You will still use the `<xsl:value-of>` element; however, you will combine it with something new, called an XSL-T function. Similar to Web programming languages like JavaScript, an XSL-T function is a predefined set of instructions that is understood and executed by the XSL-T processor.

The XSL-T language has some unique functions that you can use to process your XML file. These XSL-T functions can perform a variety of useful tasks. They can count the number of nodes at a particular point in the XML tree. They can combine two XML elements to form a single element. They can recursively search the XML file for elements that contain certain letters or words. They can test to see if and where an element occurs in the XML file so that it can be transformed in a certain way. They can also be used to return the name of a particular node in the XML tree. You can

use some of these functions to convert an element into a number, calculate the position of a particular node, return the number of characters in an element, or return just a portion of the characters. You will use an XSL-T function to return a portion of an XML element from the Golf XML file. It is important to note where you are calling upon this function from within your stylesheet. The last line of code you entered in your stylesheet created an HTML anchor tag with a `name` attribute. At this point, you will use an XSL-T function to provide a value for the `name` attribute of the anchor tag. Combining the two concepts you just learned, call on the function from the `select` attribute of the `value-of` element.

9. Type the `<xsl:value-of>` element with the `select` attribute's value being the XSL-T function called `substring()`:

```
<xsl:value-of select="substring(CourseName, 1, 6)"/>
```

Let's examine this line in more detail. You already know that the `<xsl:value-of>` element retrieves the value of an element. Which element it retrieves is determined by the `select` attribute. The select attribute's value in this case is an XSL-T function called `substring()`. The `substring` function retrieves a portion of an element's text, which is referred to as a "string", hence the name substring. The element whose text string you are examining is placed inside the parentheses following the word *substring*. The portion of the string that is extracted is determined by two values placed in the parentheses. Thus, a `substring(CourseName, 1, 6)` extracts a portion of the text found in the `CourseName` element beginning with character 1 and ending with character 6. Remember, your current context at this point in the stylesheet is the `<Course>` element as dictated by the line:

```
<xsl:for-each select="County/Course">
```

The first `CourseName` element that is a child of the `<Course>` element is:

```
<County>
    <Course>
    <CourseName>Valley Gorge Golf Course</CourseName>
```

Therefore, the stylesheet code:

```
<xsl:element name="a">
    <xsl:attribute name="name">
<xsl:value-of select="substring(CourseName, 1, 6)"/>
```

would produce the following output:

```
<a name = "Valley">
```

10. Type the closing tags for the `<xsl:element>` and `<xsl:attribute>` tags.

```
</xsl:attribute>
</xsl:element>
```

11. The template now calls for an image. Type the HTML element ``:

```
<img src="greenBorder.gif"/>
```

The next segment of code displays the contents of an XML element, so use the `<xsl:value-of>` element. You will wrap an HTML `<div>` tag around it to use the CSS that was written in the head tag in step 6.

12. Type the `<div>` tags outside of an `<xsl:value-of>` element, as follows:

```
<div class="courseStyle">
    <xsl:value-of select="CourseName"/>
</div>
```

To examine the HTML output that this stylesheet creates, you will now test the stylesheet. You may have noticed that the XSL-T stylesheet is written in well-formed XML and follows the rules you learned in Chapter 3. Therefore, to complete the stylesheet at this point, you must make sure all of your opening tags have closing tags. If an XSL stylesheet is not well formed, it cannot be processed with its corresponding XML file by the XSL-T processor. In such a case, you receive an error message similar to the one you received in Chapter 3 when your XML file was not well formed.

The tags must be closed in the proper order as well, following the XML well-formed rule that tags must be properly nested. Therefore, the first tag you must close is the `<xsl:for-each>` tag that you opened earlier to process all the `<Course>` elements that are children of `<County>` elements. The next set of tags to close are those created for the HTML output file, `<body>` and `<html>`. Finally, close the original `<xsl:template>` tag you opened to write your, thus far, one and only template. The last tag to close is the root element, `<xsl:stylesheet>`. Keep in mind that when using Dreamweaver MX 2004 to write stylesheets, you must close empty tags using `<tag></tag>`, as opposed to the shortcut method of `<tag/>`. Dreamweaver MX 2004 appends ` ` to all tags closed as `<tag/>`, which introduces an invalid character entity in your XML stylesheet.

13. Type the closing tags to end your stylesheet.

```
            </xsl:for-each>
          </body>
        </html>
      </xsl:template>
</xsl:stylesheet>
```

The completed file follows. Note the use of white space to create in-dents that visually reflects the nature of the parent/child relationship between certain tags.

```
<?xml version="1.0" encoding="UTF-8"?>
<xsl:stylesheet version="1.0"
    xmlns:xsl="http://www.w3.org/1999/XSL/Transform">
<xsl:output method="html"/>
<xsl:template match="/">
<html>
  <head>
    <title>Bay Area Golf Courses</title>
      <style type="text/css">
        * {font-family:verdana, arial, helvetica, sans-serif;
        font-size:10pt;} H1 {font-family:verdana, arial,
            helvetica,
        sans-serif;font-size:24pt; margin-left:18px;}.courseStyle
        {font-family:verdana, arial, helvetica, sans-serif;
        font-weight:bold; font-size:16pt; padding-left:18px;
        line-height:18pt; background: white;padding: 10px;} body
        {background-image:url(golfbg.jpg);
        background-attachment:fixed; background-repeat:no-
            repeat;}
      </style>
  </head>
  <body leftmargin="0" topmargin="0" marginwidth="0"
  marginheight="0" bgcolor="cccccc">
    <xsl:for-each select="County/Course">
      <xsl:element name="a">
          <xsl:attribute name="name">
          <xsl:value-of select="substring(CourseName, 1, 6)"/>
          </xsl:attribute>
      </xsl:element>
      <img src="greenBorder.gif"/>
      <div class="courseStyle">
        <xsl:value-of select="CourseName"/>
      </div>
    </xsl:for-each>
  </body>
</html>
</xsl:template>
</xsl:stylesheet>
```

14. Save the stylesheet in the Dreamweaver MX 2004 local root directory as *Golf_XSLT.xsl*.

You will now attach the stylesheet to the XML file using the same method you learned when you attached a CSS stylesheet to an XML file. Activate the XML file you opened in step 1, *Ch_4_Golf_A_E.xml*.

15. Place your cursor directly below the XML declaration, and type the following processing instruction:

```
<?xml-stylesheet type="text/xsl" href=" Golf_XSLT.xsl"?>
```

The XML file is shown in Figure 4.10 as it should look after step 15.

FIGURE 4.10 The XML file with the stylesheet attached as displayed in Dreamweaver MX 2004. Internet Explorer screen shot reprinted with permission from Microsoft Corporation.

The stylesheet transforms the XML document as follows: First, it matches the root element and transforms it to the HTML tags you indicated, which include some CSS in the head tag. Next, it process all of the <Course> elements that are children of the <County> element, placing each inside an HTML named anchor tag, naming each with the first six letters of the <Course> element. Next, it places an image that creates a green border. Following this image it places the contents of the CourseName element that has been styled in 16-point bold Verdana with a white background and 18 points of line spacing, as well as 18 pixels of padding to the left of the element. The styling comes from the fact that the CourseName has been placed in an HTML <div> tag, which calls upon the CSS style CourseStyle, which you had created earlier in the head tag.

16. Save the XML file and open it in Internet Explorer 6.0. The XML file should now be displayed as shown in Figure 4.11.

FIGURE 4.11 The XML file attached to the partially completed XSL stylesheet. Screen shot reprinted with permission from Microsoft Corporation.

17. To see the HTML file that your stylesheet has created, right-click your browser window and select View XSL Output.

You will continue writing your stylesheet to further transform the XML file.

Note the location where you will append your stylesheet. Follow the last `<div>` tag with another. The main purpose of these and the remaining `<div>` tags you write is to apply your CSS styles. The `<div>` tags also provide absolute and relative positions to the elements you will add to the HTML file.

18. Type the next `<div>` element:

```
<div style="padding-left: 20px; padding-right:6px; padding-
top:0px; padding-bottom:6px; position:relative; left:0px; top:0;
width=1024; background:#CCFFCC">
```

19. Type an HTML line break tag:

```
<br />
```

Note how you used the shortcut method for opening and closing tags within the same angle brackets. Dreamweaver MX 2004 does not add a ` ` after a `
` tag.

So far, your stylesheet contains one template. The template `<xsl:template match = "/">` matches the root element of the XML document and then transforms it according to the remaining code, which ended with the closing tag `</xsl:template>`. What happens, however, when you need to process a different template at a point inside the existing template? For example, your stylesheet is currently processing the root node match, where you have transformed the file to become an HTML file. Beginning with the `<html>` tag, you added a background graphic and a named anchor, followed by a graphic and the name of each golf course, styled with CSS. Your last tag was the HTML line break, `
`. At this point in the HTML file, you want to add the course information from the XML file. However, you do not want to close your current template, because you need to add the course information after your last line break, and ending the template would require you to close all tags, including the `</html>` tag. To allow the XSL-T processor to process other nodes on the XML file without leaving the current stylesheets template, use the `<xsl:apply-templates>` element.

The basic functionality of `apply-templates` is demonstrated in the following XML file and its stylesheet.

The XML File

```
<?xml version = "1.0"?>
<instructions>
    <header>How to write xml</header>
    <paragraph>XML must be well-formed.</paragraph>
</instructions>
```

The Stylesheet

```
<xsl:stylesheet>
    <xsl:output method="html"/>
    <xsl:template match="/">
        <html>
            <head>
                <title>Apply Templates Sample</title>
            </head>
            <body>

                <xsl:apply-templates select="header"/>
                </h1>
                <p>
                <xsl:apply-templates select="paragraph"/>
            </p>
            </body>
        </html>
    </xsl:template>
```

Here, you begin processing the first template at the root element. Next, after establishing some basic HTML tags, you apply a tag and call for a template whose match is "header", followed by the closing </h1> tag. You now want to format the <paragraph> element, so open a <p> element and call upon a template with <xsl:apply-templates> with a match attribute of "paragraph". Then close the <p> tag. The file is not complete, however, because at the moment there are no templates for "paragraph" or "header". Therefore, after your template is closed, you must create the templates for "paragraph" and "header" that the current template is calling with <apply-templates>. Your completed stylesheet might look as follows (with the two new templates in bold):

```
<xsl:stylesheet>
<xsl:output method="html"/>
<xsl:template match="/">
    <html>
        <head>
            <title>Apply Templates Sample</title>
        </head>
```

```
<body>
    <p>
    <xsl:apply-templates select="paragraph"/>
    </p>

    <xsl:apply-templates select="header"/>
    </h1>
    </body>
    </html>
    </xsl:template>

<xsl:template match="paragraph">
<font face="times new roman"><I>
<xsl:value-of select=".">
</I></font>
</xsl:template>

<xsl:template match="header">
<font face="Arial"><B>
<xsl:value-of select=".">
</B></font>
</xsl:template>

</xsl:stylesheet>
```

There are three templates; the first, which matches the root element, calls upon the other two with <xsl:apply-templates>. The templates called with <xsl:apply-templates> can be anywhere in the document, as long as they are not inside of another <xsl:template> tag. Return to the golf template and use the <apply-templates> element.

The next line of code is <xsl:apply-templates>, which applies the template for the <CourseInfo> element.

20. Type the <xsl: apply-templates> tag:

```
<xsl:apply-templates select="CourseInfo"/>
```

21. Type the remaining closing tags:

```
</div>
<p></p>
</body>
</html>
```

22. Close the template by closing the <for-each> and <template> tags:

```
</xsl:for-each>
</xsl:template>
```

23. Type the second template for `<CourseInfo>`. Including the comment makes it easier to identify this template from the previous templates, as well as from the other templates you will write.

```
<!-- Main Template Ends-->
<!-- Template for Course Address, Phone and Hours -->

<xsl:template match="CourseInfo">
    <b>
        <xsl:value-of select="Street"/>
        <xsl:text>, </xsl:text>
        <xsl:value-of select="City"/>
        <xsl:text> </xsl:text>
        <xsl:value-of select="Zip"/>
        <xsl:text> - Phone: </xsl:text>
        <xsl:value-of select="Phone"/>
        <xsl:text> - Open: </xsl:text>
        <xsl:value-of select="Hours"/>
    </b>
    <br />
</xsl:template>
```

This template begins with an HTML `` tag. It then calls for the contents of the `<Street>` and `<City>` elements, separated by a comma. The comma is generated with the `<xsl:text>` element. This element is used to add text to the output file. Thus, the line `<xsl:text>, </xsl:text>` is used to add a comma to the output file.

The template continues by using `<xsl:text>` to place a space between the `<City>` and `<Zip>` elements. Then, again you use `<xsl:text>` to add a hyphen and the word *Phone*, followed by the XML files `<Phone>` element. `<xsl:text>` is used one more time to add a hyphen and the word *Open*, followed by the contents of the XML `<Hours>` element. Close the `` tag, add a line break `
` tag, and close the template with `</xsl:template>`.

24. Save the stylesheet and view the XML file in Internet Explorer. The XML file is displayed as shown in Figure 4.12.

Let's examine the next portion of the stylesheet. You begin with a `<div>` tag to apply the CSS rule that places the forthcoming `<table>` tag 12 pixels from the left edge of the browser window. The table tag creates a table with no cell padding, one pixel of cell spacing, and a left margin of 8 pixels. The first table row's content is aligned to the vertical center (`valign = "middle"`), and the first column in the first row contains the contents of the `<CourseRating>` element, as formatted by the template for `<CourseRating>`, which you need to write. The remaining table

FIGURE 4.12 The XML file displayed in Internet Explorer with two templates complete. Screen shot reprinted with permission from Microsoft Corporation.

tags create two more columns, the first with a fixed width of 212 pixels and the second containing four images.

25. To type the remaining HTML for the first template, find the location for the following code:

```
<div style="padding-left: 20px; padding-right:6px; padding-
top:0px; padding-bottom:6px; position:relative; left:0px; top:0;
width=1024; background:#CCFFCC">
<br/>
  <xsl:apply-templates select="CourseInfo"/> </div>
<p></p>
```

At this point, continue with the following code:

```
<div style="margin-left:12px">
 <table border="0" cellpadding="1" cellspacing="1"
 style="margin-left:8px;">
  <tr valign="top">
   <td>
    <table bgcolor="white" border="3" bordercolor="darkgreen"
    cellpadding="4" width="250">
    <tr>
     <th bgcolor="darkgreen" colspan="4">
      <font color="white">Rating/Slope</font>
     </th>
     </tr>
   <tr>
    <th></th>
    <th bgcolor="blue">
     <font color="white">Blue</font>
    </th>
    <th bgcolor="white">
     <font color="black">White</font>
    </th>
    <th bgcolor="red">
     <font color="white">Red</font>
    </th>
    </tr>
    <tr align="center">
     <xsl:apply-templates select="CardInfo/CourseRating"/>
    </tr>
    <tr align="center">
     <xsl:apply-templates select="CardInfo/CourseSlope"/>
    </tr>
</table>
 <td width="212"></td>
 <td valign="top">
   <div>
    <img hspace="8" src="circle1.gif"/>
    <img hspace="8" src="circle2.gif"/>
    <img src="golfBallCircle.gif"/>
   </div>
 </td>
 </td>
</tr>
</table>
</div>
<p></p>
  <xsl:apply-templates select="CardInfo"/>
<p></p>
<div>
  <xsl:apply-templates select="CourseDescription"/>
</div>
<p></p>
```

```
<p></p>
<table border="0">
  <tr>
    <td valign="top">
      <div style="margin-right:18px; margin-left:18px">
        <xsl:apply-templates select="Facilities"/>
</div>
</td>
  <td valign="top">
    <div style="margin-right:6px; margin-left:6px">
      <xsl:apply-templates select="GreenFees"/>
    </div>
  </td>
</tr>
</table>
<p></p>
<p></p>
</xsl:for-each>
</body>
</html>
```

Notice how this code calls upon other templates with the `<xsl:apply-templates>` tag. The stylesheet is incomplete at this point because the XSL-T processor will attempt to process the template for the line `<xsl:apply-templates select="CardInfo/CourseRating"/>`, and you do not have a template for this XML tag.

26. Let's see the results of your template. Save the XML file, and click File → Preview In Browser. Your results should match Figure 4.13.

27. Beneath the template for `<CourseInfo>`, type the template for `<CourseRating>`, including the comment line:

```
<!-- Template for Course Rating Table -->
<xsl:template match="CourseRating">
 <td bgcolor="darkgreen" width="100px">
  <font color="white">Course Rating</font>
 </td>
 <td bgcolor="blue" align="center">
  <xsl:choose>
     <xsl:when test="string-length(Blue) &lt; 1">
      <xsl:text><![CDATA[n/a]]></xsl:text>
     </xsl:when>
    <xsl:otherwise>
      <font color="white">
        <xsl:value-of select="Blue"/>
      </font>
    </xsl:otherwise>
  </xsl:choose>
 </td>
```

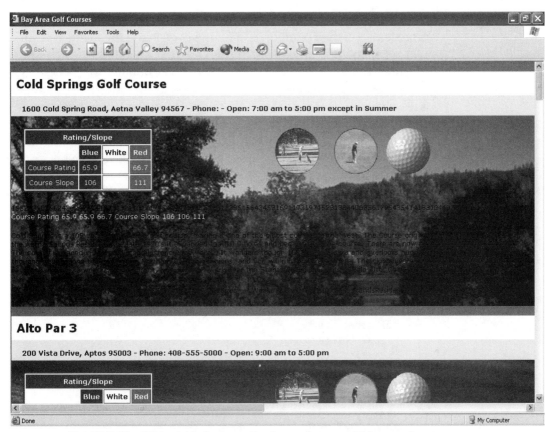

FIGURE 4.13 The XML file displayed in Internet Explorer after step 26 is complete. Screen shot reprinted with permission from Microsoft Corporation.

CONCEPT: CONDITIONALS

This template creates a new table that contains three rows with the main heading Rating/Slope across the top row and the three headers, Blue, White, and Red. The next two rows contain the values of the <Blue>, <White> and <Red> tags consecutively. The <CourseRating> template contains something new. It begins with a <td> that creates a table column within your previously defined table. It has a background color of "dark-green" and is 100 pixels wide with white text inside that reads, "Course Rating". That table cell is closed, and another <td> tag creates a second center-aligned column with a blue background. At this point one of two things can happen, based on what the template finds in the XML file. Note the new element <xsl:choose>, indicating a choice of options for the XSL-T processor to make. The <xsl:when> element specifies a specific

condition. If this condition is true, the code within the `<xsl:when>` element is processed. If the condition is false, the code in the following `<xsl:otherwise>` element is processed. In this case, the condition uses an XSL-T function called `string-length()`. This function examines the string in the parentheses that follows it (`Blue`) to see if the string's length of characters is less than one. Notice that you cannot use the < (less than character). Instead, use the character entity `<`. Essentially this function determines if the `<Blue>` tag is empty. If it is, then your stylesheet replaces its contents in the output HTML file with `"n/a"`. Notice the use of CDATA. If you are unfamiliar with character entities or CDATA, review Chapter 5.

28. Type the remaining code for the `<CourseRating>` tag. Its structure is similar to the code in step 27.

```
<td bgcolor="white" align="center">
 <xsl:choose>
  <xsl:when test="string-length(White) &lt; 1">
    <xsl:text><![CDATA[n/a]]></xsl:text>
  </xsl:when>
<xsl:otherwise>
  <font color="white">
    <xsl:value-of select="White"/>
  </font>
</xsl:otherwise>
</xsl:choose>
</td>
<td bgcolor="red" align="center">
  <xsl:choose>
    <xsl:when test="string-length(Red) &lt; 1">
      <xsl:text><![CDATA[n/a]]></xsl:text>
</xsl:when>
<xsl:otherwise>
  <font color="white">
    <xsl:value-of select="Red"/>
  </font>
</xsl:otherwise>
</xsl:choose>
</td>
</xsl:template>
```

Save the stylesheet and preview the XML file in Internet Explorer. The result is shown in Figure 4.14.

29. Type the template for `CourseDescription`:

```
<!-- Template for Course Description -->
<xsl:template match="CourseDescription">
```

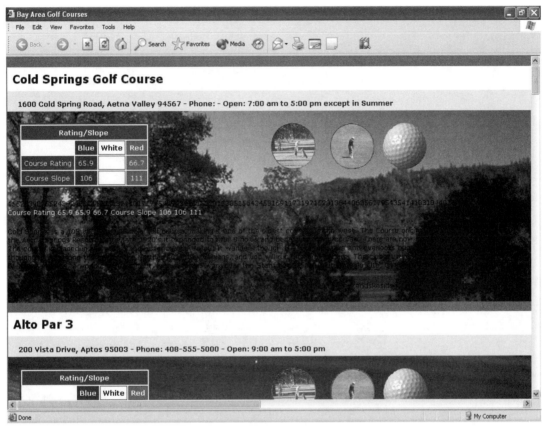

FIGURE 4.14 The XML file displayed in Internet Explorer with the almost complete stylesheet. Screen shot reprinted with permission from Microsoft Corporation.

```
<div class="courseStyle">
    <b>Course Description</b>
</div>

<div style="font-family:Times New Roman, serif; font-size:11pt;
font-color:black; line-height:14pt; padding-left: 22px; padding-
top:0px; padding-bottom:18px; position:relative; left:0px; top:-
4px;background:#99CCFF">
  <span style="width:708px; text-align:justify;padding-
top:16px;padding-bottom:16px">
  <xsl:value-of select="Paragraph"/> </span> </div>
    </xsl:template>
```

This template displays the XML `<CourseDescription>` element in 11-point, black Times New Roman with 14 points of line space, a left margin of 18 pixels, and a background color of white.

30. Type the template for `<CourseFacilities>`:

```
<!-- Template for Course Facilities Table -->
<xsl:template match="Facilities">
    <div style="left-margin:18px;">
<table align="center" bgcolor="white" border="2"
bordercolor="darkgreen" cellpadding="6" cellspacing="6"
width="450">
<tr bgcolor="darkgreen">
<td align="center" colspan="4" valign="middle">
<b>
<br/>
<font color="white">Facilities</font>
<p></p>
</b>
</td>
</tr>
```

This template creates a table that has rows and columns populated with data from the XML file. Each row contains a table cell that contains an `<xsl:apply-templates>` element. This template calls for other templates to be processed. The `select` attribute's values are the templates to be processed from within the HTML table's `<td>` tags. For example, the table's second row contains a `<td>` tag that contains the element `<xsl:apply-templates select="DrivingRange" />`, which calls the `"DrivingRange"` template. The remaining templates called by this template perform the same basic function. To understand this template let's look at the portion of the XML file that the template processes.

```
<Facilities>
<DrivingRange>no</DrivingRange>
<PuttingGreen>yes</PuttingGreen>
<ChippingGreen>no</ChippingGreen>
<Reservations>yes</Reservations>
<SnackBar>yes</SnackBar>
<CreditCards>no</CreditCards>
<BanquetFacilities>no</BanquetFacilities>
<GolfPro>yes</GolfPro>
<ProShop>yes</ProShop>
<Lessons>yes</Lessons>
<PullCarts>$2.00</PullCarts>
<Clubs>$4/$8</Clubs>
<GolfCar>no</GolfCar>
<CocktailLounge>no</CocktailLounge>
</Facilities>
```

The template examines the contents of the `<DrivingRange>` tag. If it finds the text `"yes"`, it places an image of a golf ball inside the `<td>` tag

from which the template is called. Otherwise it places the text `"no"`. Let's examine how the code accomplishes this task.

In many cases, the XML files you process with XSL-T are unknown to you when you write the stylesheet. For example, XML that contains sports scores will change daily, or stock quotes written in XML can change many times within the hour.

The XSL-T language allows you to write the code so that if a certain condition exists it formats the text in one way; otherwise, if that condition does not exist, it formats the text another way. For example, assume you are building an HTML table. For readability purposes, you want every other row in the table to have a background color of light blue. However, you do not know how many rows will be in the table because the data in the XML file changes frequently.

Consider the following XML example:

```
<Schedule>
    <BusLine>A
      <time>4:00 pm</time>
      <time>5:00 pm</time>
      <time>6:00 pm</time>
      <time>7:00 pm</time>
      <time>8:00 pm</time>
      <time>9:00 pm</time>
    </BusLine>
```

You can accomplish the formatting by having the template examine the XML file as it processes it.

The XSL-T element that examines this file to see if one condition or another exists is `<xsl:choose>`. This element tells the XSL-T processor to choose which segment of code to execute. The `<xsl:choose>` element must be followed by the `<xsl:when>` element, which requires the `test` attribute. The `test` attribute's value may consist of a variety of options. It may be an XSL-T function or an XML element from the source file. In the previous example, you use a function that determines if the position of the `<time>` element within the XML file is an even or an odd number. The first `<time>` child of the `<BusLine>` parent is element 1 and, thus, odd. The `<time>5:00</time>` is the second `<time>` element and, thus, is even. The code that determines this follows and includes the surrounding HTML elements required to build the table.

```
<tr>
    <xsl:choose>
    <xsl:when test="position() mod 2 = 0">
        <xsl:attribute name="style">
```

```
            background-color:lightblue
        </xsl:attribute>
    <xsl:otherwise>
        <xsl:attribute name="style">
            background-color:white
        </xsl:attribute>
    </xsl:otherwise>
     </xsl:choose>
```

Line 1 creates the table's first row. Line 2 tells the processor to choose between two segments of code. Line 3 dictates the condition that determines which segment of code to execute. If the condition proves to be true, the code immediately below it is invoked. If the condition proves to be false, the code segment in the `<xsl:otherwise>` element is executed. It is the `<xsl:when>` element's `test` attribute that contains the condition. The `test` attribute's value uses the `position()` function to determine the position of the `<time>` node, which is currently being processed. If this node's number, when divided by two, returns a remainder of 0, it is an even number and is, therefore, formatted with a background color of light blue. If it has a remainder, then its node position is an odd number and lines 4 through six 6 are not invoked. Instead, the code on lines 8 through 10 inside the `<xsl:otherwise>` element are executed. Now that you have a basic understanding of the structure of XSL conditional statements, let's return to the Golf XML file.

In steps 31 through 34, you write the remaining templates. As you write the templates, try to understand the code's consequences. Most of these templates use some or all of the concepts you have learned so far, so you may want to review them as you go along. Because these templates do not introduce any new concepts, there is no explanation following the code.

You will now write the templates that process the Facilities section of your golf course Web site.

31. Write the remaining code for the Facilities template.

The remaining code can be cut and pasted from the Ch_4_2 *Finished folder for Chapter 4. The file is* Ch_4_Golf_XSLT.xsl.

ON THE CD

```
<tr style="padding:3px; text-indent:3px">
 <td align="right" width="124">
  <xsl:apply-templates select="DrivingRange"/>
 </td>
 <td align="right" width="124">
```

```
    <xsl:apply-templates select="PuttingGreen"/>
 </td>
</tr>
    <tr style="padding:3px; text-indent:3px">
     <td align="right" width="124">
      <xsl:apply-templates select="ChippingGreen"/>
     </td>
     <td align="right" width="124">
     <xsl:apply-templates select="Reservations"/>
     </td>
</tr>
<tr style="padding:3px; text-indent:3px">
     <td align="right" width="124">
      <xsl:apply-templates select="SnackBar"/>
     </td>
     <td align="right" width="124">
      <xsl:apply-templates select="CreditCards"/>
     </td>
</tr>
     <tr style="padding:3px; text-indent:3px">
      <td align="right" width="124">
       <xsl:apply-templates select="BanquetFacilities"/>
      </td>
     <td align="right" width="124">
      <xsl:apply-templates select="GolfPro"/>
     </td>
     </tr>
     <tr style="padding:3px; text-indent:3px">
     <td align="right" width="124">
      <xsl:apply-templates select="ProShop"/>
     </td>
      <td align="right" width="124">
       <xsl:apply-templates select="Lessons"/>
      </td>
     </tr>
     <tr style="padding:3px; text-indent:3px">
      <td align="right" width="124">
       <xsl:apply-templates select="PullCarts"/>
      </td>
      <td align="right" width="124">
       <xsl:apply-templates select="Clubs"/>
      </td>
     </tr>
     <tr style="padding:3px; text-indent:3px">
      <td align="right" width="124">
       <xsl:apply-templates select="GolfCar"/>
      </td>
     <td align="right" width="124">
     <xsl:apply-templates select="CocktailLounge"/>
```

```
      <br/>
    </td>
  </tr>
  </table>
  </div>
  </xsl:template>
  <xsl:template match="DrivingRange">
  <xsl:text>Driving Range: </xsl:text>
    <xsl:choose>
     <xsl:when test="text()='Yes'">
      <td align="left">
       <img>
         <xsl:attribute name="src"> golfBallicon.gif
      </xsl:attribute>
   </img>
       </td>
  </xsl:when>
  <xsl:otherwise>
    <td>
      <xsl:value-of select="."/>
    </td>
  </xsl:otherwise>
  </xsl:choose>
  </xsl:template>
  <xsl:template match="PuttingGreen">
   <xsl:text>Putting Green: </xsl:text>
    <xsl:choose>
     <xsl:when test="text()='Yes'">
      <td align="left">
       <img>
        <xsl:attribute name="src"> golfBallicon.gif
    </xsl:attribute>
        </img>
        </td>
     </xsl:when>
    <xsl:otherwise>
      <td>
        <xsl:value-of select="."/>
      </td>
    </xsl:otherwise>
</xsl:choose>
  </xsl:template>
  <xsl:template match="ChippingRange">
    <xsl:text>Chipping Range: </xsl:text>
     <xsl:choose>
      <xsl:when test="text()='Yes' ">
       <td align="left">
        <img>
```

```
       <xsl:attribute name="src"> golfBallicon.gif
    </xsl:attribute>
        </img>
      </td>
      </xsl:when>
      <xsl:otherwise>
      <td>
        <xsl:value-of select="."/>
      </td>
      </xsl:otherwise>
    </xsl:choose>
</xsl:template>
<xsl:template match="ChippingGreen">
  <xsl:text>Chipping Green: </xsl:text>
    <xsl:choose>
     <xsl:when test="text()='Yes'">
      <td align="left">
        <img>
        <xsl:attribute name="src"> golfBallicon.gif
          </xsl:attribute>
        </img>
      </td>
      </xsl:when>
      <xsl:otherwise>
        <td>
          <xsl:value-of select="."/>
        </td>
      </xsl:otherwise>
    </xsl:choose>
</xsl:template>
 <xsl:template match="Reservations">
   <xsl:text>Reservations: </xsl:text>
     <xsl:choose>
        <xsl:when test="text()='Yes'">
         <td align="left">
           <img>
         <xsl:attribute name="src"> golfBallicon.gif
             </xsl:attribute>
     </img>
        </td>
        </xsl:when>
  <xsl:otherwise>
       <td>
       <xsl:value-of select="."/>
        </td>
   </xsl:otherwise>
  </xsl:choose>
</xsl:template>
```

```
      <xsl:template match="SnackBar">
    <xsl:text>Snack Bar: </xsl:text>
     <xsl:choose>
       <xsl:when test="text()='Yes'">
        <td align="left">
          <img>
        <xsl:attribute name="src"> golfBallicon.gif </xsl:attribute>
          </img>
         </td>
        </xsl:when>
    <xsl:otherwise>
    <td>
     <xsl:value-of select="."/>
    </td>
    </xsl:otherwise>
    </xsl:choose>
    </xsl:template>
    <xsl:template match="CreditCards">
       <xsl:text>Credit Cards: </xsl:text>
         <xsl:choose>
           <xsl:when test="text()='Yes'">
              <td align="left">
             <img>
             <xsl:attribute name="src"> golfBallicon.gif
             </xsl:attribute>
                </img>
           </td>
         </xsl:when>
         <xsl:otherwise>
           <td>
          <xsl:value-of select="."/>
           </td>
         </xsl:otherwise>
       </xsl:choose>
    </xsl:template>
    <xsl:template match="BanquetFacilities">
       <xsl:text>Banquet Facilities: </xsl:text>
       <xsl:choose>
           <xsl:when test="text()='Yes'">
              <td align="left">
                  <img>
                      <xsl:attribute name="src"> golfBallicon.gif
                      </xsl:attribute>
                  </img>
              </td>
           </xsl:when>
       <xsl:otherwise>
           <td>
```

```xml
                        <xsl:value-of select="."/>
                </td>
            </xsl:otherwise>
        </xsl:choose>
</xsl:template>
<xsl:template match="GolfPro">
    <xsl:text>Golf Pro: </xsl:text>
    <xsl:choose>
        <xsl:when test="text()='Yes'">
            <td align="left">
                <img>
                    <xsl:attribute name="src"> golfBallicon.gif
                    </xsl:attribute>
                </img>
            </td>
        </xsl:when>
        <xsl:otherwise>
            <td>
                <xsl:value-of select="."/>
            </td>
        </xsl:otherwise>
    </xsl:choose>
</xsl:template>
<xsl:template match="ProShop">
    <xsl:text>Pro Shop: </xsl:text>
    <xsl:choose>
        <xsl:when test="text()='Yes'">
            <td align="left">
                <img>
                    <xsl:attribute name="src"> golfBallicon.gif
                    </xsl:attribute>
                </img>
            </td>
        </xsl:when>
        <xsl:otherwise>
            <td>
                <xsl:value-of select="."/>
            </td>
        </xsl:otherwise>
    </xsl:choose>
</xsl:template>
<xsl:template match="Lessons">
    <xsl:text>Lessons: </xsl:text>
    <xsl:choose>
        <xsl:when test="text()='Yes'">
            <td align="left">
                <img>
                    <xsl:attribute name="src"> golfBallicon.gif
```

```
                                    </xsl:attribute>
                          </img>
                    </td>
              </xsl:when>
              <xsl:otherwise>
                    <td>
                          <xsl:value-of select="."/>
                    td>
              </xsl:otherwise>
          </xsl:choose>
    </xsl:template>
    <xsl:template match="PullCarts">
          <xsl:text>Pull Carts: </xsl:text>
          <xsl:choose>
              <xsl:when test="text()='Yes'">
                    <td align="left">
                          <img>
                                <xsl:attribute name="src"> golfBallicon.gif
                                </xsl:attribute>
                          </img>
                    </td>
              </xsl:when>
              <xsl:otherwise>
                    <td>
                          xsl:value-of select="."/>
                    </td>
              </xsl:otherwise>
          </xsl:choose>
    </xsl:template>
    <xsl:template match="Clubs">
          <xsl:text>Clubs: </xsl:text>
          <xsl:choose>
              <xsl:when test="text()='Yes'">
                    <td align="left">
                          <img>
                                xsl:attribute name="src"> golfBallicon.gif
                                </xsl:attribute>
                          </img>
                    </td>
              </xsl:when>
              <xsl:otherwise>
                    <td>
                          <xsl:value-of select="."/>
                    </td>
              </xsl:otherwise>
          </xsl:choose>
    </xsl:template>
    <xsl:template match="GolfCar">
```

```
<xsl:text>Golf Car: </xsl:text>
<xsl:choose>
    <xsl:when test="text()='Yes'">
        <td align="left">
            <img>
                <xsl:attribute name="src"> golfBallicon.gif
                </xsl:attribute>
            </img>
        </td>
    </xsl:when>
    <xsl:otherwise>
        <td>
            <xsl:value-of select="."/>
        </td>
    </xsl:otherwise>
</xsl:choose>
</xsl:template>
<xsl:template match="CocktailLounge">
    <xsl:text>Cocktail Lounge: </xsl:text>
    <xsl:choose>
        <xsl:when test="text()='Yes'">
            <td align="left">
                <img>
                    <xsl:attribute name="src"> golfBallicon.gif
                    </xsl:attribute>
        </img>
     </td>
    </xsl:when>
      <xsl:otherwise>
    <td>
      <xsl:value-of select="."/>
       </td>
      </xsl:otherwise>
</xsl:choose>
  <tr>
    <th colspan="4">
   <xsl:text disable-output-escaping="yes"> </xsl:text>
  </th>
 </tr>
</xsl:template>
```

32. Save the stylesheet and preview the XML file in Internet Explorer. See the result in Figure 4.15.

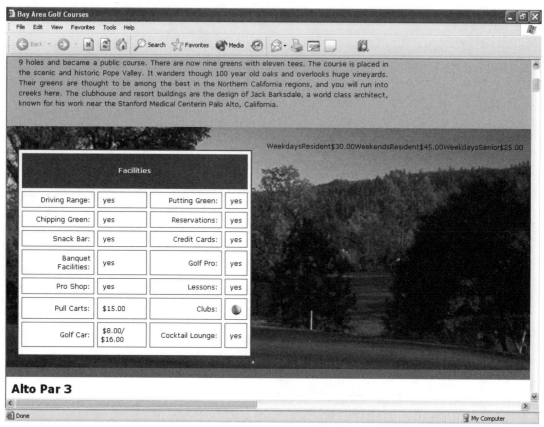

FIGURE 4.15 The XML file displayed in Internet Explorer with the Facilities template complete. Screen shot reprinted with permission from Microsoft Corporation.

33. Write the template for the `GreenFees` element and its children.

```
<!-- Template for Green Fees Table -->
<xsl:template match="GreenFees">
    <br/>
    <table align="center" bgcolor="white" border="2"
    bordercolor="darkgreen" cellpadding="6" cellspacing="6"
    width="280" height="100%">
        <tr bgcolor="darkgreen">
            <td align="center" valign="middle">
                <b>
                    <br/>
                    <font color="white">Green Fees</font>
                    <p></p>
                </b>
            </td>
```

```
            </tr>
        tr>
            <td align="center">
                    <br/>
                    <xsl:apply-templates select="Fees"/>
                </td>
            </tr>
        </table>
</xsl:template>
<!-- Template for Fees Element in Green Fees Table -->
<xsl:template match="Fees">
    <xsl:apply-templates select="Conditions"/>
</xsl:template>

<!-- Template for Conditions Element in Green Fees Table -->
<xsl:template match="Conditions">
    <xsl:apply-templates select="Condition"/>
    <xsl:apply-templates select="Discount"/>
    <xsl:apply-templates select="Fee"/>
    <br/>
</xsl:template>

<!-- Template for Condition Element in Green Fees Table -->
<xsl:template match="Condition">
    <xsl:value-of select="."/>
    <xsl:choose>
        <xsl:when test="position()=last()">
            <xsl:text> - </xsl:text>
        </xsl:when>
        <xsl:otherwise>
            <xsl:text>, </xsl:text>
            </xsl:otherwise>
    </xsl:choose>
</xsl:template>

<!-- Template for Discount Element in Green Fees Table -->
<xsl:template match="Discount">
    <xsl:text> </xsl:text>
    <xsl:value-of select="."/>
    <xsl:choose>
        <xsl:when test="position()=last()">
            <xsl:text> - </xsl:text>
        </xsl:when>
        <xsl:otherwise>
            <xsl:text>, </xsl:text>
        </xsl:otherwise>
    </xsl:choose>
</xsl:template>
```

```
<!-- Template for Fee Element in Green Fees Table -->
<xsl:template match="Fee">
    <b>
        <xsl:value-of select="."/>
    </b>
    <br/>
</xsl:template>
```

Save the file and preview in Internet Explorer as shown in Figure 4.16.

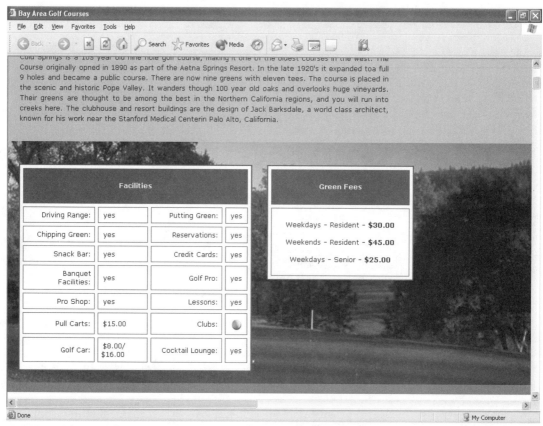

FIGURE 4.16 The XML file displayed in Internet Explorer with the GreenFees template complete. Screen shot reprinted with permission from Microsoft Corporation.

34. Write the template for the CardInfo element and its children.

```
<!-- Template for Golf Card Information Table -->
<xsl:template match="CardInfo">
  <xsl:choose>
```

```xml
<xsl:when test="count(Hole) &lt; 10">
  <div style="margin-left:18px">
   <table bgcolor="white" border="3" bordercolor="darkgreen"
   cellspacing="2">
    <tr bgcolor="darkgreen">
     <th>
      <font color="white">Hole</font>
     </th>
     <th>
      <font color="white">Par</font>
     </th>
    <th bgcolor="blue">
      <font color="white">Blue</font>
   </th>
   <th bgcolor="white">
    <font color="black">White</font>
   </th>
   <th bgcolor="red">
    <font color="white">Red</font>
   </th>
   <th>
    <font color="white">Mens<br/>HCP</font>
   </th>
   <th>
    <font color="white">Ladies<br/>HCP</font>
   </th>
  </tr>
  <xsl:for-each select="Hole">
  <tr bgcolor="lightgreen">
   <td align="center" bgcolor="darkgreen">
    <font color="white">
     <xsl:value-of select="@Number"/>
    </font>
   </td>
   <td align="center">
    <xsl:choose>
     <xsl:when test="string-length(Par) &lt; 1">
      <xsl:text disable-output-
      escaping="yes"><![CDATA[ ]]></xsl:text>
     </xsl:when>
     <xsl:otherwise>
      <xsl:value-of select="Par"/>
     </xsl:otherwise>
    </xsl:choose>
   </td>
   <td align="center" bgcolor="blue">
    <font color="white">
     <xsl:choose>
      <xsl:when test="string-length(Blue) &lt; 1">
```

```
       <xsl:text disable-output-
       escaping="yes"><![CDATA[ ]]></xsl:text>
       </xsl:when>
      <xsl:otherwise>
       <xsl:value-of select="Blue"/>
      </xsl:otherwise>
     </xsl:choose>
     </font>
    </td>
    <td align="center">
    <xsl:choose>
    <xsl:when test="string-length(White) &lt; 1">
     <xsl:text disable-output-
     escaping="yes"><![CDATA[ ]]></xsl:text>
     </xsl:when>
      <xsl:otherwise>
       <xsl:value-of select="White"/>
      </xsl:otherwise>
     </xsl:choose>
    </td>
   <td align="center" bgcolor="red">
    <font color="white">
     <xsl:choose>
      <xsl:when test="string-length(Red) &lt; 1">
       <xsl:text disable-output-
       escaping="yes"><![CDATA[ ]]></xsl:text>
      </xsl:when>
     <xsl:otherwise>
      <xsl:value-of select="Red"/>
     </xsl:otherwise>
     </xsl:choose>
     </font>
    </td>
    <td align="center">
    <xsl:choose>
     <xsl:when test="string-length(MensHcp) &lt; 1">
      <xsl:text disable-output-
      escaping="yes"><![CDATA[ ]]></xsl:text>
     </xsl:when>
    <xsl:otherwise>
      <xsl:value-of select="MensHcp"/>
     </xsl:otherwise>
    </xsl:choose>
   </td>
   <td align="center">
   <xsl:choose>
   <xsl:when test="string-length(LadiesHcp) &lt; 1">
    <xsl:text disable-output-
    escaping="yes"><![CDATA[ ]]></xsl:text>
```

```
      </xsl:when>
    <xsl:otherwise>
    <xsl:value-of select="LadiesHcp"/>
    </xsl:otherwise>
    </xsl:choose>
     </td>
     </tr>
   </xsl:for-each>
  </table>
 </div>
</xsl:when>
<xsl:when test="count(Hole) = 18">
 <div style="margin-left:18px">
   <table border="0">
    <tr>
    <td>
     <table bgcolor="white" border="1" bordercolor="darkgreen"
     cellspacing="2">
      <tr bgcolor="darkgreen">
       <th>
        <font color="white">Hole</font>
      </th>
      <th>
        <font color="white">Par</font>
      </th>
      <th bgcolor="blue">
        <font color="white">Blue</font>
      </th>
      <th bgcolor="white">
        <font color="black">White</font>
      </th>
      <th bgcolor="red">
        <font color="white">Red</font>
      </th>
      <th>
        <font color="white">Mens<br/>HCP</font>
      </th>
         <th>
        <font color="white">Ladies<br/>HCP</font>
      </th>
     </tr>
      <xsl:for-each select="Hole">
      <xsl:if test="position() &lt; 10">
     <tr bgcolor="lightgreen">
      <td align="center" bgcolor="darkgreen">
       <font color="white">
        <xsl:value-of select="@Number"/>
       </font>
      </td>
```

```
<td align="center">
 <xsl:choose>
  <xsl:when test="string-length(Par) &lt; 1">
   <xsl:text disable-output-
   escaping="yes"><![CDATA[ ]]></xsl:text>
  </xsl:when>
  <xsl:otherwise>
   <xsl:value-of select="Par"/>
  </xsl:otherwise>
 </xsl:choose>
</td>
<td align="center" bgcolor="blue">
 <xsl:choose>
  <xsl:when test="string-length(Blue) &lt; 1">
   <xsl:text disable-output-
   escaping="yes"><![CDATA[ ]]></xsl:text>
  </xsl:when>
  <xsl:otherwise>
   <font color="white">
   <xsl:value-of select="Blue"/>
   </font>
  </xsl:otherwise>
 </xsl:choose>
</td>
<td align="center" bgcolor="white">
  <xsl:choose>
  <xsl:when test="string-length(White) &lt; 1">
  <xsl:text disable-output-
  escaping="yes"><![CDATA[ ]]></xsl:text>
  </xsl:when>
 <xsl:otherwise>
   <font color="black">
   <xsl:value-of select="White"/>
   </font>
 </xsl:otherwise>
 </xsl:choose>
</td>
<td align="center" bgcolor="red">
<xsl:choose>
<xsl:when test="string-length(Red) &lt; 1">
<xsl:text disable-output-
escaping="yes"><![CDATA[ ]]></xsl:text>
</xsl:when>
<xsl:otherwise>
<font color="white">
<xsl:value-of select="Red"/>
</font>
</xsl:otherwise>
</xsl:choose>
```

```
</td>
<td align="center">
<xsl:choose>
<xsl:when test="string-length(MensHcp) &lt; 1">
<xsl:text disable-output-
escaping="yes"><![CDATA[ ]]></xsl:text>
</xsl:when>
<xsl:otherwise>
<xsl:value-of select="MensHcp"/>
</xsl:otherwise>
</xsl:choose>
</td>
<td align="center">
<xsl:choose>
<xsl:when test="string-length(LadiesHcp) &lt; 1">
<xsl:text disable-output-
escaping="yes"><![CDATA[ ]]></xsl:text>
</xsl:when>
<xsl:otherwise>
<xsl:value-of select="LadiesHcp"/>
</xsl:otherwise>
</xsl:choose>
</td>
</tr>
</xsl:if>
</xsl:for-each>
</table>
<td>
<table bgcolor="white" border="1" bordercolor="darkgreen"
cellspacing="2">
<tr bgcolor="darkgreen">
<th>
<font color="white">Hole</font>
</th>
<th>
<font color="white">Par</font>
</th>
<th bgcolor="blue">
<font color="white">Blue</font>
</th>
<th bgcolor="white">
<font color="black">White</font>
</th>
<th bgcolor="red">
<font color="white">Red</font>
</th>
<th>
<font color="white">Mens<br/>HCP</font>
</th>
```

```
<th>
<font color="white">Ladies<br/>HCP</font>
</th>
</tr>
<xsl:for-each select="Hole">
<xsl:if test="position() > 9">
<tr bgcolor="lightgreen">
<td align="center" bgcolor="darkgreen">
<font color="white">
<xsl:value-of select="@Number"/>
</font>
</td>
<td align="center">
<xsl:choose>
<xsl:when test="string-length(Par) &lt; 1">
<xsl:text disable-output-
escaping="yes"><![CDATA[ ]]></xsl:text>
</xsl:when>
<xsl:otherwise>
<xsl:value-of select="Par"/>
</xsl:otherwise>
</xsl:choose>
</td>
<td align="center" bgcolor="blue">
<xsl:choose>
<xsl:when test="string-length(Blue) &lt; 1">
<xsl:text disable-output-
escaping="yes"><![CDATA[ ]]></xsl:text>
</xsl:when>
<xsl:otherwise>
<font color="white">
<xsl:value-of select="Blue"/>
</font>
</xsl:otherwise>
</xsl:choose>
</td>
<td align="center" bgcolor="white">
<xsl:choose>
<xsl:when test="string-length(White) &lt; 1">
<xsl:text disable-output-
escaping="yes"><![CDATA[ ]]></xsl:text>
</xsl:when>
<xsl:otherwise>
<font color="black">
<xsl:value-of select="White"/>
</font>
</xsl:otherwise>
</xsl:choose>
</td>
```

```
<td align="center" bgcolor="red">
<xsl:choose>
<xsl:when test="string-length(Red) &lt; 1">
<xsl:text disable-output-
escaping="yes"><![CDATA[ ]]></xsl:text>
</xsl:when>
<xsl:otherwise>
<font color="white">
<xsl:value-of select="Red"/>
</font>
</xsl:otherwise>
</xsl:choose>
</td>
<td align="center">
<xsl:choose>
<xsl:when test="string-length(MensHcp) &lt; 1">
<xsl:text disable-output-
escaping="yes"><![CDATA[ ]]></xsl:text>
</xsl:when>
<xsl:otherwise>
<xsl:value-of select="MensHcp"/>
</xsl:otherwise>
</xsl:choose>
</td>
<td align="center">
<xsl:choose>
<xsl:when test="string-length(LadiesHcp) &lt; 1">
<xsl:text disable-output-
escaping="yes"><![CDATA[ ]]></xsl:text>
</xsl:when>
<xsl:otherwise>
<xsl:value-of select="LadiesHcp"/>
</xsl:otherwise>
</xsl:choose>
</td>
</tr>
</xsl:if>
</xsl:for-each>
</table>
</td>
</td>
</tr>
</table>
</div>
</xsl:when>
</xsl:choose>
</xsl:template>
```

You should now be at the closing stylesheet tag, `</xsl:style sheet>`. This tag closes the root element `<xsl:stylesheet>`, and the stylesheet is complete.

37. Save the file and preview it in Internet Explorer as shown in Figure 4.17.

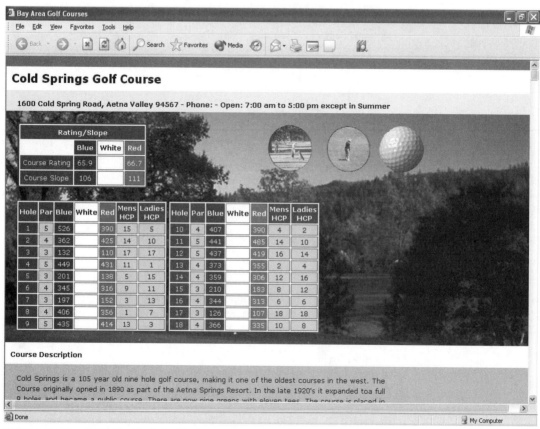

FIGURE 4.17 The XML file displayed in Internet Explorer with the template complete. Screen shot reprinted with permission from Microsoft Corporation.

Your template is now complete. Although the file works well, it is not ideal for maintaining a large number of golf course files. Another technique that you can employ here is a more efficient method for using a stylesheet with a large number of XML files. To see how this technique works, you will open a file called *Multiple.xml* in Dreamweaver MX 2004.

1. Open the file called *Multiple.xml* in Dreamweaver MX 2004.

Let's take a closer look at the files code:

```
<?xml version="1.0" encoding="UTF-8"?>
<?xml-stylesheet type="text/xsl"
href="Ch_4_Multiple_Golf_XSLT_Final.xsl"?>
<Golf_Course_Files>
<course filename="Altos Par 3.xml"/>
<course filename="Altos Seas Golf Course.xml"/>
<course filename="Atlantic Grove Golf Links.xml"/>
<course filename="Black Creek Golf Club.xml"/>
<course filename="Blueberry Farm Golf Course.xml"/>
<course filename="City of San Rivera Golf Course.xml"/>
<course filename="Full Moon Bay Golf Links.xml"/>
<course filename="Las Limas Golf Course.xml"/>
<course filename="Del Skye Golf Course.xml"/>
<course filename="Lookout Point Golf Club.xml"/>
<course filename="San Pilgrim Golf Course.xml"/>
<course filename="Middleton Municipal Golf Course.xml"/>
<course filename="Tony Rivera Golf Course.xml"/>
<course filename="Yanez Park Golf Course.xml"/>
<course filename="Diamond Ridge Par 3 Golf Course.xml"/>
<course filename="Open Valley Lake Golf Club.xml"/>
<course filename="Sutherland Greens Golf Course.xml"/>
<course filename="Hilroy Golf Course.xml"/>
<course filename="Noel Springs Golf Course.xml"/>
<course filename="Sycamore Golf Course.xml"/>
<course filename="Altos Par 3.xml"/>
<course filename="Altos Seas Golf Course.xml"/>
<course filename="Blueberry Farm Golf Course.xml"/>
<course filename="Black Creek Golf Club.xml"/>
<course filename="Cabernet Golf Club.xml"/>
<course filename="The Links at Latin Bay.xml"/>
<course filename="Tony Rivera Golf Course.xml"/>
</Golf_Course_Files>
```

All of the XML files listed in this file are processed with the stylesheet accessed in line 2. After the root element `<Golf_Course_Files>`, the remaining `<course>` elements are merely a list of XML files indicated by the value of the attribute `filename`.

The stylesheet referenced in line 2 is 99 percent similar to the stylesheet you just created. It has been modified to a small degree so that it processes all of the XML files listed in *Multiple.xml*. Let's see how the code in this file has been altered to process this XML file.

2. Open the file called *Ch_4_Multiple_Golf_XSLT_Final.xsl* in Dreamweaver MX 2004.

See if you can locate the difference between this file and the stylesheet you just created. The difference lies in the structure of your first `<template>`. This code follows:

```
<xsl:template match="/">
  <HTML>
    <HEAD>
      <TITLE>Bay Area Golf Courses</TITLE>
        <STYLE TYPE="text/css">
          * {font-family:verdana, arial, helvetica, sans-serif;
          font-size:10pt;}
          H1 {font-family:verdana, arial, helvetica, sans-serif;
          font-size:24pt;margin-left:18px;}
          .courseStyle {font-family:verdana, arial, helvetica,
          sans-serif; font-weight:bold;font-size:16pt;padding-
          left:18px;line-height:18pt; background: white; padding-
          bottom:10px;}
          body {background-image: url(GolfBG1.jpg); background-
          attachment:fixed;
          background-repeat:no-repeat;bgcolor:lightgreen;}
        </STYLE>
    </HEAD>
    <BODY bgcolor="cccccc" leftmargin="0" marginheight="0"
    marginwidth="0" topmargin="0">
      <xsl:for-each select="Golf_Course_Files/course">
        <xsl:apply-templates
        select="document(@filename)/County"/>
      </xsl:for-each>
    </BODY>
  </HTML>
</xsl:template>
```

This template's `match` attribute's value is `"/"`, thus it looks for the root element of your XML file. Following the match, it then begins to transform the file into an `<HTML>` tag followed by a `<HEAD>` tag, followed by a `<TITLE>` tag with the content `"Bay Area Golf Courses"`. Next is an HTML `<STYLE>` tag, which contains the style rules for all the element in the HTML file, indicated by the * (asterisk) followed by style rules for the tag, a custom class called `.courseStyle` and the `<body>` tag. The `<HEAD>` tag is then closed and the `<body>` tag of the HTML file opens with attributes that provide a background color and a 0-pixel margin.

At this point the stylesheet is different from the stylesheet you just created. If you look again at *Multiple.xml*, it should be clear that to provide your style information to the XML files listed you must loop through all of its `<course>` elements. Thus, you use an `<xsl:for –each>` element with a `select` attribute equal to those `<course>` elements. This is accomplished with the XPath expression, `Golf_Course_Files/course`. At this point, of course, you want to apply your template. The template you apply here is identical to the one you just created. The `<apply-templates>` element, however, is different. The `<apply-templates>` select attribute is

set to the XSL `document()` function. The purpose of the `document()` function is to allow you to process multiple source documents in a single stylesheet. The file *Multiple.xml* serves as a master document that references all of the golf course XML files that you want to process with the stylesheet. The `document()` function accepts an XPath expression that describes the elements that you want to process. In the example those elements or set of nodes are those that match the attribute `filename`, as indicated by the XPath expression: `(@filename`. This node-set is converted to a string by the `document()` function, which then uses that string as a Uniform Resource Identifier (URI). In the example, `"/County"` is appended to the URI so that it now points to the root node of that XML file. This positions you in the stylesheet at the point where you began, and your stylesheet is identical to the previous stylesheet created and, thus, transforms the file in the same way.

To see the results of this XML file and stylesheet continue to step 3.

3. Open the file Multiple.xml in Internet Explorer to see the results.

XSL-T stylesheets go far beyond the capabilities of CSS stylesheets. The concept of a CSS stylesheet is to provide rendering information for the XML tags, whereas the concept behind XSL-T is to examine the XML tags and transform them into something else, according to predefined templates. In this tutorial you transformed the original Golf XML file into HTML using the XML language known as the XML Stylesheet Language Transformation or XSL-T. This file introduced you to some of the basic concepts behind XSL-T, such as templates and the companion language, XPath. In addition, you learned how XSL-T can be used somewhat programmatically due to its built-in recursion features and loops, as well as conditional statements and functions.

ADDITIONAL RESOURCES

W3C XSL-T specification: *www.w3.org/TR/xslt*
W3C XSL Family home page: *www.w3.org/Style/XSL/*
XSL tutorial: *www.w3schools.com*

TUTORIAL THREE: HOW TO CONFIGURE DREAMWEAVER MX 2004 AS AN XML EDITOR

OBJECTIVES

- To understand the basic techniques used to customize the Dreamweaver MX 2004 user interface
- To use these techniques to configure Dreamweaver MX 2004 as an XML editor

BEFORE YOU BEGIN

What You Will Need for This Tutorial

- Dreamweaver MX 2004
- A Web browser
- A word processor
 - Macintosh: Text Editor, TeachText, SimpleText
 - Windows PC: Notepad, WordPad

IMPORTANT SETUP INSTRUCTIONS FOR THIS TUTORIAL

When configuring the Dreamweaver MX 2004 user interface, you will be altering the application's basic configuration files. It is important to back up these files. A typo or syntax error in any of these configuration files could cause Dreamweaver MX 2004 to crash on startup. By backing up the files, you can always restore the Dreamweaver MX 2004 environment to its original state. Use the following steps to back up the configuration files:

1. Locate the directory that contains the Dreamweaver MX 2004 application on your computer's hard drive (for example, *C:\Program Files\Macromedia\Dreamweaver MX 2004*).
2. The directory you need to back up is called *Configuration*. Copy this directory and rename it *Configuration Backup*.
3. Paste the directory in a safe place outside of the Dreamweaver MX 2004 directory. The *Configuration* folder is shown in Figure 4.18

The Data Files

- **Tutorial Three Directory:** *Data Files/Part_2/Chapter 4/Ch_4_Configuring DW as an XML Editor_3*
- **Student Files:** *Golf XML Tags.xsd*

FIGURE 4.18 The *Configuration* folder and its contents.

- **Finished Files Directory:** *Ch_4_3 Finished*
- **Finished Files Subdirectory:** *Add to Toolbars Directory*
- **Finished Files:**
 Golf.xml
 NewGolf.gif
- **Finished Files Subdirectory:** *Add to Menus Directory*
- **Finished Files:**
 Golf.xml
 menus.xml
- **Finished Files Subdirectory:** *Add to Objects Directory*
- **Finished Files:** *insertbar.xml*
- **Subdirectory:** *XML*
- **Finished Files:**
 CData.htm

cdata.js
CData.png
xml_stylesheet.gif
xml_stylesheet.htm
xml_stylesheet.js

Defining the Site for Chapter 4 Tutorial Three

From the CD-ROM you will use the following root directory when defining your site for Chapter 4 Tutorial Three: *Chapter 4/Chapter 4 Configuring DW as an XML Editor.*

INTRODUCTION: THE DREAMWEAVER MX 2004 INTERFACE

The Dreamweaver MX 2004 application is highly configurable. Programmers who are comfortable with a programming language like C+ can create Dreamweaver MX Extensions that add considerable functionality to the program. You do not, however, need to be a programmer to customize the Dreamweaver MX 2004 environment and add functionality. The basic skills required are knowledge of Dreamweaver MX 2004, HTML, XML, and JavaScript.

CONCEPT: HOW CAN DREAMWEAVER MX 2004 BE CUSTOMIZED?

Dreamweaver MX 2004 can be customized in a variety of ways, from setting an extensive array of preferences to writing complex programs, called Extensions, that add new functionality to the software. Some of the ways you can customize Dreamweaver MX 2004 include:

- Changing and creating keyboard shortcuts
- Changing the name of menu items
- Adding new menu items
- Creating your own commands in the Commands menu
- Creating your own floating panels
- Creating custom property inspectors
- Creating new behaviors
- Adding third-party Extensions

This tutorial focuses on configuring Dreamweaver MX 2004 as an XML editor. If you want to use Dreamweaver MX 2004 to write XML files, one of the first steps you can take is to make XML the default doc-

ument type. Currently, Dreamweaver MX 2004 launches by opening a blank HTML file. In this chapter's tutorials, you will change it to open a blank XML file instead. You can optimize Dreamweaver MX 2004 as an authoring tool for a unique XML environment as well. For example, you will create a new document type known as a Golf XML file. You will then make this new Golf document accessible from the File → New command, as well as from a button on the Standard toolbar. You can also add your unique Golf tags to a Dreamweaver MX 2004 Tag Library, thus allowing code hints to prompt you as you write Golf XML files. You will also add some new dialog boxes activated by custom objects you create for the Insert menu. These dialog boxes add functionality to Dreamweaver MX 2004 that allows you to attach a stylesheet to the XML file. The following tutorials serve as an introduction to customizing the Dreamweaver MX 2004 interface. When you are done you will understand the underlying code behind the Dreamweaver MX 2004 interface. Feel free to continue on your own to create dialog boxes, main menu items, and even custom property inspectors. You'll begin by setting the default document type.

SETTING THE DEFAULT DOCUMENT TYPE

1. Launch Dreamweaver MX 2004.
2. Click Edit → Preferences.
3. Select the New Document category, and set the Default Document Type drop-down list to XML. Uncheck Show New Document dialog box on Control + N, and click OK. To see the result of this preference setting, complete step 4.
4. Use the keyboard shortcut Control + N to create a new XML document by default.

ADDING A NEW DOCUMENT TYPE TO THE NEW DOCUMENT DIALOG BOX

When you create a new file through the File → New dialog box, Dreamweaver MX 2004 lists its document types according to category. Under the Basic Page category Dreamweaver MX 2004 presents the following choices for creating a new document: HTML, HTML Template, Library Item, CSS, JavaScript, and XML. These document types are stored in a directory called *Document Types* in the *Configuration* folder. Dreamweaver MX 2004 stores many of its user interface configurations, including the structure of its menu bars, dialog boxes, objects, panels, and property inspectors, in XML files. By editing these files you can alter the user interface. The document types that Dreamweaver MX 2004 supports

are described in the XML file called *MMDocumentTypes.xml*, located in the *DocumentTypes* directory in the *Configuration* folder. For Dreamweaver MX 2004 to support a new document type, you must edit this file, which points to an example of the document type, which you also create and store in the *NewDocuments* folder located in the same directory in the *Configuration* folder. Begin by editing the *MMDocumentTypes.xml* file.

Not all files from the Configurations *folder can be opened in Dreamweaver MX 2004. Sometimes it is best to open the file from a text editor such as Notepad. This is because Dreamweaver MX 2004 sometimes adds or deletes text from the file automatically, causing errors that may prevent Dreamweaver MX 2004 from launching successfully.*

Make sure you have backed up the Configuration *folder as explained at the beginning of this tutorial before you begin.*

1. Launch Dreamweaver MX 2004, and open the file *MMDocument-Types.xml* from the *DocumentTypes* directory in the *Configuration* folder.

 If you have completed the tutorials from Chapter 2, you now have an understanding of XML document structure. After reviewing *MMDocumentTypes.xml*, you should be able to see that it is describing the types of documents Dreamweaver MX 2004 can create. If you look further, you will see the XML file describing the properties of these documents, such as their file extensions and how Dreamweaver MX 2004 color-codes them when they are displayed in the Dreamweaver Design View.
 Note the `<documenttype>` elements in the file. Each `<documenttype>` element contains information about a document type. For each document type, essential information such as server model, color coding style, descriptions, and file extensions is described.

2. Scroll to the bottom of the document. Place your cursor above the closing tag for the root element `</documenttypes>`. Add the following new document type element:

```
<documenttype id="Golf_XML" internaltype="XML"
winfileextension="golf.xml" macfileextension="golf.xml"
file="Golf.xml">
    <TITLE>Golf XML
        <MMString:loadString id="mmdocumenttypes_64"/>
    </TITLE>
    <description>XML File Format for Creating Golf Course Data
    Files
```

```
        <MMString:loadString id="mmdocumenttypes_65"/>
    </description>
</documenttype>
```

The `<documenttype>` element contains the new document type you are defining. The `<documenttype>` attributes have the following purposes:

`id`—An identifier for this document type. All document types must have a unique id.

`internaltype`—The internal file type that Dreamweaver MX 2004 references when using this document type. What this means is that when you create a new Golf XML file, Dreamweaver MX 2004 knows that it should structure the file as an XML file, as opposed to another file type such as HTML.

`winfileextension`—The Windows platform file extension to be used with this file type. For the Golf XML files the extension is .xml.

`macfileextension`—The Macintosh platform file extension to be used with this file type.

`file`—The reference to the actual file that represents the default file type for this document type. You will create this default file and place it in the *DocumentTypes* directory next. Dreamweaver MX 2004 opens this file when you create a new Golf XML file.

The `<TITLE>` tag contains the title of the new document type as it will appear in the New Document dialog box in Dreamweaver MX 2004.

`<MMString:loadString id="mmdocumenttypes_64"/>` represents a string identifier used by Dreamweaver MX 2004 that must be unique; thus, you used `"mmdocumenttypes_64"`, the next number available in the file *MM-DocumentTypes.xml*, as follows:

```
<description>XML File Format for Creating Golf Course Data Files
    <MMString:loadString id="mmdocumenttypes_65"/>
</description>
```

The `<description>` tag is used to hold a description of the new file type and its unique identifier.

3. Save and close this file.

Now you must write the default file for the Golf XML document type that the *MMDocumentTypes.xml* file now references.

4. Click File → New in Dreamweaver MX 2004.
5. Write the following blank Golf XML file. You can also open the finished file from the Chapter 4 finished files folder called *Ch_4_Finished_Default_Golf.xml*.

6. Save the file as *Golf.xml* in the *NewDocuments* directory in the *DocumentTypes* directory in the *Configuration* folder.
7. Close the file and restart Dreamweaver MX 2004.
8. Click File → New from main menu bar. Select the Other category on the left side of the dialog box. Note the first option in the Basic Page category on the right, as shown in Figure 4.19.

FIGURE 4.19 The New File dialog box showing the new document type, Golf XML.

You can now choose Golf XML files in the New Document dialog box. The result is a blank Golf XML file ready for editing.

As you have learned in Chapter 3, most XML files contain a unique structure that conforms to a more basic structure as defined in a DTD or schema. Thus, this default XML file you have just created contains the shell of that structure. When you use this default file, you can add or delete new tags or attributes as you go. If Dreamweaver MX 2004 is made aware of this basic structure, as defined by a DTD or schema, it can suggest what tags to add at given points in the document. Dreamweaver MX 2004 calls this functionality code hints. Dreamweaver MX 2004 provides code hints as you write HTML in Code View. To see an example of code hints, launch Dreamweaver MX 2004 and open a blank HTML file. With your cursor in the body tag, type <. Notice how Dreamweaver MX 2004 displays a pop-up menu indicating a choice of HTML tags that can be placed at this location. Now type `img`. The pop-up menu selects the `` tag. Press the Enter key to select this tag. Press the space bar, and note how Dreamweaver MX 2004 now prompts you with attributes of the `` tag. These are

code hints. Close this file. Dreamweaver MX 2004 "knows" what tags to prompt for because the individual tags and their proper use are stored in Tag Libraries. You will add the Golf XML tags to the Dreamweaver MX 2004 Tag Library to allow code hints as you type Golf XML files.

ADDING A TAG LIBRARY

To add a Tag Library, you will direct Dreamweaver MX 2004 to the DTD or schema that defines the structure of the Golf XML files.

1. Launch Dreamweaver MX 2004.
2. Click Edit → Tag Libraries from the main menu bar.

 Note the existing Tag Libraries that Dreamweaver MX 2004 stores: HTML Tags, CFML Tags, ASP .NET tags, and others, as well for what file types each group of tags is used.

3. To add a new Tag Library, click + (plus sign) under the Tags section. Click DTDSchema → Import XML DTD or Schema File. The Tag Library Editor is displayed, as shown in Figure 4.20.

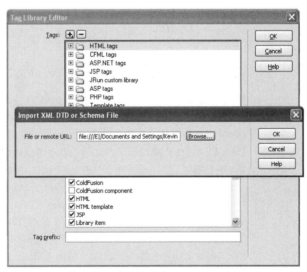

FIGURE 4.20 The Tag Library Editor.

4. Click Browse in the Import XML DTD or Schema dialog box and navigate to the *Chapter 4 Configuring Dreamweaver MX 2004* directory. Select the file, *Golf XML Tags.xsd*. This is the W3C Schema that defines your Golf XML file structure. The Tag Prefix text box is used to add a prefix, known as a Namespace, such as GOLF: to all tags you can

associate with a unique domain name. For example, `<GOLF:course-Name>` would associate the `<courseName>` tag with a URI to keep the tags unique should they be combined with another XML file with similar tag names. You will not associate your golf tags with a namespace, so leave this field blank.

5. Click OK.

The new Tag Library is now added to the others. As you click each tag name, you can see the tag's format displayed in the Preview section. Use the tag format section to change the way the tag is written in Dreamweaver MX 2004.

The XML Golf tags are now available as you develop Golf XML files in the following areas of Dreamweaver MX 2004:

- As code hints
- From the Tag Chooser, accessed by clicking Insert → Tag from the main menu bar
- From the Tag Inspector Panel, accessed by clicking Window → Tag Inspector

In addition to creating a new Golf XML file type that appears in the New Document dialog box, you can also add a button to the Dreamweaver MX 2004 standard toolbar for one-click access to new Golf files.

ADDING A CUSTOM BUTTON TO THE DREAMWEAVER MX 2004 INSERT TOOLBAR

You must have a document open to access the standard toolbar, so create a new blank document. To view the Dreamweaver MX 2004 standard toolbar, click View → Toolbars → Standard from the main menu bar. Like toolbars in many other applications, the Dreamweaver MX 2004 standard toolbar includes buttons to create new documents, open documents, and save documents. You will add an Add New Golf File button next to the Open button.

The Dreamweaver MX 2004 toolbar information is stored in *toolbars.xml* in the *Toolbars* directory in the *Configuration* folder. This file contains information about the various toolbars in Dreamweaver MX 2004 and the buttons they contain.

1. Launch Dreamweaver MX 2004 and open the file *toolbars.xml* from the *Toolbars* directory in the *Configuration* folder.
2. From the Edit menu, click Find and Replace. Select Source Code from the Search drop-down menu and type `<!-- Standard toolbar -->` in the Find field. Click Find Next. These actions take you to the standard toolbar portion of the *toolbars.xml* configuration file.

3. Close the Find and Replace dialog box. As a result of the search, the first button you see describes the toolbar Standard Toolbar with the first button DW_New.

```
<toolbar id="Standard_Toolbar" label="Standard"
initiallyVisible="false" backgroundStyle="gradient">

    <button id="DW_New"
        image="Toolbars/images/MM/new.gif"
        imageMac="dwres:6300"
        tooltip="New"
        domRequired="FALSE"
        command="dw.newDocument()"/>
```

You will add a new button definition directly below this code, causing the button to appear next to the Open button on the standard toolbar.

4. With your cursor below the above text and above the `<separator />` tag, add the following code:

```
<button id="DW_Golf_Open"
        image="Toolbars/images/MM/NewGolf.gif"
        tooltip="New Golf XML File"
        domRequired="TRUE"
        command="dw.openDocument('Golf.xml')"/>
```

The `<button>` element creates a new button on the toolbar. It contains the following attributes:

`id`—A unique identifier for the button.

`image`—An 18 x 18 pixel GIF image that will appear on the toolbar as the button. You must create an 18 × 18 GIF image for any new buttons you wish to add to the toolbar. The button you will use is in the *Chapter 4* directory and is called *NewGolf.gif*. (See step 5.)

`tooltip`—Creates a pop-up tool tip with the corresponding ALT text.

`command`—The JavaScript function that will be executed when the button is clicked. For more complex JavaScript, point to a JavaScript file (.js) that will reside in the *Configuration/Toolbars* directory. (See step 5.) Notice that this function, called `openDocument()`, accepts a parameter within the parentheses. This parameter is the name of the file that Dreamweaver MX 2004 will open and is another file that needs to be in the *Configuration/Toolbars* directory. (See step 5.)

Save and close this file.

You will now place all the required files in the *Configuration/Tool-bars* directory.

5. Open the *Ch_4_Configuration Files* directory in the *Chapter 4* folder. Open the *Add to Toolbars Directory* subdirectory. Copy the *Golf.xml* file into the *Macromedia\Dreamweaver MX\Configuration\Toolbars* directory. Copy the *NewGolf.gif* image into the *Macromedia\Dreamweaver MX 2004\Configuration\Toolbars\images\MM* directory.

6. Restart Dreamweaver MX 2004.

View the standard toolbar as shown in Figure 4.21. The second button from the left with the golf ball icon is the New Golf XML button.

You should now have a button that contains a picture of a golf ball. If you move your mouse over the button, you see the pop-up tool tip New Golf XML File. Clicking the button opens the default *Golf.xml* file.

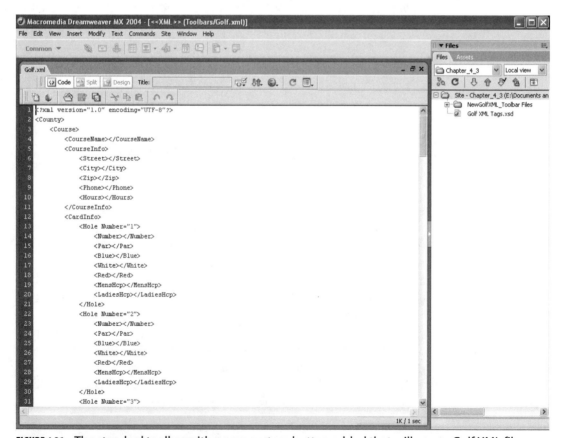

FIGURE 4.21 The standard toolbar with a new custom button added that will create Golf XML files.

In addition to adding buttons to toolbars, you can also add a new menu item. In the next section you will add a new menu item that serves the same purpose as the New Golf button on the standard toolbar.

ADDING A NEW MENU ITEM TO THE DREAMWEAVER MX 2004 FILE MENU

The Dreamweaver MX 2004 menu information is stored in *menus.xml* in the *Menus* subdirectory in the *Configuration* folder. This file contains information about the various menus throughout Dreamweaver MX 2004, including the main menu bar, the site window menu bar, and the various panels and pop-up menus.

1. Launch your word processor or text editor, such as Wordpad or Text Edit, and open the file *menus.xml* from the *Menus* subdirectory in the *Configuration* folder.
 Note the comments at the top of the file:

   ```
   <!-- This file contains all the menus for Dreamweaver. -->
   <!-- The main menu bar is located at the end of this file -->
   ```

 The hierarchy of this file follows:
 The file begins with the Dreamweaver MX 2004 shortcut keys:

   ```
   <shortcutlist id="DWMainWindow">
       <shortcut key="Cmd+Shift+Z"
       file="Menus/MM/Edit_Clipboard.htm"
       arguments="'redo'" id="DWShortcuts_Edit_Redo" />
   ```

 After the shortcut list you find the Dreamweaver MX 2004 menus. The `<menubar>` tag indicates the current menu. The `<menu>` tag is a child of `<menubar>`, and it creates a menu item. The `<menuitem>` tag is a child of the `<menu>` tag, and it creates a submenu.
 The menubar section begins with following code:

   ```
   <menubar name="" id="DWDefaultContext">
       <menu name="Default" id="DWContext_Default">
   ```

 The main menu bar is the one you will edit. Immediately after File → New, you will add File → New Golf XML.

2. Click Edit → Find and type *DWMenu_Apple* in the Find What text field.
3. Click Find Next to go to the first menu item in the Dreamweaver MX 2004 File menu. Scroll down until you see the following code:

```
<menu name="_File" id="DWMenu_File">
    <menuitem name="_New..."
            key="Cmd+N"
                domRequired="false"
                enabled="true"
                command="dw.newDocument()"
                id="DWMenu_File_New" />
```

4. Immediately following this code, type:

```
<menuitem name="New _Golf XML"
        domRequired="true"
        enabled="true"
        command="dw.openDocument('Golf.xml')"
        id="DWMenu_File_New_Golf" />
```

In your code, you are in menubar (as indicated by the `<menubar>` element) of the Dreamweaver MX 2004 main menu and the File menu (as indicated in the `<menu>` element. At this location of the main menubar, you are creating a submenu that will be called New Golf XML. Submenus are created with the `<menuitem>` tag , which contains the following attributes:

`domRequired`—Specifies that the menu command requires a valid document object model and synchronizes the Code and Design view before executing the command.

`enabled`—Specifies whether the menu item is enabled. It accepts the values `true` or `false`. You can also place a JavaScript command here that when executed returns a value of `true` or `false`.

`command`—Contains a JavaScript command that is executed when the menu item is selected. This menu item will invoke the Dreamweaver MX 2004 `document open` method and open the file *Golf.xml*. Alternatively, you can use the next attribute, `File`.

`file`—Points to an HTML file that contains the code to execute when the user selects the menu item. This HTML file may or may not contain JavaScript code.

`id`—Specifies a unique identifier for the menu item.

5. Save and close this file.
6. Place a copy of the *Golf.xml* file in the *menus* subdirectory of the *Configurations* folder.
7. Restart Dreamweaver MX 2004.

You now have a new menu item that is a submenu of the File menu in the main menu bar, as shown in Figure 4.22. Clicking File → New Golf XML creates a blank *Golf.xml* file.

FIGURE 4.22 The new menu item in the File menu.

By adding or editing the JavaScript and HTML files in the Dreamweaver MX 2004 *Configuration* folder, you can add additional functionality to the application. In the next section, you will add an XML menu to the Insert menu, which will allow you to add a stylesheet to the XML Golf files.

ADDING CUSTOM MENU ITEMS

To expedite the building of XML files, you can add menu items that write code to the file based on choices you make. In this example, you will add a submenu to the Insert menu on the main menu bar. You will create a dialog box that inserts the code to attach a stylesheet to an XML file. This dialog box will contain a drop-down menu to provide the choice of stylesheet: CSS, XSL-FO, or XSL-T, and a Browse button to locate the stylesheet file. You will also add a menu item that provides the code for a CDATA section. The result of this tutorial will be the addition of a menu item called XML to the Insert menu on the main menu bar. This XML menu will contain a submenu with two items called XML Attach Stylesheet and XML Add CDATA. In addition, this functionality will be added to a custom toolbar called XML.

Because you are adding a menu item, the file you must manipulate is *menus.xml* from the *menus* subdirectory of the *Configuration* folder.

1. Using your text editor, open the file *menus.xml* from the *menus* sub-directory in the *Configuration* folder.

2. Click Edit → Find and type `_Get More Objects...` in the Find what field. This action takes you to the following `<menuitem>` code:

```
<menuitem name="_Get More Objects..." enabled="true"
command="dw.browseDocument('http://www.macromedia.com/
exchange/dreamweaver')" id="DWMenu_Insert_GetMoreObjects" />
```

If you go back to Dreamweaver MX 2004 and select the Insert menu, you will see that the last menu item in the Insert menu is Get More Objects. Notice the closing `</menu>` tag at the end. This is where you will add a new menu called XML with a submenu containing the Stylesheet option and another submenu that will add CDATA code.

3. Type the following line of code to add a horizontal line that separates your menu from the previous menu:

```
<separator />
```

4. Type the two new menu items:

```
<menu name="_XML" id="DWMenu_XML">
    <menuitem name="XML Attach _Stylesheet"
        enabled="true"
        file="xml_stylesheet.htm"
        id="DWMenu_Insert_Stylesheet" />

  <menuitem name="XML Add _CDATA"
        enabled="true"
        file="CData.htm"
        id="DWMenu_Insert_CData" />
</menu>
```

5. Save and close this file.

As in previous examples, the `<menu>` element creates a new menu item. When naming a `menuitem`, adding an underscore before a letter creates a keyboard shortcut. For example when accessing the Insert menu, you can simply click ALT-I (I for insert). The underscore before the X in the attribute `name="_XML"` allows the user to click ALT-I to access the Insert menu and then, simply press X on the keyboard to access the new menu item. The `ID="DWMenu_XML"` serves as a unique identifier for the new menu. Nested inside the `<menu>` element is the `<menuitem>` element. Remember that `<menuitem>` elements create sub-

menus. The `name` attribute provides the name that will appear when the user clicks the menu. The attribute `enabled` enables the `menuitem`. A value of `false` for `enabled` would make the menu item unavailable. The `file` attribute is used to point to an HTML file you create to hold the menu item's functionality, which usually contains JavaScript. Alternatively, you could choose the `command` attribute, whose value would be a JavaScript file or JavaScript expression, which provides the menu's functionality. The second `<menuitem>` adds a CDATA section wherever the cursor is when the menu is accessed. In step 9, you create the HTML files that are referenced by these `<menuitems>` elements, beginning with the more complex *xml_stylesheet.htm*.

6. In Dreamweaver MX 2004, create a new HTML document.

You can do steps 7 and 8 at the same time.

7. Create a new directory in the *Objects* subdirectory of the *Configurations* folder called *XML*.
8. Save the current HTML file as *xml_stylesheet.htm* in the new *XML* directory you created in step 7.
9. Edit the file as follows:

```
<!DOCTYPE HTML SYSTEM "-//Macromedia//DWExtension layout-engine
5.0//dialog">
<html>
  <head>
    <title><MMString:LoadString id="insertbar/xml" />XML
    Stylesheet</title>
    <script language="javascript"
    src="../../Shared/MM/Scripts/CMN/string.js"></script>
    <script src="xml_stylesheet.js">
    //-------------- LOCALIZEABLE GLOBALS ---------------
    var LABEL_DefaultStyle = "CSS";
    </script>
  </head>
<body>
<a href="mailto:"></a>
<form name="styleForm">
    <table>
      <tr nowrap>
        <td align="right" valign="baseline">
        <div align="left">
          <img src="xml_stylesheet.gif">
        </div>
        </td>
        <td align="left" valign="top">Attach a Stylesheet
```

```
          </td>
        </tr>
        <tr>
          <td align="right">Type:
          </td>
          <td align="left" nowrap>
          <select name="styleType" style="width:160">
            <option value="css" name="css">CSS</option>
            <option value="xsl" name="xsl">XSL-FO</option>
            <option value="xsl" name="xsl">XSL-T</option>
          </select>
          </td>
        </tr>
          <tr>
            <td align="right" valign="baseline" nowrap>Href:</td>
            <td align="left" valign="baseline" nowrap> <input
            type="file" name="theStylesheet">
          </td>
        </tr>
      </table>
    </form>
    </body>
  </html>
```

If you view the file in Dreamweaver MX 2004 Design View, you will see it contains a form built in a three-row, two-column table, as shown in Figure 4.23.

The form contains a Select menu with options for CSS, XSL-FO, and XSL-T and a Browse button to upload the stylesheet file. When the user clicks Insert → XML → XML Stylesheet, a Dreamweaver MX 2004 dialog box is created from this HTML file. Note the JavaScript reference in the head tag: `<script src="xml_stylesheet.js"></script>`. This is the JavaScript that will execute when the user completes the form and clicks OK. In the next step you will write the JavaScript file.

10. Save and close *xml_stylesheet.html*. In Dreamweaver MX 2004, create a blank new JavaScript file by clicking File → New and selecting Basic Page, JavaScript.
11. Enter the following JavaScript code:

```
// JavaScript to add an "Insert Stylesheet" function
//Kevin Ruse

//--------------        API FUNCTIONS      ---------------

function isDOMRequired() {
```

FIGURE 4.23 The *xml_stylesheet.htm* file that will be your new dialog box.

```
// Return false, indicating that this object is available in
code view.
return false;
}

function objectTag() {
var theType = document.styleForm.styleType.selectedIndex;
if (document.styleForm.styleType.selectedIndex == "0")
theStyle = "css";
else if (document.styleForm.styleType.selectedIndex == "1")
theStyle = "xsl";
else if (document.styleForm.styleType.selectedIndex == "2")
theStyle = "xsl";

// Return the html tag that should be inserted
return   '<?xml-stylesheet type="text/' + theStyle + '"' + '
```

```
href="' + document.styleForm.theStylesheet.value + '"?>';
}
```

The code following the comment

```
//--------------       API FUNCTIONS      --------------
```

is the JavaScript that will enable the new menu. Dreamweaver MX 2004 will use its Application Programming Interface to execute this JavaScript, thus the comment API FUNCTIONS. The first function, isDomRe-quired, tells Dreamweaver MX 2004 that this menu item should work in Code View. The second function, objectTag(), declares the following:

- The variable theType is set to the stylesheet type chosen on the drop-down menu on the *xml_stylesheet.htm*
- The if statement is used to set the variable theStyle to a string equal to css or xsl, depending on the choice made in the Stylesheet type drop-down menu.
- The return statement returns the following:
 - <?xml-stylesheet type= "text/<stype type>
 - <?xml-stylesheet type = "text/css" href = <path and name of the stylesheet>

```
<?xml-stylesheet type = "text/css" href = "myStyles/myStylesheet.
css"?>
```

12. Save the file as *xml_stylesheet.js* in the *Macromedia\Dreamweaver MX 2004\Configuration\Objects\XML* directory and close the file.
13. Copy the *xml_stylesheet.gif* file from the *Chapter 4/Chapter 4 Configuring DW as an XML Editor* directory to the *Macromedia\Dreamweaver MX 2004\Configuration\Objects\XML directory*.
14. Restart Dreamweaver MX 2004.
15. Create a new Golf XML file and place your cursor below the XML declaration.
16. From the Insert menu, choose the newly created XML menu and select Attach Stylesheet. Select a stylesheet type and browse for a file. Click OK. The stylesheet code is now added to the document. See Figure 4.24.

Next, you will add the CDATA menu item's functionality.

FIGURE 4.24 The result of the new menu item, Insert → XML → Attach a Stylesheet.

17. Begin by building the HTML file that will serve as the dialog box. Create a new HTML file and type the following code:

```
<!DOCTYPE HTML SYSTEM "-//Macromedia//DWExtension layout-engine
5.0//dialog">
<html>
<head>
<title><MMString:LoadString id="insertbar/CData" /></title>
<script language="javascript" src="Cdata.js"></script>

</head>
<body>
  <form name="theForm">
    <table border=0>
      <tr>
```

```
          <td nowrap>  Add your CData Code below:<br>
          <textarea name="CDataCode" rows="4" wrap="virtual"
          class="largeTField"></textarea>
            </td>
          </tr>
        </table>
      </form>
     </body>
    </html>
```

18. Save the file as *CData.htm* in the new *XML* directory you created in step 7. It will be displayed in Dreamweaver MX 2004 Design View, as it appears in Figure 4.25.

FIGURE 4.25 The *CData.html* file as shown in Dreamweaver MX 2004.

19. Now you will create the corresponding JavaScript file that the dialog box calls to execute. Create a blank new JavaScript file in Dreamweaver MX 2004 and type the following code:

```
// CData code
//--------------     API FUNCTIONS    --------------
function isDOMRequired() {
// Return false, indicating that this object is available in
    code view.
return false;
}

function objectTag() {
// Return the html tag that should be inserted
return '<![CDATA[' + document.theForm.CDataCode.value + ']]>'
}
```

20. Save the file as *cdata.js* in the new *XML* directory you created in step 7.
21. Copy the *CData.png* file from the *Chapter 4/Chapter 4 Configuring DW as an XML Editor* directory to the *Macromedia\Dreamweaver MX 2004\Configuration\Objects\XML directory*.
22. Restart Dreamweaver MX 2004. Your new XML submenu should appear from the Insert menu, as shown in Figure 4.26.

FIGURE 4.26 The new Insert menu with the XML submenu added.

23. With a blank document open, practice using Insert → XML → CData Code to Insert CDATA.

SUMMARY

As you have seen, the Macromedia Dreamweaver MX 2004 interface is constructed in such a way that it can be fairly easily manipulated. This tutorial's main purpose was to introduce the concepts that make this possible. Dialog boxes, menu items, and the property inspector are all created through HTML, and JavaScript makes their functionality possible. As you become more familiar with your particular workflow, you will come to see what types of XML code you tend to generate. Knowing, for example, that you frequently need to attach a particular doctype or you generate numerous XML file with the same tags, helps you determine how you should modify the Dreamweaver MX 2004 interface. Adding a button or menu item not only makes the application more efficient but also helps novice users easily create custom XML files by prompting them for the correct information. Customizing Dreamweaver MX 2004 requires a knowledge of HTML and JavaScript, which is beyond the scope of this book; however, you should now understand how the existing Dreamweaver MX 2004 configuration files can be modified to create a new component. For extensive reworking of the Dreamweaver MX 2004 interface see the Additional Resources section.

ADDITIONAL RESOURCES

HTML tutorials:*http://hotwired.lycos.com/webmonkey/authoring/html_basics/index.html*

JavaScript tutorials and scripts:
 http://javascript.internet.com/
 www.webreference.com/js/
 http://hotwired.lycos.com/webmonkey/programming/javascript/

Dreamweaver MX 2004 Help files
 Help → Extensions → Extending Dreamweaver
 Help → Extensions → API Reference

Search for the following topics in: Help → Using Dreamweaver
 Dreamweaver customizing basics
 Setting General preferences for Dreamweaver
 About customizing Dreamweaver in multiuser systems

Macromedia Web Site
 www.macromedia.com
 www.macromedia.com/support/dreamweaver/custom/customizing_dwmx/

DREAMWEAVER MX 2004 AND XML ADVANCED TOPICS: PART TWO

In This Chapter

- Introduction: Overview of Dreamweaver Templates
- How to Create a Dreamweaver Template
- Tutorial One: Exporting Dreamweaver Template Data to XML
- Tutorial Two: Modifying an XML File for Import into a Dreamweaver Template
- Tutorial Three: How to Use XML with ColdFusion MX 6.1
- Tutorial Four: How to Create Dynamic Web Pages with XML and ColdFusion MX 6.1
- Tutorial Five: How to Search XML Data with ColdFusion MX 6.1

Chapter 5 addresses more advanced topics for using XML with Dreamweaver, providing an overview of Dreamweaver templates and then teaching how Dreamweaver MX 2004 can export the data from a template-based page to XML. This process creates a file that may not be usable by an application other than Dreamweaver MX 2004. In a real-world workflow, you may be presented with data in XML that will become the content of your Web site. In this case, the data will most likely not be in a format that allows for easy import into your Dreamweaver template–based Web pages. This situation is ideal for the use of XSL-T. You will transform your original Golf XML files into another XML file structure that will import seamlessly into your Dreamweaver template. The chapter concludes with a tutorial on XML and ColdFusion. ColdFusion is a Macromedia technology that facilitates the creation of database-driven Web sites. The ColdFusion mark up language can be used to create Web sites from XML files.

INTRODUCTION: OVERVIEW OF DREAMWEAVER TEMPLATES

Dreamweaver templates were introduced to automate the construction of Web pages and to decrease the time required for maintaining Web sites. You create a template that contains the elements (such as logos, images, and links) that are common to all pages. When you build subsequent Web pages using the template (a Dreamweaver .dwt file), a relationship is established between the HTML file built by the template and the template file itself. This relationship causes any changes made to the template to propagate to the Web pages created via the template. Thus, hundreds of Web pages can be maintained or changed by modifying one file: the Dreamweaver template (.dwt). Dreamweaver MX 2004 templates are now capable of importing XML files. The first two tutorials in Chapter 5 introduce this process as well as the problems you might encounter as you import XML into Dreamweaver MX 2004 templates.

HOW TO CREATE A DREAMWEAVER TEMPLATE

A Dreamweaver template is an HTML document used to create multiple pages that share the same layout. Dreamweaver templates are created through the following simple steps:

1. Mock up your Web site with paper and pencil sketches.

2. Identify those areas of the mockup that are common to all pages, such as:
 - background colors, link colors, visited link colors, text colors, and fonts
 - background images
 - banners
 - site navigation, including hypertext links and navigation bars
 - mission statements, slogans, and logos
 - copyright statements
3. Create a new HTML page.
4. Lay out the basic structure of the page according to your paper mockup, including the common elements listed in step 2.
5. Save the page as a template by clicking File → Save As Template.

When an HTML page is saved as a template, it remains an HTML file, in that it has been created using HTML. Its file format, however, is .dwt, which stands for Dreamweaver template. You cannot change the extension of this file. This .dwt file facilitates the creation and management of the Web site's remaining pages. When creating the Web site, you no longer create new HTML files; instead, you click File → New and select the template section of the New File dialog box. Subsequently, select the template and click OK. At this point, you are not looking at a blank HTML document but a document that represents your mockup with all the common elements already in place.

These elements are locked so users cannot disturb the basic layout, thus maintaining the look and feel of the site throughout the development of each individual Web page. Some areas of the template are unlocked. These areas are called editable regions, and it is within these areas that the content for each individual page is placed. The result is multiple pages with identical layout but different content.

The content for Dreamweaver templates can originate from an XML file. Because more and more content providers are now using XML, Dreamweaver MX 2004's ability to process XML makes a direct workflow possible, from original content to finished Web site with no steps between to jeopardize the integrity of the content.

TUTORIAL

TUTORIAL ONE: EXPORTING DREAMWEAVER TEMPLATE DATA TO XML

OBJECTIVES

- To open a Web page that was created with a Dreamweaver template file (.dwt)
- To export the contents of the editable regions of a Dreamweaver template to an XML file

BEFORE YOU BEGIN

What You Will Need for This Tutorial

- Dreamweaver MX 2004 (Macintosh or PC version)
- (PC) Microsoft Internet Explorer 5.x or later
- (Mac) Microsoft Internet Explorer 5.2 or later

ON THE CD

The Data Files

- **Tutorial One Directory:** Data Files/Part_2/Chapter 5/Ch_5_How to Create DW XML-Based Web Pages_1
- **Student Files Directory:** *Data Files/Part_2/Chapter 5/Ch_5_How to Create DW XML-Based Web Pages_1/Export To XML*
- **Supporting Files Directory:** *Templates*
- **Student Files:** *Winery_via_Template.htm*
- **Supporting Files Directory:** *images*
- **Finished Files Directory:** *Ch_5_1 Finished*
- **Finished Files:**
 Ch_5_Winery_Export_RegionName_Tags.xml
 Ch_5_Winery_Export_DW_Tags.xml
- **Finished Files—Supporting Directory:** *images*
- **Finished Files—Supporting Files:**
 wineryBG.gif
 shim.gif
 bwCorkBG.jpg
- **Supporting Files Directory:** *jpgs*
- **Supporting Files:**
 ferell.jpg
 davidcruz.jpg
 gullermo.jpg
 ronzini.jpg
 sun.jpg
 salmon.jpg

- **Supporting Files Directory:** *Icons*
- **Supporting Files:**
 BanquetICON.gif
 GiftICON.gif
 GuidedTourIcon.gif
 PicnicICON.gif
 TastingICON.gif
 TourICON.gif

Defining the Site for Chapter 5 Tutorial One

From the CD-ROM you will use the following root directory when defining your site for Chapter 5 Tutorial One: *Chapter 5/How to Modify XML for DW Templates*

INTRODUCTION

What if your workflow originates from your Web site? In other words, what if all of your content is currently residing in the Web site and you need to export this content for use by other applications? For example, you need to export the data from a Web-based tech-support help application to be used to create paper manuals for those customers who prefer printed documentation, and you also want to provide PDF files for those who prefer their documentation in a digital file format. In addition, the company is also working on a propriety handheld device that will read software error messages and call up the appropriate help file. The solution is to export the original data from the Web site to XML, which can then, of course, be used to create all of the necessary files.

Because this book assumes you are an experienced user of Dreamweaver MX 2004, this tutorial does not cover how to create a template. It begins by examining a Web page that was created by way of a Dreamweaver template and covers how to export the template's editable regions as XML.

1. Launch Dreamweaver MX 2004 and open the file *Winery_via_Template.htm* from *Data Files/Section_2/Chapter 5/Ch_5_How to Modify XML for DW Templates_2/Ch_5_Dreamweaver_Templates_1/Export to XML*.

The Web page is displayed as shown in Figure 5.1. This page was created from the template called *WineTemplate.dwt*, located in the *Templates* folder in the site windows. The tabbed blue areas indicate the original template's editable regions.

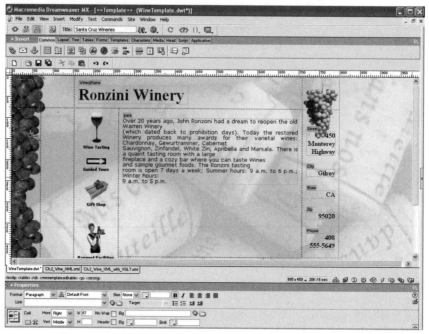

FIGURE 5.1 *Winery_via_Template.htm* as displayed in Dreamweaver MX 2004.

To examine the Dreamweaver template that created this page, look at the first line of the source code. Note the section that reads as follows:

```
<html>
<!-- InstanceBegin
template="/Templates/Ch_5_Wine_Template.dwt"
codeOutsideHTMLIsLocked="false" -->
<head>
<!-- InstanceBeginEditable name="doctitle" -->
<title>California Wineries</title>
<!-- InstanceEndEditable -->
```

The following line:

```
<!-- InstanceBegin
template="/Templates/Ch_5_Wine_Template.dwt"
codeOutsideHTMLIsLocked="false" -->
```

indicates the name of the template used to create this page—*Wine_Template.dwt*. The file is displayed in Figure 5.2.

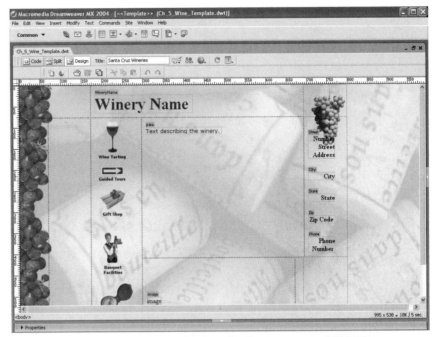

FIGURE 5.2 *WineTemplate.dwt* as displayed in Dreamweaver MX 2004.

2. To examine the .dwt template file, click File → Open → *WineTemplate.dwt* from the *Templates* directory.

Notice the names of the editable regions because they play an important role when you export to XML. The editable regions have been given logical names in regard to the data they contain in much the same way you would name your XML elements.

3. Close the template file *WineTemplate.dwt*.

It is assumed that the *Winery_via_Template.htm* file is the only source of data for your winery information. For instance, you do not have any brochures or flyers about the winery and no database contains winery information. Your goal, therefore, is to export this data from the Web site in a format that can be used to create brochures or flyers in other software, such as Quark Xpress or Adobe InDesign. In addition, you would like to import the winery information into a database such as Oracle, IBM, or Access. The ideal format is XML.

4. From the File menu, click Export → Template Data as XML. The dialog box is shown in Figure 5.3.

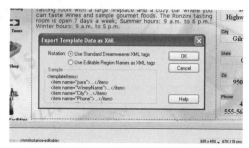

FIGURE 5.3 The Export Template Data as XML dialog box.

CONCEPT: OUTPUTTING XML FROM DREAMWEAVER MX 2004

Dreamweaver MX 2004 provides two methods for notating the XML file, as indicated by the two buttons in the Export Template Data as XML dialog box. The first method is Use Standard Dreamweaver XML Tags. This notation creates XML element names for the exported content according to a predefined tag set. When you choose this option, your XML document's root element will always be `<templateItems>`. The root element contains one or more child elements, but they all have the same name—`<item>`. What differentiates the content is the `<item>` element's `name` attribute. The content of the tag will be the content exported from the template's editable region. The `name` attribute matches the name of the editable region, and the content always is contained with a `<![CDATA` section. Therefore, the first child element of the root node in the example file will be:

```
<item name="Street"><![CDATA[3920
          Decker Pass Highway]]></item>
```

You will now export the current Web page to an XML file using the Use Standard Dreamweaver XML Tags method.

5. Select Use Standard Dreamweaver XML Tags.
6. Click OK and name the file *Ch_5_Winery_Export_DW_Tags*.

Now you will view the newly created XML file in Notepad. See Figure 5.4.

7. Open Notepad from your PC Start menu. Click Start Program Files → Accessories → Notepad.
8. From Notepad click File Open and browse to *Ch_5_Winery_Export_DW_Tags*. The file appears in Notepad, as shown in Figure 5.4.

FIGURE 5.4 The Exported template data *Ch_5_Winery_Export_DW_Tags* as XML, displayed in Notepad. Screen shot reprinted with permission from Microsoft Corporation.

Notice the XML file's structure beginning with the root element `<templateItems>` followed by the child elements named `<item>`. The tags data is made unique by the `name` attribute. Although this is an XML file, it is probably not suitable as an entirely self-describing document. For example, compare this file to the next sample file, called *Solis.xml*.

```
<?xml version="1.0" encoding="UTF-8"?>
<CentralCalifornia>
<Winery>
    <WineryName>Sun Winery</WineryName>
    <image>../images/Sun.jpg</image>
    <Phone>408-555-6306</Phone>
    <Street>3920 Decker Pass Highway</Street>
    <City>Gilroy</City>
    <State>CA</State>
    <Zip>95020</Zip>
    <Description>Sun is a family owned and operated winery
    producing award winning wines at the northeast edge of
    the San Mateo County, birthplace of Northern
    California's wine industry. The winery is located in the
```

```
        picturesque Decker Pass region which is bordered by the
        Santa Cruz Mountains to the west and south. Winemaking
        on the Sun property dates back to last week and today we
        carry on those customs blending the best of traditional
        methods and present day winemaking. Wines produced by
        Sun currently include Chardonnay, Merlot, Pinot Noir and
        Johannesburg Riesling. The Winery Tasting Room is
        available for private or corporate events. Sun holds
        many winery sponsored festivals thoughout the year.
        </Description>
        <Hours>Wed - Fri: 11 am - 5 pm</Hours>
        <WineTasting>true</WineTasting>
        <GiftShop>true</GiftShop>
        <CreditCards>Visa</CreditCards>
        <CreditCards>American Express</CreditCards>
        <BanquetFacilities>true</BanquetFacilities>
        <PicnicArea>true</PicnicArea>
        <GuidedTours>false</GuidedTours>
        <SelfGuidedTours>true</SelfGuidedTours>
    </Winery>
```

This file is more like the self-describing structure you learned in Chapter 3. The file that Dreamweaver MX 2004 creates is not the best format for using in other software applications that can import or understand XML because the tag names themselves are not descriptive and the nesting structure is only one level deep. What this file is capable of doing is being imported back into a Dreamweaver template. If you want Dreamweaver MX 2004 to export a more descriptive tag language for the winery data, you can choose the second notation method, Use Editable Region Name as XML Tags.

9. Close the Notepad file and return to Dreamweaver MX 2004.
10. Click File → Export → Template Data as XML.
11. Select Use Editable Region Name as XML Tags.
12. Click OK and name the file *Ch_5_Winery_Export_RegionName_Tags*. Now view the newly created XML file in Notepad.
13. Open Notepad from your PC Start menu. Click Start Program Files → Accessories → Notepad.
14. From Notepad Click File Open and browse to *Ch_5_Winery_Export_RegionName_Tags*. The file is displayed as shown in Figure 5.5.

Notice the structure of this file beginning with the root element <wineTemplate>. The name of the root element comes from the name of the Dreamweaver template file (.dwt), which is *wineTemplate.dwt*. The root element has 10 child tags, each with a unique name. The names of the child tags match the names of the template's editable regions,

```
Ch_5_Winery_Export_RegionName_Tags.xml - Notepad
File  Edit  Format  View  Help
<?xml version="1.0"?>
<wineTemplate template="/Templates/wineTemplate.dwt" codeOutsideHTMLIsLocked="false">
<doctitle><![CDATA[
<title>Santa Cruz wineries</title>
]]></doctitle>
    <wineryName><![CDATA[<span style="margin-left:0px; font-size: 30pt; color:#330033"><b>Ronzini
        winery</b></span>]]></wineryName>
    <Street><![CDATA[
        <p><strong>4350 Monterey Bay Highway</strong></p>
        ]]></Street>
    <State><![CDATA[
        <p><strong>CA</strong></p>
        ]]></State>
    <image><![CDATA[<img src="images/jpgs/ronzini.jpg" width="258" height="202">]]></image>
    <Phone><![CDATA[
        <p><strong>408<br>
        555-5649</strong></p>
        ]]></Phone>
    <Zip><![CDATA[
        <p><strong>95020</strong></p>
        ]]></Zip>
    <City><![CDATA[
        <p><strong>Gilroy</strong></p>
        ]]></City>
    <head><![CDATA[<style type="text/css">
<!--
body {
        background-color: #CACACA;
}
-->
</style>]]></head>
    <para><![CDATA[<span style="width:450; font-family: Verdana; font-size: 10pt; line-height:13pt; font-weight: normal;
text-align:justify; ">Over
        20 years ago, John Ronzoni had a dream to reopen the old Warren winery
        (which dated back to prohibition days). Today the restored winery produces many awards for their varietal wines:
Chardonnay, Gewurtraminer, Cabernet
        Sauvignon, Zinfandel, White Zin, Apribella and Marsala. There is a quaint tasting room with a large
        fireplace and a cozy bar where you can taste wines
        and sample gourmet foods. The Ronzini tasting
        room is open 7 days a week; Summer hours: 9 a.m. to 6 p.m.; Winter hours:
        9 a.m. to 5 p.m.</span>]]></para>
</wineTemplate>
```

FIGURE 5.5 The exported template data *Ch_5_Winery_Export_RegionName_Tags* as XML, displayed in Notepad. Screen shot reprinted with permission from Microsoft Corporation.

which have been given logical names in regard to the data they hold. This XML file is more descriptive than the previous export, although it is not as descriptive as the sample file, *Solis.xml*. The main functionality of the exported files is their unique ability to be imported as XML into existing Dreamweaver template files. They are capable of this purpose for several reasons.

Both of the exported files contain an attribute called `template` in the root element of the file. This attribute's value is the path and filename of the Dreamweaver template (.dwt) file that created the file from which the export took place. In the next tutorial you will learn how to import XML into Dreamweaver templates. It is impossible to import XML files into Dreamweaver templates without this attribute.

Another reason these exported files can be imported in templates is their simple structure of one root element with one level of tags below the root. The structure is basically like the following example:

```
<rootElement>
  <differentChildTag>
  <differentChildTag>
```

```
    <differentChildTag>
    </rootElement>
```

The root can have any number of unique children, but the child elements cannot have children. To make this XML more self-describing or to add container tags to hold additional child tags that provide more structure to the document, the XML must be transformed. You can do this using XSL-T.

Dreamweaver MX 2004 templates provide additional features, including XML support. Dreamweaver MX 2004 can export the contents of the editable regions of a template file to XML. The XML that Dreamweaver MX 2004 generates is suitable for import back into the same or different templates. This functionality can be helpful if you have original data that you would like to import into a variety of layouts using Dreamweaver templates. In addition, exporting to XML lets you view the structure of the XML file and, thus, create additional XML files for import into Dreamweaver templates.

ADDITIONAL RESOURCES

Dreamweaver MX 2004 Technical Note: *www.macromedia.com/ support/dreamweaver/ts/documents/templates_xml.htm*

TUTORIAL TWO: MODIFYING AN XML FILE FOR IMPORT INTO A DREAMWEAVER TEMPLATE

OBJECTIVE

- To examine the content of the existing Golf XML file and make it suitable for import into a Dreamweaver template.

BEFORE YOU BEGIN

What You Will Need for This Tutorial

- Dreamweaver MX 2004 (Macintosh or PC version)
- (PC) Microsoft Internet Explorer 5.x or later
- (Mac) Microsoft Internet Explorer 5.2 or later

ON THE CD

THE DATA FILES

- **Tutorial Two Directory:** *Data Files/Part_2/Chapter 5/Ch_5_How to Modify XML for DW Templates_2*
- **Student Files Directory:** *Original XML File*
- **Student Files:** *Blueberry Farm Golf Course.xml*
- **Student Files Directory:** *Templates*
- **Student Files:**
 Golf_Template_Finished.dwt
 Golf_Web_Site_Template.dwt
 Golf_Template_Student.dwt
- **Student Files Directory:** *XSL-T Stylesheets*
- **Student Files:** *Ch_5_Golf_for_Dreamweaver_Stylesheet.xsl*
- **Supporting Files Directory:** *images*
- **Supporting Files:**
 CIRCLE1.gif
 CIRCLE2.gif
 golfBallCircle.gif
 GolfBG1.jpg
 greenBorder.gif
- **Finished Files Directory:** *Ch_5_2 Finished*
- **Finished Files Subdirectory:** *Finished XML from Template*
- **Finished Files:**
 Finished_Blueberry_Farm.htm
 Finished_Black_Creek.htm
 Finished_Cabernet.htm
 Finished_Deep_Ridge.htm
 CIRCLE1.gif
 CIRCLE2.gif
 golfBallCircle.gif
 GolfBG1.jpg
 greenBorder.gif
- **Finished Files Subdirectory:** *New Transformed XML Files*
- **Finished Files:**
 Blueberry_Farm_New.xml
 Black_Creek_New.xml
 Cabernet_Club_New.xml
 Deep_Ridge_New.xml
- **Finished Files Subdirectory:** *Original XML Files with Attached Stylesheets*
- **Finished Files:**
 Blueberry Farm Golf Course_w_SS.xml
 Black_Creek_w_SS.xml

Cabernet Golf Club_w_SS.xml
Deep Ridge Golf Course_w_SS.xml
Ch_5_Golf_for_Dreamweaver_Stylesheet.xsl

ON THE CD

Defining the Site for Chapter 5 Tutorial Two

From the CD-ROM you will use the following root directory when defining your site for Chapter 5 Tutorial Two: *Chapter 5/Ch_5_How to Modify XML for DW Templates_2.*

INTRODUCTION

When your Web design workflow begins with XML data, you can design your Web pages as Dreamweaver templates and then import the XML files into your templates. The XML file must meet several requirements to be suitable for import. You have learned some of these in the previous tutorial. In this tutorial, you will begin by opening a Dreamweaver template to identify how it will accept your XML file's elements. You will then look at the XML file you created in Chapter 3 and see what makes it unsuitable for import to Dreamweaver MX 2004. The problem is ultimately resolved by transforming the Golf XML via XSL-T into a structure that can be imported into your Dreamweaver template.

1. Launch Dreamweaver MX 2004 and open the file *Blueberry Farm Golf Course.xml* from the *Original XML File* directory.

CONCEPT: XML STRUCTURE THAT IS SUITABLE FOR IMPORT INTO A DREAMWEAVER TEMPLATE

This XML file cannot be imported into a Dreamweaver template for several reasons. First, it is missing the `template` attribute in the root element that associates the XML file with a Dreamweaver template. The second problem is that Dreamweaver templates cannot contain duplicate editable regions. In other words, all editable region names must be unique. This XML file contains duplicate elements. For example, there are either 9 or 18 `<Hole>` tags in your XML files. Each `<Hole>` tag contains `<Number>`, `<Par>`, `<Blue>`, `<White>`, `<Red>`, `<MensHcp>`, and `<LadiesHcp>` tags. Another problem is the file's structure, which includes nested elements. The problem then becomes, how do you make these XML files (which con-

tain an abundance of data that you need to populate your Web site) suitable for instant automation into Dreamweaver templates. The first step is to build a Dreamweaver template. This template is already created and appears in Figure 5.6

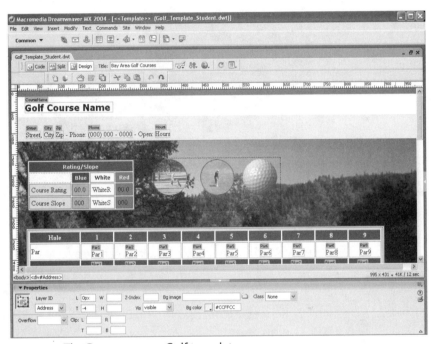

FIGURE 5.6 The Dreamweaver Golf template.

2. In Dreamweaver MX 2004, open the file called *Golf_Template_ Student.dwt* from the *Templates* directory.

Most of the template's editable regions have been created. If you have not built templates recently, refer to the next section for instruction on building the editable regions for the Rating/Slope section of the Web page.

3. Highlight the 00.0 text in the second column of the third row of the table, (The 00.0 refers to the Course Rating for the Blue Flags) as shown in Figure 5.7.
4. Right-click the text and click Templates → New Editable Region. Name the region BlueR.
5. Repeat the process for the White Rating cell and name the editable region WhiteR.
6. Repeat the process for the Red Rating cell and name the editable region RedR.

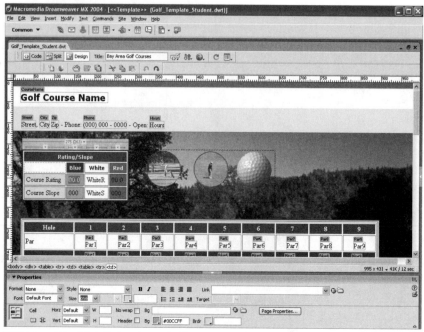

FIGURE 5.7 The highlighted text in Dreamweaver MX 2004.

7. Repeat the process for the Blue Slope cell and name the editable region `BlueS`.
8. Repeat the process for the White Slope cell and name the editable region `WhiteS`.
9. Repeat the process for the Red Slope cell and name the editable region `RedS`.

 The result of creating these editable regions is shown in Figure 5.8.
10. Save the Dreamweaver template file as *Golf_Template.dwta* and close it.

At this point, your Dreamweaver template is finished and includes editable regions that will be automatically populated with the contents of an XML file whose node names match the names of the editable regions. The problem in the real-world example is that your XML files are not structured in the format required by Dreamweaver MX 2004. You will use XSL-T to transform your current XML file into an XML file that is structured properly.

Recall from Chapter 4 Tutorial Two that XSL-T is a language that transforms an XML file into another type of file. In this case, you will be transforming the XML file into another XML file with a different

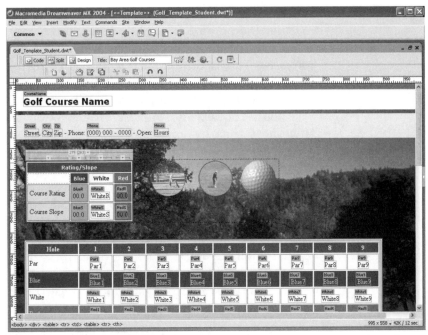

FIGURE 5.8 The Dreamweaver template with the editable regions defined for the Rating/Slope table.

structure. Remember that XML is a text file with elements that form a tree structure. The tree can include branches, which themselves include more treelike structures, with the XML elements on each branch known as leaves. The XSL-T file that you will use in this tutorial accepts one tree of nodes (the original XML file) as input and outputs a different tree of nodes (the transformed XML file). In this manner, you will restructure your XML data into a format that Dreamweaver MX 2004 can import as data for your XML template.

When using the XSL-T language to transform XML files, you may recall that you need an XSL-T processor. You have been using the MSXML parser, which is built into Microsoft Internet Explorer, as your XSL-T processor. Numerous XSL-T processors are available. By far the most common parsers and processors are written in Java. To run these XSL-T processors your computer needs the Java Virtual Machine, which can be downloaded at *www.java.com/en/index.jsp*. Once you have installed a Java Virtual Machine, you can run Java programs, including XML parsers and XSL-T processors. A common Java-based XML parser is the Xerces Java Parser from the Apache project, which is an open-source project that has produced the Apache Web Server. It is freely available from

http://xml.apache.org/xerces-j/index.html. This XML processor is run from a command prompt. The XSL-T processor that goes with Xerces Java is the Xalan-Java processor, which is also a Java program. The Xalan-Java processor can be downloaded at *http://xml.apache.org/xalan-j/index.html*. IBM, Sun, and others make other XML parsers and XSL-T processors.

For this tutorial, you will be processing the XSL-T using two different methods. You will use the Microsoft MSXML parser to process the stylesheet. Then, by right-clicking, you will choose View XSL Output and copy and paste the newly transformed file from this window to Dreamweaver MX 2004. The second method involves using a freely distributed XSL-T processor called XFactor, based on the Saxon XSL-T parser developed by Michael Kay. The Saxon XSL-T processor can be downloaded at *http://saxon.sourceforge.net/*. This processor is also a Java parser run from a command prompt. The XFactor processor contains a graphical user interface and is, therefore, much more user friendly.

ON THE CD

This process can be found on the CD-ROM in the back of the book in the directory *The Software*. Additionally it can be downloaded from the Internet at *www.nombas.com*.

11. Open the file called *Blueberry Farm Golf Course.xml*. This is the file that cannot in its current form be imported into a Dreamweaver template. See the explanation following step 1.

The XSL-T stylesheet that will transform this XML file into one more suitable for import into a Dreamweaver template has already been created. Open this stylesheet in Dreamweaver MX 2004.

You may encounter several problems when opening XSL-T files in Dreamweaver MX 2004. The most common problem is when Dreamweaver MX 2004 encounters the following:

- *An unclosed* `<P>` *tag*
- *A closed* `<P>` `</P>` *tag*
- *A closed* `<P/>` *tag.*

The problem is that Dreamweaver MX 2004 may add ` ` *inside the* `<P>` *tag. The character entity:* ` ` *represents a nonbreaking space. However, it is most likely the case that your XML file has not defined a character entity of* ` `. *You recall from Chapter 3 that XML recognizes only the following character entities:* `<`, `>`, `"`, `'` *,and* `&`. *Thus, when you open a stylesheet in Dreamweaver MX 2004, it will add an undefined entity,* ` `. *Subsequently, when you attempt to open the XML file attached to the stylesheet, you receive an error message due to the undefined entity. Therefore, you must manually remove the character entity from the stylesheet.*

12. Click File → Open and browse to the file called *Ch_5_Golf_for_Dreamweaver_Stylesheet.xsl* from the *XSL –T Stylesheets* directory.

This file probably needs some explaining, because you may not be completely comfortable with XSL at this time. If you need to refresh your memory, reread Chapter 4 Tutorial Two.

Essentially this file transforms the current XML file into a structure that Dreamweaver MX 2004 can understand. The structure that Dreamweaver MX 2004 needs follows:

```
<rootElement>
  <childTag>
  <differentChildTag>
  <differentChildTag>
  <differentChildTag>
</rootElement>
```

In addition to this structure, the XML file must not contain any duplicate elements. Therefore, your stylesheet must create new elements for the duplicated ones that will contain the information from the XML file (the text nodes).

A quick overview of this stylesheet, beginning with the prologue, follows:

```
<?xml version="1.0"?>
<xsl:stylesheet version="1.0"
xmlns:xsl="http://www.w3.org/1999/XSL/Transform">
<!-- <xsl:strip-space elements="*"/> -->
<xsl:output method="xml"/>
```

You recall from Chapter 4 that these three lines make up the prologue of your stylesheet. The first line is the XML declaration, followed by the root element `<stylesheet>` with the namespace `xsl:` and the `version` attribute set to 1.0. The namespace colon (`xsl:`) points to the *www.w3.org* Uniform Resource Identifier (URI). The next line declares that you are transforming this XML file into another XML file.

Your stylesheet's first template then begins with:

```
<xsl:template match="/">
```

The template is using the Xpath expression `"/"`, which indicates the root element. This template is invoked when it finds the source XML file's root element and begins its transformation at that point.

The first step in this transformation is creating the root element for your new XML file. The new element is called `<Golf_Web_Site_for_Dreamweaver>`, and it contains the attribute `template`, which is given the value `"/Templates/Golf_Web_Site_Template.dwt"`. This new element is created by the following code:

```
<Golf_Web_Site_for_Dreamweaver>
    <xsl:attribute name="template">
        /Templates/Golf_Web_Site_Template.dwt
    </xsl:attribute>
```

After the creation of this new element, the template is then instructed to process the template for the `<Course>` tag, which is defined later in the document. This instruction is contained in the template's next line as follows:

```
<xsl:apply-templates select="Course"/>
```

The stylesheet will now locate the template whose `match` value equals `Course` and process it. After that is executed the next line in the stylesheet code, which calls for all remaining templates to be processed in the order in which they appear from the top to the bottom of the stylesheet. This code follows:

```
<xsl:apply-templates/>
```

The code that remains creates the closing tag that you created earlier and then closes the `<xsl:template` tag.

```
    </Golf_Web_Site_for_Dreamweaver>
</xsl:template>
```

The template code throughout your stylesheet is divided visually by the use of comments, which describe what portion of the XML file the template is designed to process. The first template you see is the one that was processed earlier for the `<Course>` element. This template takes care of the course information such as the name of the course, its address, phone number, and hours of operation.

The first item it processes is the `<Course>` element. It does this with the now familiar `match` attribute, as follows:

```
<xsl:template match="Course">
```

A new element is then created called `<CourseName>`. The content of this new element is the same as the XML file's current `<CourseName>` tag. This is accomplished with the following code:

```
<xsl:element name="CourseName">
    <xsl:value-of select="CourseName"/>
</xsl:element>
```

The remaining template code uses the same technique to create the tags `<Street>`, `<City>`, `<Zip>`, `<Phone>`, and `<Hours>`.

The next template is used to set up the course rating and course slope. Because not all courses have a course rating and slope, you must first see if the tag is empty. Remember, the goal of this stylesheet is to make the XML file suitable for import into Dreamweaver templates. For that reason, if one of the course rating tags is empty, you want the template to receive a space as opposed to receiving no data at all. Ultimately, you will build a Dreamweaver template that contains a table for the course rating and course slope, and you want the table cell to contain some data so that it doesn't collapse; therefore, you use a space. Alternatively, you could insert a transparent GIF as a placeholder. If the course rating tag contains data, such as the number 55.9, then you want the template to receive that data.

An `<xsl:choose>` element is used to provide a choice as to what the template should write, depending on certain conditions. The `<xsl:when>` element, combined with its `test` attribute, is used to provide those conditions. In the example, you are testing to see if the length of the `<Blue>` element's content is less than 1, which would indicate the element is empty. If the test returns `true`, the code below it is executed, which in this case creates an element called `<BlueR>` and enters the text ` ` inside of it. The `<xsl:otherwise>` element is used to determine what should occur if the test proves false and the string inside the `<Blue>` element is greater than 1 and, therefore, not empty. At that point your template adds an element called `<BlueR>` as before; however, it adds the contents of the current XML file's `<Blue>` element to the tag.

For example, if your original file contains the following element:

```
<CardInfo>
    <CourseRating>
        <Blue>55.9</Blue>
```

then an element is created as follows:

```
<BlueR>55.9</BlueR>
```

If, however, your original XML file contains the following elements:

```
<CardInfo>
    <CourseRating>
                        <Blue></Blue>
```

then an element is created as follows:

```
<BlueR>   </BlueR>
```

The code that processes the Blue Rating tag as well as the remaining course rating and course slope elements follows:

```
<!--  Contents for Course Rating -->
   <xsl:choose>
   <xsl:when test="string-length(CardInfo/CourseRating/Blue)
        &lt; 1">
        <xsl:element name="BlueR">
            <xsl:text disable-output-escaping="yes"><![CDATA
                [ ]]></xsl:text>
        </xsl:element>
   </xsl:when>
   <xsl:otherwise>
        <xsl:element name="BlueR">
        <xsl:value-of select="CardInfo/CourseRating/Blue"/>
        </xsl:element>
   </xsl:otherwise>
   </xsl:choose>
```

The next template uses the same structure, but for a different reason. This time the template is testing to see whether the XML file is describing a nine-hole course or an 18-hole course.

```
<!-- Elements for a Nine-Hole Course -->
   <xsl:choose>
        <xsl:when test="count(CardInfo/Hole) &lt; 10">
```

The template continues to use the same techniques as before to create a `<Par1>`, `<Blue1>`, `<White1>`, and `<Red1>` element. It repeats this process to create the remaining tags through the ninth hole. The process is repeated after a check to see if the XML file is describing an 18-hole course.

The template concludes by creating the tags for the Course Facilities section of the XML file. The result of this template is similar to the result of the `<Course>` template that created tags for `<Street>`, `<City>`,

and so on, however, the technique used is different. In this case you exercise the shorter method, which uses the `<xsl:copy-of>` element. As its name implies, this element merely copies the contents of its `select` attribute. See the following code from your stylesheet:

```
<!-- Elements for Course Facilities -->
    <xsl:copy-of select="Facilities/*"/>
```

This code copies all of the elements that are children of the `<Facilities>` element.

For completeness it should be noted that similar shortcut techniques could have been employed throughout various parts of your stylesheet. An `<xsl:for-each>` element, for example, could have been used to loop through the `<Hole>` tags. The stylesheet was purposely designed to demonstrate various techniques. A complete examination of the XSL-T language is beyond the scope of this book, however. You are now done exploring this XSL-T stylesheet.

Be sure to remove any *character entities Dreamweaver MX 2004 may have added to the stylesheet.*

13. Close the stylesheet file.

CONCEPT: USING THE MSXML PARSER AND XSL-T PROCESSOR

Recall the reason for this template: You need to transform the current XML file into a format that Dreamweaver MX 2004 can import into the template. It is now time to perform the transformation. Remember that you need an XSL-T processor to do this. The first processor you employ is the MSXML parser. The first step is to attach an XML file to the stylesheet.

14. In Dreamweaver MX 2004 open the file *Blueberry Farm Golf Course.xml*.

15. Add the following line below the XML declaration:

```
<?xml-stylesheet type="text/xsl"
href="Ch_5_Golf_for_Dreamweaver_Stylesheet.xsl"?>
```

Remember, this attaches the stylesheet you just examined to the Blueberry Farm XML file.

16. Save the file as *Blueberry Farm Golf Course_w_SS.xml*, and close the file.

FIGURE 5.9 The *Blueberry Farm Golf Course.xml* file transformed by the *Ch_5_Golf_for_Dreamweaver_Stylesheet.xsl* stylesheet and displayed in Internet Explorer. Screen shot reprinted with permission from Microsoft Corporation.

17. Launch Internet Explorer and open *Blueberry Farm Golf Course_w_SS .xml*.

Your goal now is to view the newly transformed files source code so that you can copy and paste it into a new Dreamweaver MX 2004 document, thereby creating the XML you need for import into the Dreamweaver template. Figure 5.10 shows the newly transformed XML code that you need.

18. Right-click the browser window and click View XSL Output.

See the location of the scroll bar. Note that to view the first line you must scroll the length of your browser window while the portion of code that was created by `<xsl:copy-of>` appears with the line breaks. Do not attempt to fix the line breaks in this file manually because you can do this in Dreamweaver MX 2004 automatically.

19. With your cursor at the bottom of the code, click and drag to the top of the document to select all the copy.
20. Right-click the selected text and choose Edit → Copy.
21. In Dreamweaver MX 2004 click File → New to create a new document. In the New Document window, select the General tab at the top and click the Basic Page category on the left and the XML basic page on the right.

FIGURE 5.10 The newly transformed file's XML code. Screen shot reprinted with permission from Microsoft Corporation.

22. Click Create in the New Document dialog box.
23. Place your cursor to the right of the one line of text on your new Dreamweaver XML document (the XML declaration). Press Enter to move the cursor down one line.
24. Right-click and click Paste.

 Dreamweaver MX 2004 cannot parse the file with the current encoding type. In addition, you may have problems opening the file in a text editor with the current encoding type. For more information about encoding types see www.unicode.org/. You must complete step 25 to fix this parsing problem.

25. Remove the second (pasted) XML declaration with the encoding type of UTF-16. The XML file's encoding type should be UTF-8. The page is displayed as shown in Figure 5.11.

 The text must be formatted for easier human readability.

26. From the Command menu in the main menu bar, click Apply Source Formatting. The code is now color-coded and indented and includes proper line breaks after the elements, as shown in Figure 5.12.
27. Save the file as *Blueberry_Farm_New.xml*.

FIGURE 5.11 The text from the new XML document window.

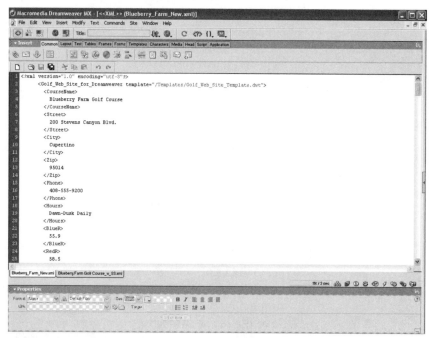

FIGURE 5.12 The formatted and color-coded text from the new XML document window.

The XML file has been opened and then transformed by Internet Explorer. The newly created XML file has been cut and pasted into a new Dreamweaver XML file suitable for import into your template.

CONCEPT: USING A THIRD-PARTY XSL-T PROCESSOR

Other methods for transforming XML files are available. This time you will use a free application called XFactor 1.1 by Richard Wagner. XFactor can be downloaded at*www.dummies.com/extras/xml_aio_fd/*. XFactor uses the Saxon XSL-T processor from Michael Kay. This XSL-T parser can be found at *http://saxon.sourceforge.net/*.

The XFactor XSL-T processor is easy to use. You will now use it to transform the *Blueberry Farm Golf Course.xml*.

1. Launch XFactor. A screen shot of the application is shown in Figure 5.13.

FIGURE 5.13 The XFactor user interface.

2. Click the XML Source button.
3. Click the Open button or click File → Open and navigate to the *Blueberry Farm Golf Course.xml* inside the *Original XML* directory.

The XML file is displayed in the document window, as shown in Figure 5.14.

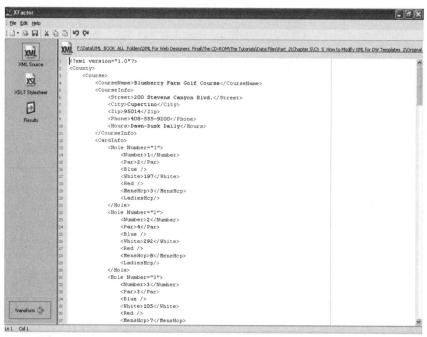

FIGURE 5.14 The *Blueberry Farm Golf Course.xml* displayed in XFactor.

4. Click the XSL-T Stylesheet button. The document window becomes blank. If you want to see the XML document, click the XML button.
5. Click the Open button, or click File → Open and navigate to the *Ch_5_Golf_for_Dreamweaver_Stylesheet.xsl* from the *XSL-T Stylesheets* directory.
6. Click the XML button.
7. Click the Transform button.
8. The newly transformed file is displayed in XFactor, as shown in Figure 5.15.
9. To save the file, click File → Save As. The file is saved as a .txt file with the default name of *results*. You can change this by typing *DW_XML.xml* as the filename and click Save. To clean up the file for easier human readability, open it in Dreamweaver MX 2004 and click Command → Apply Source Formatting. The code is now color-coded and indented and includes proper line breaks after the elements.

FIGURE 5.15 The newly transformed Blueberry Farm XML file, as displayed in XFactor.

You now know two methods for transforming an XML file and saving the results. With the newly transformed files saved, you will now import them into your Dreamweaver template.

Once again, you have seen the power of XSL-T, the XML Stylesheet Transformation language. You transformed an XML file that was not suitable for your purposes into an acceptable file. You have most likely been presented with files you could not use for a variety of reasons. Some of these reasons have included the following:

- The information file was created using obsolete software.
- The software used was an older version and not compatible with the current version.
- The file was created on a different platform (Mac OS verus Windows PC).
- The file was saved in a proprietary format and could not be opened by any available software.

Working with XML does not make this problem go away entirely; however, it does provide a built-in solution. If the XML file you receive does not fit well into your workflow you can create an XSL-T stylesheet that transforms the XML file into the format that you require.

ADDITIONAL RESOURCES

The XFactor XSL-T processor: *www.dummies.com/extras/xml_aio_fd/*
The SourceForge Command Line Saxon XSL-T processor:
 http://saxon.sourceforge.net/
The XML Spy XSL-T processor: *www.xmlspy.com/*

HOW TO IMPORT XML INTO A DREAMWEAVER TEMPLATE

As the use of XML becomes more widespread, your Web design workflow will change. Original files for use in your Web pages could, and in many cases should, come directly from an XML file. The advantages of this highly structured, human-readable format have been explained in Chapters 1 and 2. In addition to the benefits already discussed, you cannot ignore the fact that by importing the XML file directly into your Web pages, you are eliminating one more middle man, one more area in which the content file must be retyped or reformatted manually, thus reducing possible errors and maintaining the integrity of data from the originator to the final output on the Web.

So far, you have prepared your XML files for import into Dreamweaver MX 2004. By implementing an XSL-T stylesheet you have made your incoming XML suitable for the next stage, which is importing the data into your already created template. Let's begin by understanding the importing of XML into templates.

You begin in the Dreamweaver MX 2004 main menu bar File menu. The File → Export Template Data as XML method has already been covered. Now you will learn the menu item File → Import → XML into Template.

In Tutorial 5.2, you completed and saved your Golf template called *Golf_Template.dwt*. This is the template you will use for your new Web pages. You will use File → Import → XML into Template after you create the new page based on your template, inserting the selected XML content into the matching editable regions of the

template. You can also use this method to insert the exported editable regions from a page created from one Dreamweaver template into the editable regions of a page created from a second Dreamweaver template (using File Export → Template Data as XML).

The importing of XML data into a Dreamweaver template creates a static Web page. When the XML file changes, the Dreamweaver template is not automatically updated. In the next tutorial you will use XML data with ColdFusion MX 6.1 to create a dynamic Web page that changes when the XML file changes. The technique you will learn now facilitates the creation of Web pages by making the process a seamless and automated flow from an original XML file to a Web page.

1. Create a new HTML document from the Golf template. Although Dreamweaver MX 2004 builds a new document when you click File → Import XML in Template, you must have a document open to access the File → Import menu command.
2. Click File → Import XML in Template. The XML import dialogue is shown in Figure 5.16.
3. Browse to the *Blueberry_Farm_New.xml* file in the *New Transformed XML Files* folder. Figure 5.17 shows the selected file.

FIGURE 5.16 The Import XML dialog box.

The newly transformed xml files to be imported must not contain an encoding type. If the encoding type attribute is included the XML will not import into the template and you will receive the following error message: "This XML file does not specify a template to use. It cannot be imported." If necessary, remove the encoding attribute from the newly transformed XML files, so that the first line of code reads as follows: `<?xml version="1.0"?>`

4. Click Open. A new untitled document opens in the document window. The document is based on the template referenced in the XML file's root element. Recall that line reads:

```
<Golf_Web_Site_for_Dreamweaver
template="/Templates/Golf_Web_Site_Template.dwt">
```

The XML file's data then populates the template according the template's editable region names and their matching elements in the XML file.

5. Click File → Preview in Browser to view the file in your browser.
6. Close your browser.
7. Save the file as *Finished_Blueberry.htm* and close the file.
8. Repeat steps 1 through 7 for the remaining Golf XML files:
 - *Black_Creek_New.xml*
 - *Cabernet_Club_New.xml*
 - *Deep_Ridge_New.xml*

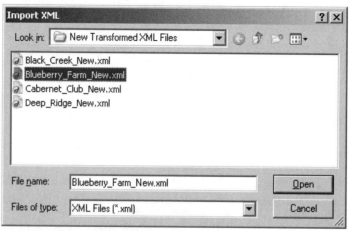

FIGURE 5.17 The Import XML dialog box with the *Blueberry_Farm_New.xml* file selected.

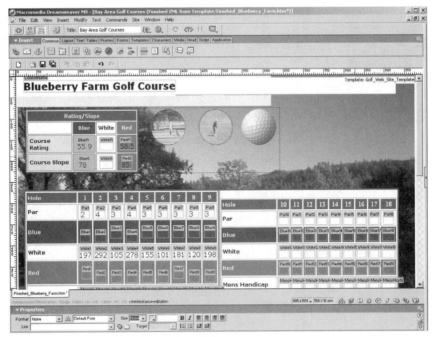

FIGURE 5.18 The new Blueberry Farm Web page.

The ability of Dreamweaver MX 2004 to directly import data from XML files creates a nonstop workflow from content originator to finished Web site with no steps in between to introduce errors and omissions. If data is collected about the golf courses and placed in a database to be output to XML, then Dreamweaver MX 2004 provides an excellent example of software that exploits the benefits of XML. Don't forget that this same XML file can also be imported by page layout software, such as Quark XPress or Adobe InDesign, for print pieces such as brochures, flyers, and books.

ADDITIONAL RESOURCES

Dreamweaver MX 2004 Technical Note: *www.macromedia.com/ support/dreamweaver/ts/documents/templates_xml.htm*

TUTORIAL

TUTORIAL THREE: HOW TO USE XML WITH COLDFUSION

OBJECTIVES

- To understand the XML Document Object in ColdFusion
- To write the code to parse an XML file in ColdFusion
- To create a dynamic Web page with content from an XML file using ColdFusion
- To create a user interface in a Web page that queries the data in an XML file and return the results to the Web browser

BEFORE YOU BEGIN

What You Will Need for This Tutorial

- (PC) Dreamweaver MX 2004
- ColdFusion MX 6.1 Developer Edition
- (PC) Microsoft Internet Explorer 5.x or later

ON THE CD

The Data Files

- **Tutorial Directory:** *Data Files/Part_2/Chapter 5/Ch_5_How To Use XML with ColdFusion_3*
- **Student Files:**
 Ch_5_4_GolfCourses.xml
 Ch_5_CF_XML_Student_1.cfm
 Ch_5_CF_XML_Student_2.cfm
 Ch_5_Golf_CF_Student.cfm
 Valley Gorge Golf Course.xml
- **Supporting Files Directory:** *images*
- **Supporting Files:**
 CIRCLE1.gif
 CIRCLE2.gif
 golfBallCircle.gif
 Golf_Ball_NO_icon.gif
 golfBallicon.gif
 GolfBG1.jpg
 golfbg1.png
 SHIM.GIF

greenBorder.gif
- **Finished Files Directory:** *Ch_5_3 Finished*
- **Finished Files:**
test.xml
ColdFusion_Test.cfm
Valley Gorge Golf Course.xml
Ch_5_4_GolfCourses.xml
Ch_5_CF_XML_1.cfm
Ch_5_CF_XML_2.cfm
Ch_5_Golf_CF_Finished.cfm

INTRODUCTION: DYNAMIC WEB PAGES

So far, you have been using XML to build static Web pages, that is, Web pages that are not capable of changing dynamically either by user activity or server activity. In this tutorial you will create dynamic Web pages. Static Web pages are basically hard-coded, predefined pages with the .htm or .html extension. Only opening and editing the HTML file can change the look, feel, and content of these pages.

Alternatively, you can build dynamic Web pages that respond to changes made by the user or changes made on the server where the pages reside. These pages are referred to as Web applications, and one of the most common is the database-driven Web site. In a database-driven Web site, the Web pages connect to a database and display the database data according to choices made by the user. For example, when viewing a directory of names, the user can display the information in alphabetical order or request only names beginning with the letters A through E. These Web applications go beyond the simple request-and-serve scenario of Web servers and Web browsers in that they require more than the retrieval and delivery of a static HTML Web page. With a Web application, such as a database-driven Web site, data on the server is being manipulated before it is served to the browser. This manipulation requires an application server. Because dynamic Web pages use database connectivity as well as some type of programming logic, they require more than HTML. The additionally required code can be written in a variety of programming languages. One such language is Active Server Pages (ASP), which is a Microsoft technology that ties together its proprietary Web servers with its Scripting languages, JScript

and Visual Basic. This technology is being replaced with Microsoft ASP .NET. JSP, which stands for Java Server Pages, is a Java-based solution to dynamic Web site development that uses a server such as the J2EE server to interpret the JSP code. The language this tutorial focuses on is called ColdFusion MX 6.1, which is based on Macromedia server technology. Its tag-based structure is easy to grasp because its syntax is similar to HTML. Regardless of the programming language being used, the additional code is embedded into the HTML and recognized by the server that then passes the page to the Application Server for processing. The server generally recognizes the programming language by the file's extension, which is no longer .htm or .html. The extensions for dynamic pages can be .asp or .jsp, for Active Server Pages and Java Server Pages, respectively. The extension you will use for the ColdFusion Markup Language is .cfm.

Macromedia Studio MX includes an Application Server called Cold-Fusion Markup Language. It is a fast, efficient, and common Application Server. You may notice many of the Web sites you visit ending with .cfm. In the past Macromedia users implemented Dreamweaver UltraDev for database connectivity. With Macromedia Studio MX, the dynamic code-generating features of UltraDev have been included in Dreamweaver MX 2004.

In this tutorial, your dynamic Web site will not retrieve its data from a database, but in keeping with the subject matter, you will use the ColdFusion Markup Language to retrieve the nodes of the XML file.

Using ColdFusion MX 6.1 is not the only way you can create Web pages that access data from XML files that reside on the server. A popular method, especially for those individuals who are already proficient in ASP, JSP, ColdFusion, and other programming languages that connect Web pages to databases, is to convert the XML file into a relational database. Note also that many database packages, such as those from Oracle, go from relational database to XML and vice versa. See *http://otn.oracle.com/tech/xml/content.html* for details. Some XML editors and other software can take XML files and convert them into database tables. A popular application for this is xmlspy® by Altova. See *www.xmlspy.com/* for more details. Once the XML file is in the form of a database, the data can be manipulated through any of the programming language's standard code. Perhaps the most common method of manipulating this type of data is the Structured Query Language (SQL).

ColdFusion Markup Language is the programming language you will implement in this tutorial. Although this tutorial does not include a

complete treatment of the language's vocabulary, you will have an understanding of its syntax and structure by the time you are done. In addition, because much of this complex language's functionality is beyond the scope of this book, you will explore only that part of the language that pertains to XML.

IMPORTANT SETUP INFORMATION

The addition of programming logic to your Web pages prevents you from accurately testing in a Web browser. The page must do more then simply appear in the Web browser; an Application Server must also process it. You need to see if an Application Server can properly process your Web page. Therefore, before you begin this tutorial you must configure your computer to run the ColdFusion Application Server as well as set up a testing environment to see if your Web application will work on a real server. You will now begin the process of setting up your testing environment.

Your testing environment has several requirements, including the following:

- Installation of Macromedia Studio MX or at least Dreamweaver MX 2004
- Installation of ColdFusion MX 6.1 Developer Edition
- Installation of a development Web Server for testing, such as:
 - The ColdFusion MX 6.1 Developer Edition running as a stand-alone
 - Windows running the Internet Information Services (IIS) for Windows 2000 and XP
 - Windows running Microsoft Personal Web Server (PWS)
 - Macintosh or Windows with Network or FTP access to the previously mentioned servers
- A properly defined Web site (via the Site Definition dialog box in Dreamweaver MX 2004) that points to the appropriate development Web Server

Macromedia Studio MX 2004 or Dreamweaver MX 2004

This must be installed. This is self-explanatory and should already have been done at this point in the book.

Installation of ColdFusion MX 6.1 Developer Edition

Macromedia Studio MX ships with the free, nonexpiring Macromedia ColdFusion MX 6.1 Developer Edition Server. This Developer Edition is not for deployment as an Application Server. Instead, it is for use on one local host machine and on one remote IP address. It can also be configured with the aforementioned Personal Web Server for use as a standalone development environment for one computer. To install the ColdFusion MX 6.1 Developer Edition, insert the Macromedia Studio MX CD and select ColdFusion MX 6.1 on the installer screen to open the Install Wizard. Follow the prompts to complete the installation. After you begin the installation, the wizard prompts you to select a Web Server from the Web Server screen. The screen lists all the Web servers detected on your system. Macromedia recommends installing the standalone Web server that comes with ColdFusion MX 6.1. Accept the default *Webroot* folder location or browse to select a different folder. When completing the entries for the Select Password screen, be sure to write down the password because you will need it frequently to access the ColdFusion Administrator. Click Install, and the Install Wizard completes the installation. When prompted, restart your system. You can confirm the installation of the ColdFusion MX 6.1 Server by clicking your Windows Start menu and clicking Settings → Control Panel → Administrative Tools → Services. You should see a list of all the services running in Windows, including the ColdFusion MX 6.1 Application Server with the status column reading Started.

Installation of a Development Web Server for Testing

If you choose not to install the standalone version of the ColdFusion MX 6.1 Developer Edition, you will need a server, such as the Microsoft IIS or PWS. To install either of these, use the Add/Remove Programs utility in the Control Panel and select Add/Remove Windows Components. You will find the Personal Web Server (PWS) in the list of components. Install with the default setup.

A Properly Defined Web Site

You will walk through this process in the initial steps of this tutorial.

Unlike previous tutorials, this tutorial begins with the site definition process. In earlier tutorials, there was nothing unique about defining your sites and it was assumed that as experienced Macromedia users you are more than familiar with the process. This Web site is different

because it is dynamic and, therefore, requires additional setup. The tutorial begins using XML with ColdFusion MX 6.1 by defining your Web site. Before you begin, make sure you have copied the folder *Golf_ColdFusion_w_XML* onto your hard disk. This will be your root directory.

1. Launch Dreamweaver MX 2004, and from the Site menu in the main menu bar choose Manage Sites. Click the New button and select Site from the drop-down menu.

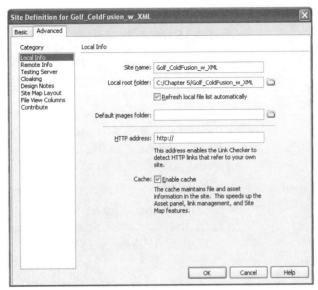

FIGURE 5.19 The Site Definition dialog box with the Advanced tab selected.

2. Click the Advanced tab.
3. Name the site *Golf_ColdFusion_w_XML*.
4. In the Local Root Folder field, browse to the *Golf_ColdFusion_ w_XML* folder, which has been copied from the CD-ROM to your hard drive.
5. Click Remote Info from the Categories on the left.

Personal Web Server for Windows 98

If you are developing with Personal Web Server for Windows 98 (see Important Setup Information) as your standalone server, double-click the Personal Web Manager icon in the system tray. Click the Advanced icon and click Edit Properties. Change the directory to the same location as

your Local Root folder (*Golf_ColdFusion_w_XML*). Then perform the following steps:

1. Choose Local/Network from the Access drop-down menu.
2. In the Remote folder field, browse to *C:\Inetpub\wwwroot\Golf_ ColdFusion_w_XML*

You must create the folder Golf_ColdFusion_w_XML *in* C:\Inetpub\ wwwroot\.

Personal Web Server for Windows XP

If you are developing with Windows XP (see Important Setup Information) as your standalone server, open Internet Information Services from the Administrative Tools control panel. Click the + (plus sign) next to the computer name and expand the Web Sites folder. Right-click the Default Web Site and choose Properties. Select the Home Directory tab, and change the Locate Path value to the same location as your Local Root folder (*Golf_ColdFusion_w_XML*). Then perform the following steps:

3. Choose Local/Network from the Access drop-down menu.
4. In the Remote folder field, browse to *C:\Inetpub\wwwroot\ Golf_ColdFusion_w_XML*.

You must create the folder Golf_ColdFusion_w_XML *in* C:\Inetpub\ wwwroot\.

ColdFusion MX 6.1 Standalone Server

If you are developing with ColdFusion MX 6.1 as your standalone server (see Important Setup Information), perform the following steps:

1. Choose Local/Network from the Access drop-down menu.
2. In the Remote folder field, browse to the CFusionMX folder on your C drive. This folder was created when ColdFusion MX 6.1 was installed. Inside that folder, navigate to the wwwroot folder and create a folder called *Golf_ColdFusion_w_XML*.
6. Click Testing Server from the categories on the left. If you are developing with ColdFusion MX 6.1 as your standalone server (see Important Setup Information):

1. Select ColdFusion from the Server Model drop-down menu.
2. Select Dreamweaver MX 2004 Pages Only from the This Site Contains drop-down menu.

3. Select Local/Network from the Access drop-down menu. In the Testing Server Folder, browse to the same directory as in step 5, *C:/CFusionMX/wwwroot/Golf_ColdFusion_w_XML*.

Personal Web Server

If you are developing with Personal Web Server (see Important Setup Information) as your standalone server:

7. Repeat the previous steps and choose *C:\Inetpub\wwwroot\ Golf_ColdFusion_w_XML* as the Testing Server Folder. Click OK.

Before you can begin developing the site, click the expand/collapse button on the site panel. Click the root directory on the right (Local Files) side of the site window. Click the Put button on the toolbar. These actions put all the files in the site on the Remote Site Directory on the left side of the Site window. Click the Expand/Collapse button again to collapse the Site window.

The dynamic Web site has now been defined. To check that the testing server is operating correctly, open the test file called *Cold-Fusion_Test.cfm*. If this page is displayed as shown in Figure 5.20, then the testing server is working properly.

FIGURE 5.20 The *ColdFusion_Test.cfm* page indicating the testing server is working correctly.

8. Close *ColdFusion_Test.cfm*.

You will begin your XML-driven Web site by creating a few straight-forward files that will help you better understand how ColdFusion MX 6.1 works with XML.

CONCEPT: COLDFUSION MX 6.1 AND XML

ColdFusion MX 6.1 represents XML as an XML Document Object. A Cold-Fusion MX 6.1 structure is like a receptacle for a variety of data, in which each unique part of the structure contains a new piece of data. The XML Document Object is similar to structures in ColdFusion MX 6.1. In addition, many ColdFusion MX 6.1 standard functions work with the XML Document Object. ColdFusion MX 6.1 can view the overall structure of an XML Document Object in two ways: Basic View and Document Object Model (DOM)–based Node View. In Basic View, the XML Document Object is presented as a container that holds one element (the root) structure. This root element can have nested element structures. Each element structure represents an element or opening and closing tag in the XML file. You begin by opening a file that represents the Document Object in Basic View.

1. Open the file *Ch_5_CF_XML_Student_1.cfm*. The page opens with an explanation of how it works. It reads, "This page loads an XML file, reads, and parses the file, then performs a ColdFusion dump to display the XML file."

When ColdFusion MX 6.1 reads the file, the file is read into a dynamic, local parameter that you can use in the page. When ColdFusion MX 6.1 parses the file, it converts it from the string created by the "read" into an XML Document Object. A `<cfdump>` outputs the elements, variables, and values of objects. Now you will create the code for this process, one step at a time.

2. If you are not in Code View, click the Code View button.
3. Place your cursor after the closing paragraph tag, `</p>`, and before the closing body tag, `</body>`, to add the code that loads the XML file.
4. Type the following code below the comment that reads, `<!-- Load the XML File -->`:

```
<CFSET MyXmlFile = ExpandPath("Valley Gorge Golf
Course.xml")>
```

This code returns to you the fully qualified pathname to the *Valley Gardens Golf Course.xml* file and stores the pathname as the variable MyXmlFile. If you were to test the page in the browser (after processing by the Application Server), you would see no change in the document's appearance because nothing has happened other than the loading of the XML file.

5. Type the next section of ColdFusion code following the comment,

```
<!-- Read the XML File -->:
    <CFFILE
            ACTION="READ"
            FILE="#MyXmlFile#"
            VARIABLE="MyXmlCode">
```

This code uses the `<CFFILE>` tag to read the contents of the *Valley Gorge Golf Course.xml* file into a variable called `MyXmlCode`. Both files must be in the same directory for this code to work. The XML file is now recognized as a string in ColdFusion MX 6.1. Here, again, you would see no change in the appearance of your file if you were to test the page in the browser.

6. Type the next section of ColdFusion code following the comment,

```
    <!-- Parse the XML File -->:
        <CFSET MyXml = XmlParse(MyXmlCode)>
```

This code uses the function `XmlParse()` to parse the XML file *Valley Gorge Golf Course.xml* into an XML Document Object. `XmlParse()` accepts any well-formed XML document as a string and returns an XML Document Object to ColdFusion MX 6.1. This XML Document Object is a representation of the XML code in the *Valley Gorge Golf Course.xml* file. Within this representation, ColdFusion MX 6.1 can find and access all of the elements, attributes, comments, and text in the XML structure. This representation can be seen visually in ColdFusion MX 6.1 by using the `<CFDUMP>` element. So far, you have not created anything visible in the Web browser. After you use the `<CFDUMP>` element, however, you will see a visual representation of your XML file.

7. Type the next section of ColdFusion code following the comment,

```
<!-- ColdFusion dump if variable holding XML file is XML -->:
        <cfif IsXmlDoc(MyXml) is "True">
          <cfdump var=#MyXml#>
        </cfif>
```

This code uses a ColdFusion conditional statement, `<cfif>`, to determine if the variable `MyXml` is an XML Document Object. This determination is accomplished with another function called `IsXmlDoc()`. If the condition is true and the variable MyXml is an XML Document Object, the code within the `<CFIF>` tags is executed. The code inside the `<CFIF>` element is a `<CFDUMP>`. A `<CFDUMP>` displays the structure of the ColdFusion code, which in this example is an XML Document Object. This visual display cannot be manipulated in terms of its appearance.

8. The document is displayed as it appears in Dreamweaver MX 2004, as shown in Figure 5.21. To see the results of this page, after the ColdFusion MX 6.1 Application Server has processed it, click View → Live

FIGURE 5.21 The *Ch_5_CF_XML_1_Student.cfm* file as it appears in Dreamweaver MX 2004.

Data from the main menu bar. If the Live Data View button does not respond, you must move your mouse away from the button. The processing of the file by the testing server is indicated by the spinning Dreamweaver icon on the right side of the document window next to the Settings field. The file is displayed as it appears in Live Data view, as shown in Figure 5.22. Alternatively, you can press the keyboard

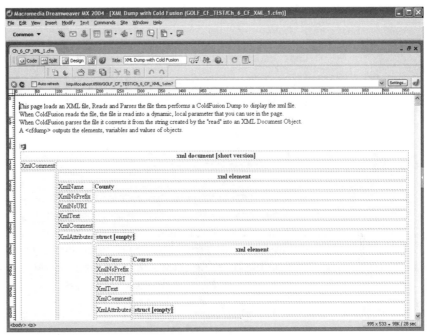

FIGURE 5.22 The *Ch_5_CF_XML_1.cfm* file after the ColdFusion MX 6.1 Application Server has processed it.

equivalent Control + Shift + R. You can also use the Live Data View button on the Document toolbar. If this toolbar is not visible, click View → Toolbars → Document. The Live Data View button is the fifth button from the left and appears with a document icon that has a thunderbolt through it. You can also test the file in the browser by pressing the F12 key on your keyboard. When the testing server finishes processing the page, you will see the XML Document structure as it appears in the Web browser. You will notice that the view in the Web browser differs from the view in the Dreamweaver Live Data view. These differences are in appearance and display only and do not affect the ability to locate and extract the various elements and attributes within the XML file.

If your pages do not match the figures, feel free to open the finished file in the Finished Files directory. You can test this finished file to make sure it works. If it does not, then review your setup instructions for ColdFusion MX 6.1 as well as the site definition instructions. If the finished file works, compare its code to yours to locate your errors.

9. Save the file and click View → Code View.

Code Summary for *Ch_5_CF_XML_1_Student.cfm*

The code has been commented to make it easier to find the location and purpose of the ColdFusion markup. Locate line 16, which reads as follows:

```
<!-- Load the XML File -->
<CFSET MyXmlFile = ExpandPath("Valley Gorge Golf
Course.xml")>
```

The <CFSET> tag creates a ColdFusion variable. In this case, the variable name is MyXmlFile, and the variable is set to a string. This string is returned by the ColdFusion function called ExpandPath(), which returns a string containing the absolute path equivalent to the value of the relative path that is supplied as an argument (*Valley Gorge Golf Course.xml*).

Locate line 19, which reads as follows:

```
<!-- Read the XML File -->
<CFFILE
  ACTION="READ"
  FILE="#MyXmlFile#"
  VARIABLE="MyXmlCode">
```

The <CFFILE> tag manages interactions with files on the server. Common actions such as MOVE, COPY, READ, and WRITE are handled by the <CFFILE> tag's attributes. In this case, you are implementing a READ action on the file given the name MyXmlFile. This READ action reads the file from the server as a text file and as a dynamic local parameter that can be used by the page. The text file is placed into a variable called MyXmlCode and can be referenced though that variable's name.

Locate line 25, which reads as follows:

```
<!-- Parse the XML File -->
<CFSET MyXml = XmlParse(MyXmlCode)>
```

Again, you use <CFSET> to declare a variable. This variable is called MyXml, and its value is the result returned by the ColdFusion XmlParse() function. This function converts the XML Document from the string created by the READ action earlier into an XML Document Object.

Locate the line which reads as follows:

```
<!-- ColdFusion dump if variable holding XML file is XML -->
<cfif IsXmlDoc(MyXml) is "True">
    <cfdump var=#MyXml#>
</cfif>
```

This line is an example of a ColdFusion conditional element. In this example, the <CFIF> tag is using the IsXmlDoc() function to determine if MyXML is an XML Document Object. If this condition is true, the Cold-Fusion MX 6.1 Application Server performs the code in the markup between the <CFIF> tags. In this example, the code to be executed is a <CFDUMP>. This tag outputs the elements, variables, and values of the object it accepts as an argument, which is MyXml.

This file displays the XML Document Object in Basic View.

10. Close the file *Ch_5_CF_XML_Student.cfm*.

 Now you will create another page that is slightly more complicated.

11. Open the file called *Ch_5_CF_XML_2_Student.cfm*. The file appears in Dreamweaver MX 2004 as shown in Figure 5.23.

FIGURE 5.23 The *Ch_5_CF_XML_1.cfm* after the ColdFusion MX 6.1 Application Server has processed it.

This page loads *Valley Gorge Golf Course.xml*, reads the XML file and assigns it a variable name (MyXmlCode), then parses the XML into a variable called MyXML.

A ColdFusion script then searches for the children of the Facilities element and outputs the results.

12. Place your cursor after the appropriate comment code and type the code to load, read, and parse the XML file. When you are finished, your code should read as follows:

```
<!-- Load the XML File -->
<CFSET MyXmlFile = ExpandPath("Valley Gorge Golf
Course.xml")>

<!-- Read the XML File -->
<CFFILE
        ACTION="READ"
        FILE="#MyXmlFile#"
        VARIABLE="MyXmlCode">

<!-- Parse the XML File -->
<CFSET MyXml = XmlParse(MyXmlCode)>
```

13. Type the next section of ColdFusion code after the comment

```
<!-- Search the courses Facilities-->:
    <cfscript>
        selectedElements = XmlSearch(MyXml,
        "County/Course/Facilities/*");
        for (i = 1; i LTE ArrayLen(selectedElements); i = i + 1)
        writeoutput(selectedElements[i].XmlName & " = " &
        selectedElements[i].XmlText & "<br>");
    </cfscript>
```

14. Click the Live Data View button to see how the page is displayed after it is processed. You can also press the F12 key on your keyboard to test the page in the Web browser. The file is shown as it is displayed in Internet Explorer in Figure 5.24.

15. Click the Code View button.

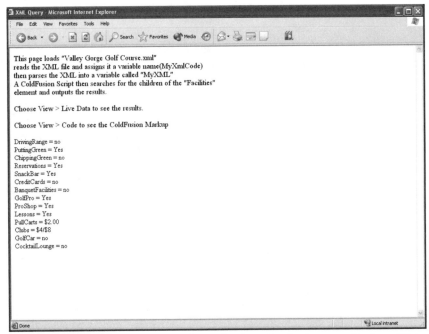

FIGURE 5.24 The *Ch_5_CF_XML_2.cfm* as displayed in the Internet Explorer Web browser. Screen shot reprinted with permission from Microsoft Corporation.

Code Summary for *Ch_5_CF_XML_2_Student.cfm*

The file is loaded, read, and parsed in the same manner as the last example, so you will begin examining the code at line 31. This code is a ColdFusion script, and it reads as follows:

```
<!-- Search the courses Facilities-->
<cfscript>
  MyXml = XmlParse(MyXmlCode);
  selectedElements = XmlSearch(MyXml,
  "County/Course/Facilities/*");
  for (i = 1; i LTE ArrayLen(selectedElements); i = i + 1)
  writeoutput(selectedElements[i].XmlName & " = " &
  selectedElements[i].XmlText & "<br>");
</cfscript>
```

The <cfscript> tag encloses markup that is executed when the page loads. This script begins by declaring a variable called MyXml, which is set to the MyXmlCode variable that represents the XML Document Object. The second line creates another variable called selectedElements. That variable is set by way of a function called XmlSearch(). This function uses an XPath

expression to locate particular elements in the XML file. If you are unfamiliar with XPath, review Chapter 4, Tutorial Two. This XPath expression (`County/Course/Facilities/*`) locates all children of the `<Facilities>` tag, which are children of the `<Course>` tag that are children of the `<County>` tag. The script then implements a ColdFusion `for` loop. This loop (`for (i = 1; i LTE ArrayLen(selectedElements); i = i + 1)` uses the variable `i` as a counter that begins counting at the number 1. When `i` is less than or equal (`LTE`) to a certain number, then the next line of code (the `writeoutput()` function) is executed. Then the variable `i` is incremented by 1. The number of times this code loops is based on the result returned by the `ArrayLen()` function. This function returns the number of elements in the array passed to it as an argument within the functions parentheses. In this example that argument is `selectedElements`, which is the number of children of the `<Facilities>` element. Therefore, the `writeoutput()` function executes once for every child of `<Facilities>`. The `writeoutput()` function does exactly what you would think it does, which is to write the output of the argument passed to it in the parentheses. Take a closer look at the `writeoutput()` line:

```
writeoutput(selectedElements[i].XmlName & " = " &
selectedElements[i].XmlText & "<br>");
```

`selectedElements[i]` represents each individual child of the `<Facilities>` element that is looped through. `.XmlName` is a way of representing the name of an XML element in the XML Document Object. This structure is joined or concatenated by & (ampersand) with an = (equals sign). On the right side of the equals sign, the `selectedElements` content is output, followed by an HTML `
` tag. This ColdFusion script is located in the body tag of the ColdFusion file and is processed by the ColdFusion MX 6.1 Application Server when the page is displayed. You can review the end result by clicking the Live Data View button again.

You will now begin the exercise that builds your Web site dynamically from information contained in an XML file.

1. Open the file called *Ch_5_Golf_CF_Student.cfm* and view the file in Code View. In Design View, the page appears as shown in Figure 5.25. The file is not completely displayed in Live Data View because it is not finished.

FIGURE 5.25 The *Ch_5_CF_XML_Student.cfm* file as displayed in Dreamweaver
MX 2004.

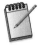

*When building ColdFusion MX 6.1 pages that process XML, the placehold-
ers or variables can become very long strings of text. These long text areas
can interfere with the visual design process. For example if the placeholder
text currently reads:*

```
{MyXml.County.Course[c].CardInfo.Holes.Hole[w].White.XmlText}
```

and the actual data you expect to receive is 315 *(or some other maximum-
three-digit number). At this point your Web page layout is erroneously dis-
playing a field that is far wider than it will actually be when processed. You
can have Dreamweaver MX 2004 display the variables or placeholder text
as curly brackets instead of the long string of text, which will cause
Dreamweaver MX 2004 to render your Web page more accurately. To do
this, click Edit → Preferences and select the Invisible Elements category.
From the Show Dynamic Text as drop-down menu, choose {}. Unfortu-
nately, the side effect of this choice is that your placeholders no longer show
any text; thus, it becomes difficult to determine what the curly brackets are
supposed to contain. To compensate for this, you can open the Code Inspec-
tor from the Window menu in the main menu bar. Now you can click the
curly brackets in the document window and see the corresponding high-
lighted text in the Code Inspector to determine what data the selected curly
brackets contains.*

The file begins with the usual `<html>`, `<head>`, and `<title>` tags, followed by a CSS with the following styles defined:

```
<style type="text/css">
<!--
    .text {
 font-family: Verdana, Arial, Helvetica, sans-serif;
font-size: 13px;
line-height: 18px;
width: 375px;
text-align:justify;
    }

body {
margin-left:1in;
background-attachment: fixed;
background-image: url(golfbg1.png);
background-repeat: repeat-y;
    }

.greenFees {
font-family: Verdana, Arial, Helvetica, sans-serif;
font-size: 10px;
line-height: 15px;
color: #000000;
position: relative;
left: 500px;
top: 0px;
background-color: #FFFFFF;
}
.courseName {
        font-family:Verdana, Arial, Helvetica, sans-serif;
        font-size:36px;
        }
.address {
        font-family:Verdana, Arial, Helvetica, sans-serif;
        font-size:18px;
    }
.fees {
        font-family:Verdana, Arial, Helvetica, sans-serif;
        font-size:18px;
        color:white;
    }
.greenFeesText {
font-family: Verdana, Arial, Helvetica, sans-serif;
font-size: 10px;
line-height: 15px;
color: #000000;
}
```

```
-->
</style>
```

The CSS is followed by the closing head tag, `</head>`, and the opening body tag, `<body>`. The file continues with the same code you wrote earlier to load, read, and parse the XML file.

2. Scroll down to the comment, `<!-- loop through all the courses -->`. This ColdFusion file extracts various nodes from an XML file that contains four golf courses, and thus four `<course>` tags. You must write a line of code that essentially loops through each `<course>` tag. As you loop through each course, you access information such as the course name, address, and phone number. You will ultimately close this loop element when you are done extracting all the information you need from the XML file.

3. Underneath the comment code, type the following line:

```
<cfloop index="c" from="1"
to="#ArrayLen(MyXml.County.Course)#">
```

To create a loop, use the `<cfloop>` tag. Let's look at the tag's attributes, beginning with `index`. This attribute creates a variable that counts as you loop through the code. Use the variable letter `c` instead of the more common `i`. The `c`represents the current course you are looping through in the code. The value of `index` is not limited to one character; you could use a more verbose value, such as `courseCounter`. You will use the letter `c` as an abbreviation. The `from` and `to` attributes determine when to start looping and when to stop. Begin your loop from the number 1 and end the loop after the last `<Course>` tag in the file. You might be wondering how ColdFusion MX 6.1 is coded so as to determine the last `<Course>` tag. In this case, you use a ColdFusion function called `ArrayLen()`. This function accepts a particular node set as an argument and returns as a result the number of nodes in that set. This number is the stopping point for our loop. So, which node set are you processing in your `ArrayLen()` function? Let's figure out that argument now. The value being passed to the `ArrayLen()`function is `MyXml.County.Course`. Recall from the following code:

```
<!-- Parse the XML File -->
<CFSET MyXml = XmlParse(MyXmlCode)>
```

that `MyXml` represents your XML document. This code is followed by the dot (.) syntax and the next node, which is `<County>`, which is the parent

to your next node, `<Course>`. Therefore, the element you are counting in your node set is the `<Course>` element, of which there are four in the XML file. All of the code contained in your `<cfloop>` tag executes four times as a result of the four `<Course>` tags in the file. The # (crosshatches) that surround the `ArrayLen()` value of the `to` attribute indicate a ColdFusion variable and distinguish it from another datatype, as in the `from` attribute's value of `1`. ColdFusion MX 6.1 treats text that is surrounded by crosshatches as a ColdFusion variable or function call.

Your loop will work just fine. However, you have not yet allowed any text to be displayed in the browser. The next line of code does just that.

4. Locate the comment, `<!-- Display the course name -->`, and type the following code:

```
<cfoutput><div
class="courseName">#MyXml.County.Course[c].CourseName.XmlText#
</div></cfoutput>
```

5. To see the results of this code, switch to Design View and click the Live Data View button. The page appears in Dreamweaver MX 2004 as it is shown in Figure 5.26.

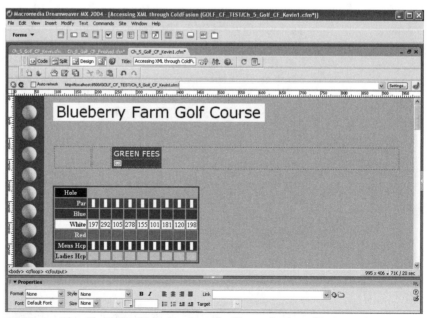

FIGURE 5.26 The *Ch_5_CF_XML_Student.cfm* file as displayed in Dreamweaver MX 2004 with one variable in place for the course name.

The `<cfoutput>` element outputs whatever is inside of it to the browser, including the result of ColdFusion variables and function calls. Therefore, in your code the output includes an HTML `<div>` tag, which contains the results of the ColdFusion variable called for within the crosshatches. Remember, `MyXml` is your XML document. In the XML document is the root node `<County>` followed by whatever `<Course>` tag is currently being processed in the (previously written) loop represented by the counter `c`. The current `<Course>` tag's `<CourseName>` child is located next and its text is displayed as output to the browser window using `.XmlText`. Thus, you access the golf course name by combining `MyXml.County.Course[c].CourseName.XmlText` . You will take a similar approach to accessing the `<Street>`, `<City>`, and `<Phone>` elements.

6. Locate the comment `<!-- Display the course address -->`, and type the following code:

```
    <cfoutput><br />
    <div> class="address">
    #MyXml.County.Course[c].CourseInfo.Street.XmlText#,
    #MyXml.County.Course[c].CourseInfo.City.XmlText# California

    <strong>#MyXml.County.Course[c].CourseInfo.
    Phone.XmlText#</strong>
    <p></p>
    <strong>#MyXml.County.Course[c].CourseInfo.
    Hours.XmlText#</strong>
    </div>
        </cfoutput>
```

This code will cause the street, city, phone number, and hours of operation information to be displayed in the browser. To view the document in Design View, click the Live Data View button. The code should be displayed as shown in Figure 5.27.

Each line uses a similar syntax to access the required node in the XML file, beginning with the XML document represented by `MyXML`, followed by the root element `<County>`, the Child `<Course>` from the array of child nodes indicated by `[c]`, followed by the tag you want to access, which is `City` for the first line, `Phone` for the second, and `Hours` for the last, followed by `.XmlText` to access the tag's content.

A table has already been built to accommodate the code you want to insert next. The first section is for the course description. To see the table being used for layout and presentation, view the page in Design

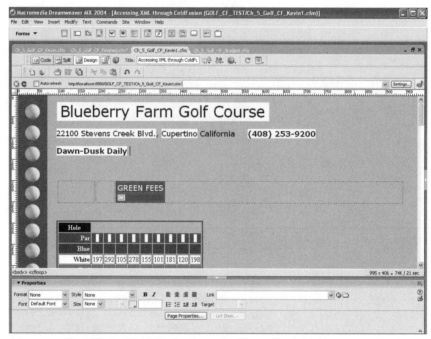

FIGURE 5.27 The *Ch_5_CF_XML_Student.cfm* file as displayed in Dreamweaver MX 2004 with the variables in place for the street, city, phone number, and hours of operation.

View. You will now place the `<CourseDescription>` element where it belongs in the table.

7. Locate the following code:

```
<cfoutput>
  <table width="850">
    <tr>
      <td width="375" valign="top"> <span
      class="text"></span></td>
```

This code represents the beginning of the table. Specifically, it is the first cell in the first row. Place your cursor between the opening and closing `` tags, which is currently an empty element, and type the following code to access the `<CourseDescription>` element from your XML file:

```
#MyXml.County.Course[c].CourseDescription.
Paragraph.XmlText#
```

The file is now displayed in Dreamweaver Design View and Live Data View as shown in Figure 5.28.

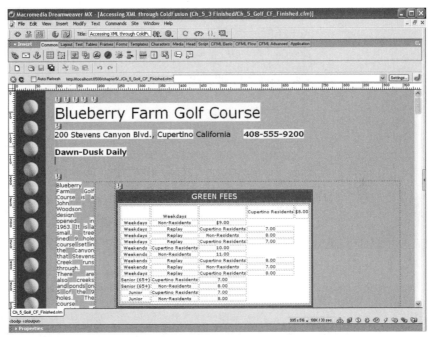

FIGURE 5.28 The *Ch_5_CF_XML_Student.cfm* file as displayed in Dreamweaver MX 2004 with the variables in place for the course description.

The layout may not look correct; however, the file looks considerably different than when displayed in the Web browser. You will view the page in the Web browser shortly. Of course, if you can't wait to see what this file looks like, click the Live Data View button or press the F12 key to preview the page in the browser. Then continue with the ColdFusion code to add the Green Fees.

8. Place your cursor after the following code:

```
<!-- Output Green Fees -->
<table bgcolor="darkgreen">
<tr>
<td align="center"><div class="fees">GREEN FEES</div></td>
<tr>
<td>
<table border="1" bordercolor="darkgreen" bgcolor="white">
<tr><td>
```

```
<table border="0" cellspacing="2" bgcolor="##FFFFFF"
width="100%">
  <tr align="center">
```

You will now place the content for the <GreenFees>. Because you do not know in advance how many <GreenFees> elements you will encounter per golf course, you will do a loop similar to the first <Course> tag loop.

9. Type the following loop code:

```
<cfloop index="f" from="1"
to="#ArrayLen(MyXml.County.Course[c].GreenFees.Fees)#">
 <cfset conditions="#ArrayLen(MyXml.County.Course[c].
GreenFees.Fees[f].Conditions.XmlChildren)#">
  <cfloop index="cd" from="1" to="#conditions#">
```

Also add the necessary closing loop and closing output tags. Your entire code from the beginning of the loop to the next comment section should match the following:

```
<cfloop index="f" from="1"
to="#ArrayLen(MyXml.County.Course[c].GreenFees.Fees)#">
            <cfset conditions="#ArrayLen(MyXml.County.Course[c].
            GreenFees.Fees[f].Conditions.XmlChildren)#">
          <cfloop index="cd" from="1" to="#conditions#">
            <td align="center">
            <cfoutput>
              <div class="greenFeesText">#MyXml.
              County.Course[c].GreenFees.Fees[f].
              Conditions.XmlChildren[cd].XmlText#</div> </td>
            </cfoutput>
          </cfloop>
        </tr>
        </cfloop>
      </table>
      </td>
      </tr>
  </table>
  </table>
  </td>
  </tr>
  </table>
  </cfoutput>
  <p></p>
```

10. Proofread your code to match the previous code, including the new variable inside the `<div>` tag:

```
#MyXml.County.Course[c].GreenFees.Fees[f].Conditions.
XmlChildren[cd].XmlText#
```

Be sure you have added all the proper closing tags.

11. Press the F12 key to view the page in Internet Explorer. If prompted to save your changes, click Save. The file is displayed as shown in Figure 5.29.

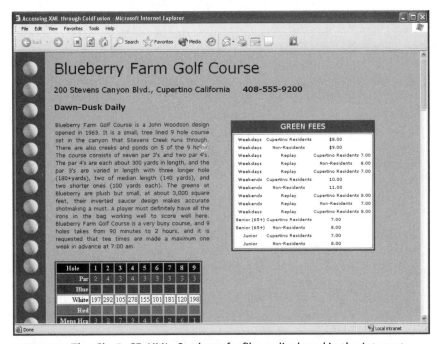

FIGURE 5.29 The *Ch_5_CF_XML_Student.cfm* file as displayed in the Internet Explorer Web browser with the variables in place for the Green Fees. Screen shot reprinted with permission from Microsoft Corporation.

Now you are ready to build the golf card. Because you do not know if the course you are currently looping through is a 9- or an 18-hole course, you must first create an array for the <hole> tags.

12. Locate the comment, `<!-- get an array of holes -->`, and type the following code:

```
<cfset theHoles = MyXml.County.Course.CardInfo.
Holes.XmlChildren>
<cfset size = ArrayLen(theHoles)>
<cfset numHoles = #size#>
```

This code simply declares a variable with the <CFSET> tag. The variable name is theHoles, and its value is set to the children of the <Holes> tag. Again, use the ArrayLen() function to count the number of elements, then declare the variable numHoles equal to the variable size, which holds the number of individual <Hole> tags. You can open the XML file to see the structure of these tags. A portion of the code follows:

```
<CardInfo>
        <Holes>
         <Hole Number="1">
                <Number>1</Number>
                <Par>2</Par>
                <Blue/>
                <White>197</White>
                <Red/>
                <MensHcp>3</MensHcp>
                <LadiesHcp/>
         </Hole>
         <Hole Number="2">
```

You will now output the first hole in the golf card. The remaining holes are already completed.

13. Locate the following code:

```
<!-- output golf card -->
<cfoutput>
  <table border='3' bordercolor="darkgreen">
    <tr bgcolor="black">
      <th><font color="white">Hole</font></th>
```

This code is where you will place your loop code.

14. Type the following code:

```
<cfloop index="h" from="1"
to="#ArrayLen(MyXml.County.
Course[c].CardInfo.Holes.XmlChildren)#">
 <th><font color="white">
#MyXml.County.Course[c].CardInfo.
Holes.Hole[h].Number.XmlText#</font></th>
</cfloop>
```

Remember, the remaining `<Hole>` tag code is already in place.

15. Click Design View and Live Data View to see the page in Dreamweaver MX 2004. Press the F12 key to view the page in the Web browser. It is displayed as shown in Figure 5.30.

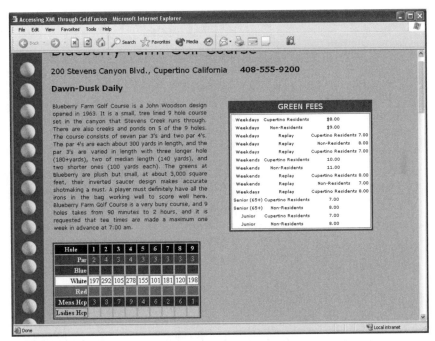

FIGURE 5.30 The *Ch_5_CF_XML_Student.cfm* file as displayed in the Internet Explorer Web browser with the variables in place for the golf card. Screen shot reprinted with permission from Microsoft Corporation.

The last section requires a ColdFusion conditional statement. You will create a chart of each golf courses' facilities; however, once again, you do not know in advance what facilities each course provides. The chart will list all of the golf course facilities available and use graphical icons to indicate if a course provides a facility. For example, if a golf course contains a driving range, then an icon of a golf ball will appear in the chart. If the course does not provide a driving range, a different icon will appear. Now you will write the ColdFusion `<cfif>` tag to implement this conditional statement.

16. Locate the following code:

```
<!-- Display Chart of Facilities -->
<cfoutput>
  <table width="750" border="1" cellpadding="2"
  cellspacing="2" bgcolor="darkgreen">
    <tr>
      <td><table width="775" border="0" cellpadding="2"
      cellspacing="2" bgcolor="##FFFFFF">
          <tr align="center" valign="top">
            <td width="135"><strong><font size="2"
            face="Verdana, Arial, Helvetica,
            sans-serif">Driving
          Range: <br>
```

17. Type the following code:

```
<cfif MyXml.County.Course[c].Facilities.DrivingRange.XmlText
is 'no'>
<img src="Golf_Ball_NO_icon.gif" align="absmiddle" /><br/>
<cfelse>
<img src="golfBallicon.gif" align="absmiddle"/><br/>
</cfif>
```

This code uses the `<cfif>` element to determine if the text inside the `<DrivingRange>` element is equal to no. If it is, then the code directly below is output. This code is a simple image tag, which displays the graphic *Golf_Ball_NO_icon.gif* on the page. If the `<cfif>` statement is false, the processor moves on to the `<cfelse>` statement and places a different graphic on the page. After that code the `<cfif>` element is closed with `</cfif>`. At this point the ColdFusion page is complete.

18. Save the file. View the page in Design View and Live Data View, and preview it in the browser. The completed file is shown in Figure 5.31 as it appears in Internet Explorer.

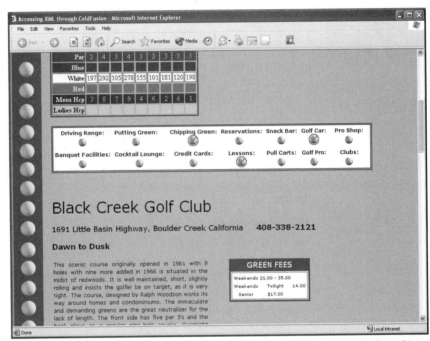

FIGURE 5.31 The completed *Ch_5_CF_XML_Student.cfm* file as it is displayed in the Internet Explorer Web browser. Screen shot reprinted with permission from Microsoft Corporation.

ColdFusion MX 6.1 supports a wide variety of Web Application technologies, one of which is XML. This tutorial serves as a brief introduction to accessing XML from a server by way of ColdFusion code. In this way you can build dynamic Web sites where the information served to the Web browser originates from XML, which resides on the server. As more businesses store data in XML, the need arises to retrieve that data dynamically. ColdFusion MX 6.1 is an excellent tool for accessing XML. In addition, ColdFusion MX 6.1 supports the XPath standard for accessing nodes.

TUTORIAL FOUR: HOW TO CREATE DYNAMIC WEB PAGES WITH XML AND COLDFUSION MX 6.1

OBJECTIVE

- To understand and create ColdFusion Queries

BEFORE YOU BEGIN

What You Will Need for This Tutorial

- Dreamweaver MX 2004 (PC version)
- ColdFusion MX 6.1 Developer Edition
- (PC) Microsoft Internet Explorer 5.x or later

The Data Files

ON THE CD

- **Tutorial Four Directory:**
 Ch_5_How To Use XML with ColdFusion_3
 Ch_5_CF_XML_Student_1.cfm
 Ch_5_CF_XML_Student_2.cfm
 Ch_5_Golf_A_E.xml
 Valley Gardens Golf Course.xml
 Ch_5_Golf_CF_Student.cfm
 Ch_5_4_GolfCourses.xml
- **Finished Files Directory:** *Ch_5_4 Finished*
- **Finished Files:**
 Ch_5_ActionPage_Finished.cfm
 Ch_5_ActionPage_Result_Finished.cfm
 Ch_5_Basic_Query_Finished.cfm
 Ch_5_Golf_A_E.xml

INTRODUCTION

This tutorial explores the dynamic aspects of ColdFusion MX 6.1 and XML. Using the ColdFusion Markup Language you will query the XML file to return only the results you desire. For example, your XML file contains information for numerous golf courses; however, through ColdFusion queries, you can search for a specific golf course by name. The

query code searches the entire XML file and returns to the browser the one golf course for which you were searching. The use of ColdFusion queries can get quite complex, depending on your search criteria. This tutorial introduces the topic of queries and creating dynamic Web pages using ColdFusion MX 6.1. When you finish this tutorial you should have a basic understanding of how to query XML through ColdFusion MX 6.1 and return the results to the Web browser.

The idea of creating dynamic Web pages with ColdFusion MX 6.1 and XML begins with the concept of a ColdFusion query.

CONCEPT: COLDFUSION QUERIES

You can convert XML documents into ColdFusion query objects and manipulate them using queries of queries. This technique does not require the use of XPath, yet it provides a method for searching XML documents and extracting the nodes or elements from the XML file. Dreamweaver MX 2004 provides two methods for creating queries: simple and advanced. Neither of these methods works when querying XML files because they are designed to query the contents of a database, not an XML file. ColdFusion MX 6.1 supports the creation of queries that query an XML file; however, you must type the code in the ColdFusion file yourself. By definition a query looks up data from a file. In a database file, the query searches records in a table. Both the records and the tables to be searched must be indicated in the query. The most common language used to query a database is the Structured Query Language, or SQL. In this tutorial you will query an XML file and must write your queries in the ColdFusion Markup Language while in the Dreamweaver Code View. You begin with a simple query to get comfortable with the structure of the language.

1. Open the file called *Ch_5_Basic_Query_Student.cfm* from the *Chapter 5* directory and select the Design View button. The text on the Web page indicates what this Web page will do. It reads: "This page:
 - Calculates and displays the number of courses.
 - Calculates and displays the number of `<CourseInfo>` tags.
 - Queries the `<Course>` tags and dumps the query
 - Queries and displays the Altos course

2. View the page in Code View. You will see that it loads, reads, and parses the XML file called *Ch_5_Golf_A_E.xml*, which is the same XML file you used in the previous tutorial. Comments in the code show where you need to perform the queries.

Before writing your queries, you must gather some information and store it as variables. The purpose for this information will become clear when you build your queries.

Locate the comment that reads, `<!-- create an array of course in-formation -->`, and place your cursor below the comment.

3. Type the following code:

```
<cfset CourseInfoArray =
MyXml.County.Course.CourseInfo.XmlChildren>
<cfset theCourseInfo = ArrayLen(CourseInfoArray)>
```

This code uses the `<cfset>` tag to declare a variable. The name of the variable is `CourseInfoArray`, and it is set to the array of tags that are children of the `<CourseInfo>` tag. Notice the syntax ColdFusion MX 6.1 uses to get to this array: `MyXml`, which is the variable name that represents the XML file called *Ch_4_Golf_A_E.xml* as a string, followed by the dot syntax, and the root element `County` followed by the dot syntax, and the `<Course>` tag (which is a child of `<County>`) followed by the dot syntax, and the `<CourseInfo>` tag, followed by the dot syntax, and the ColdFusion Markup `XmlChildren`, which is the array of child nodes of the preceding node, `<CourseInfo>`. Thus, the variable `CourseInfoArray` is equal to all the children of the `<CourseInfo>` element, which is a child of the `<Course>` element, which is a child of the `<County>` element of the loaded XML file referred to as `MyXml`.

The next line also declares a variable whose name is `theCourseInfo` and whose value is set to the result returned by the `ArrayLen()` function. This function returns a number equal to the length or the total number of members of a given array. The array is provided as an argument to the function and appears within the parentheses. The array in this example is denoted by the variable name `CourseInfoArray`. The purpose of this code is to make variables of the number of children of the `<CourseInfo>` tag. The variables declared here are used later in your queries. Therefore, the variable `theCourseInfo` is equal to the number of child elements of the `<CourseInfo>` element. You will repeat the same code with different variable names and arguments to determine the amount of `<Course>` tags in the XML file.

4. Locate the comment, `<!-- create an array of courses-->`, place your cursor on the line below it, and type the following code:

```
<cfset theCoursesArray = MyXml.County.XmlChildren>
<cfset numCourses = ArrayLen(theCoursesArray)>
```

As you can see, this code is identical to the previous code, with the exception of the `XmlChildren` array that it locates. This code returns the number of children of the root element `<County>`. If you look at the XML file, you will see that the root element `<County>` has only one child element, called `<Course>`; however, multiple occurrences of the `<Course>` tag exist within the XML file.

Now you are ready to write your first query. This query searches the XML file, creating a table of rows with records that reference the nodes or elements in the XML file. Specifically, you will search for the course name, street, city, Zip code, phone number, and hours of operation.

5. Locate the comment, `<!-- create the XML Golf Course Information Query -->`, place your cursor on the line below it, and type the following comment:

```
<!--- create a query object with the golf course data --->
```

6. Type the following variable declaration:

```
<cfset courseInfoQuery = QueryNew("CourseName, Street, City,
Zip, Phone, Hours")>
```

This line declares a variable called `CourseInfoQuery` and uses the `QueryNew()` function to set its value to a new ColdFusion Query. The `QueryNew()` function accepts one parameter, which is a list of one or more columns upon which to search. In this example, you provide as an argument to the function the names of the XML tags you want the query to search for: `CourseName`, `Street`, `City`, `Zip`, `Phone`, `Hours`. Notice that you must quote the entire list and separate the element names by a comma. You do not want the query to return the `CourseName`, `Street`, `City`, `Zip`, `Phone`, and `Hours` for the first course in the XML file but for all courses in the XML file. Therefore, you must loop through all the `<Course>` tags when performing the query. This process calls for the ColdFusion loop tag. The next line of code opens your loop.

A common mistake is leaving out the loop. The end result is that your Web page contains only the data from one portion of the XML structure. For example, in this case, only one golf course's information would be returned. When you have recurring child tags in your XML file and you wish to extract all the data, you must loop through all the child tags with the Cold-Fusion loop tag.

7. Type the following opening loop tag:

```
<cfloop index="i" from = "1" to = #numCourses#>
```

A ColdFusion loop tag loops through the tag body 0 or more times, based on a condition specified by the tag attributes. These attributes include index, which is the counter for the loop represented by its value—in this example, the letter i. Should your code ever need to work on the currently processed element, you can indicate it through the index value. You will see an example of the index value at work in the next tutorial. At this point, indicate the tag you are looping through with the index attribute equal to i for index; however, you can and should use any letter you wish that corresponds the tag you are looping through. For example, if you are looping through the course tag, the index could be equal to any of the following values:

```
index= "course"
index = "c"
index= "crse"
```

You indicate how many times to loop the code through the from and to tags. In this example, you will loop from the first instance of the code (from = "1") and continue to execute or loop through the code until you have reached the total number of <Course> tags indicated by the variable numCourses. Recall that whenever you wish to retrieve the value of a ColdFusion variable, surround the variable name with crosshatches. Here you see the usefulness of declaring the variable numCourses as a placeholder for the total number of <Course> tags in the XML file.

When you are working with XML data that is subject to updates, deletions, and other changes, you often do not know how many tags you will encounter at a given point. Because the XML data may change the number of golf course tags, you used a variable to hold that number. Alternatively, if you hard-coded the from attribute of the loop to a number such as 22 (assuming at the time of coding you had 22 golf courses), your code would not account for added golf courses over time. You should always use variables that dynamically create values that may change over time.

The QueryAddRow() function adds a specified number of empty rows to a query. You then populate the row with cells, which represent the data you wish to query. Essentially you are building a table of data from the XML file. The queryAddRow() function does not specify the number of rows you want and, therefore, defaults to 1.

8. Type the next variable declaraton:

```
<cfset temp = QueryAddRow(courseInfoQuery)>
```

This code declares a variable called `temp` and sets its value to the result of the `QueryAddRow()` function, which adds one row to the `CourseInfoQuery`.

You are now ready to set the cells in the row of the table equal to the values in the XML file that you wish to query.

9. Type the following code to set a cell to a value:

```
<cfset CourseName = QuerySetCell(courseInfoQuery,
"CourseName",
    #MyXml.County.Course[i].CourseName.XmlText#)>
```

The first value you set uses the variable name `CourseName` and sets it to the result of the `QuerySetCell()` function. This function accepts three parameters. The first is the name of the executed query (`courseInfoQuery`). The second is the name of the column in the query (`CourseName`), and the third is the value to set in the cell. So, what value are you looking for here? With XML, you indicate that value by its location within the XML tree of nodes and surround it by crosshatches:

```
#MyXml.County.Course[i].CourseName.XmlText#
```

It can be helpful to read this value from right to left. You are looking for the `XmlText` of the `CourseName` node that is a child of the `Course` node (notice how you use your `index` value to indicate the `Course` node currently being looped through the XML file) that is a child of the root element `County` of the XML document known as `MyXml`.

You will now declare the remaining cells in the row.

10. Type the remaining code to set the cells equal to the values of the remaining XML tags: `Street`, `City`, `Zip`, `Phone`, and `Hours`.

```
<cfset Street = QuerySetCell(courseInfoQuery, "Street",
        #MyXml.County.Course[i].CourseInfo.Street.XmlText#)>
<cfset City = QuerySetCell(courseInfoQuery, "City",
        #MyXml.County.Course[i].CourseInfo.City.XmlText#)>
<cfset Zip = QuerySetCell(courseInfoQuery, "Zip",
        #MyXml.County.Course[i].CourseInfo.Zip.XmlText#)>
<cfset Phone = QuerySetCell(courseInfoQuery, "Phone",
        #MyXml.County.Course[i].CourseInfo.Phone.XmlText#)>
<cfset Hours = QuerySetCell(courseInfoQuery, "Hours",
        #MyXml.County.Course[i].CourseInfo.Hours.XmlText#)>
```

11. Close the opening ColdFusion loop tag:

```
</cfloop>
```

You will now output the results of your code to the Web page, beginning with the total number of `<Course>` tags in the XML file.

12. Locate the code that reads:

```
<!-- output the Number of courses-->
  <cfoutput>
    <p> </p>
```

Place your cursor below the code, and type the following line:

```
<p>Number of courses = #numCourses# </p>
```

Here you simply type the HTML code for a paragraph, followed by the text `Number of courses =` followed by the ColdFusion variable for the number of courses: `#numCourses#`.

13. Click the Design View button and then the Live Data View button to see the results. Your files should indicate `Number of courses = 15` on the screen, as shown in Figure 5.32.

FIGURE 5.32 The partially completed file in Design View with the Live Data View displayed.

14. Click the Live Data View button again and return to Code View.
15. Locate the code that reads:

```
<!-- output the Number of <CourseInfo> tags -->
    <p> </p>
```

Place your cursor below it, and type the following:

```
<p>Number of &lt;CourseInfo&gt; tags = #theCourseInfo#
    <p> </p>
```

This code creates essentially the same result as the previous code, except it calls for the variable named `#theCourseInfo#`. It should be noted that everything you have added thus far, that has resulted in an output to the browser window, has been in between the `<cfoutput>` tags, which were already in place before you opened the file. Look at code view carefully to locate the opening and closing `<cfoutput>` tags. These tags are required when outputting ColdFusion variables to the browser window.

16. Click the Design View button and then the Live Data View button to see the results. Your files should now indicate `Number of courses = 15` followed by `Number of <CourseInfo> tags = 5` on the screen, as shown in Figure 5.33.

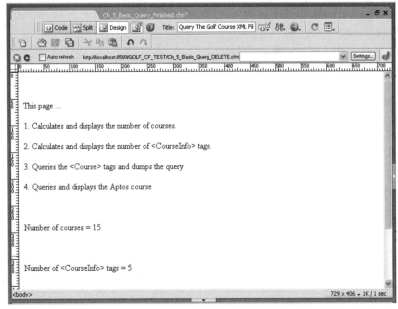

FIGURE 5.33 The partially completed file in Design View with the Live Data View displayed.

17. Click the Live Data View button again and return to Code View.

 So far, you have used all of your code except the query itself. Perhaps the quickest way to test whether or not your query is working is to use a `<cfdump>` to dump the results of the query to the browser window.

18. Locate the code that reads:

    ```
    <!-- output the contents of the courseInfoQuery -->
    Contents of the courseInfoQuery object: <br>
    ```

19. Place your cursor on the line below it, and type the following ColdFusion dump code:

    ```
    <cfdump var=#courseInfoQuery#>
    ```

20. View the results in Design View, Live Data View, or test the page in the Web browser by clicking the F12 key. See Figure 5.34 for the results. If your XML file is long, it may take several minutes for the processor to access and dump the data to the browser window.

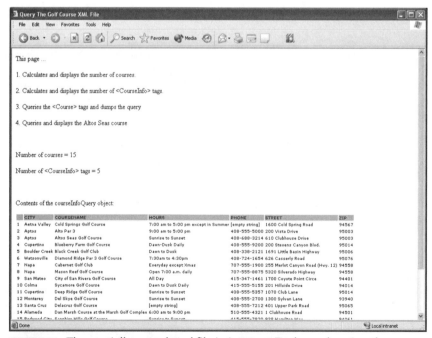

FIGURE 5.34 The partially completed file in Internet Explorer showing the ColdFusion dump of the `courseInfoQuery` query.

The final step in the introduction to queries is to query a query. You will query the query you just made to extract specific information. Type the query and then review the code in detail.

21. Locate the comment code that reads:

```
<!-- query the Altos Golf Course -->
```

and place your cursor on the line below.
22. Type the following query of the query:

```
<cfquery name="AltosQuery" dbType="query">
    SELECT CourseName
    FROM courseInfoQuery
    WHERE CourseName LIKE 'Altos Seas Golf Course'
</cfquery>
```

This code is similar to the simple and advanced queries that Dreamweaver MX 2004 creates through the dialog boxes. Because you are querying an XML file, you must type the code manually.

Begin with the ColdFusion query tag, `<cfquery>`, which requires the `name` attribute to name the query, allowing you to call it as necessary by name. You must also use the attribute `dbtype` set to `query`. Within the ColdFusion query tag, indicate what column you wish to query and where that column can be found. The term `column` comes from the database world where data is in tables with columns and rows. The column you are looking for is indicated by the `SELECT` statement followed by the column name, `CourseName`. The `FROM` statement indicates where the column can be found, which is the `courseInfoQuery`. The `WHERE` statement is a clause that acts as a filter to find a specific record stipulated by a condition. Thus, the condition you are specifying is that the `CourseName` column be equal to `Altos Seas Golf Course`. The ColdFusion `LIKE` statement is equivalent to the = comparison operator in other languages.

Now you will dump the results of your query of the query.

23. Locate the code that reads:

```
<br>
Select the Altos Seas Golf Course <br>
<!-- use a ColdFusion dump tag to output the Aptos Query -->
```

and place your cursor on the line below it.

24. Type the following ColdFusion dump tag:

```
<cfdump var=#AltosQuery#>
```

25. View the results in Design View or Live Data View, or test the page in the Web browser by clicking the F12 key. See Figure 5.35 for the results.

FIGURE 5.35 The completed file in Dreamweaver MX 2004 showing the ColdFusion dump of the `courseInfoQuery` query and the `AltosQuery`.

The first query dump displays the results returned by the `courseInfoQuery`. The second query queries the `courseInfoQuery`, returning only the `Altos Seas Golf Course`.

You are now finished with this tutorial; however, before you leave this file, save some of your code so that you can reuse it in other files. Dreamweaver MX 2004 allows you to save all or parts of your code for use on the Code panel.

26. Click Window → Snippets.

CONCEPT: SNIPPETS

You can create and insert snippets of HTML, JavaScript, CFML, ASP, JSP, and more. Dreamweaver MX 2004 also contains some predefined snippets

that you can use. Snippets of code are stored on the Code panel's Snippets tab. From this panel you can insert, create, edit, or delete code snippets.

To make the code easier to find when you need it, file it in this new directory.

27. Make sure none of the current directories in the Snippets panel are selected and click the New Snippets Folder button at the bottom left of the Snippets panel. The folder icon is the New Snippets Folder button.
28. Name the directory *Golf XML ColdFusion Code.*
29. Highlight the following text in the ColdFusion file:

```
<!-- Load the XML File -->
<CFSET MyXmlFile = ExpandPath("Ch_4_Golf_A_E.xml")>
```

30. With the previous text still highlighted, click the New Snippet button (+) on the Snippets panel. The dialog box in Figure 5.36 appears.

 In the Name field type `Load the Golf XML`
 In the Description field type, `this codes loads the "Ch_4_Golf _A_E.xml" file into the variable "MyXmlFile."`
 The Insert Before field will already contain the snippet you highlighted.

31. Click OK.

If the new code snippet is not inside the *Golf XML ColdFusion code* directory, drag it into the directory.

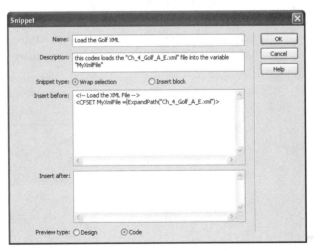

FIGURE 5.36 The Add New Snippet dialog box.

32. Repeat the process of creating a new snippet for the following code:

```
<!-- Read the XML File -->
    <CFFILE
      ACTION="READ"
      FILE="#MyXmlFile#"
      VARIABLE="MyXmlCode">
```

Name this snippet *Read the Golf XML* and give it the following description:

```
"this reads the MyXmlFile into a variable called MyXmlCode."
```

33. Repeat the process of creating a new snippet for the following code:

```
<!-- Parse the XML File -->
<CFSET MyXml = XmlParse(MyXmlCode)>
```

Name this snippet *Parse the Golf XMLML* and give it the following description:

```
"this parses the XML string MyXmlCode into a variable called
MyXml."
```

The preceding three snippets are now available to you whenever you need them.

This concludes the introduction to ColdFusion queries. The next tutorial features what Macromedia refers to as Action Pages. You will build a simple form containing a drop-down menu. The drop-down menu's options come from the XML file. The Form's submit button sends the data to another ColdFusion page that is dynamically created based on the selection the user makes in the drop-down menu. �ॐ

TUTORIAL

TUTORIAL FIVE: HOW TO SEARCH XML DATA WITH COLDFUSION MX 6.1

OBJECTIVES

- To create Web pages that search XML files
- To create ColdFusion Action Pages
- To enable the ColdFusion Action Page to return a result to the Web browser

BEFORE YOU BEGIN

What You Will Need for This Tutorial

- Dreamweaver MX 2004 (PC version)
- ColdFusion MX 6.1 Developer Edition
- (PC) Microsoft Internet Explorer 5.x or later

ON THE CD

The Data Files

- **Tutorial Five Directory:**
 Ch_5_How To Use XML with ColdFusion_3
 Ch_5_ActionPage_Result_Student.cfm
 Ch_5_Basic_Query_Student.cfm
 Ch_5_Golf_A_E.xml
- **Finished Files Directory:** *Ch_5_4 Finished*
- **Finished Files:**
 Ch_5_ActionPage_Finished.cfm
 Ch_5_ActionPage_Result_Finished.cfm
 Ch_5_Basic_Query_Finished.cfm
 Ch_5_Golf_A_E.xml

INTRODUCTION

This tutorial demonstrates the use of a ColdFusion Action Page. A Cold-Fusion Action Page is just like any other application page, except you can use the form variables passed to it from an associated form. The Action Page gets a form variable for every form control that contains a value when the form is submitted. Your form has only one control: a drop-down menu. The drop-down menu itself retrieves its options from your XML file.

A form variable's name is the name that you assigned to the form control on the form page. Your form variable name is `whichCourse`. You can refer to the form variable by name within tags, functions, and other expressions on an Action Page.

Because form variables extend beyond the local page—their scope is the Action Page—prefix them with `Form.` to explicitly tell ColdFusion MX 6.1 that you are referring to a form variable. For example, the following code references your form's `whichCourse` form variable for output on an Action Page:

```
<cfoutput>
    #Form.whichCourse#
</cfoutput>
```

You will refer to the page with the Form as the Action Page in its file name. However, the true ColdFusion action page is the page that receives the forms variables and processes them. In this tutorial you will refer to this page as the Action Page Results page.

Begin by creating a new blank Cold Fusion document.

1. Click File → New. In the New Document dialog box, select Dynamic Page, ColdFusion, as shown in Figure 5.37.
2. Click Create.
3. Select Code View, and place your cursor in the `<Body>` tag.
4. Open the Code panel and select the Snippets tab.

FIGURE 5.37 The New Document dialog box with the Dynamic Page Category selected and the ColdFusion Dynamic Page.

5. Select the Load the Golf XML snippet and click the Insert button. The code is inserted into the document.
6. Select the Read the Golf XML snippet and click the Insert button. The code is inserted into the document.
7. Select the Parse the Golf XML snippet and click the Insert button. The code is inserted into the document.
8. With your cursor where you left off in step 7, below the three added snippets, type the code from the last tutorial that counted the `<Course>` tags:

```
<!-- create an array of courses-->
<cfset theCoursesArray = MyXml.County.XmlChildren>
<cfset numCourses = ArrayLen(theCoursesArray)>
```

Now you are going to write your query. This query uses the same code structure as the query in the last tutorial; therefore, the query code will not be dissected line by line. This query is longer because you are creating more columns to search. This query searches the XML file for: `CourseName, Street, City, Zip, Phone, Hours, CourseDescription, DrivingRange, PuttingGreen, ChippingGreen, Reservations, SnackBar, CreditCards, BanquetFacilities, GolfPro, ProShop, Lessons, PullCarts, Clubs, GolfCar,` and `CocktailLounge`.

9. Type the following query code:

```
<!--- create a query object with the golf course data --->
<cfset courseInfoQuery = QueryNew("CourseName, Street, City,
Zip, Phone, Hours, CourseDescription, DrivingRange,
PuttingGreen, ChippingGreen, Reservations, SnackBar,CreditCards,
BanquetFacilities, GolfPro, ProShop, Lessons,PullCarts, Clubs,
GolfCar, CocktailLounge") >
<cfloop index="i" from = "1" to = #numCourses#>
<cfset courseRow = QueryAddRow(courseInfoQuery)>
    <cfset CourseName = QuerySetCell(courseInfoQuery,
    "CourseName",
        #MyXml.County.Course[i].CourseName.XmlText#)>
    <cfset Street = QuerySetCell(courseInfoQuery, "Street",
        #MyXml.County.Course[i].CourseInfo.Street.XmlText#)>
    <cfset City = QuerySetCell(courseInfoQuery, "City",
        #MyXml.County.Course[i].CourseInfo.City.XmlText#)>
     <cfset Zip = QuerySetCell(courseInfoQuery, "Zip",
        #MyXml.County.Course[i].CourseInfo.Zip.XmlText#)>
    <cfset Phone = QuerySetCell(courseInfoQuery, "Phone",
        #MyXml.County.Course[i].CourseInfo.Phone.XmlText#)>
    <cfset Hours = QuerySetCell(courseInfoQuery, "Hours",
        #MyXml.County.Course[i].CourseInfo.Hours.XmlText#)>
```

```
            <cfset CourseDescription = QuerySetCell(courseInfoQuery,
            "CourseDescription",
                #MyXml.County.Course[i].CourseDescription.
                Paragraph.XmlText#)>
            <cfset DrivingRange = QuerySetCell(courseInfoQuery,
            "DrivingRange",
                #MyXml.County.Course[i].Facilities.
                DrivingRange.XmlText#)>
            <cfset PuttingGreen = QuerySetCell(courseInfoQuery,
            "PuttingGreen",
                #MyXml.County.Course[i].Facilities.
                PuttingGreen.XmlText#)>
            <cfset ChippingGreen = QuerySetCell(courseInfoQuery,
            "ChippingGreen",
                #MyXml.County.Course[i].Facilities.
                ChippingGreen.XmlText#)>
            <cfset Reservations = QuerySetCell(courseInfoQuery,
            "Reservations",
                #MyXml.County.Course[i].Facilities.
                Reservations.XmlText#)>
            <cfset SnackBar = QuerySetCell(courseInfoQuery, "SnackBar",
                #MyXml.County.Course[i].Facilities.SnackBar.XmlText#)>
             <cfset CreditCards = QuerySetCell(courseInfoQuery,
             "CreditCards",
                #MyXml.County.Course[i].Facilities.
                CreditCards.XmlText#)>
            <cfset BanquetFacilities = QuerySetCell(courseInfoQuery,
            "BanquetFacilities",
                #MyXml.County.Course[i].Facilities.
                BanquetFacilities.XmlText#)>
            <cfset GolfPro = QuerySetCell(courseInfoQuery, "GolfPro",
                #MyXml.County.Course[i].Facilities.GolfPro.XmlText#)>
            <cfset ProShop = QuerySetCell(courseInfoQuery, "ProShop",
                #MyXml.County.Course[i].Facilities.ProShop.XmlText#)>
            <cfset Lessons = QuerySetCell(courseInfoQuery, "Lessons",
                #MyXml.County.Course[i].Facilities.Lessons.XmlText#)>
            <cfset PullCarts = QuerySetCell(courseInfoQuery,
            "PullCarts",
                #MyXml.County.Course[i].Facilities.PullCarts.XmlText#)>
            <cfset Clubs = QuerySetCell(courseInfoQuery, "Clubs",
                #MyXml.County.Course[i].Facilities.Clubs.XmlText#)>
            <cfset GolfCar = QuerySetCell(courseInfoQuery, "GolfCar",
                #MyXml.County.Course[i].Facilities.GolfCar.XmlText#)>
           <cfset CocktailLounge = QuerySetCell(courseInfoQuery,
           "CocktailLounge",
                #MyXml.County.Course[i].Facilities.
                CocktailLounge.XmlText#)>
        </cfloop>
```

10. Click the Design View button.

You will now build the short form that will serve as the input for your Action Page.

11. Save the page as *Ch_5_Golf_Action_Page.cfm*.
12. From the Insert bar, select Forms, as shown in Figure 5.38.

FIGURE 5.38 The Insert bar with the Forms category selected.

13. Click the Form button to place a form tag on the stage.
14. In the Property Inspector, place your cursor in the Action field and enter, `Ch_5_Golf_XML_Results.cfm`, as shown in Figure 5.39. In Code View you must change the `<form>` tag into a ColdFusion Form tag. Replace the `<form>` and `</form>` tags with `<cfform>` and `</cfform>`, respectively.

FIGURE 5.39 The Property Inspector with the `Form` tag selected and the `action` attribute set to `Ch_5_Golf_XML_Results.cfm`.

15. Click within the red dotted outline in the document window and type: `Select a Golf Course:`. The type should appear within the red dotted line that represents the form.
16. From the Insert bar, click the List/Menu button to create a drop-down list. On the Property Inspector, name the Menu `whichCourse`.

While Dreamweaver MX 2004 automates—through dialog boxes—the creation of dynamic form components such as drop-down menus, it

does not do so if the data originates from an XML file. Thus, you use the Dynamic button on the Property Inspector. Instead you will manually write the code in the drop-down menu's `<select>` tag.

17. Select Code View.
18. Replace the `<select>` tag with the following code:

```
<cfselect name="whichCourse" query="courseInfoQuery"
value="CourseName">
</cfselect>
```

Notice the tag is `<cfselect>` as opposed to `<select>`.

19. Return to Design View.
20. Click the Enter key on your keyboard to move the cursor down a line.
21. Click the Submit button from the Insert bar. Your Web page should now look like that shown in Figure 5.40.

FIGURE 5.40 The Form data for the Action Page in Dreamweaver MX 2004.

The data for your Action Page is finished. You can now test it in the browser to see if the drop-down menu works. It should use the query to retrieve the golf course names.

22. Press the F12 key to test the page in the Web browser. The page should appear as shown in Figure 5.41.

FIGURE 5.41 The Action Page as it is displayed in Internet Explorer with the drop-down menu's options retrieved from the XML file's `<CourseName>` tags.
Screen shot reprinted with permission from Microsoft Corporation.

Now the page with your initial data (the drop-down menu) works, but recall that the Submit button is programmed to direct the form's data to *Ch_5_Golf_XML_Results.cfm* from the `action="Ch_5_Golf_XML_ Results.cfm"` in the `<cfform>` tag. However, the page *Ch_5_Golf_ XML_Results.cfm* does not exist yet. You must build that ColdFusion MX 6.1 page now. This is the Action Page, but you will refer to this page as the "results" page because it displays in the Web browser the results of your search for a golf course from the drop-down menu in the form page.

Let's look at how this new page works. The page contains the load, read, and parse instructions for the XML file. It also contains the

same query you wrote for the first page. Your first page used only the CourseName column of that query to populate the drop-down menu, and, in reality, the query would have worked if all it looked for was the CourseName column. If you reexamine the query, however, you will see that it also contains the columns for Street, City, Zip, Phone, Hours, CourseDescription, DrivingRange, PuttingGreen, ChippingGreen, Reservations, SnackBar, CreditCards, BanquetFacilities, GolfPro, ProShop, Lessons, PullCarts, Clubs, GolfCar, and CocktailLounge. The Action Page never looks for these columns, but your results page will.

The question is, for which golf course will it retrieve a Street, City, Zip, and so on? The answer lies in the form on the Action Page. Recall from the previous lesson the query of a query. That is exactly what you need now. You must write a query that queries your original query for the information you need for the one golf course chosen in the drop-down menu. How can you reference through code the choice the user made in the drop-down menu? Recall the name of the Select menu is whichCourse. You can retrieve this information by preceding it with the ColdFusion code for the form on the Action Page, which is the word Form. Separate the two statements with the dot syntax, so the end result for obtaining the choice made by the user in the Action form's select menu is Form.whichCourse, and because it is a ColdFusion variable, surround it with the crosshatches for an end result of #Form.whichCourse#. Open the partially completed "results" page (ColdFusion Action Page) and write the query that queries the courseInfoQuery.

23. Open the file called *Ch_5_ActionPage_Result_Student.cfm.*

Take a closer look at this file in Code View. Starting at the top you can see some CSS that provides the presentation or style information for the page. Following that you load, read, and parse the Golf XML file, build the array of <Course> tags, and write the main courseInfoQuery.

Below the query is where you begin actually outputting information to the Web browser. Notice the ColdFusion <output> tag. Now you will apply some CSS to the ColdFusion variable you want to output. The first line you present for output is #Form.whichCourse#. This line simply uses the information passed from the Action Page, which is the same information used to populate the drop-down menu: the name of the golf course.

Following that, use more CSS to format the output that comes next:

```
#Info.Street#, #Info.City# #Info.Zip# - #Info.Phone#
   - Open: #Info.Hours#
```

This code displays on the page the results of the `Info` queries' `Street` column, thus the syntax, `Info.Street`, followed by a comma and another variable that represents the Info queries' `City` column, and so on.

24. To see how the page is displayed in the browser without showing the actual data, click the Design View button. This process gives you an indication of the look of the page. It also provides a comfortable and familiar WYSIWIG environment in which to build your Web page while at the same time seeing placeholders where the actual data will be. Your page should be displayed in Design View as shown in Figure 5.42.

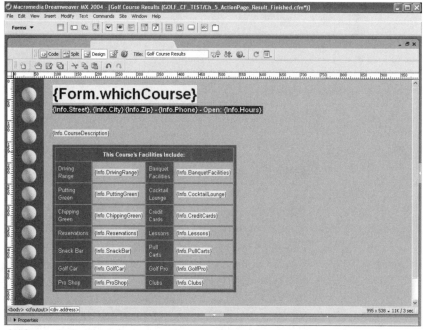

FIGURE 5.42 The Action results page as it is displayed in Dreamweaver MX 2004 without showing the actual data.

After you write the query of the query, view the page in Live Data View to see if it works.

25. Place your cursor after the `courseInfoQuery`, and type the new query:

```
<cfquery name="Info" dbType="query">
  SELECT CourseName, Street, City, Zip, Phone, Hours,
  CourseDescription, DrivingRange, PuttingGreen,
```

```
ChippingGreen, Reservations, SnackBar,CreditCards,
BanquetFacilities, GolfPro,
ProShop, Lessons,PullCarts, Clubs, GolfCar, CocktailLounge
FROM courseInfoQuery
WHERE CourseName LIKE '#Form.whichCourse#'
</cfquery>
```

Notice its structure is identical to the last tutorial. However, the WHERE clause is looking specifically for the nodes in the XML file whose CourseName element is equal to the choice made on the Action Page's drop-down menu. This is indicated by the WHERE statement that reads, WHERE CourseName LIKE '#Form.whichCourse#'.

26. Save the file, switch to Design View, and test the form the following way:
 1. Activate the Action Page called *Ch_5_Golf_Action_Page.cfm* in Dreamweaver MX 2004.
 2. Click File → Preview in Browser.
 3. Make a selection from the drop-down menu.
 4. Click the Submit button.
 5. Wait for the ColdFusion Results page to process.

 See Figure 5.43.

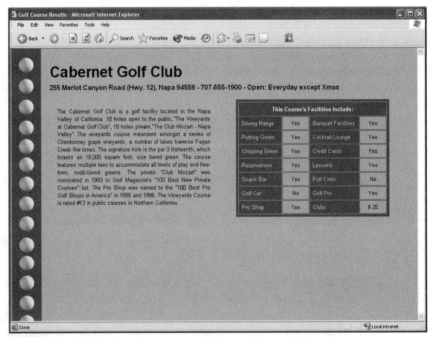

FIGURE 5.43 The results of the Action Results page as displayed in Internet Explorer. Screen shot reprinted with permission from Microsoft Corporation.

You can click the back button on your browser and select any other course for similar results. The Action Page sends the course name it should query to the results page, which then displays the information according to the HTML code in the page called *Ch_5_ActionPage_Result_Student.cfm*.

SUMMARY

As you have seen, the ColdFusion Markup Language can be used to create dynamic Web pages from the data that originates from an XML file. Therefore, as the server-side XML is updated or changed, the Web pages containing that data, obtained via ColdFusion Markup, change as well. In addition, ColdFusion MX 6.1 XML pages can be made more dynamic by allowing the user to dictate which parts of the XML file they wish to see. This tutorial provides a basic introduction to obtaining XML data from Coldfusion MX 6.1, and in it you have been shown how to access the individual elements within an XML file as well as how to query the XML file for specific results. This chapter concludes our examination of the XML support provided by Dreamweaver MX 2004. The next chapter covers Macromedia Fireworks MX 2004.

ADDITIONAL RESOURCES

Search for the following topics in the Dreamweaver MX 2004 Help Files:
Using ColdFusion MX 6.1
About XML and ColdFusion
Macromedia Web Site:
Utilizing XML and XSL-T in ColdFusion MX 6.1: *www.macromedia.com/devnet/mx/coldfusion/articles/xmlxslt.pdf*

XML and Fireworks MX Professional 2004

Dreamweaver MX 2004 is not the only Macromedia product in the Macromedia Studio MX 2004 suite that offers XML support. Chapter 6 explores the XML support that comes with Fireworks MX Professional 2004. The tutorial walks you through a process known as the Data-Driven Graphics Wizard. This wizard, accessed from the Fireworks Command menu on the main menu bar, creates Fireworks PNG files like a macro. The graphics files that the wizard creates extract information from an XML file. This information can be imported bitmap images, hypertext links, or text. The wizard creates the graphics files saves them as PNGs in a specified directory, and exports the graphics as GIFs or JPGs also to the directory you specify.

The Data-Driven Graphics Wizard provides an ideal method for creating multiple graphics files from a single template. Web banners that look basically the same except for changing content are good candidates for using the Data-Driven Graphics Wizard. As in Dreamweaver MX 2004, you create a Fireworks template containing common graphics, links, verbiage, background colors, and so on. From the template you create the graphics files. The dynamic or changing part of the graphics file comes from information stored in an XML file.

6

XML AND FIREWORKS MX 2004

In This Chapter:

- Overview of Fireworks Templates
- Tutorial One: Running the Data-Driven Graphics Wizard

Chapter 6 examines the XML support built into Fireworks MX 2004. Fireworks MX 2004 uses XML to create multiple graphics files from one basic template, which contains the artwork common to all desired graphics files. It then uses information from an XML file to create the dynamic elements of the file. For example, if your Web site involves splash screens that appear when you enter various parts of the site, a Fireworks MX 2004 file can be created with the common background color and icons. The remaining splash screens can be created like a macro, where slogans and logos found in an XML file are used to create the different splash screens. This chapter teaches you how to use this macro-like functionality, known as the Data-Driven Graphics Wizard.

OVERVIEW OF FIREWORKS TEMPLATES

When you plan to use the Data-Driven Graphics Wizard, you should build a Fireworks file as you normally do, creating your art and layers as needed. Remember, you will ultimately use this file as a template. Like a Dreamweaver template, you should place only art that is common to all files in it. In other words, include only art in this file that you want to see in all the files, such as background colors and logos. On those parts of the file where the information changes, you use placeholder text, called variables. Fireworks MX 2004 can create three different types of these variables:

- Text variables
- Image variables
- URL variables

Let's examine how you create these variables in your Fireworks file, beginning with the easiest, text variables. If the files you intend to create using this Fireworks template and the Data-Driven Graphics Wizard include changing text lines, such as product names, slogans, and model numbers, you should create text variables to act as placeholders for the text that will ultimately be extracted from an XML file. These variables are the easiest to create. Simply surround the placeholder text (or variable) with curly brackets, as in the following example:

{new slogans go here}

This line is typed directly into your Fireworks canvas and formatted as you would like it to appear in each of your graphics files. Format this text as you would any other text, by selecting it and choosing a color, typeface, size, and so on.

Image variables are created a bit differently. You must place a dummy or placeholder image into the graphics file. Then you name the graphic image in the Property Inspector with the name surround by curly brackets, as in: {graphic}.

For URL variables, you first create a hypertext link, just as you would normally do in Fireworks MX 2004. You then create a slice with the Slice Tool that surrounds the area that you would like to be a hypertext link. In the Link field of the Property Inspector type the placeholder or variable URL in curly brackets as in the following:

{www.WebAddress.com}

When naming these variables use names that match the names of elements in the XML file.

This tutorial includes two exercises. The first exercise begins with finished artwork (a Web page) created entirely in Fireworks MX 2004. Variables have been placed in the Fireworks art that match the nodes on an XML file. You use the Data-Driven Graphics Wizard to create additional Web Pages. In the second exercise, you create a Web banner template from scratch and use the Data-Driven Graphics Wizard to import an XML file's data to automate the creation of four additional banner ads.

Begin the first exercise by opening the XML file that contains the data that will populate your Web site, which was created in Fireworks MX 2004 as a template.

TUTORIAL

TUTORIAL ONE: RUNNING THE DATA-DRIVEN GRAPHICS WIZARD

OBJECTIVES

- To create a Web banner in Fireworks MX 2004 as a graphics template file (.png)
- To use the Data-Driven Graphics Wizard to create additional banners automatically

BEFORE YOU BEGIN

What You Will Need for This Tutorial

- Fireworks MX 2004 (Macintosh or PC version)
- (PC) Microsoft Internet Explorer 5.x or later
- (Mac) Microsoft Internet Explorer 5.2 or later

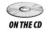
ON THE CD

The Data Files

- **Tutorial One Directory:** *Data Files/Part_3/Chapter 6/*
- **Student Files Directory:**
 Ch_6_XML_Generated_Images
 Ch_6_XML_Generated_PNGs
- **Student Files:**
 Ch_6_Fireworks_XML.xml
 Ch_6_Golf_XSL_for_FW.xsl
 Blueberry Farm Golf Course.xml
 Ch_6_Golf_WebPage.png
- **Student Files Subdirectory:** *Data Files/Part_3/Chapter 6/Web_Banner*

- **Student Files:** *resorts.xml*
- **Student Files Subdirectory:** *Data Files/Part_3/Chapter 6/Web_Banner/images*
- **Student Files:** *Iron.jpg*
- **Student Files Subdirectory:** *Data Files/Part_3/Chapter 6/Web_Banner/Exported Web Banner PNGs*
- **Student Files:** This folder is intentionally empty
- **Student Files Subdirectory:** *Data Files/Part_3/Chapter 6/Web_Banner/Exported Web Banner Graphics*
- **Student Files:** This folder is intentionally empty
- **Student Files Subdirectory:** *Data Files/Part_3/Chapter 6/Web_Banner/Banner_Images*
- **Student Files:**
 Banner1.png
 Banner2.png
 Banner3.png
 Banner4.png
- **Finished Files Directory:** *Data Files/Part_3/Chapter 6/Web_Banner/Finished Web Banner Files*
- **Finished Files:** *Golf_Resort_Banner_Template.png*
- **Finished Files Subdirectory:** *Exported Web Banner Graphics*
- **Finished Files:**
 Golf_Resort_Banner_Template1.jpg
 Golf_Resort_Banner_Template2.jpg
 Golf_Resort_Banner_Template3.jpg
 Golf_Resort_Banner_Template4.jpg
- **Finished Files Subdirectory:** *Exported Web Banner PNGs*
- **Finished Files:**
 Golf_Resort_Banner_Template1.jpg
 Golf_Resort_Banner_Template2.png
 Golf_Resort_Banner_Template3.png
 Golf_Resort_Banner_Template4.png

INTRODUCTION

Oftentimes in Web development you need to create multiple versions of a graphics file, each with minor changes. A perfect example of this is Web banners, which often have a similar look but with differing content. Other examples are charts and tables that have a consistent look and feel, with each having different data. Rather than painstakingly re-creating each of these graphics files, the Fireworks MX Data-Driven

Graphics Wizard allows you to create one file that creates many files. The key to this functionality is to store the changing content in an XML file. When more graphics files need to be created, simply add to the XML file and run the Wizard. The XML data file may already exist as XML becomes more widespread. If you need to create a large number of graphics, you may want to generate this XML file yourself and then let Fireworks do the tedious work of creating each individual graphics file. You will begin the first exercise by examining this file creation process.

 Due to changes in the Fireworks Data-Driven Graphics Wizard, you should download the latest trial version of Fireworks MX 2004 before beginning this tutorial, including any updates. You can download the latest version of Fireworks MX 2004 at www.macromedia.com.

1. Launch Internet Explorer or Dreamweaver MX 2004 and open the XML file called *Ch_6_Fireworks_XML.xml* from the *Chapter 6* Student Folder. This file is displayed in Figure 6.1.

FIGURE 6.1 The *Ch_6_Fireworks_XML.xml* file that you will use for your Fireworks template data.

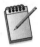

This XML file was created from the original Golf XML files that were created in Chapter 3. They were transformed into the XML in Figure 6.1 by the XSL-T stylesheet named Ch_6_Golf_XSL_for_FW.xsl. This file is inside the Chapter 6 directory. You can use this stylesheet with Internet Explorer or XFactor to transform any of the existing Golf XML files for use in Fireworks MX 2004. For more information refer to Tutorial One in Chapter 5 (How to Modify XML for Use in Dreamweaver Templates).

The root element is `<Golf_Web_Site_for_Fireworks>`. The root element has four children called `<Course>`. The child elements, of course, have names that match the names of the variables in the Fireworks template. Take a close look at this XML file, which you will use to create multiple Web pages. It contains four golf courses: Valley Gorge Golf Course, Black Creek Golf Club, Cabernet Golf Club, and Deep Ridge Golf Course. Each course contains its corresponding address, golf card information, and facilities.

2. Close the XML file. Now look at the Fireworks file that will use the data in the XML file.
3. Launch Fireworks MX 2004. It opens and displays a screen, as shown in Figure 6.2. Click the Open a recent item link and open the

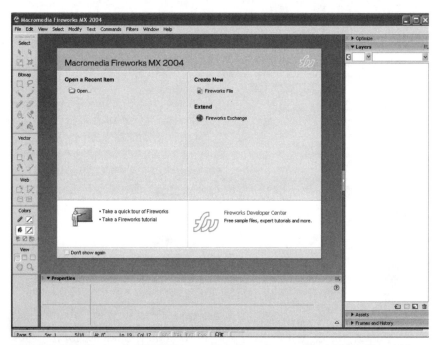

FIGURE 6.2 The Fireworks MX 2004 user interface shown after its initial launching.

file *Ch_6_Golf_WebPage.png*. The file is displayed as shown in Figure 6.3.

This file could be a complete Web page by itself or, more likely, because it has no built-in navigation, part of a Web page, perhaps a frame. Examine this file from the top. The green text that reads {courseName} is the first variable. It will be replaced with the element <courseName> from the XML file you just examined. Below the {courseName} text are the variables—Street, City, Zip, Phone, and Hours—all surrounded by curly brackets. The text that is not surrounded by curly brackets—Hours: and California—is static text, meaning that it will not change but appear as it does here on every page the Data-Driven Graphics Wizard creates. Inside the golf ball are the variables—BlueR, WhiteR, RedR, BlueS, RedS, and WhiteS—all of which match nodes in the XML file. The static text includes the titles Course Rating and Course Slope and the color-coded

FIGURE 6.3 The *Ch_6_Fireworks_XML.xml* file that you will use for your Fireworks template data.

Red, White, and Blue subheadings. The golf card contains all the variables for the course holes, including Red Flags, White Flags, Blue Flags, Par, Men's Handicap and Ladies' Handicap. These variables look bad because some of them overlap. This is not a problem because the data that replaces the variables will not exceed three digits, resulting in no overlap on the final pages. Finally, the Facilities section contains the variables for each courses' facilities. Now you will run the Data-Driven Graphics Wizard.

4. From the Command menu choose Data-Driven Graphics Wizard. The Wizard is displayed in a new window, as shown in Figure 6.4.

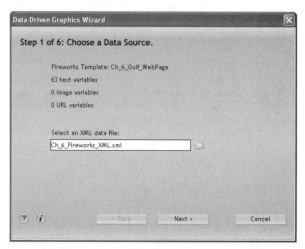

FIGURE 6.4 The Data-Driven Graphics Wizard displaying step 1 of 6.

Step 1 of 6 begins by indicating which Fireworks PNG file is being used as a Fireworks template. The number of variables in each category beginning with the text variables follows this. This example shows 86 text variables with no graphics or URL variables. (In the next exercise you will create all three types of variable.) The only field in step 1 of the wizard is to browse to the XML file that contains the data that will populate the template.

5. Click the Browse icon and navigate to *Ch_6_Fireworks_XML.xml* from the *Chapter 6* student directory.
6. Click the Next button to move to step 2 of 6, as indicated in Figure 6.5.

Step 2 allows you to preview the XML data and the variable it will replace in the Fireworks template file.

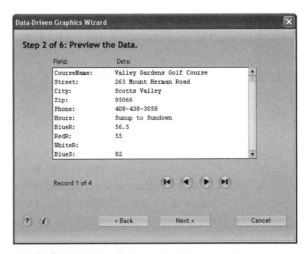

FIGURE 6.5 The Data-Driven Graphics Wizard
displaying step 2 of 6.

Fireworks considers each <Course> child element of the root element
as a record. Thus, a total of four records are in the file, each correspond-
ing to a <Course> tag in the document—Valley Gorge Golf Course, Black
Creek Golf Club, Cabernet Golf Club, and Deep Ridge Golf Course.

7. Click the Next Record button to traverse each <Course> tag and its
 children.
8. Click the Next button to see step 3 of 6, as displayed in Figure 6.6.

FIGURE 6.6 The Data-Driven Graphics Wizard displaying
step 3 of 6.

Step 3 of 6 allows you to decide which of these records, or in this case <Course> elements, you would like the Wizard to process. You can choose All Records. Again, in this case that would be all four golf courses. You can also choose First Record Only. Your last choice is a specific number of records. For example, if you wanted to create Web pages for the Black Creek and Deep Ridge Golf Courses only, you would enter 2, 4 in the Specific Record Numbers field. These records can be seen by clicking the back button and using the navigation buttons to traverse the records.

9. Click the button at the top to process All Records.
10. Click the Next button to move on to step 4 of 6, as displayed in Figure 6.7.

FIGURE 6.7 The Data-Driven Graphics Wizard displaying step 4 of 6.

Step 4 of 6 maps the variable names to their corresponding XML nodes. Currently the variables all match, so no variables are in the Select a Variable Field. If a variable had no matching XML node, you would select the variable from the left and click a Field from the Select A Field area on the right. The section at the bottom titled Mapped Variables displays the current variables and their corresponding field from the XML file. (Because it is not necessary to map any variables in this example, you will map a variable to a field in the next exercise.)

11. Click the Next button to move on to step 5 of 6, as displayed in Figure 6.8.

FIGURE 6.8 The Data-Driven Graphics Wizard displaying step 5 of 6.

Step 5 of 6 deals with the exported files that the wizard creates, starting with the filenames. In the File Name section are two buttons. These choices determine how the files Fireworks MX 2004 creates are named. The first choice is to use a field from the XML file as the filename. The drop-down list to the right allows you to choose the XML node that you would like to use as the basis for your filenames. The second button numbers the files sequentially using the filename of your choice. In the text field to the right you can type the name you want to use for your files. Then, in the following subsection titled File Numbering, indicate the value that follows the filename. The choices increment by one with each newly created file, and they are 1, 2, 3…, 01, 02, 03…, and 001, 002, 003.

12. Select the Use Data Field button. In the drop-down menu to the right select CourseName. Leave the File Numbering field at its default of 1, 2, 3… and the Start Value at 1. As a result, our final pages will be called by the course name followed by the file extension .png.

The wizard can export two different files for each golf course. One file is exported as a graphic, such as a GIF or JPG. The file format depends on what the file's optimization is set to. For example, if the Optimize panel in Fireworks MX 2004 indicates a JPG at low compression with no smoothing, then that is how the file is exported. If you wish to export the file as a graphic in a file format other than the one indicated in the Optimization panel, you can choose a different file format from the drop-down menu. By default, this setting is Template Export Settings.

13. Make sure the Export Images check box is checked. Leave the export settings at their default value. Follow step 14 to choose a directory to which to save the exported image files.

14. Click the browse icon to the right of the field and navigate to the *XML_Generated_Graphics* directory, which is currently empty. If you are unable to browse for this directory, type the directory name in the field.

In addition you can choose to export a Fireworks PNG file. It is wise to export the PNG file as it is the native format for Fireworks file so that you retain all of your layers and other native Fireworks MX 2004 functionality. To save the native PNG files, follow the directions in step 15.

15. Click the browse icon to the right of the field and navigate to the *XML_Generated_PNGs* directory, which is currently empty. If you are unable to browse for this directory, type the directory name in the field.

16. Click the Next button to move on to step 6 of 6, as displayed in Figure 6.9.

Now review the choices you made in the previous five steps. Verify they are correct as indicated in Figure 6.9.

FIGURE 6.9 The Data-Driven Graphics Wizard displaying step 6 of 6.

17. Click the Done button and wait a moment for the wizard to create the files. The disappearance of the wizard dialog box signifies the completion of the process. Unfortunately, this step can take several minutes and there is no progress bar. When the wizard is finished,

the dialog box closes and you are left with the original Fireworks template file.

18. Close the template file.

You will now open the PNG files that the wizard created.

19. Click File→Open and navigate to the *XML_Generated_PNGs* directory. Open all four files in the directory.

Notice that Fireworks MX 2004 does not remove any variables or placeholder text when the variable has not been replaced by data from the XML file. This text must be manually deleted in Fireworks MX 2004.

You can also preview these files in your Web browser by pressing the F12 key.

As you can see, the Data-Driven Graphics Wizard has created these four files using the data from your XML file. Figure 6.10 shows a completed Web page in Internet Explorer.

Now that you have seen how the Data-Driven Graphics Wizard works, try to create your own template from scratch.

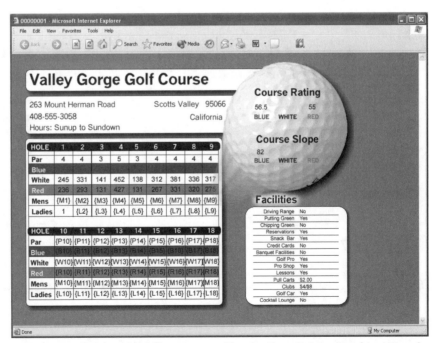

FIGURE 6.10 A finished PNG file generated by the Data-Driven Graphics Wizard and displayed in Internet Explorer. Screen shot reprinted with permission from Microsoft Corporation.

CREATING A FIREWORKS GRAPHICS TEMPLATE

In this exercise you will build a graphics file to be used as a template for the Data-Driven Graphics Wizard. You will build a Web banner template and use it to create a variety of Web banners.

1. Launch Fireworks MX 2004.
2. Select File → New from the main menu.
3. In the New Document dialog box, create a new file that is 600 pixels wide by 200 deep, 72 pixels per inch with a white background.
4. Click OK and save the file as *Ch_6_Banner.png*.
5. Open the Layers panel from Window → Layers.
6. Rename Layer 1 as theCourse. From the View menu click View → Rulers. Drag horizontal and vertical ruler guides out 30 pixels from the top, bottom, left, and right sides of the document. Your file should appear as it does in Figure 6.11.

FIGURE 6.11 The new PNG file in Fireworks MX 2004.

7. Create a new layer in the Layers panel by clicking the New/Duplicate Layer button at the bottom of the panel and name it `theClub`.
8. Create a new layer in the Layers panel and name it `theBackground`.
9. Arrange the layers in the following order:
 - Layer 1 is the Web layer by default and cannot be moved.
 - Layer 2 should be `theCourse` layer.
 - Layer 3 should be `theClub` layer.
 - Layer 4 is the last layer and should be `theBackground`.

 The Layers panel should match Figure 6.12.
10. Select `theCourse` layer and select the Type tool from the toolbar.
11. From the Property Inspector set the following type properties:
 - Typeface: Franklin Gothic Medium
 - Size: 42
 - Color: White*

FIGURE 6.12 The new PNG file in Fireworks MX 2004 showing the proper naming and stacking order of the layers.

*The stroke and fill colors can be set from the Colors section of the toolbar.

- Stroke: Black*
- Typestyle: Bold, Italic
- Alignment: Flush left

12. Place your cursor on the upper-left corner of the canvas approximately 20 pixels over and 20 pixels down. Type `{ResortName}`. Be sure to include the curly brackets.

13. Keep the same type properties and change the size to 54. With your cursor below `{ResortName}` about 30 pixels down and 30 pixels over, type `{days}`.

14. Change the size of type to 36 and type the word *days*. Size the text back to 54 and type `/{nights} nights`.

15. Temporarily hide the two layers you just created.

16. Reset the type tool to the following settings:
 - Size: 18
 - Typeface: Verdana
 - Leading: 145
 - Alignment: Flush right

17. Type the following words:
 - `{availability}`
 - `{holes}`
 - `{par}`
 - `{yards}`

18. Place your cursor in the lower-left corner approximately 30 pixels from the left and 30 pixels from the bottom and type `{Phone}`.

19. Set the following typographic properties with the type tool selected.
 - Typeface: Frankin Gothic Medium
 - Size: 22
 - Color: Blue
 - Stroke: Black
 - Typestyle: Underline
 - Range Kerning: 6

20. With your cursor level with the line you just typed, move your cursor to the lower-right corner, approximately 30 pixels from the right and type `visit our Web site` with the following typographic settings:
 - Typeface: Franklin Gothic Medium
 - Size: 45
 - Typestyle: Italic
 - Color: White
 - Stroke: Black

type the following:

{cost}

21. With the Pointer tool, click the `{ResortName}` text box.

22. While holding the Shift key, click the following text boxes:
 - `{days}` days/`{nights}` nights
 - `{cost}`

23. From the Properties Inspector, press + (plus sign) next to Effects, click Shadow, and click Glow → Drop Shadow.

 With all the layers visible, your file should now appear as shown in Figure 6.13.

24. Select `theClub` layer and click File → Import. Browse for the image called *Iron.jpg* from the *Images* directory.

FIGURE 6.13 The new PNG file in Fireworks MX 2004 with the type layers in place and visible.

25. Click in the document window to place the image. Place the image as shown in Figure 6.14. You can scale the graphic so that it is slightly smaller. Rename the layer Iron.

FIGURE 6.14 The PNG file in Fireworks MX 2004 with the type and iron layers in place and visible.

26. With the theBackground layer selected, import the graphic called *Banner4.jpg* from the *WebBanner/Images* directory. This image should fill the entire canvas, as shown in Figure 6.15.

At this point you may notice the white pixels around the *iron* graphic. You will fix that in step 30.

To make the background graphic a variable, you must name it with curly brackets in the Property Inspector.

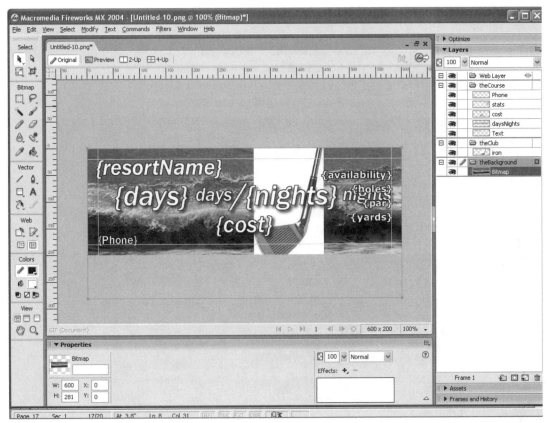

FIGURE 6.15 The PNG file in Fireworks MX 2004 with the type and `iron` layers selected.

27. With the background graphic selected, locate the Name field on the left side of the Property Inspector to the left of the thumbnail image, below the word *bitmap*. In this name field type `{graphic}`.

So far, you have created nine text variables: ResortName, days, nights, availability, holes, par, yards, cost, and Phone.
You have just created the one image variable: graphic.
Now you will create a URL variable.

28. Select the Slice tool and make a slice around the text `visit our Web Site`.

29. With the slice selected, type the following variable in the Link field of the Property Inspector:

`{www.WebAddress}`

30. Before continuing, you must to remove the white pixels from around the *iron* graphic. Select `theClub` layer. With the Magic Wand tool selected, click the white area around the *iron* graphic. Figure 6.16 shows the selected white pixels.

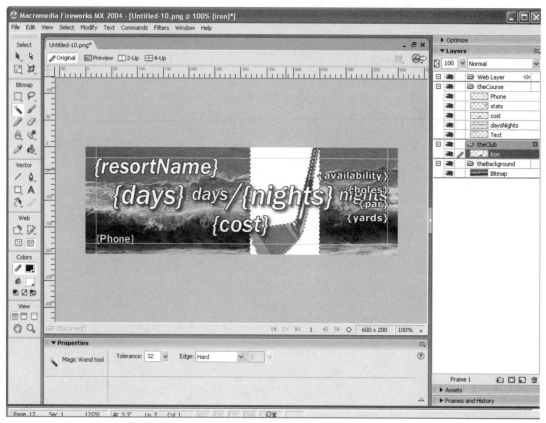

FIGURE 6.16 The PNG file in Fireworks MX 2004 with the selected white pixels around the *iron* graphic.

Press Control-X to cut the pixels. Figure 6.17 shows the PNG file with the pixels around the *iron* graphic cut away.

All of the templates variables are now in place. For organizational purposes you can rename all the layers with appropriate names. If you would like to check the placement of text and images, open the completed file in the *Chapter 6 Finished files* directory.

Now you are ready to run the Data-Driven Graphics Wizard.

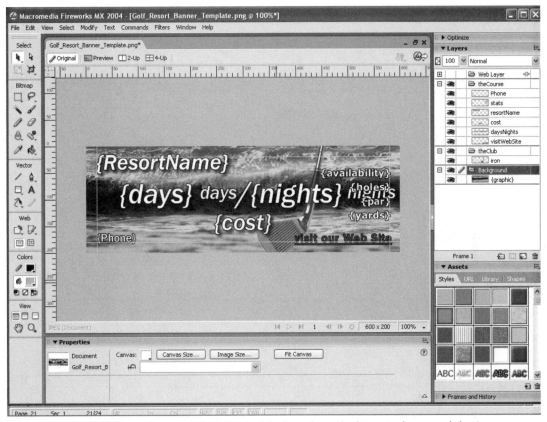

FIGURE 6.17 The PNG file in Fireworks MX 2004 with the selected white pixels around the *iron* graphic.

31. From the Command menu choose Data-Driven Graphics Wizard.
32. Click the Browse icon and navigate to *Resorts.xml* from the *Chapter 6* Student directory.
33. Click the Next button to move to step 2 of 6.
34. Click the Next Record button to traverse each `<Course>` tag and its children.
35. Click the Next button to see step 3 of 6.
36. Click the button at the top to process All Records.
37. Click the Next button to move on to step 4 of 6.

Step 4 of 6 requires you to map a variable name to field in the XML file. From the Select a variable field click URL:`{webAddress}`. From the Select a Field field, click `webAddress`. After you have selected both the variable and field, click the + (plus sign) as shown in Figure 6.18.

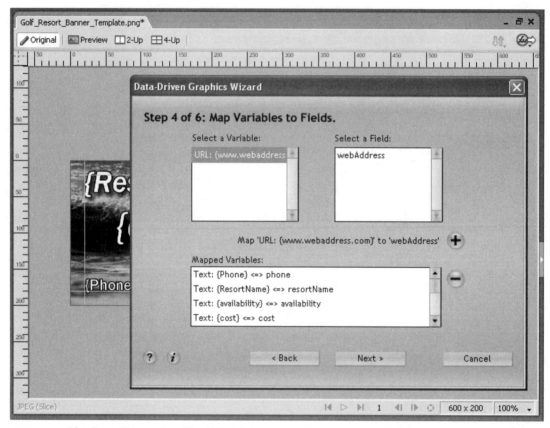

FIGURE 6.18 The Data-Driven Graphics Wizard at step 4 of 6, mapping variables to fields.

38. Click the Next button to move on to step 5 of 6.
39. Type `Golf_Resort_Banner_Template` in the File Name field as the name of the exported file. Leave the File Numbering field at its default of "1, 2, 3…"
40. Make sure the Export Images check box is checked. Leave the export settings at their default value. Follow step 41 to choose a directory to which to save the exported image files.
41. Click the Browse icon to the right of the field and navigate to the *XML_Generated_Graphics* directory, which is currently empty.
42. Click the Browse icon to the right of the field and navigate to the *XML_Generated_PNGs* directory, which is currently empty.
43. Click the Next button to move on to step 6 of 6.
44. Click the Done button and wait a moment for the wizard to create the files.

45. Open the completed files from the *XML_Generated_PNGs* directory and preview them in the browser. A completed file is displayed in Figure 6.19.

FIGURE 6.19 The completed graphic file created from the Data-Driven Graphics Wizard as displayed in Internet Explorer. Screen shot reprinted with permission from Microsoft Corporation.

SUMMARY

As you have seen the Data-Driven Graphics Wizard in Fireworks MX 2004 can make easy work of file creation when the files have a similar look and feel. The whole process works like a macro where the dynamic data comes from a simple XML file. After the creation of a Fireworks template and the existence of an XML file, you are only six easy steps away from as many files as you need.

7

MACROMEDIA FLASH MX PROFESSIONAL 2004 AND XML FUNDAMENTALS

In This Chapter

- Introduction
- Tutorial One: How to Create an XML Project in Flash MX Professional 2004
- Tutorial Two: How to Work with XML in Flash MX Professional 2004 : The Basics
- Tutorial Three: Retrieving the XML Data
- Tutorial Four: The XMLConnector

Chapter 7 concludes the discussion of XML and the Macromedia products: Dreamweaver MX 2004, Fireworks MX 2004, and Flash MX Professional 2004. This chapter introduces the XML capabilities built into Flash MX Professional 2004 at the fundamental level. You learn how Flash MX Professional 2004 recognizes XML and outputs the data in the XML file to the Flash movie player. Flash MX Professional 2004 also allows for a live connection to XML data much like a database-driven Web site. The basics of this functionality are explored at the end of the chapter. Initially you learn how to organize your XML-based Flash movie as a project, which is a new feature of Flash MX Professional 2004.

INTRODUCTION

Macromedia Flash MX Professional 2004 XML support began with version 5.0, which included an XML parser in its Flash Player. The Flash MX Professional 2004 XML parser could load an external XML document as one long string, then convert the XML elements or nodes into an object structure, which could be referenced through ActionScript. Flash MX Professional 2004 could extract the nodes and display them on the stage and in the Macromedia Flash Player.

The Macromedia Flash MX Professional 2004 XML parser for version 5.0 could be quite slow and was upgraded in the Macromedia Flash MX Professional 2004 version. The Macromedia Flash MX Professional 2004 XML parser is not a validating parser; therefore, structure enforced through a DTD or schema cannot be verified in Flash MX Professional 2004. Your XML files must come into Flash MX Professional 2004 as valid XML, if that is a requirement of your Web application. In addition, version 5 of the Flash Player does not ignore white space in the XML file, such as line breaks, spaces, or tabs. This could lead to unpredictable results; for example, when you expect tagged content to be blank, you might receive the leading white space instead. The Flash MX Professional 2004 XML parser includes an ignore white space property that can be set to deal with an XML file's native white space.

Macromedia Flash MX 2004 has the most robust XML support to date and includes many new features. This chapter introduces the use of XML in Flash MX Professional 2004, but it is not a complete reference. However, by the time you are done with the tutorials you will feel comfortable working with XML in Flash MX Professional 2004. Resources are included at the end of the chapter for more information about working with XML within Flash MX Professional 2004.

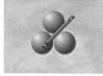

TUTORIAL

TUTORIAL ONE: HOW TO CREATE AN XML PROJECT IN FLASH MX PROFESSIONAL 2004

OBJECTIVES

- To understand the new project feature in Flash MX Professional 2004

- To create and organize a Flash Project for an XML-based Web page

BEFORE YOU BEGIN

What You Will Need for This Tutorial

- Macromedia Flash MX Professional 2004 (Macintosh or PC version)
- (PC) Microsoft Internet Explorer 5.x or later
- (Mac) Microsoft Internet Explorer 5.2 or later

ON THE CD

The Data Files:

- **Chapter Seven Directory:** *Part_4/Chapter 7*
- **Directories:** *Ch_7_Finished Files*
- **Subdirectory:** *Flash Basic Functionality*
- **Files:**
 Ch_7_Flash_1_Finished.fla
 Ch_7_Flash_XML_1.xml
 Ch_7_Flash_1_Finished.swf
 Ch_7_Flash_XML_Display_Finished.fla
- **Subdirectory:** *XMLConnector Files*
- **Files:**
 Ch_7_Golf_A_E.xml
 Ch_7_Golf_XML_Finished.fla
 FinishedXMLConnector_Edit.fla
 Ch_7_XMLConnector_Finished.fla
 Ch_7_Student Files
- **Subdirectory:** *Basic Flash Functionality*
- **Files:**
 Ch_7_Flash_XML_1.xml
 Ch_7_Flash_XML_Display_Student.fla
 Ch_7_Flash_1_Student.fla

INTRODUCTION TO PROJECTS

Flash MX Professional 2004 offers a Project panel used to manage multiple document files in a single project. This panel is similar in functionality, to some degree, to the site window in Dreamweaver. In complex Web applications you often need to track more than one file type. In other words, your Web site requires more than HTML files. Your Web application may use database files, text files, Excel spreadsheets, and XML files. To keep all of these files organized you will arrange and categorize them with the new Project panel. Flash Project files are themselves XML files that use the extension .flp for Flash Project. These XML files use elements that reference all the document files in the project. Flash Pro-

jects can contain any type of file, including previous versions of Flash (.fla) or Shockwave (.swf) files. Any time after a project is created you can add additional files to the project. Folders may contain subfolders for more organization, as needed. If you are working on an extremely large or sophisticated site, you may want to break it up into smaller projects. Flash Project files (.flp) can contain other Flash Project files. This .flp file maintains a constant current status—any changes you make to the project are updated to the .flp file immediately. You will begin the tutorial by setting up an XML project to be used for the upcoming Flash tutorials in Chapter 7.

1. Launch Macromedia Flash MX 2004 Professional. The new version of Macromedia Flash MX Professional 2004 has a different look from Flash MX. See Figure 7.1 for a view of Flash MX Professional 2004 upon launching. Notice your options.

2. From the middle column called Create New, click the first item on the list, Flash Document. You should see the stage of a blank Flash document. You will not need the timeline, so collapse it. Flash panels collapse somewhat differently in the 2004 version. When you hover your mouse over the panel name, it becomes underlined like a hypertext link. Click the text and the panel collapses.

FIGURE 7.1 The new Flash MX Professional 2004 user interface.

3. From the Windows menu on the main menu bar choose Project. The Project window opens with the following text:

To work with Flash projects:

- Create a new project or
- Open an existing project.

The words *new project* and Open appear as hypertext links.

4. Click the new project link to create a new project.
5. The New Project dialog box appears as shown in Figure 7.2.

FIGURE 7.2 The Flash MX Professional 2004 New Project dialog box.

Navigate to the *Chapter 7* folder and save the project as *Ch_7_Flash_Project.flp*.

Notice how the Project panel's title bar now reads *Ch_7_Flash_ Project*. This panel organizes the site into a collapsible tree structure similar to Windows Explorer or the Dreamweaver Site Files view. If you move the selected directory from its original location, Flash MX Professional 2004 displays a missing icon where the project file icon appears now. If you are working on several Flash files within a project, you can publish them simultaneously by pressing the Project button in the upper-left corner of the Project panel below the title bar and choosing Publish Project from the drop-down menu. You can have only one project open at a time in Flash MX Professional 2004.

You will now add files to the Chapter 7 XML project, beginning with the XML files.

6. Press the Project button in the upper-left corner of the Project panel and choose Add File. Navigate to the *Basic Flash Functionality* folder, click the file named *facilitiesFlash.xml*, and click Open. The file appears below *Ch_7_Flash_Project* in the Project panel. For organization purposes you will create a directory called *XML* and place the XML file inside of this new directory.

7. Press the Project button in the upper-left corner of the Project panel and choose Add Folder. The Project Folder dialog box appears as shown in Figure 7.3.

FIGURE 7.3 The Flash MX Professional 2004 Project Folder dialog box.

Name the folder *XML Files* and click Okay. The Project panel now includes the new directory.

8. To move the XML file into the new directory, drag it over the *XML Files* folder. After the file is copied into the directory the Project panel appears as shown in Figure 7.4. All file directories within a project must have unique names.

FIGURE 7.4 The Flash MX Professional 2004 Project panel.

9. Add all of the remaining files to the project from the CD-ROM *Chapter 7* directory, including the finished files in the proper folders, as shown in Figure 7.5.

FIGURE 7.5 The Flash MX Professional 2004 Project panel completed for Chapter 7.

You will add the files you create to your project in Chapter 7 as you build them. To do so, remember that Flash files must be saved before they can be added to projects, and they can be added to a project only once.

To further control Flash Projects click Edit → Preferences and select the Edit tab. Under the Project Preferences section you can choose:

Close tiles on project close.
Save project files on test project or publish project.

The Project panel provides an excellent tool for organizing a complex Flash Web site. It is one of those small, minor enhancements that in the end saves developers a tremendous amount of time. By allowing one location from which to access files, you avoid the tedious task of navigating to the various files in the projects, particularly those that are not native Flash files. If the file is of a native file type (a type supported by the Flash authoring tool), the file opens in Flash MX Professional 2004. If it is non-native file type, the file opens in the application used to create it. In addition you can publish and test many Flash files at once through the Project panel and quickly rename the files while in full view of all the files on our Web site.

TUTORIAL

TUTORIAL TWO: HOW TO WORK WITH XML IN FLASH MX PROFESSIONAL 2004 : THE BASICS

OBJECTIVES

- To understand how Flash MX Professional 2004 recognizes XML (the XML class)

- To create a Flash file that loads, reads, and parses an XML File

- To understand how the Flash Player retrieves the XML nodes

BEFORE YOU BEGIN

What You Will Need for This Tutorial

- Macromedia Flash MX Professional 2004 (Macintosh or PC version)
- (PC) Microsoft Internet Explorer 5.x or later
- (Mac) Microsoft Internet Explorer 5.2 or later

The Data Files

- **Directory:** *Ch_7_Student Files*
- **Subdirectory:** *Basic Flash Functionality*
- **Files:**
 Ch_7_Flash_XML_1.xml
 Ch_7_Flash_1_Student.fla
- **Directory:** *Ch_7_Finished Files*
- **Subdirectory:** *Flash Basic Functionality*
- **Files:**
 Ch_7_Flash_1_Finished.fla
 Ch_7_Flash_XML_1.xml
 Ch_7_Flash_1_Finished.swf

INTRODUCTION

Flash MX Professional 2004 recognizes XML files by the creation of an XML object. ActionScript code includes a constructor function for creating an XML object. After an XML object is instantiated, an XML file is then loaded and parsed through further ActionScript code. The Flash file's ActionScript triggers the Flash Player's XML parser, which parses the file. Subsequent code in this tutorial explains how to access the individual elements or nodes in the XML object and display them on the Flash stage. You will begin with the most basic code required to load an XML file.

1. Launch Flash MX Professional 2004.
2. Open the Flash Project created in the previous tutorial (Chapter 7 Tutorial One) and open the Flash file called *Ch_7_Flash_1_ Student.fla*. The file opens as shown in Figure 7.6. The file contains a single text box that describes the page's functionality.
3. Click Window → Development Panels → Actions from the main menu bar to display the Actions panel. In this panel, you will write the ActionScript code to load an XML file.
4. Type the variable name golf, click the + (plus sign) on the upper-left corner of the Actions panel (this is the Add a new item to the script button), and click Built-in Classes → Client/Server → XML → new XML, as shown in Figure 7.7. The new XML (source) prompt appears after the ActionScript code, new XML(). The bold source is a code hint.

FIGURE 7.6 The Flash file *Ch_7_Flash_1_Student.fla*.

Type a semicolon to end the statement, which should now read as follows:

```
golf = new XML();
```

5. Press Enter on your keyboard to move the cursor down one line. Click + (plus sign) on the upper-left corner of the Actions panel (this is the Add a new item to the script button), click Built-in Classes → Client/Server → XML → Methods → Load, and type the name of the XML file to load between the method's parentheses. Replace the text that reads `instanceName` with the name of the instantiated XML object assigned in line 1, which is `golf`. Your ActionScript panel should now contain the following code:

```
        golf = new XML();
golf.load("Ch_7_Flash_XML_1.xml");
```

Now take a closer look at how this ActionScript works, beginning with:

```
        golf = new XML();
```

This line creates a new instance of the XML object and assigns the name `golf` to it. After this, if you want to refer to your XML object, you can just refer to the instance name you set as you do in line 2. You must instantiate an XML object to work with XML in Flash MX Professional 2004.

CONCEPT: THE XML OBJECT

The object concept is the basic theory of object-based and object-oriented programming. An object is something you can interact with or control via your programming code. JavaScript for HTML, for example, uses the Document Object Model (DOM) to objectify various components of a Web page as well as the browser. These objects include the document object (the HTML file), the form object (any forms on the Web page), and the Window object (the browser window), as well as many others—think of objects as nouns or things. These objects can then perform certain actions, called methods—think of methods as verbs. Finally, objects have qualities called properties—think of properties as adjectives. Like JavaScript, all of these components are combined in ActionScript to allow you to manipulate the various parts or objects in your Flash file. The syntax for retrieving the various objects, methods, and properties involves the use of the period character. Thus, if you had access to a car object and wanted to assign it the `make` property of `Toyota` and employ the `drive` method, the code would read as follows:

```
Celica.Toyota.drive();
```

Method names are always followed by parentheses.

CONCEPT: THE XML CLASS

A class is a type of object, and an object is an instance of a class. In the previous example, the Celica is an instance of the class of objects known as cars, thus the code hint prompt you received earlier: `instanceName`, which you replaced with `golf`. Although Flash MX Professional 2004 supports many classes, objects do not exist until you create them. You create an object by instantiating it from a class definition. Think of classes as the blueprints or instructions required to make individual objects.

The XML class is a native object in Flash MX Professional 2004. You can use methods and properties of the XML object to load, parse, send, build, and manipulate XML and its tree of nodes. You must use the con-

structor function, new XML(), to create an XML object before calling any of the methods of the XML class.

The code:

```
golf = new XML();
```

creates a new XML object called golf.

The next line of code:

```
golf.load("Ch_7_Flash_XML_1.xml");
```

uses the load method of the XML object to load the XML file called *Ch_7_Flash_XML_1.xml* into the instantiated golf XML object created on line 1. The load method accepts one parameter within its associated parentheses and that is the path to the XML file you want to load. Because the XML file you are using is located in the same directory as the Flash file, just type the name of the XML file.

 A common mistake at the previous step is to simply indicate the XML file by name. Remember that when this is executed in a live environment on a Web browser, the Flash Player needs to find the XML file to load it, thus a complete path to the XML file must be supplied. This can be a relative path.

6. To test the Flash movie, click Control → Test Movie from the main menu bar or click CTRL + Enter on your keyboard.
 The file is displayed as shown in Figure 7.7.
7. From the main menu bar click Debug → List variables. Scroll to the top of Output window. The Variables tab in the Debugger displays the names and values of any global and Timeline variables in the SWF file. The first line references the root timeline, Level0. Level0 represents the initial Shockwave file loaded into the Flash player, and it is automatically loaded. This object contains the frame rate, background color, and frame size of your Flash movie. The third line:

```
Variable _level0.golf = [object #1] {
```

represents object 1, your Golf XML file. If you see this line followed by the XML file itself, you have successfully loaded and parsed the XML file for use in Flash MX Professional 2004.

Whenever you require XML data in your Flash files, you must create an instance of the XML class. This XML object must then be loaded with the URL of an actual XML file. Test the movie to see if your XML data ap-

This page:

1. Creates a new XML object
2. Loads an XML file called "Ch_7_Flash_XML_1.xml" into the object

FIGURE 7.7 The Flash file *Ch_7_Flash_1_Student.fla*.

pears in the Variables tab of the Debugger. At this point you are ready to retrieve the XML data, which you will do in the next tutorial.

TUTORIAL

TUTORIAL THREE: RETRIEVING THE XML DATA

OBJECTIVES

- To create text boxes that display text from an XML file
- To write the necessary ActionScript to allow access to data in an XML file
- To understand how the Flash Player displays XML data

BEFORE YOU BEGIN

What You Will Need for This Tutorial

- Macromedia Flash MX Professional 2004 (Macintosh or PC version)
- (PC) Microsoft Internet Explorer 5.x or later
- (Mac) Microsoft Internet Explorer 5.2 or later

The Data Files

- **Directory:** *Ch_7_Student Files*
- **Subdirectory:** *Basic Flash Functionality*
- **Files:** *Ch_7_Flash_XML_Display_Student.fla*
- **Directory:** *Ch_7_Finished Files*
- **Subdirectory:** *Flash Basic Functionality*
- **Files:** *Ch_7_Flash_XML_Display_Finished.fla*

INTRODUCTION

Flash recognizes the data in an XML file by using various built-in XML functions. In this tutorial you use these built-in functions in conjunction with custom functions that you define.

1. Launch Flash MX Professional 2004 and open the file called *Ch_7_Flash_XML_Display_Student.fla*.

The bulk of this tutorial involves writing ActionScript that allows you to recognize and display data from an XML file. First, get comfortable with the file as it stands now. Click the two text fields that have already been built and note their names. The text area to the left has been given the instance name CourseName. The larger text area on the right has been given the instance name golf.

2. To write the ActionScript, click Windows → Development Panels → ActionScript or press the F9 key.

You begin by writing your own function called ShowGolf. To indicate what the function is to be used for, start with a comment.

3. With nothing selected on the stage, place your cursor in the Action-Script panel and type the following comment:

```
// Extract information from the XML file
```

4. Type the name of the function and its one parameter between the parentheses, followed by the opening curly bracket as follows:

```
function showGolf(FacilitiesNode){
```

The function begins with a conditional `if` statement.

5. Type the `if` statement:

```
If (FacilitiesNode.nodeName.toUpperCase() ==
"FACILITIES"){
```

An `if` statement tests to see if a certain condition exists, and if this condition does exist, the code that follows is executed. The condition you are testing for appears between the parentheses.

`FacilitiesNode` is simply the placeholder name for the functions parameter. You will supply the argument for the `FacilitiesNode` parameter later when you call the function. For example, when you call on the function you will do so as follows:

```
showGolf(a Node Name Will Go Here)
```

For now, we simply refer to the node name as `FacilitiesNode`. This conditional statement is testing to see if the name of the node (which you will supply later as an argument) is equal to the string `FACILITIES`. `toUpperCase()` is a built-in ActionScript function that converts the supplied text string to `UpperCase`. Thus you are checking to see if the node you supply when converted to uppercase is the same as the string `FACILITIES`. The code that will be executed if this condition is true follows.

 A common misconception in the previous step is to believe that `FacilitiesNode` *is a variable that must be declared or referenced by some other line of code.* `FacilitiesNode` *is a placeholder similar to a variable; however, it does not need to be declared. You are using this placeholder when you write the function; however, when you use or call the function you must replace this text (`FacilitiesNode`, in this example) with actual data. In this example, it will be a node name from the XML file. When using placeholders like this, conform to normal variable-naming conventions, such as no spaces or punctuation.*

6. Type the next statement:

```
_root.golf = "";
```

This line sets the text area called `golf`, which is on the root timeline of the movie, to an empty string.

The next line declares a variable called `course` and sets it to the first child element of the `FacilitiesNode`. Notice that Flash ActionScript uses the dot syntax. The dot is followed by the ActionScript code for an element's first child, `firstChild`. When an XML file is loaded and parsed by the Flash Player, ActionScript recognizes the parent/child/sibling relationship among the various tags and uses its dot syntax to locate various nodes in the XML file. For example, `firstChild` is a property of the XML object that refers to the first child node of a specified element.

7. Type the next statement:

```
Course = FacilitiesNode.firstChild
```

The next line of code is a `while\` loop. This loop causes the code that follows to execute repeatedly until the condition in the `while` loop's parentheses is no longer true.

8. Type the next statement:

```
while (Course != null){
```

The test condition that the `while` loop is testing is if the `Course` variable declared earlier is not empty or null. Notice the `not` operator is `!=`.

If this condition is true, the next line of code continues to execute until the condition is false.

9. Type the next statement:

```
if (Course.nodeName.toUpperCase() == "COURSE"){
```

Notice that this code is another `if` conditional, testing to see if the `Course` variable is equal to the string COURSE.

If this condition is true a series of variables are initialized and set to an empty string with the code listed in the next step.

10. Type the next series of statements:

```
Name = "";
drivingRange = "";
puttingGreen = "";
chippingGreen = "";
reservations = "";
snackBar = "";
creditCards = "";
```

```
banquet = "";
golfPro = "";
proShop = "";
lessons = "";
pullCarts = "";
clubs = "";
golfCar = "";
cocktailLounge = "";
```

The next line declares a variable called `element` and sets its value to the first child element of the `Course` element.

11. Type the next statement:

```
element = Course.firstChild;
```

12. Type the next statement:

```
if (element.nodeName.toUpperCase() == "NAME")
    {
        Name = element.firstChild.nodeValue;

    }
```

Using a similar `if` conditional to the previous code, this line then declares a variable named `Name` that is set to the element variable's (which is the first child of the `<Course>` tag) first child element's node value. The code that follows uses the same technique to declare the remaining 13 variables.

13. Type the next series of statements:

```
if (element.nodeName.toUpperCase() == "DRIVINGRANGE")
{
drivingRange = element.firstChild.nodeValue;
}

if (element.nodeName.toUpperCase() == "PUTTINGGREEN"){
puttingGreen = element.firstChild.nodeValue;
}

if (element.nodeName.toUpperCase() == "CHIPPINGGREEN"){
chippingGreen = element.firstChild.nodeValue;
}
if (element.nodeName.toUpperCase() == "RESERVATIONS"){
reservations = element.firstChild.nodeValue;
}
```

```
if (element.nodeName.toUpperCase() == "SNACKBAR"){
snackBar = element.firstChild.nodeValue;
}
if (element.nodeName.toUpperCase() == "CREDITCARDS"){
creditCards = element.firstChild.nodeValue;
}
if (element.nodeName.toUpperCase() == "BANQUET"){
banquet = element.firstChild.nodeValue;
}
    if (element.nodeName.toUpperCase() == "GOLFPRO"){
golfPro = element.firstChild.nodeValue;
}
if (element.nodeName.toUpperCase() == "PROSHOP"){
proShop = element.firstChild.nodeValue;
}
if (element.nodeName.toUpperCase() == "LESSONS"){
lessons = element.firstChild.nodeValue;
}
if (element.nodeName.toUpperCase() == "PULLCART"){
pullCart = element.firstChild.nodeValue;
}
if (element.nodeName.toUpperCase() == "CLUBS"){
clubs = element.firstChild.nodeValue;
}
if (element.nodeName.toUpperCase() == "GOLFCAR"){
golfCar = element.firstChild.nodeValue;
}
if (element.nodeName.toUpperCase() == "COCKTAILLOUNGE"){
cocktailLounge = element.firstChild.nodeValue;
}
```

The next line of code sets the `element` variable to its current value, which you will recall is the first child of the `<Course>` tag to its next sibling element. In other words, it is setting the variable `element` to the next `<Course>` tag that follows in the XML file. If you are unsure of the parent /child/sibling relationship between tags, review Chapter 3.

14. Type the next statement:

```
element = element.nextSibling;
}
```

The next section of code sets the text area called golf to HTML text, which includes the variables you declared in the function and results in the text area text to read:

```
Driving Range = yes
Putting Green = yes
```

As you type the next step, notice the HTML code that formats the text as it appears in the Flash Player.

15. Type the next statement:

```
_root.golf += "<br /><H4>Driving Range: </H4>" + drivingRange
+ "<br /><H4>Putting Green: </H4>" + puttingGreen + "<br
/><H4>Chipping Green: </H4>" + chippingGreen + "<br
/><H4>Reservations: </H4>" + reservations + "<br /><H4>Snack
Bar: </H4>" + snackBar + "<br /><H4>Credit Cards: </H4>" +
creditCards + "<br /><H4>Banquets: </H4>" + banquet + "<br
/><H4>Golf Pro: </H4>" + golfPro + "<br /><H4>Pro Shop: </H4>"
+ proShop + "<br><H4>Lessons: </H4>" + lessons + "<br
/><H4>Pull Carts: </H4>" + pullCarts + "<br /><H4>Clubs:
</H4>" + clubs + "<br /><H4>Golf Car: </H4>" + golfCar + "<br
/><H4>Cocktail Lounge: </H4>" + cocktailLounge + "<br><br />";
```

The next line of ActionScript sets the text of the text area named CourseName to the variable Name.

16. Type the next statement:

```
_root.courseName = Name;
```

The next line of code resets the course variable to the `<Course>` element's next sibling.

17. Type the next statement and close the function by closing all the opening curly brackets.

```
}
            Course = Course.nextSibling;
        }
     }
}
```

Recall from the basic discussion of Flash MX Professional 2004 and XML that to work with XML data you must write ActionScript to create an instance of an XML object and load the XML file.

At this point you will write the code to do just that, preceded by a comment indicating what you are doing. Although you could place this code at the top of your ActionScript file, you are going to write it here below the function to demonstrate that it doesn't matter where you do it.

18. Type the comment and the next series of statements:

```
// Create a new XML object and load the XML file

golfXML = new XML();
golfXML.onLoad = myLoad;
golfXML.load("facilitiesFlash.xml");
```

Notice the third line of code. The XML object has two event handlers associated with it: onData and onLoad. Therefore, this line of code is accessing the golfXML object and calling on the onLoad event to trigger a function called myLoad(), which you have not written yet. This function will execute when the XML data has finished loading and has been parsed by the Flash Player's XML parser.

Now you'll write the myLoad() function.

19. Type the comment followed by the myLoad() function:

```
// Check to make sure the XML file loaded, call the next
function

function myLoad(ok){
    if (ok == true) {
        showGolf(this.firstChild);
      }
}
```

The function myLoad() has one parameter called ok. This parameter is set to either true or false, depending on whether the XML was loaded and parsed successfully. The next line of code tests if the value of ok is true and, if it is, executes the next line of code, which is a call to the showGolf() function.

This is all you need to extract the data from the XML file and display it in the text areas that appear on the stage.

 In some testing environments your XML file is displayed without the function in the previous step. However, you should always ensure that your XML file has loaded before you attempt to access and display nodes from the XML file. Remember, more often than not, you are accessing XML data from a server and this XML data is subject to change. Thus, the more you expect your data to change, the more your ActionScript must check the data to ensure that it is suitable for display.

20. Save the file. Your completed code should read as follows:

```
// Extract information from the XML file
function showGolf(FacilitiesNode){
    if (FacilitiesNode.nodeName.toUpperCase() ==
    "FACILITIES"){
        _root.golf = "";
        Course = FacilitiesNode.firstChild;
        while (Course != null){
            if (Course.nodeName.toUpperCase() == "COURSE"){
    Name = "";
    drivingRange = "";
    puttingGreen = "";
    chippingGreen = "";
    reservations = "";
    snackBar = "";
    creditCards = "";
    banquet = "";
    golfPro = "";
    proShop = "";
    lessons = "";
    pullCarts = "";
    clubs = "";
    golfCar = "";
    cocktailLounge = "";

    element = Course.firstChild;
    while (element != null){
    if (element.nodeName.toUpperCase() == "NAME"){
    Name = element.firstChild.nodeValue;
    }
    if (element.nodeName.toUpperCase() == "DRIVINGRANGE"){
    drivingRange = element.firstChild.nodeValue;
    }
    if (element.nodeName.toUpperCase() == "PUTTINGGREEN"){
    puttingGreen = element.firstChild.nodeValue;
    }
    if (element.nodeName.toUpperCase() == "CHIPPINGGREEN"){
    chippingGreen = element.firstChild.nodeValue;
      }
    if (element.nodeName.toUpperCase() == "RESERVATIONS"){
    reservations = element.firstChild.nodeValue;
    }
    if (element.nodeName.toUpperCase() == "SNACKBAR"){
snackBar = element.firstChild.nodeValue;
}
if (element.nodeName.toUpperCase() == "CREDITCARDS"){
creditCards = element.firstChild.nodeValue;
}
```

```
if (element.nodeName.toUpperCase() == "BANQUET"){
banquet = element.firstChild.nodeValue;
}
if (element.nodeName.toUpperCase() == "GOLFPRO"){
golfPro = element.firstChild.nodeValue;
}
if (element.nodeName.toUpperCase() == "PROSHOP"){
proShop = element.firstChild.nodeValue;
}
if (element.nodeName.toUpperCase() == "LESSONS"){
lessons = element.firstChild.nodeValue;
}
if (element.nodeName.toUpperCase() == "PULLCART"){
pullCart = element.firstChild.nodeValue;
}
if (element.nodeName.toUpperCase() == "CLUBS"){
clubs = element.firstChild.nodeValue;
}
if (element.nodeName.toUpperCase() == "GOLFCAR"){
golfCar = element.firstChild.nodeValue;
}
if (element.nodeName.toUpperCase() == "COCKTAILLOUNGE"){
cocktailLounge = element.firstChild.nodeValue;
}
element = element.nextSibling;
}
_root.golf += "<br /><H4>Driving Range: </H4>" + drivingRange
+ "<br /><H4>Putting Green: </H4>" + puttingGreen + "<br
/><H4>Chipping Green: </H4>" + chippingGreen + "<br
/><H4>Reservations: </H4>" + reservations + "<br /><H4>Snack
Bar: </H4>" + snackBar + "<br /><H4>Credit Cards: </H4>" +
creditCards + "<br /><H4>Banquets: </H4>" + banquet + "<br
/><H4>Golf Pro: </H4>" + golfPro + "<br /><H4>Pro Shop: </H4>"
+ proShop + "<br><H4>Lessons: </H4>" + lessons + "<br
/><H4>Pull Carts: </H4>" + pullCarts + "<br /><H4>Clubs:
</H4>" + clubs + "<br /><H4>Golf Car: </H4>" + golfCar + "<br
/><H4>Cocktail Lounge: </H4>" + cocktailLounge + "<br><br />";
_root.courseName = Name;
}
        Course = Course.nextSibling;
        }
    }
}

// Check to make sure the XML file loaded, call the next
function

function myLoad(ok){
    if (ok == true) {
```

```
                  showGolf(this.firstChild);
        }
}

// Create a new XML object and load the XML file

golfXML = new XML();
golfXML.onLoad = myLoad;
golfXML.load("facilitiesFlash.xml");
```

This tutorial went beyond the loading and parsing of an XML file to the display of the XML data in the Flash Player. You learned the syntax and structure that ActionScript uses to access the various nodes of the XML object. You also learned how to check that the nodes of the XML file match your expectations before you attempt to use them. Remember that XML data is prone to change on the server as it gets updated over time. Finally, you learned how to attach the selected nodes to Flash text areas for display.

T U T O R I A L

TUTORIAL FOUR: THE XMLCONNECTOR

OBJECTIVES

- To understand the new Flash MX Professional 2004 components
- To understand the function of data components as they pertain to XML
- To create instances of data components and set their parameters
- To understand the function of the XMLConnector component
- To understand the function of the DataSet component
- To understand how Flash MX Professional 2004 uses data binding

BEFORE YOU BEGIN

What You Will Need for This Tutorial

- Macromedia Flash MX Professional 2004 (Macintosh or PC version)
- (PC) Microsoft Internet Explorer 5.x or later
- (Mac) Microsoft Internet Explorer 5.2 or later

The Data Files

- **Directory:** *Ch_7_Student Files*
- **Files:** *Ch_7_Golf_A_E.xml*
- **Directory:** *Ch_7_Finished Files*
- **Subdirectory:** *XMLConnector Files*
- **Files:**
 Ch_7_Golf_A_E.xml
 Ch_7_Golf_XML_Finished.fla
 Ch_7_XMLConnector_Edit_Finished.fla
 Ch_7_XMLConnector_Finished.fla

INTRODUCTION

In this tutorial you will add more functionality to the fictional golf course Web site. This time the functionality is for the golf course managers. Assume a portion of the site is password-protected for access by course managers only. Once they sign in, they have access to the Flash file you will build in this tutorial. It will display the XML data that describes the golf course cards: all of the holes, each hole's par, blue, red, and white flag distance, and the men's and ladies' handicaps. In addition to viewing the data, the course manager will be able to edit the data and send it back to the server to update the database. So, when a course manager wishes to move his flag's distance he can do so through this Web application, which will update the data on the server and immediately update the course information on his portion of the Web site. This tutorial uses Flash data components to dynamically retrieve the data from an XML file to a Flash movie file. The second half of the tutorial describes the process for making the data editable. Several steps are involved to complete this process. To complete this procedure you will explore components in general and the data components specifically.

By the time you are done with this tutorial you will understand how Flash MX Professional 2004 works with XML by combining an XMLConnector component with a DataSet component: the XMLConnector to connect to an XML file and the DataSet to bind the XML data to the DataSet. Flash MX Professional 2004 cannot retrieve XML data directly, which is why you bind the XML to the DataSet component.

CONCEPTS: COMPONENTS

Flash MX Professional 2004 components derive their functionality from their predecessor, Flash 5 smart clips. Flash MX Professional 2004 has expanded and improved upon the concept of smart clips. Flash MX Professional 2004 components provide built-in building blocks and pre-built code that not only save you development time but also provide additional features and functionality to your Flash movie. Think of components as pre-coded chunks of code that you can modify as you wish. A component is essentially a movie clip with parameters or properties that allow you to modify its appearance as well as its behavior. User interface components such as combo boxes, data grids, and multimedia controller bars can be dragged onto your Flash movie with their basic functionality built-in, while also offering the developer the ability to change the look and feel of the component as well as modify its behaviors. In addition to the components that ship with Flash MX Professional 2004, you can download components from the Macromedia Web site, and, perhaps most important, you can develop your own components that are capable of any functionality you desire. If you frequently work with the same data, your component can contain its own reusable content. By including components like scroll bars with built-in code, Flash MX Professional 2004 has saved developers a lot of time coding in ActionScript, while at the same time allowing developers to customize the components' appearance and behavior to match their design needs. Each component has predefined parameters that you can set while in Flash MX Professional 2004 using Code View or the Component Inspector.

Just as their name implies, components are parts or sections of a Flash Movie. Rather than code your Flash Movie from scratch, you can build it from drag-and-drop components, either built-in or user-created.

Flash MX Professional 2004's built-in components are organized in the Components panel in five categories:

- User Interface components
- Data components
- Media components
- Managers
- Screens

This tutorial concentrates on the Data Components, which allow you to load and manipulate information from data sources such as XML files.

You will begin by creating a new Flash file.

1. Launch Flash MX Professional 2004 and create a new Flash document.

2. Click Window → Developers Panels → Components to open the Components panel. All Components are stored in the Components panel, including those you create yourself and those you can download from the Macromedia Web site. Assuming you have not created or downloaded any components, your Components panel should appear as shown in Figure 7.8.

FIGURE 7.8 The Flash MX Professional 2004 Components panel.

You create an instance of a component by dragging it from the Components panel onto the stage; then you name the instance in the Property Inspector and specify the parameters for the instance using the fields on the Parameters tab. When you add a component to a document, it is displayed as a compiled clip (SWC file) symbol in the Library panel. An SWC file is the file format for a Flash MX Professional 2004 component file. A SWC file is a compiled movie clip file.

3. From the Components panel, drag an XMLConnector component onto the stage. Click Window → Properties to show the Properties Inspector and click Window → Development Panels → Component Inspector to show the Components Inspector. In the Property Inspector, enter the instance name `golf_connection`.

You can also double-click a component from the Components panel to place a component on the stage.

4. In the Property Inspector select the Parameters tab. For the URL parameter enter `golf.xml`. This tells Flash MX Professional 2004 the location of the external XML file. For the direction parameter, select Receive from the pop-up menu. This option indicates to Flash MX Professional 2004 that the data in the XML file is being received. The stage and Property Inspector should now match what is shown in Figure 7.9.

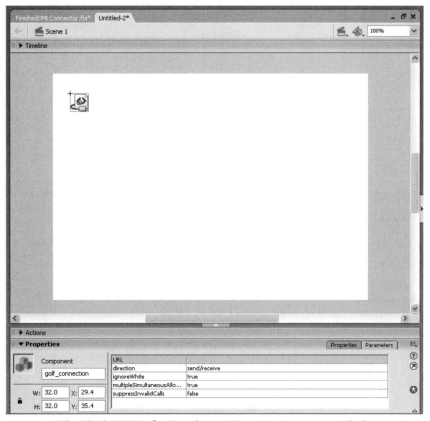

FIGURE 7.9 The Flash MX Professional 2004 Property Inspector with the XMLConnector selected and configured.

5. Save the file as *Ch_7_Golf_XML.fla* in the *Ch_7_Student Files* directory.
6. To view the file in the library, click Window → Library.

After you add an instance of a component to a Flash document, you use the Property Inspector to set and view information for the instance. You create an instance of a component by dragging it from the Components panel onto the stage; then you name the instance in the Property

Inspector and specify the parameters for the instance using the fields on the Parameters tab. Although you used the Property Inspector to set your parameters, you can also use the Component Inspector panel. Figure 7.10 shows the Component Inspector showing the selections you made in the Property Inspector.

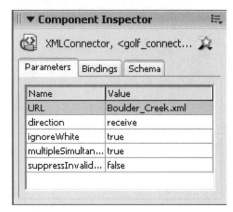

FIGURE 7.10 The Flash MX Professional 2004 Component Inspector with the XMLConnector selected and configured.

In addition to making these selections from the Property Inspector or the Component Inspector, you can also select them using Action-Script. An example of the ActionScript required to complete what you have already selected using the Property Inspector follows:

```
golf_connection.direction = "receive"
```

It is included here for completeness; however, the remainder of the tutorial focuses on using the panels and inspectors as opposed to writing ActionScript.

CONCEPT: THE XMLCONNECTOR

The XMLConnector component is a Flash MX Professional 2004 component whose purpose is to read or write XML documents using the Hypertext Transfer Protocol get operation or post operation. It connects other Flash MX Professional 2004 components to external XML data sources. The XMLConnector communicates with components in your application using either data binding features in the Flash MX Professional 2004 environment (via panels) or through ActionScript code. The XMLConnector component has properties, methods, and events, but it has no

visual appearance and is not seen in the Flash Player. While in the Flash authoring environment, however, the XMLConnector appear as an icon.

By implementing an XMLConnector you are providing a system that enables your Flash Movie to connect to an external XML file (or data source that receives or returns XML). Once connected to the XML data you have access to its structure (nodes or elements), but first you must specify the XML file's schema. This schema identifies for Flash MX Professional 2004 the data elements in the XML document that you can bind to the user interface component properties in your Flash file. In other words you want to tell Flash MX Professional 2004, "Here are the elements or nodes in my XML files. You can use these in the Flash movie." You provide this information to Flash MX Professional 2004 in the next steps.

7. From the Components panel, drag a DataSet component onto the stage, and in the Property inspector name the instance `golf_dataset`. See Figure 7.11 as a guide to your stage and Property Inspector.

FIGURE 7.11 The Flash MX Professional 2004 Component Inspector with the DataSet component-selected and given an instance name.

CONCEPT: THE DATASET COMPONENT

The DataSet component manages the data obtained from an external source; in this tutorial, that data is the XML file. Note that the DataSet component works only in the Flash 7.0 Player. The DataSet component treats the incoming data as a collection of items (array), each item representing a record of data from the XML file. The data being returned from the XMLConnector (`golf_connector`) is an array of XML nodes. This array of XML nodes is returned because you specify an XML schema, which you will do now in the next step.

8. On the stage select the XMLConnector component, and in the Component Inspector choose the Schema tab. This is where you indicate to Flash MX Professional 2004 the structure of the XML file. Flash MX Professional 2004 accepts a copy of the external XML document as a model for the schema.

9. Select the `results:XML` property, then click Import a schema from a sample XML file button on the upper-right side of the Schema tab (it looks like a down arrow), or select Import XML Schema from the Component Inspector panel's title bar menu .

Notice the direction of the arrow when you click `results:XML` indicating the receive direction of the XML data.

10. Browse for and select the *Boulder_Creek.xml* file from the *Chapter 7* directory.

This step is the means by which you access XML documents in Flash MX Professional 2004. When you import a sample XML file to use as a schema, Flash MX Professional 2004 examines the sample document and creates a schema that represents the nesting structure of the document's XML elements and attributes, as well as the data type (number, Boolean value, or string) of the text values. Any element that occurs more than once appears in the schema as an array. Importing the XML schema exposes the XML file's treelike structure of nodes to Flash MX Professional 2004 so that you can bind them to your Flash file user interface components such as text boxes and menus.

This is made clear through the visual representation of the XML data as it appears after in the Component Inspector, as shown in Figure 7.12.

The schema now appears in the Schema tab. You can now create a binding between the XML elements and the component property within the application.

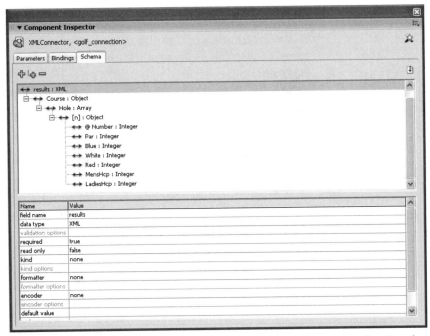

FIGURE 7.12 The Flash MX Professional 2004 Component Inspector showing the XML file structure.

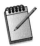

Some XML documents may have a structure that Flash MX Professional 2004 cannot represent—for example, elements that contain text and child elements mixed together.

Review what you have accomplished at this point. You created an instance of an XMLConnector component whose purpose is to connect an XML file to your Flash file. You also created an instance of a DataSet component, for which you provided Flash MX Professional 2004 with the structure of your XML File through the Import a Schema button. You are still not quite ready to retrieve the data from the XML file because the data that contains the array of XML nodes returned from the XML-Connector is not supported by the DataSet component. In other words, the DataSet can receive the XML nodes but does not understand them in a way that makes them available to your Flash movie. The solution is to use the Flash data-binding mechanism that will copy the data from the XMLConnector component to the DataSet component. This implements the DataProvider interface that allows us to assign the array of XML nodes to the `DataSet.dataProvider` property. The data-binding feature then enables us to access the XML nodes for the Flash Movie.

CONCEPT: DATA BINDING

It is important to realize that the various data components you have used in Flash MX Professional 2004 contain no data. They are like empty boxes or shells for which Flash MX Professional 2004 provides various properties. These properties allow you to get data into and out of a component. Data binding, then, is a way of connecting components to each other. You use data binding in this tutorial as a way of connecting a user interface component (the DataGrid component) to an external data source (the XML document). The DataSet component in the tutorial acts as sort of a middleman between the XMLConnector data and the Data-Grid. This is necessary because Flash MX Professional 2004 cannot inter-act with the data in the XMLConnector directly. Therefore, you bind the XMLConnector data to the DataSet component and retrieve the DataSet's data from your DataGrid component. However, for a DataSet component to use the data it requires a schema. The schema of a com-ponent shows you what properties and fields are available for data bind-ing. The Schema tab allows you to view the schema for the selected component. The schema contains a list of the component's bindable properties, their data types, their internal structure, and various special attributes. This is the information that the data-binding feature needs to handle your data correctly.

Now you will bind the XML file to the DataSet. The Bindings tab of the Component Inspector allows you to view, add, and remove bind-ings. All the bindings for a component are displayed here. The Binding List pane, the top pane of the Bindings tab, displays a component's bound properties, represented by schema location. The Binding Attrib-utes pane, the bottom pane, displays name/value pairs for the selected binding. When you click the Add Binding (+) button on the Bindings tab, the Add Binding dialog box appears.

11. In the Component Inspector, select the Bindings tab and click + (Add Binding) button in upper-left side of the panel. The Add Bind-ing dialog box appears. This dialog box displays all the schema items for your component. Use this dialog box to select which schema item to bind to. Component properties are displayed as root nodes within the schema tree. An arrow icon represents whether a schema item has read/write access, as follows: a right-pointing arrow represents a write-only property, a left-pointing arrow repre-sents a read-only property, and a bidirectional arrow represents a read-write property. Select the Hole Array, as shown in Figure 7.13, and click OK.

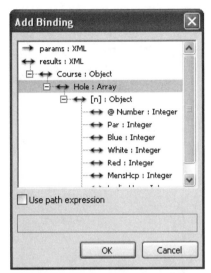

FIGURE 7.13 The Add Binding dialog box with Hole Array selected.

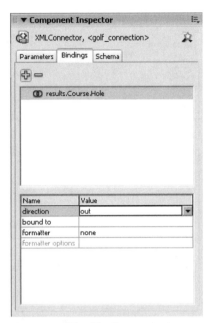

FIGURE 7.14 The Bindings panel.

12. In the Bindings panel attribute pane, locate the direction field and select out. The panel is shown in Figure 7.14.
13. Click in the Bound To field of the attribute pane and click the magnifying glass icon that appears on the right side of the Bound To field. The Bound To dialog box appears. On the left Component path: side of the dialog box select the Data Set, <golf_dataset>. On the right Schema Location side of the dialog box, select the dataprovider: Array, as shown in Figure 7.15.

FIGURE 7.15 The Bound To dialog box.

Because you cannot retrieve the data from the XML file directly through Flash MX Professional 2004, you must take this step, which binds the data from the XML file to the DataSet property. You can now access the XML data from the DataSet property. The Bindings panel should appear as it is shown in Figure 7.16.

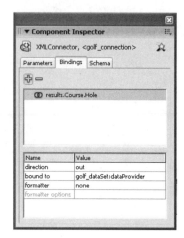

FIGURE 7.16 The Bindings panel.

You have bound to the `<Hole>` array; however, you must create fields for the individual elements in the array to retrieve the XML data from the array.

14. Select the Schema tab of the Component Inspector and select `re-sults: XML` from the top. Then click + (plus sign) at the top-left corner of the panel to add a new field. This is the Add a Component Property button. Name the field `Number in the "field name"` field and set the field's datatype to integer by clicking the datatype field and selecting `integer`.

The field names you add must exactly match their corresponding properties from the XMLConnector to retrieve the data using the dataset property.

15. Create the remaining field by clicking + (plus sign), naming the fields and setting their datatypes as follows:

Naming the Component Properties Fields and Their Datatypes

NAME OF FIELD	DATATYPE
Par	integer
Blue	integer
White	integer
Red	integer
MensHcp	integer
LadiesHcp	integer

Now you'll add another component to your Flash file. The DataGrid component creates a spreadsheet of columns and rows that displays the data bound to it via the Bindings tab of the Component Inspector.

16. From the Components panel, drag a DataGrid component from the UI Interface category onto the stage. With the DataGrid still selected on the stage, set its width and height properties from the Property Inspector. The width should be 475 pixels, the height 250 pixels, the x-coordinate 64, and the y-coordinate 32.

Your stage should appear shown in Figure 7.17.

FIGURE 7.17 The Flash Movie as it appears in the stage after step 16.

The DataGrid uses a `dataProvider` property to obtain its data. You will bind the DataGrid's `dataProvider` property and the DataSet's `dataProvider` property. You must set the direction to `in` so that the DataGrid receives its data from the DataSet.

17. Name the DataGrid `golf_grid` by typing `golf_grid` in the Instance Name field on the left side of the Property Inspector while the Data-Grid is still selected.
18. Select the Bindings tab of the Component Inspector and click + (plus sign) to display the Add Binding dialog box. For the DataGrid to retrieve data you must bind its `DataProvider` property to the Golf DataSet's `DataProvider` property.
19. From the Add Binding dialog box select the `dataProvider:Array` and click OK. From the Component Inspector's direction field, choose `in` and set the Bound To field to the `DataSet,<golf_dataset> for the "Component Path"` and `DataProvider:Array` for the schema location and click OK.
20. Select the Bindings tab of the Component Inspector and click + (plus sign) to display the Add Binding dialog box. You must bind the `selectedIndex` properties so the data in the array is connected by its index number.
21. Select `selectedIndex: Number` and click OK.
22. In the Component Inspector select the Bound To field and click the magnifying glass icon. On the left Component Path side of the dialog box select `DataSet, <golf_dataset>`. On the right schema location side, select `selectedIndex:Number` and click OK. Set the direction field on the Component Inspector to `in`.

Now you will add a button and set a behavior for the button that will trigger the data.

23. From the Components panel, drag a Button component from the UI Interface category onto the stage. From the Property Inspectors' Instance Name field, name the button `golf_button`. In the label field on the Property Inspector, type the label, `Get Golf Data`.

To add functionality to the button, use a Flash Behavior.

24. Click Window → Development Panels → Behaviors.
25. With the button selected, click the Add Behavior button from the Behaviors panel and click Data → Trigger Data Source. The Trigger Data Source dialog box opens.
26. Select `golf_connection` as the data source to trigger, as shown in Figure 7.18.

FIGURE 7.18 The Trigger Data Source dialog box with
`golf_connection` selected.

You are now ready to test the file.

27. Click Control → Test Movie or press CTRL + Enter from your keyboard to test the movie. The Shockwave file is displayed.
28. Click the Get Golf Data button to display the XML data. The Golf XML data appear as shown in Figure 7.19.

LadiesHc	MensHcp	Red	White	Blue	Par	Num
15	17	225	0	225	4	1
5	7	177	0	177	3	2
1	5	310	0	310	4	3
17	1	387	0	387	4	4
9	13	139	0	139	3	5
3	3	189	0	189	3	6
13	9	159	0	159	3	7
7	15	157	0	157	3	8
11	11	207	0	265	4	9
8	2	182	0	182	3	10
4	4	125	0	168	3	11

Get Golf Data

FIGURE 7.19 The Shockwave file displaying the Golf
XML data.

You have successfully displayed the XML data in the Web browser. You now must make it editable so that the course manager can make changes to his course information and update the data on the server. You may want to save the Flash file at this point with a new name so that you have both the editable and non-editable versions.

29. Click File → Save As and name the file *Ch_7_Golf_XML_editable.fla*.

You begin by simply making the DataGrid editable. This is the DataGrid that is displayed in the Flash Player in the browser window.

30. On the stage, select the DataGrid component and then select the Parameters tab in the Component Inspector panel and set the `editable` property to `true`, as shown in Figure 7.20.

FIGURE 7.20 The Component Inspector with the editable property set to `true`.

31. Click Control → Test Movie or press CTRL + Enter from the keyboard to test the movie. The Shockwave file is displayed, and you can now edit the data within the grid. Click the Get Golf Data button, then place your cursor inside the data grid and change some of the data.

At this point you need to add code to the Flash file that will accept the golf course manager's changes and submit them to update the XML data on the server. Recall from Chapters 1 and 2 that XML is supported by the manufacturers of database software and that this support comes in the form of the ability of the software to import and export XML data. It stands to reason then that you need some kind of connector to allow you to connect to that database software. If you can communicate with the XML data that resides in the database through the Hypertext Transfer Protocol, you can update your XML via the Internet. A connector exists in the form of a language called XUpdate, and it is supported by

an XML database standards organization called XML:DB. See *www
.xmldb.org/index.html* for more information about XML and database
standards and the XUpdate language. XUpdate is an XML language for
updating arbitrary XML documents. It uses a vocabulary of tags to en-
capsulate the changes made to an XML file and communicate those
changes to a database of XML data that understands the XUpdate lan-
guage. Flash MX Professional 2004 supports this language with another
component called XUpdateResolver. XUpdateResolver is used in con-
junction with a DataSet component to enable you to convert changes
made to the data within the Web browser into a format that is under-
stood by the external XML file that you are updating. Like the DataSet
and XMLConnector components, you do not see the XupdateResolver
component in the Web browser; it appears as an icon in the Flash file.

CONCEPT: DELTAPACKETS AND THE XUPDATERESOLVER

DeltaPackets are created by DataSet components in your Flash file. The
DeltaPacket is a set of instructions that describes any changes made to
your data at runtime. Runtime refers to the loading of data by the Shock-
wave file. Flash Resolver components convert the data to the appropri-
ate format as an update packet. If the data changes on the server, the
server sends a response, called a result packet, containing the updates.
The Flash Resolver components can then change this information back
into a DeltaPacket, which is applied to the DataSet component to keep
it in sync with the data on the server. Resolver components allow you to
keep your Web application current without writing a lot of ActionScript
code. The XUpdate Resolver component translates the DeltaPacket into
XUpdate statements. These statements are understood by any database
or external data source file (including an ASP page or Java servlet) that
supports the XUpdate language. All the necessary information for for-
matting and updating the database is contained in this XML file written
in XUpdate.

The updates from the XUpdateResolver component are sent in the
form of an XUpdate data packet, which is communicated to the data-
base or server through a connection object. The XUpdate packet con-
sists of a set of instructions that describes the inserts, edits, and deletes
performed on the DataSet component (XML file in the example). The
Resolver component gets a DeltaPacket from a DataSet component,
sends its own XUpdate packet to a connector, receives any server errors
back from the connection, and communicates them back to the DataSet
component—all using bindable properties.

You will now add an XupdateResolver to your Flash application. Remember that the DataSet is managing the data—it is tracking changes made to the data into the DeltaPacket. You must send the changes made in the Web browser back to the server, and that requires a Resolver. The XUpdate Resolver is what you need to update your XML source.

32. Drag an XUpdate Resolver component onto the stage, and in the Property Inspector enter the instance name `golf_resolver`. Your stage should resemble Figure 7.21.

FIGURE 7.21 The Flash stage showing the XUpdate Resolver and the Property Inspector.

33. With XUpdate Resolver still selected, select the Schema tab in the Component Inspector panel and select the `deltaPacket` component property within the schema tree on the top pane.

34. Change the `deltaPacket`'s encoder setting to `DataSetDeltaToXUpdat-eDelta`.

This encoder converts data within the DeltaPacket into XPath statements that are supplied to the XUpdateResolver to locate the nodes in the XML tree structure. Flash MX Professional 2004 needs help, however, in determining where these XPath expressions can be located within the DataSet. Step 35 provides this information.

35. Select the `encoder options` property. You will be prompted for a value for the `rowNodeKey` property. This property identifies which node within the XML file will be treated as a record within the DataSet. It also defines which element or attribute combination makes the row node unique. Click the magnifying glass icon in the `encoder options` property field and type the datapacket identifier followed by the node `<hole>` and the attribute that makes each `<hole>` tag unique, which is the `number` attribute. ? indicates the `number` attribute as a placeholder in general, as opposed to a particular node. Type the line as follows:

```
datapacket/hole[@Number = '?Number']
```

The DataSetDeltaToXUpdateDelta dialog box appears as shown in Figure 7.22.

FIGURE 7.22 The DataSetDeltaToXUpdateDelta
dialog box.

The next step is to bind the XUpdate Resolver's deltaPacket to the DataSet components deltaPacket so that the data can be updated before being sent to the server.

36. In the Component Inspector select the Bindings tab. Select the DataSet component on the stage and add a binding from the XUpdate Resolver's `deltaPacket` property to the DataSet component's `deltaPacket` property and set the direction to `in/out`. Remember that bindings are created by clicking the Add Binding (+) sign at the

upper-left corner of the Component Inspector. When you are fin-
ished the Component Inspector appear as shown in Figure 7.23.

FIGURE 7.23 The Component Inspector with the
Bindings panel showing the binding from the
XUpdate Resolver's `deltaPacket` property to
the DataSet component's `deltaPacket`
property and the direction set to `in/out`.

 The Flash Web application is now complete, and the DeltaPacket
with the changes would be submitted to the server via the XUpdate-
Resolver component. However, if you test the file now, you would not
see this functionality take place because you need a qualified database
on the server that understands and can process the XUpdate language.
Instead, what you will do is create a text box that will hold the XUpdate
statements so that you can see both what this XUpdate language looks
like and the XupdateResolver component in action.

37. Drag a text area component onto the stage. In the Property Inspec-
 tor enter the instance name `XUpdateText`. Move the remaining com-
 ponents on the stage to resemble what is shown in Figure 7.24.
 Make the text area 50 pixels wide by 100 pixels deep.
38. With the new text area component selected, select the Bindings tab
 on the Component Inspector. Add a binding from the text area's
 `text:string` property to the XUpdate Resolver's `xupdatePacket` prop-
 erty. The UpdatePacket contains the version of the XML data that
 was changed by the golf course manager on the Web site. It is the

FIGURE 7.24 The Flash stage with the new text area.

DeltaPacket that will be sent to the server. The direction should be `in/out`.

This new text area now displays the XupdatePacket that would normally be sent to the server. This step would not be taken in your final Web Application—you are doing this here for practice only. Now create a button to trigger this text to display in the new text area component.

39. Drag a button onto the stage, and in the Property Inspector enter the instance name `showUpdates_button`. Make the button's width 250 pixels. In the Component Inspector, select the Parameters tab and change the label to `Show Hole Changes sent to XupdatePacket`.

The button needs some ActionScript to enable its functionality, which is to display the XupdatePacket in the text area.

40. With the button selected, open the Actions panel (press the F9 key) and enter the following code:

```
on (click)
  {
    _parent. golf_dataSet.applyUpdates();
  }
```

Now you can test the application by testing the movie, making changes to the golf hole data, and clicking the Show Hole Changes sent to XupdatePacket button.

41. Click "Control →Test Movie" or press CTRL + Enter from your keyboard to test the movie. The Shockwave file is displayed. Click the Get Golf Data button and change one or more of the data fields.

42. Click the Show Hole Changes sent to XupdatePacket button to see the XupdatePacket that will be sent to the server. Figure 7.25 shows the application after the Show Hole Changes sent to XupdatePacket button has been clicked.

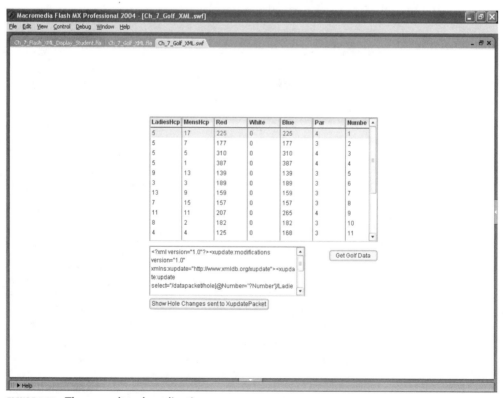

FIGURE 7.25 The completed application.

You can now see how the XupdateResolver works through this demonstration. The XUpdate language, which appears in the text area, is beyond the scope of this book; however, you can visit the Web site *www.xmldb.org/index.html* for more information.

SUMMARY

You have concluded this Flash MX Professional 2004 chapter with the latest functionality from Macromedia Flash MX Professional 2004, the XMLConnector. You don't need to stretch your imagination too far to see the usefulness of obtaining XML in this way. It suits your golf Web site ideally as a method to allow users to update the data, although XMLConnectors can be used to simply display XML Data.

ADDITIONAL RESOURCES

Flash MX Professional 2004 General Information: *www.macrome-dia.com/software/flash/flashpro/*

Flash MX Professional 2004 Support Page: *www.macromedia.com/support/flash/*

Tutorials from Macromedia:
www.macromedia.com/support/flash/applications/xml/
www.macromedia.com/support/flash/applications/jpeg_slideshow_xml/

Tips: *www.macromedia.com/support/flash/ts/documents/ff_view_xml.htm*

LIST OF DATA FILES FOR THE TUTORIALS

L isted in this appendix are all of the files included on the CD-ROM that pertain to the tutorials. Each chapter's directories are listed along with the files in each directory. If a directory contains subdirectories, they are listed as well. The data files themselves are end-user files that are opened or edited in a tutorial, as opposed to supporting files, which are listed separately. Supporting files include any files that are required to open or display the end-user files, such as linked files and graphics.

Chapter 1

This folder is intentionally empty.

Chapter 2

Directory: *Data Files/Part 1/Chapter 2/Ch_2_The_XML_Tour*
Student Files:
 Ch.2_BayAreaGolfCourse_HTML.html
 Ch.2_Golf_XML_Sample.xml
 Ch.2_Golf_XML_with_XSLT.xml
 Ch.2_Golf_XML_for_WML.xml
 Final_Golf.xml
 Ch.2_Golf_XSL_to_WML.xsl
 Ch.2_Golf_XSLT.xsl

Ch_2_Golf_XSLT_Final.xsl
Ch.2_Golf_WML.wml
Ch.2_Wine_XML.xml
Ch.2_Wine_XML_with_CSS.xml
Ch.2_Wine_XML_with_XSLT.xml
Ch.2_Wine_XSLT.xsl
Ch.2_Wine.xsl
Ch.2_Wine_CSS.css

Supporting Files:
BanquetICON.gif
ferrell.jpg
circle1.gif
circle2.gif
davidcruz.jpg
GiftICON.gif
golfBallCircle.gif
golfBallicon.gif
GolfBG1.jpg
golfbg3.jpg
greenBorder.gif
gulermo.jpg
PicnicICON.gif
ronzini.jpg
SHIM.GIF
sun.JPG
TastingICON.gif
TourICON.gif
salmon.jpg
wineryBG.jpg

Chapter 3

Tutorial One

Directory: *Data Files/Part_2/Chapter 3/Ch_3_Well-Formed_XML_1*
Student Files Directory:
 Data Files/Part_2/Chapter 3/Ch_3_Well-Formed_XML_1/
 How To Write Well Formed XML
Student Files: There are no student files to open.
Finished Files Directory: *Data Files/Part_2/Chapter 3/Ch_3_Well-*
 Formed_XML_1/Ch_3_1 Finished

Finished Files:
 Ch.3_Finished_Well_Formed_Error.xml
 Ch.3_Finished_Well_Formed_Golf.xml

Tutorial Two

Directory: *Data Files/Part_2/Chapter 3/Ch_3_DTD_2*
Student Files: *Ch_3_Finished_Well_Formed_Golf.xml*
Finished Files Directory: *Ch_3_2 Finished*
Finished Files:
 Ch.3_Golf_XML_with_Entity_dtd.XML
 Ch_3_Golf.dtd
 Ch_3_Golf_ExternalDTD.xml
 Ch_3_Golf_InternalDTD.xml
 Ch_3_Golf_InternalDTDwError.xml

Tutorial Three

Directory: *Data Files/Part_2/Chapter 3/Ch_3_Schema_3*
Student Files:
 Ch.3_Finished_Golf_MSSchema.xdr
 Ch.3_Golf_XML_with_External_DTD.xml
Finished Files Directory: *Ch_3_3 Finished*
Finished Files:
 Ch.3_Finished_Golf_MSSchema.xdr
 Ch.3_Finished_Golf_W3Schema.xsd
 Ch.3_Finished_Golf_XML_ParFour_wDTD.xml
 Ch.3_Finished_Golf_XML_with_Mistake_dtd.xml
 Ch.3_Finished_Golf_XML_with_Mistake_xdr.xml
 Ch.3_Golf_XML_with_InternalDTD.xml
 Ch.3_Golf_XML_with_MSSchema.xml
 Ch.3_Golf_XML_with_W3Schema.xml

Chapter 4

Tutorial One

Directory: *Data Files/Part_2/Chapter 4 /Ch_4_How to write XML with
 CSS_1*
Student Files: *Ch.4_XML_For_CSS_Golf.xml*
Supporting Files:
 golfBallicon.gif
 GOLFBG1.JPG

Finished Files Directory: *Ch_4_1 Finished*
Finished Files:

 Ch.4_Finished_XML_For_CSS_Golf.xml
 Ch.4_Finished_XML_Golf_CSS.css
 Ch.4_Finished_XML_Golf_CSS_Modified.css
 Ch.4_Finished_XML_Modified_Golf.xml
 Ch.4_XML_For_CSS_Golf1.xml
 Ch.4_XML_For_CSS_Golf2.xml
 Ch.4_XML_For_CSS_Golf3.xml
 Ch.4_XML_For_CSS_Golf4.xml
 Ch.4_XML_For_CSS_Golf5.xml
 Ch.4_XML_For_CSS_Golf6.xml
 Ch.4_XML_For_CSS_Golf7.xml
 Ch.4_XML_Golf_CSS1.css
 Ch.4_XML_Golf_CSS2.css
 Ch.4_XML_Golf_CSS3.css
 Ch.4_XML_Golf_CSS4.css
 Ch.4_XML_Golf_CSS5.css
 Ch.4_XML_Golf_CSS6.css
 Ch.4_XML_Golf_CSS7.css

Supporting Files:

 golfBallicon.gif
 GOLFBG1.JPG

Finished Files Directory: *Finished Wine Examples*
Finished Files:

 Ch.4_Wine_XML_with_CSS.xml
 Ch.4_Wine_CSS.css

Supporting Files:

 BanquetICON.gif
 GiftICON.gif
 PicnicICON.gif
 SHIM.GIF
 TastingICON.gif
 TourICON.gif
 wineryBG.jpg

Tutorial Two

Directory: *Data Files/Part_2/Chapter 4 /Ch_4_How to write XSLT_2*
Student Files: *Ch_4_Golf_A_E.xml*
Supporting Files:
 CIRCLE1.GIF

CIRCLE2.GIF
golfBallCircle.gif
golfBallicon.gif
GolfBG1.jpg
greenBorder.gif

Student Files Directory: *Data Files/Part_2/Chapter 4 /Ch_4_How to write XSLT_2/XML*

Student Files:

Cold Springs Golf Course.xml
Altos Par 3.xml
Altos Seas Gold Course.xml
Blueberry Farm Golf Course.xml
Black Creek Golf Club.xml
Diamond Ridge Par 3 Golf Course.xml
Cabernet Golf Club.xml
Masonry Reef Golf Course.xml
City of San Rivera Golf Course.xml
Sycamore Golf Course.xml
Deep Ridge Golf Course.xml
Del Skye Golf Course.xml
Delacruz Golf Course.xml
Dan Marsh Course at the Marsh Golf Complex.xml
Sapphire Hills Golf Course.xml
Hilroy Golf Course.xml
Roneagles Golf Club.xml
Full Moon Bay Golf Links.xml
Yanez Park Golf Course.xml
Open Valley Lake Golf Club.xml
Cowboy Valley Golf Club.xml
John Clark Course at the Marsh Golf Complex.xml
Two Lagoons Golf Course.xml
Lake Kabob Golf Course.xml
Las Limas Golf Course.xml
Catrina Golf Course.xml
Mt. St. Milo Golf Course.xml
Atlantic Grove Golf Links.xml
Najaro Valley Golf Club.xml
Middleton Municipal Golf Course.xml
Boardwalk Golf Course.xml
San Pilgrim Golf Course.xml
Sutherland Greens Golf Course.xml
Seashore Golf Links.xml

Brook Hills Golf Course.xml
Red Valley Golf Course.xml
Hourglass Hill Golf Course.xml
Lookout Point Golf Club.xml
Noel Springs Golf Course.xml
The Links at Latin Bay.xml
Tony Rivera Golf Course.xml
Valley Gorge Golf Course.xml
GolfCourses_3.xml
Multiple.xml
Ch_4_Golf_XSLT_Final.xsl
Ch_4_Multiple_Golf_XSLT_Final.xsl

Supporting Files:
CIRCLE1.GIF
CIRCLE2.GIF
golfBallCircle.gif
golfBallicon.gif
GolfBG1.jpg
greenBorder.gif

Tutorial Three

Directory: *Data Files/Part_2/Chapter 4 /Ch_4_Configuring DW as an XML Editor_3*
Student Files: *Golf XML Tags.xsd*
Finished Files Directory: *Ch_4_3 Finished*
Finished Files Subdirectory: *Add to Toolbars Directory*
Finished Files:
Golf.xml
NewGolf.gif
Finished Files Subdirectory: *Add to Menus Directory*
Finished Files:
Golf.xml
menus.xml
Finished Files Subdirectory: *Add to Objects Directory*
Finished Files: *insertbar.xml*
Subdirectory: *XML*
Finished Files:
CData.htm
cdata.js
CData.png
xml_stylesheet.gif

xml_stylesheet.htm
xml_stylesheet.js

Chapter 5

Tutorial One

Directory: *Data Files/Part_2/Chapter 5 /Ch_5_How to Create DW XML-Based Web Pages_1*
Student Files Directory:
Data Files/Part_2/Chapter 5 /Ch_5_How to Create DW XML-Based Web Pages_1/Export To XML
Supporting Files Direrctory: *Templates*
Student Files: *Winery_via_Template.htm*
Supporting Files Directory: *images*
Finished Files Directory: *Ch_5_1 Finished*
Finished Files:
　　Ch_5_Winery_Export_RegionName_Tags.xml
　　Ch_5_Winery_Export_DW_Tags.xml
Finished Files
Supporting Directory: *images*
Supporting Files:
　wineryBG.gif
　shim.gif
　bwCorkBG.jpg
Supporting Files Directory: *jpgs*
Supporting Files:
　ferrell.jpg
　davidcruz.jpg
　gullermo.jpg
　ronzini.jpg
　sun.jpg
　salmon.jpg
Supporting Files Directory: *Icons*
Supporting Files:
　BanquetICON.gif
　GiftICON.gif
　GuidedTourIcon.gif
　PicnicICON.gif
　TastingICON.gif
　TourICON.gif

Tutorial Two

Directory: *Data Files/Part_2/Chapter 5 /Ch_5_How to Modify XML for DW Templates_2*

Student Files Directory: *Original XML File*

Student Files: *Blueberry Farm Golf Course.xml*

Student Files Directory: *Templates*

Student Files:

 Golf_Template_Finished.dwt

 Golf_Web_Site_Template.dwt

 Golf_Template_Student.dwt

Student Files Directory: *XSL-T Stylesheets*

Student Files: *Ch_5_Golf_for_Dreamweaver_Stylesheet.xsl*

Supporting Files Directory: *images*

Files: *CIRCLE1.gif*

 CIRCLE2.gif

 golfBallCircle.gif

 GolfBG1.jpg

 greenBorder.gif

Finished Files Directory: *Ch_5_2 Finished*

Finished Files Subdirectory: *Finished XML from Template*

Finished Files: *Finished_Blueberry_Farm.htm*

 Finished_Black_Creek.htm

 Finished_Cabernet.htm

 Finished_Deep_Ridge.htm

 CIRCLE1.gif

 CIRCLE2.gif

 golfBallCircle.gif

 GolfBG1.jpg

 greenBorder.gif

Finished Files Subdirectory: *New Transformed XML Files*

Finished Files:

 Blueberry_Farm_New.xml

 Black_Creek_New.xml

 Cabernet_Club_New.xml

 Deep_Ridge_New.xml

Finished Files Subdirectory: *Original XML Files with Attached Stylesheets*

Finished Files:

 Blueberry Farm Golf Course_w_SS.xml

 Black_Creek_w_SS.xml

 Cabernet Golf Club_w_SS.xml

Deep Ridge Golf Course_w_SS.xml
Ch_5_Golf_for_Dreamweaver_Stylesheet.xsl

Tutorial Three

Directory: *Data Files/Part_2/Chapter 5/Ch_5_How To Use XML with ColdFusion_3*
Student Files:
 Ch_5_4_GolfCourses.xml
 Ch_5_CF_XML_Student_1.cfm
 Ch_5_CF_XML_Student_2.cfm
 Ch_5_Golf_CF_Student.cfm
 GolfCourses_4.xml
 GolfCourses_4holes.xml
 Valley Gorge Golf Course.xml
Supporting Files Directory: *images*
Supporting Files:
 CIRCLE1.gif
 CIRCLE2.gif
 golfBallCircle.gif
 Golf_Ball_NO_icon.gif
 golfBallicon.gif
 GolfBG1.jpg
 golfbg1.png
 SHIM.GIF
 greenBorder.gif
Finished Files Directory: *Ch_5_3 Finished*
Finished Files:
 test.xml
 ColdFusion_Test.cfm
 Valley Gorge Golf Course.xml
 Ch_5_4_GolfCourses.xml
 Ch_5_CF_XML_1.cfm
 Ch_5_CF_XML_2.cfm
 Ch_5_Golf_CF_Finished.cfm

Chapter 6

Tutorial One

Directory: *Data Files/Part_3/Chapter 6/*
Student Files Directory: *Ch_6_XML_Generated_Images*
 Ch_6_XML_Generated_PNGs

Student Files:

Ch_6_Fireworks_XML.xml
Ch_6_Golf_XSL_for_FW.xsl
Blueberry Farm Golf Course.xml
Ch_6_Golf_WebPage.png

Student Files Subdirectory: *Data Files/Part_3/Chapter 6 /Web_ Banner*

Student Files: *resorts.xml*

Student Files Subdirectory: *Data Files/Part_3/Chapter 6 /Web_ Banner/images*

Student Files: *Iron.jpg*

Student Files Subdirectory: *Data Files/Part_3/Chapter 6 /Web_ Banner/Exported Web Banner PNGs*

Student Files: This folder is intentionally empty

Student Files Subdirectory: *Data Files/Part_3/Chapter 6 /Web_ Banner/Exported Web Banner Graphics*

Student Files: This folder is intentionally empty

Student Files Subdirectory: *Data Files/Part_3/Chapter 6 /Web_ Banner/Banner_Images*

Student Files:

Banner1.png
Banner2.png
Banner3.png
Banner4.png

Finished Files Directory: *Data Files/Part_3/Chapter 6 /Web_Banner/ Finished Web Banner Files*

Finished Files: *Golf_Resort_Banner_Template.png*

Finished Files Subdirectory: *Exported Web Banner Graphics*

Finished Files:

Golf_Resort_Banner_Template1.jpg
Golf_Resort_Banner_Template2.jpg
Golf_Resort_Banner_Template3.jpg
Golf_Resort_Banner_Template4.jpg

Finished Files Subdirectory: *Exported Web Banner PNGs*

Finished Files:

Golf_Resort_Banner_Template1.jpg
Golf_Resort_Banner_Template2.png
Golf_Resort_Banner_Template3.png
Golf_Resort_Banner_Template4.png

Chapter 7

Finished Files Directory: *Ch_7_Finished Files*
Ch_7_Flash_Project.flp
Finished Files Subdirectory: *Flash Basic Functionality*
Finished Files: *Ch_7_Flash_1_Finished.fla*
Ch_7_Flash_1_Finished.swf
Ch_7_Flash_XML_1.xml
Ch_7_Flash_XML_Display_Finished.fla
Finished Files Subdirectory: *XMLConnector Files*
Finished Files: *Ch_7_Golf_A_E.xml*
Ch_7_Golf_XML_Finished.fla
Ch_7_XMLConnector_Finished.fla
FinishedXMLConnector_Edit.fla
Student Files Directory: *Ch_7_Student Files*
Student Files Subdirectory: *Basic Flash Functionality*
Student Files: *Ch_7_Flash_1_Student.fla*
Ch_7_Flash_XML_1.xml
Ch_7_Flash_XML_Display_Student.fla
Student Files Subdirectory: *XMLConnector Files*
Student Files: *Ch_7_Golf_A_E.xml*

B

SITE DEFINITION INSTRUCTIONS

The tutorials in the chapters for Dreamweaver—Chapters 3, 4, and 5—begin by defining the site. This appendix shows you the directory you should choose as the root directory when defining your Web site in Dreamweaver.

Listed here are the file directories, which should be used when defining sites in Dreamweaver. These are the directories that should be your sites Root Directory.

Chapter 1

It is not necessary to define a site for Chapter 1.

Chapter 2

Root Directory: *Data Files/Part_1/Chapter 2/Ch_2_The_XML_Tour*

Chapter 3

Tutorial One
Root Directory: *Data Files/Part_2/Chapter 3/Ch_3_Well-Formed_XML_1*

Tutorial Two
Root Directory: *Data Files/Part_2/Chapter 3/Ch_3_DTD_2*

Tutorial Three
Root Directory: *Data Files/Part_2/Chapter 3/Ch_3_Schema_3*

Chapter 4

Tutorial One
Root Directory: *Data Files/Part_2/Chapter 4 /Ch_4_How to write XML with CSS_1*

Tutorial Two
Root Directory: *Data Files/Part_2/Chapter 4 /Ch_4_How to write XSLT_2*

Tutorial Three
Root Directory: *Data Files/Part_2/Chapter 4 /Ch_4_Configuring DW as an XML Editor_3*

Chapter 5

Tutorial One
Root Directory: *Data Files/Part_2/Chapter 5 /Ch_5_How to Create DW XML-Based Web_Pages_1*

Tutorial Two
Root Directory: *Data Files/Part_2/Chapter 5/Ch_5_How to Modify XML for DW Templates_2*

Tutorial Three
Root Directory: *Data Files/Part_2/Chapter 5/Ch_5_How To Use XML with ColdFusion_3*

Chapter 6

It is not necessary to define a site for Chapter 6.
Student files are located in the directory *Data Files/Part_3/ Chapter 6.*

Chapter 7

It is not necessary to define a site for Chapter 7.
Student files are located in directory: *Data Files/Part_4/Chapter 7*

XSL-T REFERENCE: ELEMENTS

Chapter 4 Tutorial Two introduces the XML Stylesheet Language-Transformation (XSL-T). Appendix C serves as a list of elements for the XSL-T language. Most but not all of these elements are used in the tutorial. They have been provided here as a more complete reference of the XSL-T language's vocabulary.

<xsl:apply-imports>
 Applies any overridden templates to the node currently being processed.
<xsl:apply-templates>
 Applies a template to a node set.
<xsl:attribute>
 Creates an attribute for the output document.
<xsl:attribute-set>
 Creates a group of attributes for the output document.
<xsl:call-template>
 Invokes a particular template by name.
<xsl:choose>
 Creates a conditional statement similar to a switch or a case statement in other programming languages that will provide a set of choices based on an existing condition.
<xsl:comment>
 Creates a comment in the output document.

<xsl:copy>

Copies the current node and its namespace nodes to the output document. It will not copy the nodes children or attributes.

<xsl:copy-of>

Copies whatever nodes are indicated in its `select` attribute to the result document.

<xsl:decimal-format>

Defines a number format to be used in the output document where numeric values are present.

<xsl:element>

Creates an element in the output document.

<xsl:fallback>

Defines a template to be used when an extension element cannot be found.

<xsl:for-each>

Creates a loop where the `select` attributes value indicates which nodes from the current context to iterate through.

<xsl:if>

Creates a conditional statement similar to an `if` statement in other programming languages. It contains a `test` attribute whose value will indicate the condition that is being tested for.

<xsl:import>

Allows you to import templates from another XSLT stylesheet.

<xsl:key>

Creates an index against the current document. It uses the attributes `name` to name the index, `match`, whose value will indicate the nodes to be indexed, and a `use` attribute to define the property used to create the index.

<xsl:message>

Sends a message to the XSL-T processor and is useful for debugging stylesheets.

<xsl:namespace-alias>

Allows you to define a namespace. It can be useful when writing a stylesheet that generates another stylesheet.

<xsl:number>

Formats a numeric value or counts something.

<xsl:otherwise>

Creates a conditional statement similar to the `else` statement used in other programming languages and is used with the `<xsl:choose>` element.

Defines the characteristics of the output document such as what type of document it is (such as XML, HTML, or text), the version number of the document, the encoding type, doctype, and so on.

<xsl:param>

Creates a parameter to be used by a template. Its value can be another element indicated with an XPath expression.

<xsl:preserve-space>

Preserve white space for the elements indicated in the value of its `elements` attribute.

<xsl:processing-instruction>

Creates a processing instruction in the output document.

<xsl:sort>

Creates a sort key for the node currently being processed. It must be a child of the `<xsl:apply-templates>` or `<xsl:for-each>` elements. It uses the attribute `order` with the values `ascending` or `descending`, as well as the attribute `case-order` with the values `upper-first` and `lower-first`.

<xsl:strip-space>

Removes whites pace for the elements indicated in the value of its `elements` attribute.

<xsl:stylesheet>

Represents the root element of an XSL-T stylesheet.

<xsl:template>

Defines an output template where the `match` attribute defines the elements for which the template should be used.

<xsl:text>

Allows you to write any text to the output document.

<xsl:value-of>

Interprets the value of an XPath expression and returns that value as a string, and then writes that value to the output document.

<xsl:variable>

Defines a variable.

<xsl:when>

Defines an existing condition when used with the `<xsl:choose>` element. It is similar to a `case` statement in other programming languages.

<xsl:with-param>

Defines a parameter to be passed to a template.

D XSL-T REFERENCE: FUNCTIONS

Chapter 4 Tutorial Two introduces the XML Stylesheet Language-Transformation (XSL-T). Whereas Appendix C referenced the XSL-T vocabulary, Appendix D serves as a list of functions for the XSL-T language. Chapter 4 also introduces the language XPath, and this language's functions are included here as well. Many but not all of these functions are used in the Chapter 4 tutorial. They have been provided here as a more complete reference of the XSL-T language.

boolean()
 This converts its argument to a Boolean value.

ceiling()
 Returns the smallest integer not less than its argument.

concat()
 Concatenates all of its arguments as strings.

contains()
 Calculates if the first argument string contains the second argument's string.

count()
 Counts the number of nodes in its arguments node set.

current()
 Returns a node set that has the current node as its only member.

document()

Allows multiple source documents to be processed by one stylesheet.

element-available()

Determines if its argument (an element name) is available to the XSL-T processor.

false()

Returns a Boolean value of `false`.

floor()

Returns the largest integer not greater than its argument.

Format-number()

Formats number that is an argument as a string.

Function-available()

Determines if its argument (an function name) is available to the XSL-T processor.

Generate-id()

Generates a unique ID for an XML name, given a node-set as an argument.

id()

Returns the node in the source document whose ID attribute matches the value passed to it as its argument.

key()

References a relation defined with the `<xsl:key>` element.

lang()

Determines if its argument (a string representing a language code) is the same as the language of the node being processed (the context node).

last()

Returns the position number of the last node in the current context.

local-name()

Returns the local part (the tag name without the namespace prefix) of the first node in the argument (node-set).

name()

Returns the qualified name (the tag name including the namespace prefix) of a node in the argument (node-set).

namespace-uri()

Returns the namespace URI of the first node in the argument node-set.

Normalize-space()

Removes extra white space from its argument, which is a string.

not()
Returns the negative of its Boolean value argument.

number()
Converts its argument to a number.

position()
Returns a number that is equal to the position of the current context node.

round()
Returns the integer closest to its argument.

starts-with()
Determines if the first argument string begins with the second argument's string.

string()
Returns its argument as a string.

string-length()
Returns the number of characters in its argument string. If no argument is input, the context node is converted to a string and the length of that string is returned.

substring()
Returns a portion of a given string. It requires three arguments. The first argument is the string to be evaluated. The second argument specifies the position of the first character of the substring, and the third argument, which is optional, indicates how many characters should be returned in the substring.

substring-after()
Returns the substring of the first argument after the first occurrence of the second argument in the first argument.

substring-before()
Returns the substring of the first argument before the first occurrence of the second argument in the first argument.

sum()
Converts all the nodes in the arguments node-set to numbers and return the sum of those numbers.

true()
Returns the Boolean value of true.

unparsed-entity-uri()
Returns the URI of the unparsed entity with the name specified by its argument.

E

CSS REFERENCES

Chapter 4 Tutorial One introduces the topic of Cascading Style Sheets (CSS). Appendix E serves as a list of the CSS language's properties and their associated values. Many but not all of these properties are used in Chapter 4 Tutorial One. They are included here for a more complete reference of the CSS language's functionality.

Font Controls

NAME	POSSIBLE VALUES
font-family	font family-name, serif, sans-serif, cursive, fantasy, monospace
font-style	normal, italic, oblique
font-variant	normal, small-caps
font-weight	normal, bold, bolder, lighter, 100–900
font-size	a number size, a percentage size, smaller, larger, xx-small, x-small, small, medium, large, x-large, xx-large
font:	font-style, font-variant, font-weight, font-size/line-height, font-family

Text Controls

NAME	POSSIBLE VALUE
word-spacing	a length value, normal
letter-spacing	a length value, normal
vertical-align	a percentage value, baseline, sub, super, top, text-top, middle, bottom, text-bottom
line-height	a percentage value, a length value, a number value, normal
text-decoration	none, underline, overline, line-through, blink
text-transform	none, capitalize, uppercase, lowercase
text-align	left, right, center, justify
text-indent	a length value, a percentage value
white-space	normal, pre, nowrap

List and Mouse Controls

NAME	POSSIBLE VALUES
list-style-type	disc, circle, square, decimal, lower-roman (i), upper-roman (I), lower-alpha (a), upper alpha (A), none
list-style-image	none, a url() for a graphic file
list-style-position	outside, inside
list-style	list-style-type, list-style-position, list-style-image
cursor	auto,crosshair, hand, pointer, move, n-resize, ne-resize, e-resize, se-resize, s-resize, sw-resize, w-resize, nw-resize, text, wait, help

Color and Background Controls

NAME	POSSIBLE VALUES
color	a color by name, hexadecimal value or rgb value
background-color	transparent or a color by name, hexadecimal value or rgb value
background-image	none or a url() of a graphic file
background-repeat	repeat, repeat-x, repeat-y, no-repeat
background-attachment	scroll, fixed
background-position	a percentage value, a length value, top, center, bottom, left, center, right
background	background-color, background-image, background-repeat, background-attachment, background-position

Margin and Border Controls

NAME	POSSIBLE VALUES
margin-left	a length value, a percentage value, auto
margin-right	a length value, a percentage value, auto
margin-bottom	a length value, a percentage value, auto
margin-top	a length value, a percentage value, auto
margin	auto, a length value, a percentage value
padding-top	auto, a length value, a percentage value
padding-bottom	auto, a length value, a percentage value
padding-left	auto, a length value, a percentage value
padding-right	auto, a length value, a percentage value
padding	auto, a length value, a percentage value
border-color	a color by name, hexadecimal value or rgb value
border-style	none, dotted, dashed, solid, double, groove, ridge, inset, outset
border-top	a length value, medium, thin, thick
vborder-bottom	a length value, medium, thin, thick
border-right	a length value, medium, thin, thick
border-left	a length value, medium, thin, thick
border-width	a length value, medium, thin, thick
border	border-width, border-style, color
width	auto, a length value, a percentage value
height	auto, a length value
float	none, left, right, both
clear	none, left, right, both
display	block, inline, list-item, none

Positioning Controls

NAME	POSSIBLE VALUES
position	static, absolute, relative, fixed, auto
left	auto, a length value, a percentage value
top	auto, a length value, a percentage value
bottom	auto, a length value, a percentage value
right	auto, a length value, a percentage value
z-index	auto, a number value

Visibility Controls

NAME	POSSIBLE VALUES
clip	auto, a shape value
overflow	visible, hidden, scroll, auto
visibility	inherit, visible, hidden, hide, show

F

ABOUT THE CD-ROM

The CD-ROM contains all the files necessary for completing the tutorials in the book in addition to software trial versions and helpful freeware. Please refer to the book preface for the minimum system requirements. You must also configure your Web browser according to the instructions found in Part I, Chapter 1.

There are two folders on the CD-ROM:

- *Tutorials*
- *Software*

TUTORIALS

The *Tutorials* folder contains the files you need to complete each tutorial in the book. The directories are divided first by the part number of the book to which they apply. The files are then divided into directories named for the chapter in which they appear. Each chapter's directory includes the student files you will need to complete the lesson as well as finished files for each stage of the current project.

To complete the tutorials in the book, you should copy the *Tutorials* directory to your computer's hard drive.

There are four main folders in the Tutorials Folder:

Part_I
- *Chapter 1* directory (This directory is intentionally empty because there are no files necessary.)
- *Chapter 2* directory includes the subdirectory *Ch_2_The_XML_ Tour*

Part_II
- *Chapter 3* directory includes the following subdirectories:
 - Ch_3_Well-Formed_XML_1
 - *Ch_3_DTD_2*
 - *Ch_3_Schema_3*
- *Chapter 4* directory includes the following subdirectories:
 - *Ch_4_Display XML with CSS_1*
 - *Ch_4_How to write XSLT_2*
 - *Ch_4_Configuring DW as an XML Editor_3*
- *Chapter 5* directory includes the following subdirectories:
 - *Ch_5_How to Create DW XML-Based Web Pages_1*
 - *Ch_5_How to Modify XML for DW Templates_2*
 - *Ch_5_How To Use XML with ColdFusion_3*

Part_III
- *Chapter 6* directory includes the following subdirectories:
 - *Web_Banner*
 - *Ch_6_XML_Generated_Images*
 - *Ch_6_XML_Generated_PNGs*

Part_IV
- *Chapter 7* directory includes the following subdirectories:
 - *Ch_7_Finished Files*
 - *Ch_7_Student Files*

A complete list of files is included in Appendix A. At the beginning of each chapter in the book, you will find a list of the data files used in that chapter's tutorials.

SOFTWARE

The *Software* folder contains trial versions of the Macromedia software needed to complete the tutorials in the book. In addition, freeware used in Chapter 5, Tutorial One is included.

Macromedia Trial Software Folder: This folder contains the following subdirectories:
- *PC Software*
- *Mac Software*

XFactor Folder: This folder contains the following files:
- *xfactor.exe*
- *readme.htm*
- *XFactor.jpg*
- *arw.gif*
- *saxon.exe*

Macromedia Software can be downloaded from *www.macromedia.com*.

GLOSSARY

application server—Performs processing on behalf of the Web server. The Application server provides access to a database and interprets the code necessary to process the data (such as JSP, ASP, and ColdFusion).

ASP—Active Server Pages. A server-side scripting technology based on JavaScript or VBScript that is used to create database-driven Web sites.

ASP .NET—Active Server Pages .NET. A server-side scripting technology developed by Microsoft that is used to create database-driven Web sites.

attribute—XML content that adds additional information to an element. Attributes are in the form of a name with a value that is associated with an XML element. This name/value pair further describes an XML element. The follow example is an attribute named `type` whose value is equal to `fax`.
`<phone type= "fax">`

attribute declaration—A declaration in a DTD that specifies an attribute's name, type, and default value, if any.

Cascading Style Sheets (CSS)—CSS is a style sheet language used to format and lay out HTML pages. CSS can also be used to add presentation or formatting information to an XML file.

Cascading Style Sheet rule—An individual rule written in CSS that provides formatting or layout information for an element in an HTML or XML file. The following example formats the address element in 18-point bold Helvetica:

address { font-size:18pt; font-face: Helvetica; font-weight: bold }

character entity—Pre-defined code symbols that allow you to use reserved markup characters in an XML document. Similar to character entities (such as © for the copyright symbol) in HTML; however, only five pre-defined character entities are available in XML. Any other characters must be declared in a Document Type Definition. The five pre-defined character entities for XML are: & (ampersand), > (great-than symbol), < (less-than symbol), " (quotation mark), and ' (apostrophe).

ColdFusion—A Macromedia server technology with a tag-based syntax used to create dynamic Web sites.

ColdFusion Markup Language—The markup language recognized by the ColdFusion Application server.

comment—A section of markup within an XML document containing text that is not part of the document and is there for the benefit of human readers of the XML file.

<![CDATA[]]>—Part of an XML file in which the code inside of it is not interpreted as markup. A CDATA section can include the characters < and >, and the characters are treated as text, not markup.

Document Type Definition (DTD)—A set of rules that dictate what elements an XML file may contain as well as the content of those elements, their attributes, and their possible values and the order in which the element should appear. DTDs also declare entities and notations.

Dreamweaver Application Programming Interface (DWAPI)—The programming interface used by the Dreamweaver application. It is the methodology that you use to program the Dreamweaver application.

Dreamweaver document rype—The document types that Dreamweaver supports such as HTML, XML, and WML.

Dreamweaver tag library—A tag library, in Dreamweaver, is a collection of tags of a particular type, along with information about how Dreamweaver should format the tags. Tag libraries provide the information about tags that Dreamweaver uses for code hints, target browser checks, the Tag Chooser, and other coding capabilities.

Dreamweaver template—Web pages given the .dwt extenstion that are used to create multiple Web pages with the same layout and design. They contain the common elements of all Web pages within a Web site, with some areas designated as locked and others as editable. (See **editable re-**

gion) A document that is created from a template remains connected to that template (unless you detach the document later). You can modify a template and immediately update the design in all documents based on it.

dynamic Web page—A Web page that is partially or completed created by information dynamically supplied to it from an independent source such as a database.

editable region—An unlocked region in a template-based document—a section a template user can edit. This is the portion of a Web page created by a Dreamweaver template (.dwt) file that can be altered or edited. It is not locked, as are other parts of a template.

element—An element is a unit of information in an XML file. It is the proper name for XML tags. An element consists of an opening tag, a closing tag, and the content between the two. The following example is an address element:

```
<address>123 Main Street</address>
```

encoding type—An encoding type identifies the system used to assign a character to a computer byte number (the 1s and 0s that computers understand). Different encoding types are capable of assigning numbers to different characters. For example 0-9, A-Z, a-z, and some fairly common symbols such as $, %, and * use the ASCII encoding type. Some encoding types clash or duplicate one another, using a different number for the same symbol. Unicode provides a unique number for every character, no matter what the platform, the program, or the language. XML uses Unicode.

entity—A component of an XML file that represents a discrete object such as an external file, for example, a graphic file.

external Document Type Definition—A DTD file that is given the extension .dtd. XML files then link to this .dtd file in the prologue.

GML—The first of the markup languages, which ultimately became an International Standards Organization (ISO) Standard called SGML.

image variable—Fireworks variables that are placed within curly brackets. Image variables are specified in the name field of the Image Property Inspector.

internal Document Type Definition—A document type definition that is declared within an XML document before the first start tag.

\<item\>—The only child tag for \<templateItems\> and the root element of an XML file created by exporting the contents of a Dreamweaver template using the Use Standard Dreamweaver XML Tags option.

JSP—A Java-based technology for creating fast, responsive, dynamic Web sites. JSP requires a Java server such as a J2EE server to interpret the code.

meta-data—Information or meaning about data.

metalanguage—A markup language used to create other markup languages. SGML is a metalanguage that was used to create HTML. XML is a metalanguage.

Microsoft Schema—A Microsoft-endorsed alternative to a DTD that is better suited to data-intensive XML or XML generated from a database. A Microsoft Schema is known as an XML Data Reduced (XML-DR) schema, and it uses the extension .xdr.

MSXML—The Microsoft XML Parser for the Internet Explorer 5.x browser or later. A version number, for example, MSXML 4.0, usually follows it.

namespace—A method of qualifying the names used in XML documents to make them unique (and assign ownership of the tag vocabulary) by associating the element names with contexts identified by a Uniform Resource Identifier, such as a URL.

nodes—Discrete elements of an XML document.

Node-Set—A group of nodes returned by an XPath expression considered as an explicit set.

optimize (image)—Managing the settings of a Fireworks graphic to control its size, file type, and colors. The goal of optimizing an image is to reduce the file size to as small as possible without sacrificing the overall quality of the image.

Personal Web Server (PWS)—A Windows component that allows developers to test dynamic Web sites by simulating Web server software.

processing instruction—A part of XML markup that provides instructions for the software that is processing the XML file.

Resource Description Framework—A method of processing meta-data that enables the automated processing of Web-based documents.

root element—An element that contains all the other elements in the document. An XML document must contain one and only one root element. This is also known as the Document Element.

Saxon—A command-line XSL-T processor for the Windows operating system written by Michael Kay.

schema—An alternative to a DTD that is better suited to data-intensive XML or XML generated from a database.

Semantic Web—A representation of data on the World Wide Web. It is a collaborative effort led by W3C with participation from a large number of researchers and industrial partners. It is based on the Resource Description Framework (RDF), which integrates a variety of applications using XML for syntax and URIs for naming.

Structured Query Language (SQL)—A standard query language used for retrieving information from a database.

<templateItems>—The root element of an XML file created by exporting the contents of a Dreamweaver template using the Use Standard Dreamweaver XML Tags option.

text variable—Fireworks variables that are placed directed in on-screen text.

URL variable—Fireworks variables that are assigned to slices and placed in the Link field of the Slice Property Inspector.

valid XML—A well-formed XML file that conforms to the rules set forth in a DTD or schema.

W3C Schema—A World Wide Web Consortium-endorsed alternative to a DTD that is better suited to data-intensive XML or XML generated from a database.

WML—The Wireless Markup Language (WML) that uses the Wireless Application Protocol (WAP) to convert HTML Web pages or XML files into a format that cell phones, portable digital assistants (PDAs), and other wireless devices can display on their small screens.

Web Services—Programmatic interfaces made available on the World Wide Web that can be used for application-to-application communication.

well-formed XML—The minimal structural requirement to which XML documents must conform. An XML file that contains one root element followed by properly nested elements, where any elements containing attributes have values in quotation marks and all elements contain open and

closing tags. Well-formed documents also conform to a few other rules. See Chapter 3.

World Wide Web Consortium (W3C)—An international group of vendor companies that act to create standards-type recommendations for the World Wide Web.

XHTML—The latest version of HTML that conforms to the XML standard.

XML—The Extensible Markup Language, a metalanguage, is a simplified version or subset of the Standard Generalized Markup Language (SGML) that is published and maintained by the World Wide Web Consortium.

XML declaration—A processing instruction at the start of an XML document that declares it to be XML code.

XML Document Object Model—The Document Object Model used to manipulate or navigate an XML file with JavaScript, ColdFusion, and other languages. It is a node-based application-programming interface for XML.

XML parser—An application that extracts information from an XML document and parses it back to another application for display or processing.

XML prologue—The beginning of an XML file prior to the root element that describes the document that follows, including the XML declaration and links to DTDs, schemas, or stylesheets.

XML tree structure—The treelike structure of elements in an XML file composed of recurring elements called node-sets and individual elements called nodes. Element nodes with child elements are branches on the tree, and elements without children are leaves.

XPath—A syntax for defining the exact location of information contained in an XML file through expressions that can access nodes, attributes, comments, text, and characters; A W3C-recommended language used to reference parts of an XML document.

XSL—A World Wide Web Consortium (W3C) language for expressing style sheets for XML. It has been divided into two parts: XSLFO and XSL-T.

XSL-T—The XML Stylesheet Language developed specifically by XML that includes scripting abilities, conditional statements, and processing through loops and templates.

XSL-T processor—A component of an XML parser that is capable of processing XSL-T style sheets.

XSL Template—The portion of an XSL-T file that provides the XML node to match and ultimately transform via the XSL-T language. The template body contains the literal instructions, elements, and text that make up the content of the `<xsl:template>` element.

INDEX